ONE THOUSAND NEW YORK BUILDINGS

ONE
THOUSAND
NEW YORK
BUILDINGS

PHOTOGRAPHY BY JORG BROCKMANN

TEXT BY BILL HARRIS

Foreword by Judith Dupré

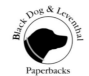

Black Dog & Leventhal
Paperbacks

ISBN 1-57912-443-7

Library of Congress Cataloging-in-Publication Data

Brockmann, Jorg.
1000 New York buildings / photography by Jorg Brockmann ; text by Bill Harris.
p. cm.
Includes index.
ISBN 1-57912-443-7
1. Historic buildings—New York (State)—New York—Pictorial works.
2. New York (N.Y.)—Buildings, structures, etc.—Pictorial works.
3. Architecture—New York (State)—New York—Pictorial works.
4. New York (N.Y.)—Tours. I. Title: One thousand New York buildings. II. Harris, Bill, 1933- III. Title.

F128.37 .B76 2002
974.7'1'00222—dc21

2001056614

Book design: Sheila Hart Design, Inc.

Printed in China

Published by
Black Dog & Leventhal Publishers, Inc.
151 West 19th Street
New York, New York 10011

Distributed by
Workman Publishing Company
708 Broadway
New York, New York 10003

g f e d c b a

The photographer would like to acknowledge
James Driscoll and Erik Freeland for providing additional photography for this book.

CONTENTS

FOREWORD

Tall masts of Mannahatta! Superb-faced Manhattan! Beautiful hills of Brooklyn! Vast, unspeakable show and lesson! My city! Has anyone since Walt Whitman done justice to the ecstatic inventory of New York? This book comes close, with a thousand portraits, some familiar, some less so. It is a year-book of sorts, picking out individuals in a cast of thousands, putting names to faces that are some-times overlooked in the presence of New York's powerful, indivisible gestalt.

On New York streets, time, history, and memory converge and disperse with breathtaking speed. It is a living space, framed by street after street of widely disparate structures, every corner, every inch impossibly cobbled together by generations alike only in their ambition. It is gritty with dirt and failed dreams, a gray city made alabaster by virtue of the hopes of the sheer numbers who call it home.

There is no ambivalence in New York. It's too tough a place. Sure, there are days of ambivalence, years even, but the thought of living anywhere else is unfathomable to those under its spell. Native birth has nothing to do with being a New Yorker. Nor years—one can become a New Yorker in an instant. Even those who have physically left never leave completely. Welded into a wrought-iron fence at the World Financial Center, overlooking the Hudson River, are Frank O'Hara's words: "One need never leave the confines of New York to get all the greenery one wishes. I can't even enjoy a blade of grass unless I know there's a subway handy, or a record store, or some other sign that people do not totally regret life."

Another poet. Describing the world pulse that beats here always comes down to distillation. One can attempt to categorize New York, realizing all the while that its essence, like the elephant described by the six blind men, defies pat definition. Aficionados of skyscrapers, churches, bridges, restaurants, or residences in any of the five boroughs could speak volumes on all those subjects, and have. In its infi-nite variety and fluidity, the city cannot be pinned down. One view can merely be added to the thou-sands that have been offered and yet will come.

Kurt Vonnegut coined the phrase "Skyscraper National Park" to describe Manhattan. The idea of the city as a national park, a rare configuration that deserves protection, approaches truth. Some call the deep spaces that are formed by New York's tall buildings "canyons" but, with a connotation more geologic than urban, the word seems inadequate to describe the city's chiseled verticality. Skyscrapers, the most spectacular display of our civilization's technical prowess, are made by human hands. We are dwarfed by their shadows and yet they are our creations. This uneasy possession, we by them or them by us, sets up a reflexive tension that adds to the city's nerve.

Manhattan's brash ascendancy is made possible by the island's solid schist foundation and exagger-ated by the two rivers that contain its twenty-two square miles. Because of her skyscrapers, Manhat-tan invariably claims the lion's share of visibility, though it is but a fraction of the 320 square miles that make up New York City.

Everyone in New York weighs 150 pounds. As any elevator mechanic can tell you, that's the weight those "maximum occupancy" notices in elevators are based on. Ask him about skyscrapers and he'll

speak the language of his profession—"low-rise, high-rise and freight"—about twenty such elevators in a building a block wide. It was all uphill once Elijah Otis figured out in 1854 that people get grumpy if they have to climb more than six flights of stairs. Though every other aspect of a skyscraper can change, its core—the elevators—rarely do. If you pause too long between car and lobby, the door will begin to close, a process known in the business as "nudging," no doubt with New Yorkers in mind. Don't try to stop them. The doors will win every time.

What is a skyscraper? Existing beyond the debate of steel skeletons versus the inclusion of elevators is the one true definition: intent of scale. Only in New York would a fifty-story building appear a modest proposal. Louis Sullivan built only one building here, the Bayard Building on Bleecker Street, yet surely he had New York's swagger in mind when he defined a skyscraper: "The force and power of altitude must be in it, the glory and pride of exaltation must be in it. It must be every inch a proud and soaring thing, rising in sheer exaltation that from bottom to top it is a unit without a single dissenting line."

The Empire State, Chrysler, Daily News, American Radiator buildings and Rockefeller Center epitomize the golden age of the skyscraper between the two World Wars. Mies van der Rohe's bronze Seagram Building heralded the arrival of the International Style, presaged six years earlier and just across Park Avenue, by the remarkable glass-clad Lever House. Only a New York character like Philip Johnson could recycle the past with postmodern buildings that have been notoriously compared to Chippendale furniture (the Sony Building) or a tube of lipstick (53rd at Third). The current hybrids bred from modernist, postmodern, and vernacular styles pale beside a true original, Frank Lloyd Wright's Guggenheim Museum.

It was in October 2001, in Washington, DC, that I began to grasp the enormity of New York's loss after the fall. When that city was laid out it was conceived as a star, with each of the main avenues punctuated by a view of the domed Capitol, a constant reminder of democratic ideals. When the World Trade Center went up, the twin towers shunned the mere scale of the streets, preferring instead to be creatures of the sky. They had no relationship to human measure, their size was beyond even New York's large grasp. They were always there, a navigational constant that was taken for granted. We are exhausted by the effort of understanding the new emptiness left in their wake. Like New York itself, they have entered the realm of myth, as real now in memory as they once were in steel and concrete. Perhaps more so. My ferocious love of the skyline has never been stronger.

I cannot decide if New York is a city of sidewalks or of sky. The sidewalks are addictive in their turbulence, theatricality, and liberating anonymity. The latter quality, the city's most delectable by far, left few convinced that a certain gentleman was innocent of his crimes by virtue of insanity, proof of which, his lawyers argued, was his propensity for walking around the Village in a bathrobe. I've ignored worse.

If you want to know New York, walk. Many of the gems portrayed in this book are tucked away in neighborhoods known best on foot. The shops comprise a world bazaar, especially in Brooklyn and Queens, the latter a veritable United Nations, just without the seats. The sidewalks are wide enough to hold despair and elation. The energy rising off them, whether yours or another's, can change the face of a day. It's theater at its finest, and free. Gawk upwards if you must, but *gimmeabreak*, don't block the flow.

New York's greatest mystery is the collective knowledge of its inhabitants, which travels from one to another through some strange osmosis that may or may not be related to the 96-point type used in the headlines of the *New York Post*. The street cannot be switched on or off. Its spiritual force is a religion.

The Woolworth Building, in lower Manhattan, is called the "cathedral of commerce." The uptown Asphalt Green, a parabolic-arched sanctuary for pothole repair, was condemned by Robert Moses as the "cathedral of asphalt." Between and beyond them are cathedrals that are, well, cathedrals. New York City is home to St. Patrick's Cathedral, spiritual anchor of Midtown; Cathedral of St. John the Divine, the world's largest cathedral; and Temple Emanu-El, the world's largest synagogue. From Abyssinian to Zion, the five boroughs boast hundreds of churches, temples, mosques, and synagogues. In Brooklyn, known as the Borough of Churches, spires are still visible on the skyline. It recalls the century, from 1790 to 1890, when Trinity Church at the head of Wall Street was the city's tallest building. Like New York's museums, theaters, and libraries, each of these houses of worship offers a presence and a possibility that enrich the city and our conception of it whether one enters them or not.

Bridges, those momentous doorways, connect New York City to itself and so to the world. A daily flood pours over them. The Gothic arches of the Brooklyn Bridge, the filigreed grace of the Queensboro Bridge, the immense span of the Verrazano Narrows Bridge, and the muscular heroics of the George Washington Bridge, known familiarly as George, are monuments. Each of them, along with their depots and innumerable smaller bridges, is breathtaking in history, conception, and utility.

On the day I moved to Manhattan, twenty years old and hungry, I missed the exit that takes you across the Triborough Bridge, into the city and away from everything that is small, safe, and predictable. I still question that ridiculously diminutive exit sign, which leads to the greatest city on earth. On that day, I landed somewhere in Brooklyn. A helpful soul gave me directions three times, and three times I squinted back at this exotic creature. I couldn't understand a word he was saying. Years later, I learned that this particular accent, of the "toidy-toid and toid" variety that has been mercilessly parodied in the media, is nearly extinct. Now I know it is a treasure, one of the many that come together to form this improbable, intriguing, demanding, generous place. On that day though, I would have handed over my passport if asked. Truly, New York was another world.

<div align="center">

Judith Dupré
January 2002

</div>

Judith Dupré is a cultural historian with a background in art, architecture, and education. She is the author of six books which have been translated into ten languages, including the best-selling titles Skyscrapers, Bridges, *and* Churches. *She graduated from Brown University with degrees in English literature and studio art, and studied architecture at the Open Atelier of Design and Architecture in New York City. She has been a New Yorker all of her life, although she managed to be born somewhere else.*

Photographer's Note

On the morning of September 11, 2001, I was in the kitchen with my family, twelve blocks from the World Trade Center, when the first plane flew just over our heads. I was scheduled to make a portrait of Castle Clinton in Battery Park, but I was running a little late. Within the next hour, the nature and meaning of this project changed just as the whole world changed. It became harder to accomplish—emotionally as well as logistically—but it also became much more personally important and meaningful. What had been a challenging job became a passion.

I use the term "portrait" when I refer to the pictures in this book because I have tried to capture the unique life within each building, the soul inside the stones and bricks of even the most mundane structures, the experiences and history they have absorbed over the years they have been silently serving us. And I have tried, as much as possible, to pare away the world surrounding the buildings, the confusion of city life, in order to unleash the true essence of each building.

But the buildings of New York don't exist in isolation—they live crowded together in sometimes unlikely juxtapositions just as its people do, presenting endless contrasts of style, size, materials, and function. And out of this visual chaos there emerges a kind of harmony. It wasn't until that harmony was so suddenly and radically disrupted that we paused to contemplate it. I mean this book to celebrate it.

I would like to dedicate *One Thousand New York Buildings* to my kids, Léo and Sasha, to my wife Céline, and to all of our American friends who made our stay in New York so wonderful over the seven years we lived there. I gratefully thank J. P. Leventhal, Laura Ross, True Sims, and Magali Veillon of Black Dog & Leventhal for recruiting me to work on this book and supporting my efforts at every turn. It has been one of the most fulfilling projects in my photography career. Photographers Erik Freeland and James Driscoll and my assistant Devin Hartmann were indispensable in helping me get the book finished on time, on budget, and with style. I salute the creativity and care of author Bill Harris, designer Sheila Hart, and master separator Thomas Palmer. I would like to thank Jim and Cornelia from MV Lab for carefully handling the film, and the team at Fotocare for their assistance. Finally, I would like to thank all of the people who provided access, encouragement, and sometimes even coffee throughout the months that I hauled cameras and equipment around the streets of New York.

Jorg Brockmann
January 2002

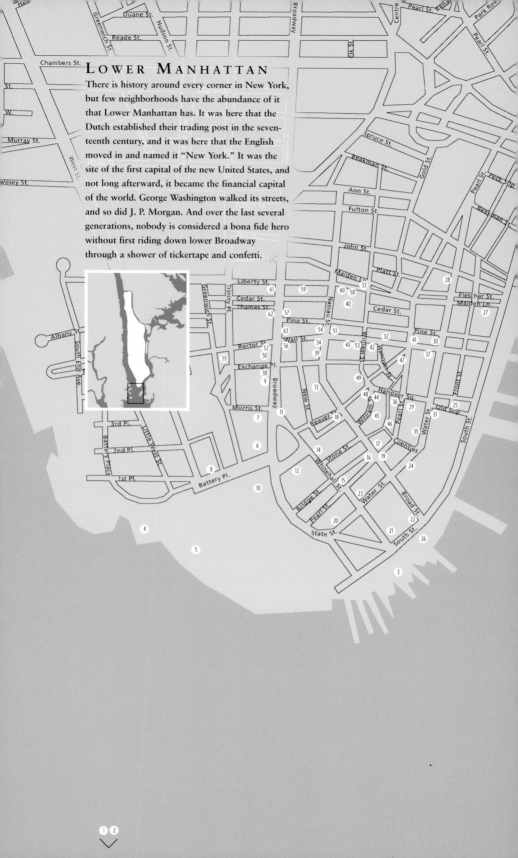

LOWER MANHATTAN

There is history around every corner in New York, but few neighborhoods have the abundance of it that Lower Manhattan has. It was here that the Dutch established their trading post in the seventeenth century, and it was here that the English moved in and named it "New York." It was the site of the first capital of the new United States, and not long afterward, it became the financial capital of the world. George Washington walked its streets, and so did J. P. Morgan. And over the last several generations, nobody is considered a bona fide hero without first riding down lower Broadway through a shower of tickertape and confetti.

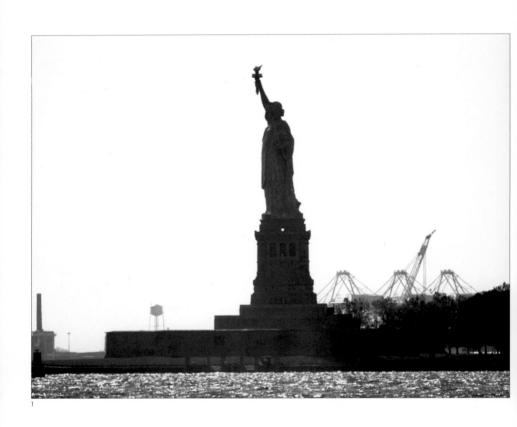

1

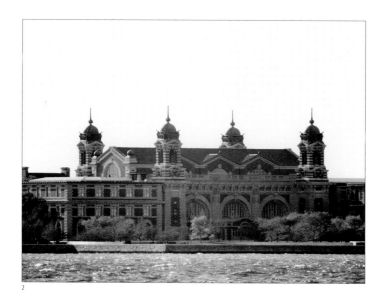

2

STATUE OF LIBERTY *L*

LIBERTY ISLAND

1886, FRÉDÉRIC AUGUSTE BARTHOLDI
PEDESTAL, RICHARD MORRIS HUNT
STEEL FRAMEWORK, ALEXANDRE GUSTAVE EIFFEL

When the French government offered Miss Liberty as a gift, the U.S. government turned a cold shoulder to the idea. The official United States position was that the Statue of Liberty was only going to benefit New York City. The New York State legislature refused to open its purse strings to get the statue erected on what was then called Bedloe's Island and, predictably, money ran out before the pedestal was finished. Joseph Pulitzer's newspaper, *New York World*, raised the needed $100,000 from more than 121,000 individuals. For the statue's centennial in 1986, the Statue of Liberty–Ellis Island Foundation spent more than $425 million to restore it and the former immigration station, all of it from donations made by people in every part of the United States who knew all along that the Statue of Liberty belonged to them all.

ELLIS ISLAND NATIONAL MONUMENT *L*

1898, BORING & TILTON
RESTORATION, 1991, BEYER BLINDER BELLE AND
NOTTER FINEGOLD & ALEXANDER

This was the gateway to America for more than 16 million immigrants who arrived here between 1892 and 1954. The last arrival was a Norwegian sailor who had jumped ship to find his way in the new country. The names of most of them are inscribed on the Wall of Honor outside the Main Building, now the National Museum of Immigration. President Lyndon Johnson declared the island a National Monument in 1965, but Congress refused to appropriate the money it would take to restore it. The "private sector" finally did the job, but the dormitories and hospital buildings on the island's south side are still weed-choked and waiting for somebody to heed their call for help.

L = Officially designated landmark

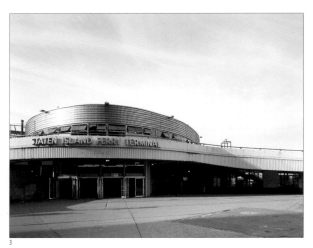

3

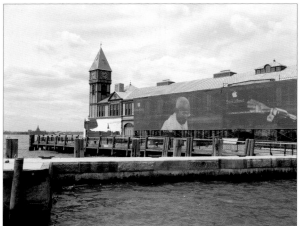

4

5

3
STATEN ISLAND FERRY TERMINAL

SOUTH STREET AT WHITEHALL STREET

1954, ROBERTS & SCHAEFER

This structure is functional, but that is about all that can be said for it. It will be replaced one of these days, just as it replaced an ornate, French-inspired building itself. But in the meantime, the free boat ride to Staten Island and back makes it one of the city's top tourist attractions.

4
PIER A

BATTERY PLACE AT WEST STREET

1886, GEORGE SEARS GREENE, JR.

Now with a new lease on life as a visitors' center, this former fireboat station is one of the oldest piers on the Hudson River and the only one designated by a letter rather than a number. Its seventy-foot tower and clock, which peals the time in ship's bells, is a memorial to the 116,000 servicemen who died in World War I.

5
CASTLE CLINTON NATIONAL MONUMENT

NORTHWEST CORNER OF BATTERY PARK

1811, JOHN McCOMB, JR.

Built as part of the defense preparations for the War of 1812, the former West Battery became the city's immigrant reception center before the entry point was moved to Ellis Island. Later it was converted to a 6,000-seat concert hall, and then the New York Aquarium. In the 1940s Robert Moses had it condemned to make way for a new bridge to Brooklyn. Cooler heads prevailed, but all that was left to save was the fort's eight-foot-thick walls, now enclosing the ticket office for the Statue of Liberty Ferry.

6

What's Your Street Address?

In 1811, the state legislature established an orderly rectangular grid of streets and avenues above 14th Street and, thanks to them, if you can count, you can't get too lost in Manhattan. The 2,000 long, narrow blocks they created were subdivided into building lots, usually twenty-five by one hundred feet, which were just as orderly as the grid itself. But if a developer were to combine several of these lots, he had a choice of street addresses. To prevent the confusion that might result, the Borough President was given the responsibility of assigning building numbers. Under the rule, a builder must submit a diagram showing how lots are to be combined or divided, and a number is assigned. The process isn't very complicated, but sometimes a builder proposes filling an entire block, which offers a choice of all the addresses on four sides, and sometimes the request for an assigned number is "none of the above." In those cases, the Borough President gets personally involved in approving a "vanity address." That is how we wound up with the super-blocks at the foot of Water Street identified as "New York Plaza," for example. It may confuse people, but those who need to know, such as the police and fire departments and the postal service, are let in on the secret.

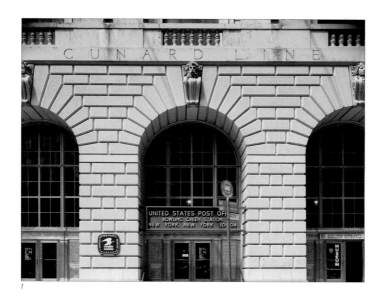

7

ONE BROADWAY ℒ

AT BOWLING GREEN

1884, EDWARD H. KENDALL
REMODELED, 1922, WALTER B. CHAMBERS

Once the office of the United States Lines, the building's frieze is decorated with symbols of its fleet's ports of call. The doors to the bank that replaced the steamship company's ticket offices are marked with classes of passage on such ocean liners as *America*, *Leviathan*, and *George Washington*.

CUNARD BUILDING ℒ

25 BROADWAY ON BOWLING GREEN

1921, BENJAMIN WISTAR MORRIS WITH CARRÈRE & HASTINGS
CEILING SCULPTURE, C. PAUL JENNEWEIN
CEILING MURALS, EZRA WINTER
ALTERATIONS, 1977, HANDREN ASSOCIATES

Built for the owners of such great ocean liners as *Queen Mary* and *Queen Elizabeth*, the landmarked interiors of this building are among the city's greatest treasures, intended to give passengers an advance taste of the voyage ahead and proving the line's yet uncoined advertising slogan that "Getting There Is Half the Fun." When this gorgeous space was built, one critic wrote that the Great Hall of the Metropolitan Museum "suffers by comparison." Cunard's former ticket offices on the ground floor have been obscured, although left untouched, by the addition of a post office facility.

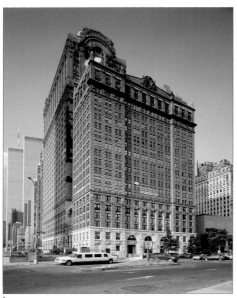

8

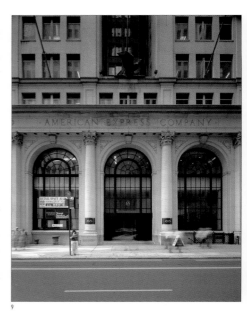

9

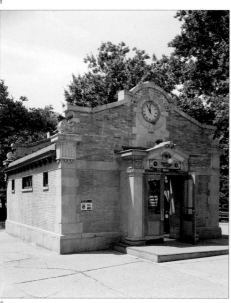

10

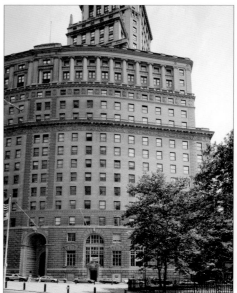

11

8 WHITEHALL BUILDING *L*

17 BATTERY PLACE AT WEST STREET

1900, HENRY J. HARDENBURGH
REAR ADDITION, 1910, CLINTON & RUSSELL

Before the bulky addition was built on its north side, Hardenburgh's building was three-sided, with façades on West and Washington Streets and Battery Place. He carefully made it part of the view across Battery Park, and the view from the other direction is just as fabulous. That is why the McAlister Towing Company chose it for their offices: it's the best place in the neighborhood to keep an eye on their tugboats.

9 STANDARD & POORS BUILDING *L*
(ORIGINALLY RAILWAY EXPRESS COMPANY)

65 BROADWAY
BETWEEN EXCHANGE ALLEY AND RECTOR STREET

1919, RENWICK, ASPINWALL & TUCKER

Before there were overnight air shipping companies, Railway Express was the fastest, often the only, way to get packages from here to there. It was a big business and it was run from this unusual H-shaped building until the wave of the future caught up with it.

10 BOWLING GREEN IRT CONTROL HOUSE *L*

BATTERY PLACE AT STATE STREET

1905, HEINS & LA FARGE

Along with its twin at 72nd Street and Broadway, this is a reminder of the intended glory of New York's first subway, the Interborough Rapid Transit Company. Although most of the original subway's entry points had steel and glass kiosks, important stations like this one were marked with brick and stone structures meant to resemble garden pavilions. "Control house" refers to its function of controlling the comings and goings of passengers in and out of the stations.

11 STANDARD OIL BUILDING *L*

26 BROADWAY AT BOWLING GREEN

1922, CARRÈRE & HASTINGS

When John D. Rockefeller arrived in New York in 1886, he commissioned Ebenezer L. Roberts to build a nine-story headquarters building on this site for his Standard Oil Company. Ten years later he hired Kimball & Thompson to add a nineteen-story annex and another six floors on top of the original building. Then in 1922, he called in Carrère & Hastings to make some sense of the resulting mess and add yet another annex. What they gave him was a building that hugs the curve of Broadway, but matches the grid of the skyline in its tower. The chimney at the top is hidden inside a representation of an oil lamp, a nod to Rockefeller's success at marketing kerosene for the lamps of America.

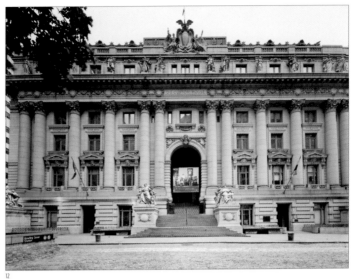

ALEXANDER HAMILTON CUSTOM HOUSE

ONE BOWLING GREEN
BETWEEN STATE AND WHITEHALL STREETS

1907, CASS GILBERT
"FOUR CONTINENTS" SCULPTURES, DANIEL CHESTER FRENCH
ROTUNDA MURALS, 1937, REGINALD MARSH
ALTERATIONS, 1994 EHRENKRANTZ & EKSTUT

When he won this commission, architect Cass
Gilbert wrote, "while having a practical pur-
pose [the building] should express in its adorn-
ment something of the wealth and luxury of the
great port of New York." Once the country's
biggest collector of import duties, the building
became surplus federal property after the Cus-
toms Service moved to the World Trade Center
in 1977, and has since become home to the
Smithsonian's Museum of the American Indian.
This is the site of Fort Amsterdam, which the
Dutch built to protect their original settlement
and where Director General Peter Stuyvesant
was forced to surrender it to the British, who
renamed it New York. In those days it was the
water's edge. Everything west of the Custom
House is landfill.

THE WORLD IN STONE

The façade of the Custom House is one of the most impressive examples of the Beaux Arts style anywhere in the city. The window arches contain heads of the "eight races of mankind": Caucasian, Celtic, Eskimo, Slavic, African, Hindu, Mongolian, and Latin (this is the work of artists, not anthropologists). The row of statues above the cornice represent twelve great commercial nations throughout history, and the cartouche over the main entrance, by Karl Bitter, makes it a baker's dozen by representing the United States. Mars, the Roman god of commerce, is represented in the capitals of each of the forty-four Corinthian columns that surround the building.

The centerpiece of all this iconography is the sculptures on the ground floor level by Daniel Chester French, representing the four corners of the world. Asia is seen as the mother of religions, with a Buddha in her lap, a lotus in her hand, and a cross behind her. A tiger glares at her, suffering people surround her, and skulls are littered at her feet. Next on the left of the stairway is America, surrounded by symbols of confidence and industry. Europe is represented by a figure, shrouded in Grecian robes, with an open book, a ship's prow, a frieze borrowed from the Parthenon, and a shadowy figure representing a long past. Last on the right is Africa, a sleeping figure between a sphinx and a lion. Another draped figure seems to be contemplating an unknown future.

Daniel Chester French, the creator of this group, is best known for his statue of Abraham Lincoln at the Lincoln Memorial in Washington. He also created three of the statues on the Appellate Court at Madison Square, four on the façade of the Chamber of Commerce Building on Liberty Street, and the statue of Alma Mater at Columbia University.

40 Broad Street

BETWEEN EXCHANGE PLACE AND BEAVER STREET

1982, GRUZEN & PARTNERS

Though relatively undistinguished on its Broad Street side, this building has a wonderful rear façade that slopes downward to New Street. In the days the Dutch were doing business here, the intersection of Broad Street and Exchange Place was at the very heart of commercial activity, and the space this building occupies was almost constantly filled with beaver pelts, piled higher than a man's head, that were bound for the Old Country.

2 Broadway

BETWEEN STONE AND BEAVER STREETS

1959, EMERY ROTH & SONS
REMODELED, 1999, SKIDMORE, OWINGS & MERRILL

The first building in the financial district to break with the tradition of solid masonry walls, its bland curtain walls didn't do a thing for the banking community's sense of aesthetics. Even its owner, Uris Brothers, seemed to agree and attempted to make it interesting by adding abstract mosaics over the entrances. That didn't work, either. *Architectural Forum* magazine called it "Off-Tune on Broadway."

Broad Financial Center

33 WHITEHALL STREET AT PEARL STREET

1986, FOX & FOWLE

When the Dutch ran this city, the main thoroughfare was a canal called de Heere Gracht, but when the British took over in 1664, they filled it in and called it Broad Street—an appropriate name because, thanks to the size of the canal, it was the widest street in the colony. The name has been considered important ever since, which is why this tower on Whitehall Street pretends it has a Broad Street address.

New York Clearing House

100 BROAD STREET BETWEEN PEARL AND BRIDGE STREETS

1962, ROGERS & BUTLER

Owned by 11 of the country's biggest financial institutions, more than $1.5 trillion moves through the Clearing House's computers every business day, including about 95 percent of all international electronic payments in US dollars. The organization was formed in 1853 to move checks from one bank to another and settle debts among them. Check clearing and electronic transfers are handled elsewhere, but its headquarters in this little building could be considered New York's real world trade center.

Goldman-Sachs Building

85 BROAD STREET AT PEARL STREET

1983, SKIDMORE, OWINGS & MERRILL

According to the zoning law, the design of this monster was supposed to be complementary to the landmarked Fraunces Tavern block on the other side of Pearl Street, which provided the air rights necessary to make it as large as it is. But something was obviously lost in the translation. There is a very small nod to history inside, in a pair of glassed-in displays of seventeenth-century artifacts uncovered during the excavation of its foundations.

American Bank Note Company

70 BROAD STREET
BETWEEN MARKETFIELD AND BEAVER STREETS

1908, KIRBY, PETIT & GREEN

Breaking with the tradition of dividing a façade into individual floors, this building is fronted with a monumental order of Corinthian columns. The attic above the cornice contains executive offices and a private dining room.

13

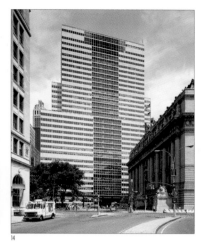

14

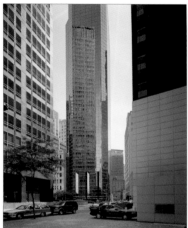

15

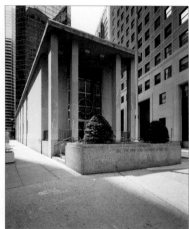

16

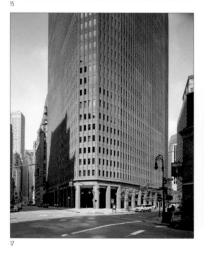

17

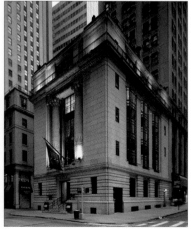

18

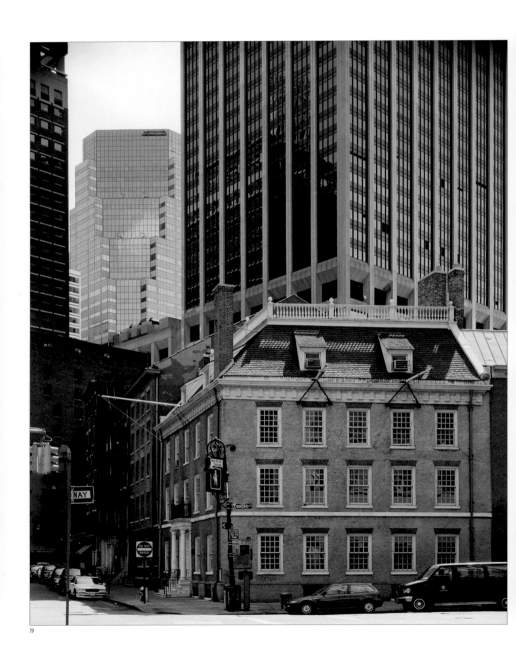

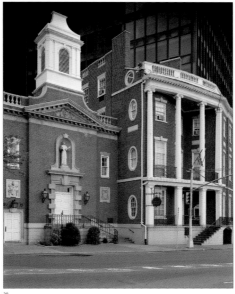

20

FRAUNCES TAVERN

54 PEARL STREET AT BROAD STREET

1907, WILLIAM MERSEREAU

The Tavern is a recreation of the 1719 Etienne DeLancey, which became the Queens Head Tavern in 1762. It was operated by Samuel Fraunces, a West Indian who also served as General George Washington's chief steward, which gave him an inside track as caterer for the gala banquet hosted by Governor Clinton to mark the evacuation of British troops from New York in 1783. The guest of honor was George Washington himself, who bade farewell to his own troops on the tavern's second floor. The building deteriorated until the Sons of the Revolution bought it in 1907 and rebuilt it from the ground up. There has been a restaurant on the site ever since, as well as a museum.

SHRINE OF
ST. ELIZABETH ANN BAYLEY SETON

7 STATE STREET
BETWEEN PEARL AND WHITEHALL STREETS

1806, JOHN McCOMB, JR.
RESTORATION, 1965, SHANLEY & STURGIS

Looking around the neighborhood today, it is hard to believe that State Street was once lined with a magnificent row of Federal-style houses that matched this one with its striking columns. Originally the James Watson house, the shrine is dedicated to the first American saint, Mother Seton, the founder of the Sisters of Charity and America's parochial school system. She may have lived in the house, which overlooked her native Staten Island. The adjoining Church of Our Lady of the Rosary was built at the time the shrine was restored in the 1960s.

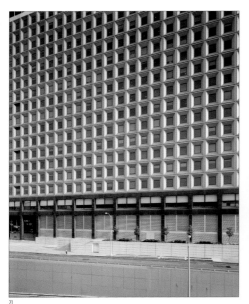

21

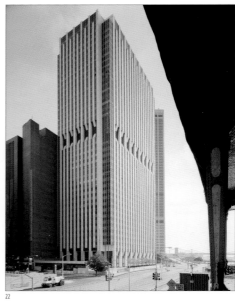

22

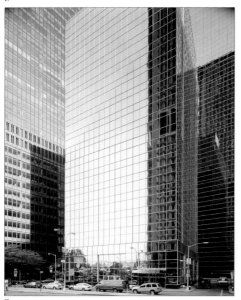

23

24

ONE NEW YORK PLAZA

WHITEHALL STREET AT SOUTH STREET

1969, WILLIAM LESCAZE & ASSOCIATES
DESIGN BY KAHN & JACOBS

Architecture critic Paul Goldberger compared this building's façade to "fifty stories of Otis elevator buttons (or blank TV screens)." His colleague, Ada Louis Huxtable, said it reminded her of "stamped barber shop ceilings." The AIA Guide chimed in that "Thousands of interior decorators' picture frames form an unhappy façade on this all too prominent, dark, brooding office tower."

2 NEW YORK PLAZA

125 BROAD STREET, AT SOUTH STREET

1970, KAHN & JACOBS

When this monster was ready for occupancy in 1971, there wasn't a moving van anywhere to be seen. The market for office space had dried up and there wasn't a single tenant interested in any of its 1.1 million square feet of space. Of course, that didn't stop the developers. By 1972, 55 Water Street, with three times the space of 2 New York Plaza, was looking for tenants and, as often happens in the New York real estate market, finding them was no problem.

3 NEW YORK PLAZA

39 WHITEHALL STREET
BETWEEN WATER AND PEARL STREETS

1886, S. D. HATCH
RECONSTRUCTED, 1986, WECHSLER, GRASSO & MENZIUSO

A flashpoint for Vietnam War protesters, this former U.S. Army Building was where generations of draftees went for their pre-induction physicals as far back as the Korean War. In the days when the draft was still in effect, any eighteen-year-old who got a letter beginning, " Greetings…" didn't have to read any further. It wasn't even necessary to ask how to get get here—every young man in the city knew exactly where it was. "Whitehall Street" said it all. The building, which resembled a castellated fortress, was swallowed up behind the glass walls that now enclose a health club, and offices rise above the original structure, which is still just under the surface.

4 NEW YORK PLAZA

WATER STREET
BETWEEN BROAD STREET AND COENTIES SLIP

1968, CARSON, LUNDIN & SHAW

In an unusual attempt to emulate its nineteenth-century neighbors, the architects specified a brick façade here, but they missed the point with larger-than-average bricks and narrow windows that give it a fortress-like appearance. The windows are intentionally small to keep sunlight and heat from the computers inside.

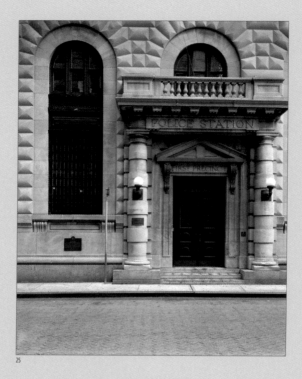

25

Streets for Ships

In Colonial times, fingers of water called "slips" were built along the East River to allow ships to load and unload their cargoes inland. Many of them were sites of what we today call "greenmarkets," where Long Island farmers brought their produce on barges to sell to the locals. By now, all of the slips have been filled in, but the names of many of them live on in the streets that replaced them: Burling Slip, Old Slip, Catherine Slip, and Beekman, Pike, and Coenties Slips.

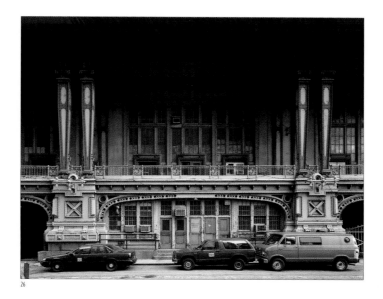

26

First Precinct, NYPD ℒ

100 Old Slip
BETWEEN FRONT AND SOUTH STREETS

1911, Hunt & Hunt

This precinct was called "the most important police district in the world," by A. E. Costello in his 1885 history of the force, *Our Police Protectors*. He explained: "Treachery on the part of [the] patrolmen for a couple of hours would enable criminals to possess themselves of booty amounting to millions." At the time the precinct was established here in 1884, its officers watched over the assets of thirty-two banks, the Custom House, the Federal Sub-treasury, and the New York Stock Exchange. All of these institutions, and others that have since joined them, have their own security departments today, and the precinct was moved to TriBeCa in 1973. The building housed the Landmarks Commission until 2001, whereafter it became the home of the Police Museum.

Battery-Maritime Building ℒ

11 South Street at Whitehall Street

1909, Walker & Gillette

Long after the Brooklyn Bridge was opened in 1883, fourteen different ferry lines still connected lower Manhattan and Brooklyn. The last of them, which wasn't shut down until 1942, was one of several that used this elegant terminal whose sheet metal exterior is painted green to match the weathered copper skin of the Statue of Liberty. It was also at the Manhattan end of the ferry to Governor's Island when it was a Coast Guard base, and is still the only connection to the island for the caretakers stationed there. At the time it was built as the Whitehall Ferry Terminal, it was one of dozens of buildings like it lining the waterfront, but it is the only one that has survived.

CONTINENTAL CENTER

180 MAIDEN LANE
BETWEEN PINE, FRONT, AND SOUTH STREETS

1983, SWANKE HAYDEN CONNELL & PARTNERS

Boston's Fenway Park has its "green monster," and this is New York's. Hitting a baseball in its direction is not recommended, although quite a few architecture critics have hurled brickbats at it.

NATIONAL WESTMINSTER BANK

175 WATER STREET
BETWEEN FLETCHER AND JOHN STREETS

1983, FOX & FOWLE

A pair of mirrored glass cylinders seems to be holding this building together. Workers excavating its foundations unearthed an eighteenth-century sailing ship buried in the landfill, and when word got out, the builders agreed to allow the public to have a look at it, but only on a single Sunday when the workers had the day off and digging wouldn't be interrupted. Part of the ship was rescued and sent to the Mariners' Museum at Newport News, Virginia.

7 HANOVER SQUARE

BETWEEN WATER AND PEARL STREETS

1982, NORMAN JAFFE AND EMERY ROTH & SONS

If the builders of eighteenth-century Georgian townhouses had known about steel beam construction, they might have built something like this twenty-six-story interpretation of their craft. On the other hand, aren't you glad they didn't?

WALL STREET PLAZA

88 PINE STREET AT WATER STREET

1973, I. M. PEI & ASSOCIATES

This white aluminum and glass building earned a special award from the American Institute of Architects for its "Classical purity." It isn't actually on Wall Street, but it does have one of the best plazas in the Wall Street neighborhood, containing a two-part stainless steel sculpture by Yu Yu Yang consisting of a L-shaped vertical slab with a circular opening facing a twelve-foot polished disk. It is a memorial to the Cunard liner *Queen Elizabeth I*, which burned in Hong Kong harbor as this building was being built.

77 WATER STREET

AT OLD SLIP

1970, EMERY ROTH & SONS

Zoning laws mandated public spaces for buildings like this, but few developers took the challenge as seriously as Melvyn Kaufman did for this twenty-six-story office building. Among its amenities is an old-fashioned candy store, "heat trees" to ward off the cold, and pools with bridges over them. He also installed a World War I fighter plane on the roof.

MORGAN BANK

60 WALL STREET, BETWEEN PEARL AND WILLIAM STREETS

1988, KEVIN ROCHE, JOHN DINKELOO & ASSOCIATES

This massive fifty-two-story tower gets along quite well with its neighbors. It contains an incredible 1.7 million square feet of office space, almost without flaunting its size. The bank is among the many legacies of John Pierpont Morgan, who was born in Connecticut and began his New York career as the American agent of his father's London-based firm, Dabney, Morgan and Company, in 1861.

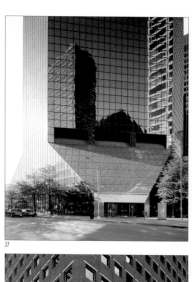

27

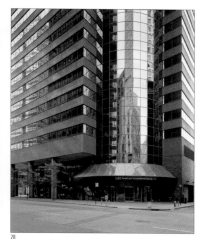

28

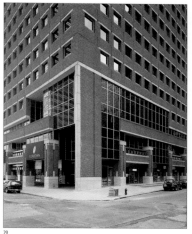

29

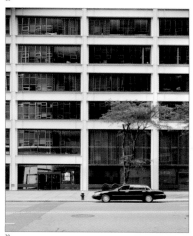

30

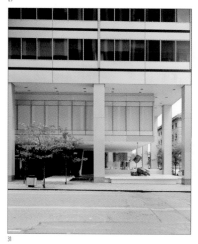

31

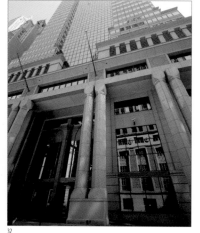

32

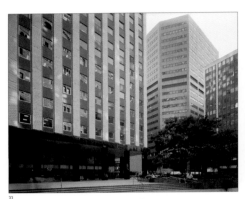

33

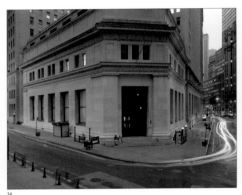

34

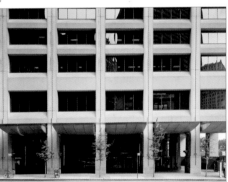

35

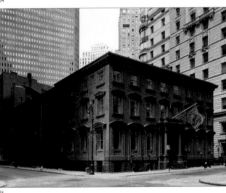

36

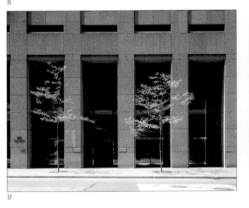

37

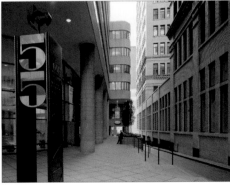

38

33

HOME INSURANCE PLAZA

59 MAIDEN LANE AT WILLIAM STREET

1966, ALFRED EASTON POOR

The small plaza in front of the Home Insurance Company is more important than the buildings that surround it. Maiden Lane is among Manhattan's oldest streets, originally a dirt path leading through the woods to a brook where young women (maidens, they say) came out every morning to do their laundry.

34

MORGAN GUARANTY TRUST BUILDING

23 WALL STREET AT BROAD STREET

1913, TROWBRIDGE & LIVINGSTON

The simple Classicism of this, his nerve center, was said to have been inspired by the personality of J. P. Morgan, who had been dominating American finance for a quarter-century when it was built. It was also a lightning rod for anti-capitalists, who set off a wagonload of dynamite on the sidewalk outside in 1920, killing 33 and injuring 400 innocent bystanders, and leaving visible scars on the Wall Street façade to this day.

35

55 WATER STREET

BETWEEN COENTIES AND OLD SLIPS

1972, EMERY ROTH & SONS

With more than 3 million square feet of rentable space, this was the largest commercial office building in the world when it was built. Only the Pentagon had more space. It consumed four small city blocks, in return for which the developer, Uris Brothers, agreed to rebuild Jeanette Park to its east. It is an unremarkable public space with nothing to recommend but the nearly forgotten seventy-foot New York Vietnam Veterans Memorial, designed by M. Paul Friedberg & Associates.

36

INDIA HOUSE

ONE HANOVER SQUARE
BETWEEN PEARL AND STONE STREETS

1853, RICHARD F. CARMAN

Since 1914, this has been a private club for businessmen dealing in foreign trade. In earlier times it was the headquarters of the Hanover Bank, then it became the New York Cotton Exchange, and later the home of W. R. Grace & Company. Hanover Square has been a public common since 1637, familiar to Captain William Kidd who, before he was hanged as a pirate in 1699, lived around the corner at 119 Pearl Street.

37

BARCLAY BANK

75 WALL STREET BETWEEN WATER AND PEARL STREETS

1987, WELTON BECKET ASSOCIATES

Among other public amenities mandated in return for added floor space here is a waterfall and enough greenery around it to qualify for the designation of a "park." But otherwise, this almost forbidding building doesn't hold much attraction. The façade above the entrance is hardly worth an upward glance.

38

ONE EXCHANGE PLAZA

BROADWAY, EXCHANGE ALLEY TO TRINITY PLACE

1982–84, FOX & FOWLE

Along with its twin, 45 Broadway Atrium, this brick and glass tower was originally conceived as a single building, but the developer wasn't able to assemble a lot large enough because the owner of a small restaurant in the middle of the site realized that he was sitting on a gold mine and set his price accordingly. The potential buyer refused to pay the price, so instead of one tower, he built two and let the restaurateur keep his business where it was.

THE FINANCIAL CAPITAL OF THE WORLD

It was Alexander Hamilton's idea that New York should be the center of securities trading when, as the country's first Secretary of the Treasury, he began issuing bonds to pay off the debts of the Revolutionary War. Two years later, in 1792, a group of twenty-four merchants and bankers met under a buttonwood tree on Wall Street and signed an agreement to regulate the buying and selling of stocks and bonds. The New York Stock Exchange was organized in 1817 by brokers who expanded and formalized those basic rules. In its early years, there were two sessions a day, during which the president of the exchange called out the names of each security, and members bid on them one at a time. Each member had his own assigned chair, and membership became known as having "a seat" on the exchange. The number of seats is now fixed at 1,366, and the average cost of one is about $50,000.

The exchange doesn't buy or sell securities, and a firm that wants to have its shares traded there must satisfy the very strict requirements of the Securities and Exchange Commission. More than 2,500 companies are listed, and the exchange handles some 100 million transactions a day. The institution is governed by a board that has ten members from the securities industry and ten representing the public.

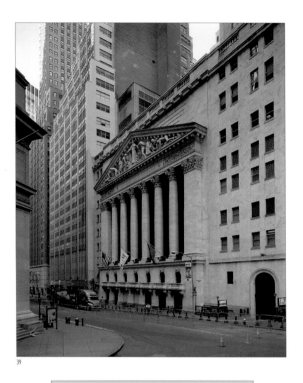

39

39

NEW YORK STOCK EXCHANGE

8 BROAD STREET
BETWEEN WALL STREET AND EXCHANGE PLACE

1903, GEORGE B. POST
PEDIMENT BY J. Q. A. WARD AND PAUL BARTLETT

Although Wall Street is synonymous with high finance, the real nerve center of the money world is inside this neo-Classical building around the corner, on Broad Street. The busy trading floor is accessible to the public, but only discreetly, through the annex next door at 20 Broad Street. The sculpture above the Corinthian columns, formally called *Integrity Protecting the Works of Man*, is a lead-coated replica of the original marble carving, placed there in 1936. The relief symbolically represents the Exchange as a reflection of national wealth.

CHASE MANHATTAN BANK TOWER

ONE CHASE MANHATTAN PLAZA
BETWEEN PINE AND LIBERTY STREETS

1960, SKIDMORE, OWINGS & MERRILL

When David Rockefeller announced plans to build a new headquarters for Chase Manhattan Bank, it was taken as a signal that lower Manhattan in general and the financial community in particular had finally turned the corner after the Great Depression. Better buildings would follow, but none as filled with hope for the future as this one. The stage was set by cladding the 800-foot tower with anodized aluminum panels that make it shine and stand out among its masonry neighbors. The plaza at its base is graced by Jean Dubuffet's forty-two-foot abstract sculpture called *Group of Four Trees*, installed in 1972 after a ten-year search for something appropriately monumental.

WILLIAMSBURGH SAVINGS BANK

74 WALL STREET AT PEARL STREET

1927, BENJAMIN WISTAR MORRIS

This ornate building was originally the headquarters of the Seaman's Bank for Savings. The architect made good use of his client's long association with the harbor by commissioning three large murals by Ernest Peixotta to trace the history of the port, then decorated the banking room and the Romanesque façade with representations of ships and mermaids, dolphins, and other iconography of the sea. If it weren't a bank, you might say that the design is playful.

REGENT WALL STREET HOTEL
(FORMERLY CITIBANK)

55 WALL STREET AT WILLIAM STREET

1841, ISAIAH ROGERS
CONVERTED TO CUSTOM HOUSE, 1863, WILLIAM A. POTTER
REMODELED, 1910, MCKIM, MEAD & WHITE

Originally the Merchant's Exchange, this structure served as the United States Custom House and for nearly ninety years it was the headquarters of National City Bank, and its successor, Citibank. After a brief stint as a catering hall, it was converted into a 144-room hotel in 1999. The wonderful Great Hall, designed by McKim, Mead & White, now serves as one of the most elegant ballrooms in the world.

TRUMP BUILDING

40 WALL STREET BETWEEN WILLIAM AND BROAD STREETS

1930, H. CRAIG SEVERANCE
WITH YASUO MATSUI AND SHREVE & LAMB
LOBBY ALTERATIONS, 1997, DERR SCUTT

Originally the main office of the Bank of the Manhattan Company, which merged with Chase Bank and moved into its building. In his book, *New York: The Wonder City*, W. Parker Chase said of this skyscraper, "no building ever constructed more thoroughly typifies the American spirit of hustle than does this extraordinary structure."

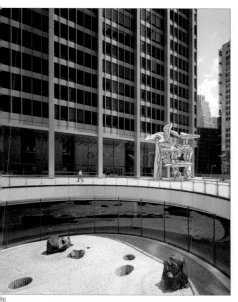

40

41

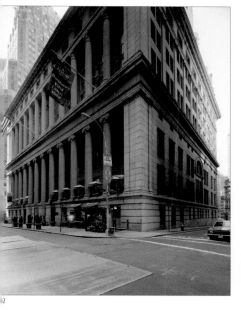

42

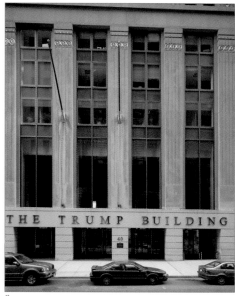

43

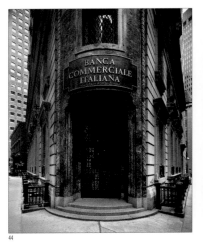

44

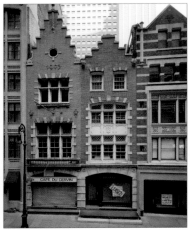

45

46

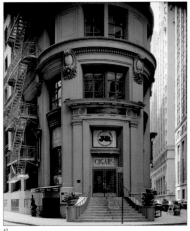

47

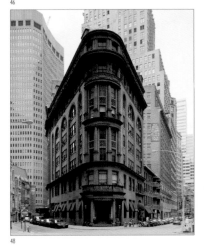

48

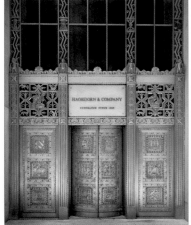

49

44

BANCA COMMERCIALE ITALIANA \mathcal{L}

ONE WILLIAM STREET AT HANOVER SQUARE

1907, FRANCIS H. KIMBALL & JULIAN C. LEVI
ALTERATIONS, 1929, HARRY R. ALLEN

Originally the Seligman Building, this twelve-story Baroque structure displeased turn-of-the-century architecture critics, but considering the angles of the intersection it fills, it was something of a triumph. The 1986 addition by Gino Valle, Jeremy P. Lang, and Fred Liebman is also a triumph, a rare example of a modern building in harmony with its surroundings.

45

13–15 SOUTH WILLIAM STREET AND 57 STONE STREET

BETWEEN COENTIES ALLEY AND HANOVER SQUARE

1903–1908, C. P. H. GILBERT

All of the buildings of old Nieuw Amsterdam are long gone, but these stepped gables offer an educated guess of what the whole colony probably looked like. The most impressive building the Dutch built was the Stadt Huys, originally built in 1641 as a tavern, on the other side of the square. An imposing five-story building, it was the tallest in town and, as the city hall, the most important.

46

CHUBB & SONS

54 STONE STREET
BETWEEN COENTIES ALLEY AND HANOVER SQUARE

1919, ARTHUR C. JACKSON

This is a modern addition to the city's oldest paved street. Once known as Brouwers Straet because it meandered past Stephanus Van Cortlandt's brewery, it was paved with cobblestones in 1657 in response to complaints by Mrs. Van Cortlandt about the dust raised by her husband's customers.

47

NEW YORK COCOA EXCHANGE \mathcal{L}

82–92 BEAVER STREET, AT PEARL STREET

1904, CLINTON & RUSSELL

Originally known as the Beaver Building, the architects solved the problem of designing for an angular site by rounding off the corner. The Cocoa Exchange is a commodities trader, now part of the New York Coffee and Sugar Exchange. It moved from here to the World Trade Center in the 1990s.

48

DELMONICO'S \mathcal{L}

56 BEAVER STREET AT SOUTH WILLIAM STREET

1891, JAMES BROWN LORD
CONDOMINIUM CONVERSION, 1996, MARK KEMENY

New York's oldest restaurant, founded in 1825, Delmonico's has had seven different locations over the years. After its original building on this site was destroyed by fire, it was replaced by this one, as a hotel and restaurant for men only. The hotel now houses condominium apartments and the restaurant is open to all. The marble pillars at the entrance, said to have been excavated at Pompeii, also graced the first building.

49

CANADIAN IMPERIAL BANK OF COMMERCE \mathcal{L}

22 WILLIAM STREET
BETWEEN BEAVER STREET AND EXCHANGE PLACE

1931, CROSS & CROSS

By the time this building was built for the City Bank Farmer's Trust Company, bankers had begun demanding Modern Classicism as their architectural statement. Cross & Cross delivered the goods and pleased the bankers even more with a fifty-seven-story limestone tower that was ready for occupancy just one day short of a year from the time it was begun.

TRINITY CHURCH ℒ
(EPISCOPAL)

78–79 BROADWAY AT WALL STREET

1846, RICHARD UPJOHN

This is third church on the same site, beginning
with a 1697 structure that was destroyed by
the Great Fire of 1776 and replaced by another
that fell victim to snow piled on its roof during
a blizzard in 1839. The parish itself was estab-
lished as the colonial outpost of the Church of
England by a 1705 land grant from England's
Queen Anne that included all of the territory
west of Broadway from Fulton Street north to
Christopher Street. The grant also transferred
the rights to the contents of any ships that
might run aground there and to all of the
whales that washed ashore. But the real riches
came in the form of leases for buildings that
went up in that area known as "The Queen's
Farms." Apart from being the richest and old-
est parish in New York, Trinity is also its best-
known church, thanks to its setting in a
two-and-a-half-acre Colonial graveyard adjoin-
ing the canyons of the Financial District.

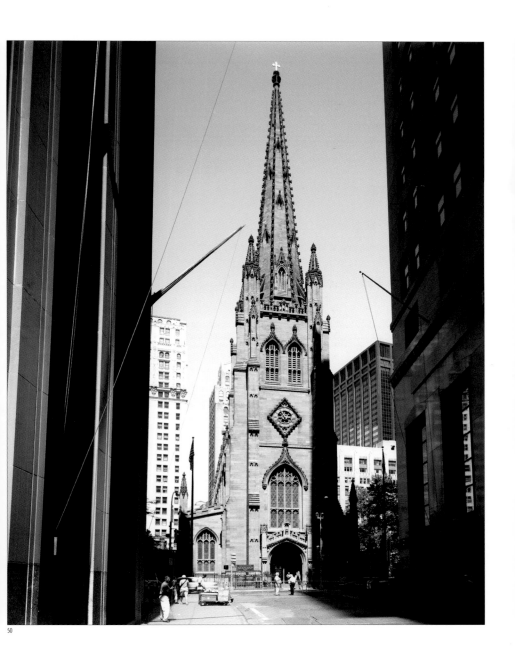

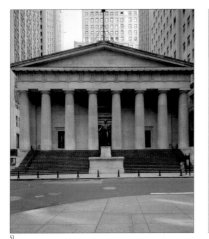

51

FEDERAL HALL NATIONAL MEMORIAL \mathcal{L}

28 WALL STREET AT NASSAU STREET

1842, TOWN & DAVIS

Less than twenty-five years after George Washington took his oath of office on a balcony at New York's former City Hall, the building was torn down and sold for scrap, netting $425. It was replaced by this Greek Revival temple, which served first as the U.S. Custom House and then as a sub-treasury building. It became a National Historic Site in 1939. J. Q. A. Ward's 1883 statue of President Washington had already been placed on the front steps to mark the important moment.

51

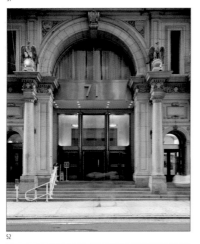

52

EMPIRE BUILDING \mathcal{L}

71 BROADWAY AT RECTOR STREET

1898, KIMBALL & THOMPSON

Now an apartment building overlooking Trinity Churchyard, this wonderfully detailed Classical building, with a monumental triumphal arch forming its main entrance, was the original headquarters of the United States Steel Corporation, which was located here from the time of its founding in 1901 until 1976. Its conversion to apartments began the following year, making it one of the earliest residential buildings in the Financial District.

52

53

45 WALL STREET

AT WILLIAM STREET

1997, MELTZER/MENDL ARCHITECTS

The dream of being able to walk to work has persisted among New Yorkers for generations, but on Wall Street the dream wasn't realized until the present generation, with buildings like this one. Laundromats and grocery stores may be few and far between, but since the '80s, even these amenities have begun to spring up to service the growing number of residential buildings within walking distance of the world's financial center.

53

BANKERS TRUST COMPANY BUILDING

16 WALL STREET AT NASSAU STREET

1912, TROWBRIDGE & LIVINGSTON
ADDITION, 1933, SHREVE, LAMB & HARMON

The stepped pyramid that crowns this tower was used for many years as the bank's corporate symbol. The Classical building, which Bankers Trust sold in 1987, was created only partly for its own offices, with a healthy share of its space left over for rental. The 1933 addition contains muted Art Deco touches, which blend perfectly with the Doric-columned main façade of the original structure.

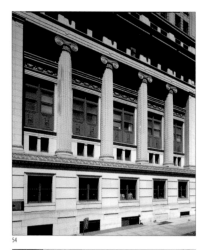

54

AMERICAN EXPRESS COMPANY

46 TRINITY PLACE
BETWEEN EXCHANGE ALLEY AND RECTOR STREET

1880S, ARCHITECT UNKNOWN

Before it moved to the World Financial Center in 1975, the headquarters of American Express was at 65 Broadway, but this building predates it. The company, now known for credit cards and travelers' checks, began as a transporter of freight and currency to the far corners of New York State, and for this purpose, it had to operate out of warehouses like this one. The company went out of the "express" business in 1918—but is unlikely ever to change its name to something more apt.

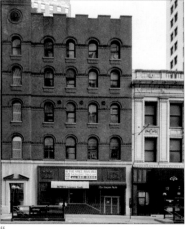

55

BANK OF NEW YORK
(FORMERLY IRVING TRUST COMPANY)

ONE WALL STREET AT BROADWAY

1932, VOORHEES, GMELIN & WALKER

Ralph Walker, who designed this building, wrote that, "the skin [of a building] becomes a matter of whatever ardent experience that man can bring forth to create delight as well strength." One Wall Street is proof that he practiced what he preached. The limestone tower appears delightfully rippling. The interior is a tour de force of mosaics that look like fine tapestries.

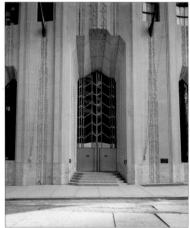

56

EQUITABLE BUILDING

57

120 BROADWAY
BETWEEN PINE AND CEDAR STREETS

1915, ERNEST R. GRAHAM & ASSOCIATES

The floor space inside this behemoth works out to 1.2 million square feet, but the lot it stands on is just about an acre. What was called a "wholesale theft of daylight" led to the zoning resolution of 1916. America's first such law, it regulated building heights in relation to the width of the street and set a fixed formula for skyscraper setbacks.

LIBERTY TOWER

58

55 LIBERTY STREET AT NASSAU STREET

1910, HENRY IVES COBB

A neo-Gothic freestanding skyscraper with a handsome terra-cotta façade lavishly decorated with representations of birds and animals, this was one of the earlier downtown buildings to be converted into apartments. The renovation dates back to 1981, and prior to that, Liberty Tower was the headquarters of the Sinclair Oil Company.

CHAMBER OF COMMERCE OF THE STATE OF NEW YORK

59

65 LIBERTY STREET
BETWEEN NASSAU STREET AND BROADWAY

1901, JAMES B. BAKER

The exterior of this gem is a close cousin to Charles Garnier's Paris Opera with lavish ornamental detail and oval windows lighting the main chamber which is, if anything, even more lavish. Measuring sixty by ninety feet, the chamber is covered with a gilded and intricately paneled ceiling with a skylight in the center, fifty feet above the floor. The Chamber of Commerce moved on in 1990 and its jewel box became a bank.

FEDERAL RESERVE BANK OF NEW YORK

60

33 LIBERTY STREET AT NASSAU STREET

1924, YORK & SAWYER

More pure gold is stored in the five levels under this building, inspired by the Florentine Strozzi Palace, than any other spot on earth. It is the property of a host of different nations who order the ingots moved from one vault to another to satisfy trade debts between them.

HSBC BANK BUILDING

61

140 BROADWAY BETWEEN LIBERTY AND CEDAR STREETS

1967, SKIDMORE, OWINGS & MERRILL

Built on designs by Gordon Bunshaft, this is curtain-wall minimalism at its best. Its flat façade rises 677 feet straight up from the sidewalk, which is wide enough to accommodate the giant red-pierced cube by Isamu Noguchi on the Broadway side. Critic Ada Louise Huxtable wrote that the building, created for HSBC's predecessor, Marine Midland Bank, was, "not only one of [the] buildings I admire most in New York, but that I admire most anywhere."

TRINITY AND U.S. REALTY BUILDINGS

62

111 AND 115 BROADWAY AT THAMES STREET

1905, FRANCIS H. KIMBALL

Designed in a Gothic style to complement Trinity Church on the other side of the graveyard, the twin lots these buildings fill are only 50 feet wide, though 264 feet long. The southernmost Trinity Building is on the site of the first office building ever built in New York.

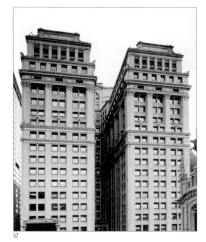

57

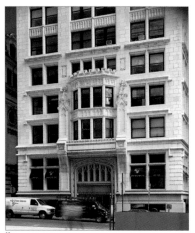

58

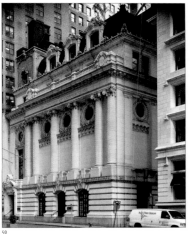

59

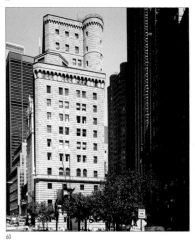

60

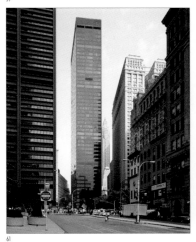

61

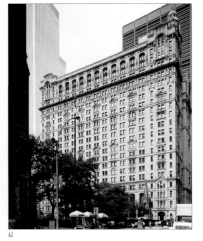

62

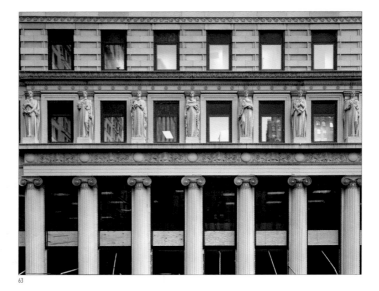

63

Bank of Tokyo *L*

100 BROADWAY AT PINE STREET

1895, BRUCE PRICE

In 1975, the Japanese design firm of Kajima International modernized Bruce Price's rusticated façade, bringing the former American Surety Building squarely into the twentieth century. Happily, they didn't touch the row of eight allegorical stone goddesses created by sculptor J. Massey Rhind. The top of the building has decorated façades on all four sides, uncommon among most corner buildings built in the late nineteenth century. Another unusual innovation is the construction of the top two floors above the cornice line.

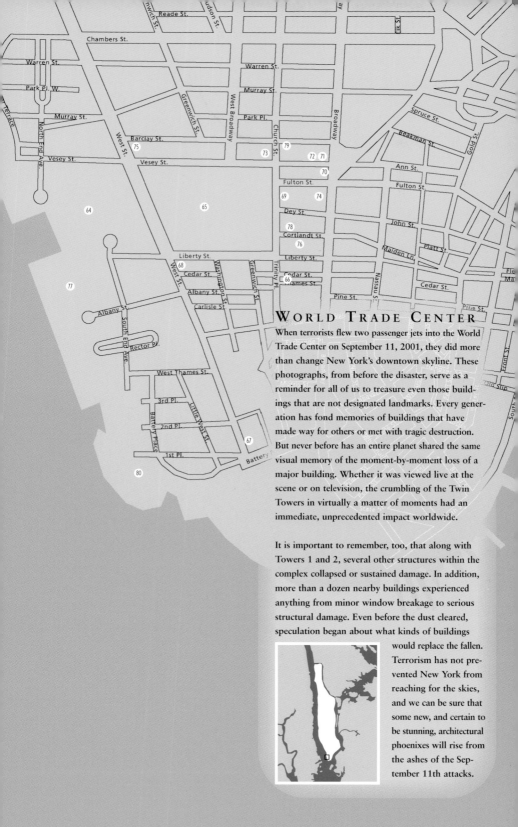

WORLD TRADE CENTER

When terrorists flew two passenger jets into the World Trade Center on September 11, 2001, they did more than change New York's downtown skyline. These photographs, from before the disaster, serve as a reminder for all of us to treasure even those buildings that are not designated landmarks. Every generation has fond memories of buildings that have made way for others or met with tragic destruction. But never before has an entire planet shared the same visual memory of the moment-by-moment loss of a major building. Whether it was viewed live at the scene or on television, the crumbling of the Twin Towers in virtually a matter of moments had an immediate, unprecedented impact worldwide.

It is important to remember, too, that along with Towers 1 and 2, several other structures within the complex collapsed or sustained damage. In addition, more than a dozen nearby buildings experienced anything from minor window breakage to serious structural damage. Even before the dust cleared, speculation began about what kinds of buildings would replace the fallen. Terrorism has not prevented New York from reaching for the skies, and we can be sure that some new, and certain to be stunning, architectural phoenixes will rise from the ashes of the September 11th attacks.

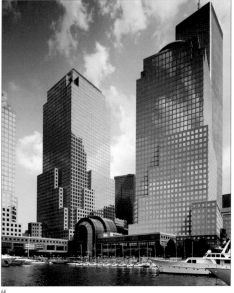

64

WORLD FINANCIAL CENTER

WEST STREET BETWEEN LIBERTY
AND VESEY STREETS ON THE HUDSON RIVER

1980s, CESAR PELLI WITH ADAMSON & ASSOCIATES

These glass and granite office towers house such giants of the financial world as Dow Jones, American Express, Merrill Lynch and Oppenheimer & Company. Although the buildings were virtually intact after the collapse of the World Trade Center, it took a full year to restore them. The Winter Garden, a huge glass-walled interior space, was reopened on September 11, 2002, the first anniversary of the attack, with its rows of 90-foot palm trees replaced. The open plaza beyond overlooks the river and a cove with anchorages for the yachting set.

WORLD TRADE CENTER

CHURCH TO WEST STREETS
LIBERTY TO VESEY STREETS

1972–1977, MINORU YAMASAKI & ASSOCIATES
WITH EMERY ROTH & SONS

The now-destroyed 110-story stainless steel Twin Towers were, at 1,350 feet, the tallest buildings in the world for a couple of weeks when they were finished in 1974, until an upstart in Chicago called the Sears Tower topped them by 104 feet. But the World Trade Center was more than just a pair of monoliths, it was seven buildings connected by a vast underground concourse and a wide windswept plaza at ground level. The sixteen-acre site now known as "Ground Zero" is expected to be cleared of debris by the summer of 2002.

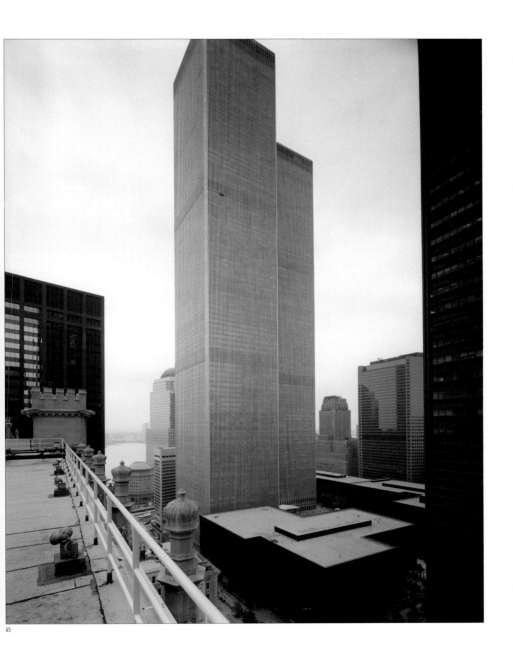

66
FORMER NYU GRADUATE SCHOOL OF BUSINESS ADMINISTRATION

100 TRINITY PLACE
BETWEEN THAMES AND CEDAR STREETS

1959, SKIDMORE, OWINGS & MERRILL

When New York University built this modern structure in 1959, its next-door neighbor was a Classical school building designed for Trinity Church by Richard Upjohn. Sixteen years later, it was replaced by another squat modern building connected to its neighbor by a bridge over Thames Street.

67
DOWNTOWN ATHLETIC CLUB

19 WEST STREET
BETWEEN MORRIS AND BATTERY PLACE

1926, STARRETT & VAN VLECK

The glazed tile exterior of this thirty-six-story club is interesting enough, but it doesn't prepare you for what you'll find inside, a Modern Classical design that puts the great ocean liners to shame. You'll also find a miniature golf course in there, and a stylish roof garden up on top.

68
CHURCH OF ST. NICHOLAS

155 CEDAR STREET, CORNER OF WEST STREET

1914

This tiny parish doggedly refused hundreds of lucrative offers for the little plot of land under its church which, in addition to serving the spiritual needs of the large community of Greek immigrants who work in the Financial District, gave them a sweet reminder of home. The church was completely demolished in the collapse of the World Trade Center, but within days, plans were being made to rebuild it, and the parish still declines to sell its unbelievably valuable piece of lower Manhattan.

69
MILLENIUM HILTON HOTEL

55 CHURCH STREET, BETWEEN FULTON AND DEY STREETS

Before anyone pointed out that they had spelled "millennium" wrong, apparently, all the letterheads and brochures had been printed, and the builders of this 58-story hotel decided to let the mistake go. The 561-room property more than made up for it in its standards of luxury and service, and its location across from the World Trade Center made it a sell-out from the beginning. The collapse of the Twin Towers resulted in a lot of broken glass in its sleek façade and a good deal of smoke damage, but the Millenium is still standing, still sound.

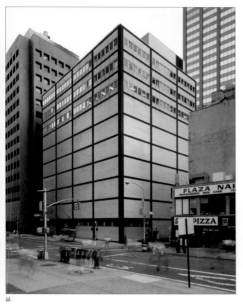

66

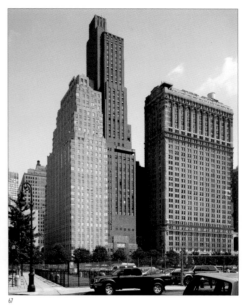

67

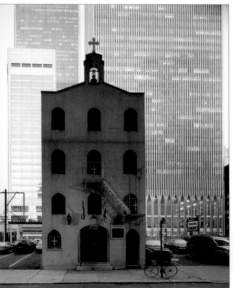

68

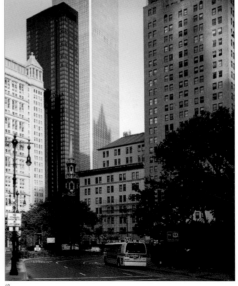

69

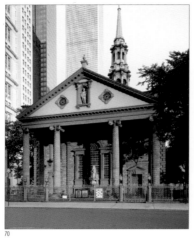

70

71

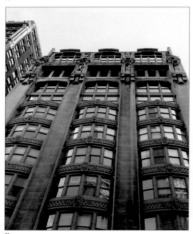

72

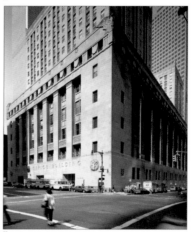

73

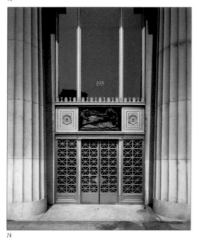

74

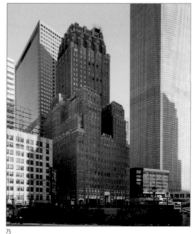

75

St. Paul's Chapel *L*
(Episcopal)

BROADWAY BETWEEN FULTON AND VESEY STREETS

1768, THOMAS MCBEAN

Influenced by London's Church of St. Martin's in the Fields, this is the oldest church building in Manhattan. George Washington worshipped here, in fact. Originally built as an outpost of Trinity Parish at the edge of the city, its front door was made to face the churchyard on the west side because no one knew that Broadway would ever amount to anything. The steeple was added in 1796, but beyond that the church is unchanged from the day it opened.

New York County Lawyers Association *L*

14 VESEY STREET
BETWEEN CHURCH STREET AND BROADWAY

1930, CASS GILBERT

This delicate rendering of a Georgian townhouse overlooking St. Paul's churchyard is by the architect of the Woolworth Building around the corner.

Garrison Building *L*

20 VESEY STREET
BETWEEN CHURCH STREET AND BROADWAY

1907, ROBERT D. KOHN
SCULPTURES BY
GUTZON BORGLUM AND ESTELLE RUMBOLD KOHN

Built as the headquarters of the *New York Post*, the sculptures here represent the "Four Periods of Publicity," and the colophons of early printers are worked into the spandrels between the windows and the elaborate Art Nouveau top.

Federal Office Building

90 CHURCH STREET
BETWEEN VESEY AND BARCLAY STREETS

1935, CROSS & CROSS

Originally housing the Department of Commerce, the Federal Housing Administration, and the Treasury Department, this monolith represented a shift in official government architecture from historic statements to demonstrations of post-Depression power and strength.

American Telephone and Telegraph Building

195 BROADWAY BETWEEN DEY AND FULTON STREETS

1923, WELLES BOSWORTH

When AT&T moved from here, they took along Evelyn Beatrice Longman's sculpture, *The Genius of the Telegraph*, after it had spent sixty years on the roof. It is now at the company's headquarters in New Jersey. Its former headquarters here at 195 Broadway, now an office building, has more Classical columns on its façade than any other structure in the world, and the parade continues gloriously inside.

Barclay-Vesey Building *L*

140 WEST STREET
BETWEEN BARCLAY AND VESEY STREETS

1927, MCKENZIE, VOORHEES & GMELIN

Built as a switching center for the New York Telephone Company, this Art Deco treasure incorporates an innovative seventeen-foot pedestrian arcade that allows its interior space to extend out to the street line. Its ornamentation is exotic and playful, including giant elephants lounging up at the top. The brickwork comes in no less than nineteen different colors, from deep rose at street level to bright orange, tinged with pink, at the roof line.

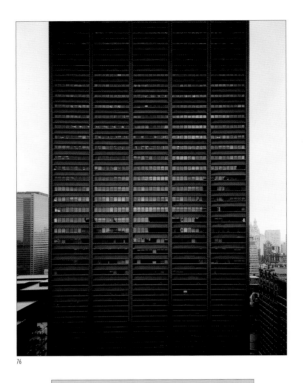

ONE LIBERTY PLAZA

BROADWAY, LIBERTY, CHURCH, AND CORTLANDT STREETS

1974, SKIDMORE, OWINGS & MERRILL

Built by U.S. Steel as a demonstration of the possibilities of its newly developed Cor-ten steel for building exteriors, the architects got the message and came up with a structure with unusually wide bays spanned by deep girders that are exposed on the outside. The effect is overpowering, but nowhere more so than at the entrance, where the low beams make you instinctively want to duck so that you won't bump your head. This building replaced Ernest Flagg's 1908 Singer Tower, the tallest building ever demolished in the name of progress. During television coverage of the September 11 World Trade Center disaster, One Liberty Plaza was authoritatively pronounced dead all afternoon by reporters who were blocks away. But when the dust cleared, it was still standing.

The Landlord of New York

John Jacob Astor, who had arrived penniless in New York in 1783, became the world's most important fur trader before he retired at the age of seventy, in 1832, and began a whole new life. He had invested in real estate during most of his life, and by the time he left the fur business, he owned more land in Manhattan than any other individual. Now he had the time to improve its value. He began by demolishing all of the buildings on the west side of Broadway, including his own mansion, between Barclay and Vesey Streets and replacing them with a luxury 300-room hotel. It had no less than seventeen bathrooms on its six floors, as well the most elegant restaurant in town. When a financial panic gripped the city three years later, homeowners and storekeepers were forced to mortgage their properties, and Astor was more than willing to help them out at the then-usurious rate of seven percent. He foreclosed on them early and often. Up until then, his investments were largely on undeveloped land in upper Manhattan, which he bought as large tracts of acreage and sold as small building lots. But his foreclosures gave him a taste of the profits of renting rather than selling, and during the last five years of his life, he was earning more than $150,000 a year in rents alone. It prompted him to say that if he had his life to live over again, he would own every inch of Manhattan. Some New Yorkers thought he already did.

BATTERY PARK CITY

ON THE HUDSON RIVER SOUTH FROM LIBERTY STREET

1980S, MASTER PLAN BY
COOPER, ECKSTUT & ASSOCIATES

The earth excavated from the World Trade Center site across West Street added ninety-two acres to Manhattan's shoreline, which was designated as a new residential area in 1979. The result is a mixture of different communities, bound together by a welcoming riverside esplanade.

EAST RIVER SAVINGS BANK
(NOW CENTURY 21 DEPARTMENT STORE)

26 CORTLANDT STREET AT CHURCH STREET

1934, WALKER & GILLETTE

If you're a bargain hunter, you've surely been inside this building. Your mother probably remembers the former Art Deco bank with stainless steel eagles over the entrances. Banks have been converted into every conceivable re-use, from churches to discos, but few have, like this one, become department stores.

ST. PETER'S CHURCH *L*
(ROMAN CATHOLIC)

22 BARCLAY STREET AT CHURCH STREET

1840, JOHN R. HAGGERTY AND THOMAS THOMAS

The oldest Catholic parish in the city, this building stands on the site of its predecessor, built on land purchased from the Episcopalian Trinity Parish in 1785. There were only about two hundred Catholics in New York at the end of the Revoloutionary War, but in less than a century, it became the city's largest religious denomination and it still is.

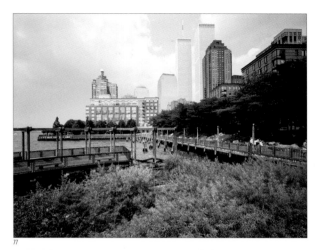

77

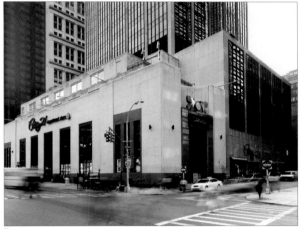

78

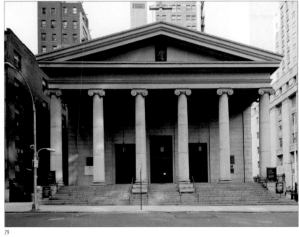

79

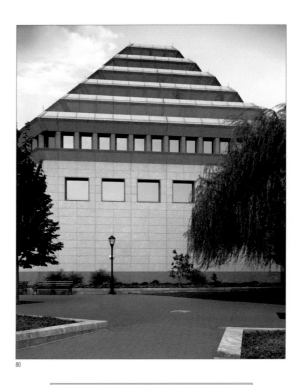

80

80

MUSEUM OF JEWISH HERITAGE

ONE BATTERY PARK PLAZA
FOOT OF BATTERY PLACE

1996, KEVIN ROCHE, JOHN DINKELOO & ASSOCIATES

Serving as an anchor to the lower end of the
Battery Park City Esplanade, this is a memorial
to victims of the Holocaust and also includes
artifacts tracing the history of the Jewish peo-
ple. Although hundreds of New York's Jewish
families are Holocaust survivors, their history
in New York begins with twenty-three
Sephardic refugees from Portuguese Brazil who
were given asylum here in 1654. Over the next
two centuries, a large majority of Jews who
emigrated to the United States went no further
than New York, and today there are about 1.1
million Jews living here, more than double the
Jewish population of Jerusalem.

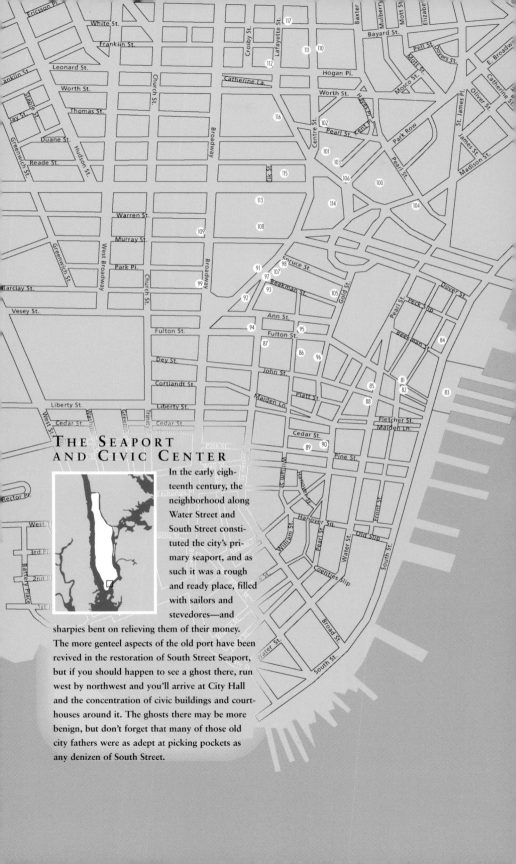

THE SEAPORT AND CIVIC CENTER

In the early eigh-
teenth century, the
neighborhood along
Water Street and
South Street consti-
tuted the city's pri-
mary seaport, and as
such it was a rough
and ready place, filled
with sailors and
stevedores—and
sharpies bent on relieving them of their money.
The more genteel aspects of the old port have been
revived in the restoration of South Street Seaport,
but if you should happen to see a ghost there, run
west by northwest and you'll arrive at City Hall
and the concentration of civic buildings and court-
houses around it. The ghosts there may be more
benign, but don't forget that many of those old
city fathers were as adept at picking pockets as
any denizen of South Street.

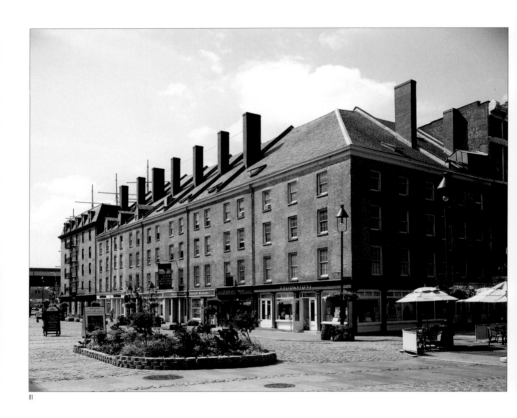

81

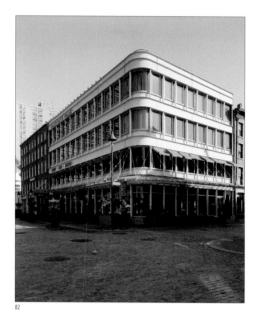

82

SCHERMERHORN ROW

2–18 FULTON STREET
(ALSO 91, 92 SOUTH AND 195 FRONT STREETS)

1812, BUILT BY PETER SCHERMERHORN

This is the last surviving row of Federal-style warehouses in a city that once had hundreds of them. They have their original pitched roofs and dormers that were a later addition, and they still show their original Flemish-bond brickwork and splayed lintels. Peter Schermerhorn, who ran a successful ship chandlery around the corner at 243 Water Street, acquired the property for these buildings in 1800 when the city offered the new landfill as "water lots" to local landowners on the condition that they would be used for buildings and not left vacant. The Schermerhorn family owned the buildings he built until 1939.

BOGARDUS BUILDING

15–19 FULTON STREET AT FRONT STREET

1983, BEYER BLINDER BELLE

The orginal version of South Street Seaport's Bogardus Building was stolen. The current one is based on a cast-iron structure made from elements created by James Bogardus, a pioneer master of the art, that was dismantled and stored in a warehouse for later installation at the restored Seaport. But it was purloined by person or persons unknown and melted down for scrap before anybody knew it was missing. Fortunately, photographs and drawings of it still existed, and this is what the twentieth-century architects saw in them.

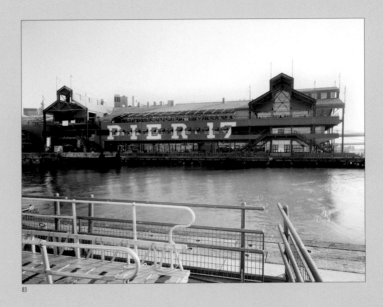

Our Maritime Tradition

*Because it is a tidal estuary connecting Long Island Sound
and New York Bay, the strong flow of water through the
East River makes it almost completely ice-free in the win-
ter months. In the era of wooden ships, it became
Manhattan's preferred anchorage. After the Civil War,
iron-hulled steamships were lured to the deeper waters of
the Hudson River, and the once-busy area along South
Street fell into deep decline, before it was almost complete-
ly abandoned and left to its memories.*

*In the mid-1960s, a citizens' group called the South Street
Museum went to work to save the old port by acquiring
the deteriorating buildings and collecting a fleet of ships.
Ten years later, the organization merged its interests with
the Rouse Company, which had rebuilt Boston's Quincy
Market, to help restore the buildings and build new ones
with the same character. Whether the result is preservation
or commercialism is still being debated, but it has brought
life to a neighborhood that had been given up for dead.*

84

PIER 17

EAST RIVER AT FULTON STREET

1984, BENJAMIN THOMPSON & ASSOCIATES

Not every structure at South Street Seaport is a nineteenth-century original, and Pier 17 is among the new ones, although the pier itself was the busy centerpiece of the old port. After the fun of exploring the Seaport's fleet of historic ships, including the barque Pekin and the occasional visiting vessels that tie up among them, a visit to this mall-like building across the way that houses stores and restaurants affords the best available views of the Brooklyn Bridge and the traffic on the East River.

FULTON FISH MARKET

FULTON STREET
BETWEEN PIER 17 AND THE BROOKLYN BRIDGE

ESTABLISHED 1821

Still the best place to be when the sun comes up while the fish you'll have for dinner is being boisterously bought and sold, this was once much more than just a fish market. It was created, in the words of its original owners, "to supply the common people with the necessities of life at a reasonable price." You could buy a book here, or hardware; ice cream, or a new shirt. But the main attraction for the upper crust was the oyster bars where the shellfish was always fresh, succulent, and plentiful.

ONE SEAPORT PLAZA

199 WATER STREET
BETWEEN JOHN AND FULTON STREETS

1983, SWANKE HAYDEN CONNELL & PARTNERS

In a bow to its neighbors in South Street Seaport, the façade on Front Street, at the rear of this building, is more subdued than its Water Street frontage. But it still towers more than thirty stories above the Seaport.

ILX SYSTEMS
(AETNA INSURANCE COMPANY BUILDING)

151 WILLIAM STREET AT FULTON STREET

1940, CROSS & CROSS WITH EGGERS & HIGGINS

Among the last corporate headquarters built before World War II, this compact Modernist structure communicated a special identity for the client, as was expected of pre-war architecture. But it also set the stage for postwar buildings that would make statements of their own.

FULTON BUILDING

87 NASSAU STREET AT FULTON STREET

1893, DE LEMOS & CORDES

This office building was designed by an architectural firm that went on to greater glory uptown seven years later with its design for R. H. Macy's store on Broadway at 34th Street. Its neighbor around the corner at 127 Fulton Street is also the work of the same firm. The building and the street are named for Robert Fulton, who arrived in New York in 1806, where he built the North River Steamboat of Clermont that sailed up to Albany—and into history—the following year.

127 JOHN STREET

AT WATER STREET

1969, EMERY ROTH & SONS

Once past the canvas panels over the entrance, a visitor goes through a neon-lit tunnel leading to the lobby in back, where Oriental rugs and soft light calm the nerves. Service rooms on the tenth floor can be seen through clear glass and at night, flashing lights make the building seem like a living, breathing entity. A digital clock on an adjacent building at the south side will tell you if you're late for an appointment, but it may take you a minute or two to figure out what time it is.

DOWN TOWN ASSOCIATION

60 PINE STREET BETWEEN PEARL AND WILLIAM STREETS

1887, CHARLES C. HAIGHT
ADDITION, 1911, WARREN & WETMORE

Among the oldest private clubs in the Financial District, this is a quiet retreat where executives and lawyers meet for power lunches. Since its founding in 1860, its membership has included lawyer William M. Evarts, who represented President Andrew Johnson in his 1868 impeachment and became secretary of state in the administration of Rutherford B. Hayes, Henry L. Stimson, who served as secretary of war during all of World War II, and President Franklin D. Roosevelt.

AMERICAN INTERNATIONAL BUILDING
(FORMER CITIES SERVICE BUILDING)

70 PINE STREET AT PEARL STREET

1932, CLINTON & RUSSELL WITH HOLTON & GEORGE

Because the site was so small, the architects saved space by reducing the number of elevator shafts in this building, making each serve two floors at a time with double-decked cars. That meant the lobby had to be a double-decker, too, but thanks to a natural slope in the lot, both levels are accessible directly from the street on different sides. In order to squeeze in more floor space, the building is in the shape of a cross, intersected by rectangles that give it twenty-eight different sides (and lots of window offices).

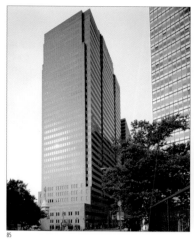

85

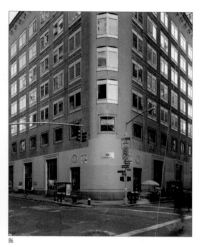

86

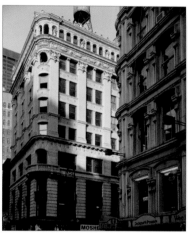

87

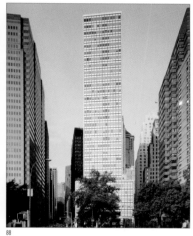

88

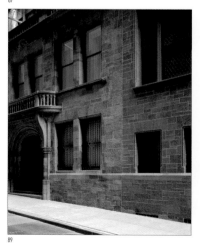

89

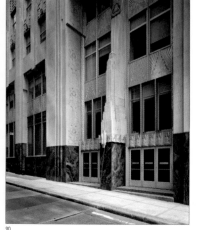

90

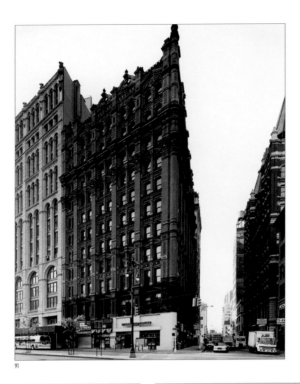

91

POTTER BUILDING

38 PARK ROW AT BEEKMAN STREET

1886, NORRIS G. STARKWEATHER

Developer Orlando B. Potter lost his New York
World building on this site to a fire in 1882
(you probably read about it in Jack Finney's
book, *Time And Again*), and he was deter-
mined not to let that happen again. The result
was the city's first fireproof building, which
used terra-cotta to protect the steel beams and
more of the same to dress up the façade in a
masterpiece of ornamental detail. It now con-
tains forty-one spacious loft apartments, the
nicest of which feature views of City Hall and
its adjoining park just across Park Row. The
park's recently restored fountain features orig-
inal gas lamps.

PARK ROW BUILDING

15 PARK ROW
BETWEEN ANN AND BEEKMAN STREETS

1899, R. H. ROBERTSON

When the idea of skyscrapers arrived in New
York, most businessmen were dubious. Tall
buildings made sense to them as long as they
were freestanding and not abutting their neigh-
bors, since the lack of side windows would
surely make the space unrentable. As if to prove
the theory wrong, this structure, which was the
world's tallest building for eight years, went up
in mid-block with party walls on both sides. The
architect added cupolas above the cornice to
give it the illusion of a freestanding tower. This
building, familiar to shoppers who frequent
J&R's superstore, is among the most recent
landmarks to be converted into apartments.

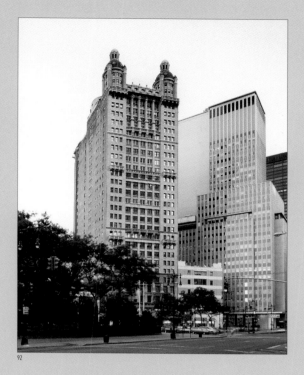

92

REACHING FOR THE SKY

Although the skyscraper was invented in Chicago, the idea flowered in New York beginning in 1899 with 15 Park Row, which soared to 390 feet. Its record was broken eight years later by the Singer Tower's 612-foot reach for the sky. A year after that, the Metropolitan Life Tower rose to 700 feet, only to be eclipsed by the 792-foot Woolworth Building in 1913. The next record-holder was 40 Wall Street at 927 feet, followed in 1930 by the Chrysler Building, the first to go over a thousand feet, and then by the Empire State Building, which held the record from 1931 until the World Trade Center was built forty-six years later. Upon the horrific collapse of the Twin Towers on September 11, 2001, the Empire State Building became, by default, the city's tallest structure.

MORSE BUILDING

93

12 BEEKMAN STREET AT NASSAU STREET

1879, SILLIMAN & FARNSWORTH

A former manufacturing loft building, 12 Beekman Street was converted into spacious and unique apartments in 1980 by Hurley & Farinella. The original architects were Benjamin Silliman, Jr., who designed nearby Temple Court, and James M. Farnsworth, who was responsible for the additions to another neighbor, the Bennett Building. The cast-iron streetlights in this area, known as "bishop's crooks," were once common throughout the city and are enjoying a comeback in some historic neighborhoods.

BENNETT BUILDING ℒ

94

93–99 NASSAU STREET AT FULTON STREET

1873, ARTHUR D. GILMAN
ADDITIONS, 1892 AND 1894, JAMES M. FARNSWORTH

This loft building had a mansard roof until 1892, when it was replaced by four more floors of work space, providing more income for its owner, James Gordon Bennett, better known as the owner of the *New York Herald*. It began as a seven-story office building, was enlarged with a four-story addition, and then expanded again two years later with an extension on the Ann Street side. The three stages blend together seamlessly, making it the tallest cast-iron building in the city.

ROYAL GLOBE INSURANCE COMPANY

95

150 WILLIAM STREET
BETWEEN FULTON AND ANN STREETS

1927, STARRETT & VAN VLECK

Nicely conceived setbacks on every side culminate in a Classical temple on the roof of this building, constructed as the home of a liability insurer, which fills the entire block. It dominates the pathway to South Street Seaport from the Civic Center, but it doesn't overshadow the comparative airiness of the port itself.

EXCELSIOR POWER COMPANY

96

33–48 GOLD STREET
BETWEEN FULTON AND JOHN STREETS

1888, WILLIAM MILNE GRINNELL

Built to generate electrical power with the steam from coal-burning furnaces, this might have been a place to look for a way to solve New York's present shortage of power plants. But it's too late: The generators are gone and this Romanesque building is now an apartment house.

TEMPLE COURT ℒ

97

119–129 NASSAU STREET AND 5 BEEKMAN STREET

1883, SILLIMAN & FARNSWORTH

Although the twin steeples that crown this office building suggest a temple, it was actually named for the London landmark that houses two of the Inns of Court, which was itself named for its site replacing the headquarters of the medieval Templars. Inside, awaiting restoration, is an atrium that soars through nine stories to the roof, with delicate cast-iron balustrades. The building extends to the corner of Theater Alley, which in the first half of the eighteenth century was the site of the city's first major showplace.

AMERICAN TRACT SOCIETY BUILDING

98

150 NASSAU STREET AT SPRUCE STREET

1896, R. H. ROBERTSON

This Romanesque building, whose original tenants were publishers of religious flyers and newspapers called "tracts," faces Printing House Square, where a statue of Benjamin Franklin by Ernst Plassman has been standing with a copy of his newspaper, the *Pennsylvania Gazette*, since 1872. The neighborhood was already home to such well-known newspapers as the *New York Times*, the *New York World*, the *Herald*, and the *Daily Graphic*.

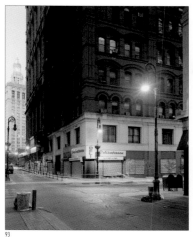

93

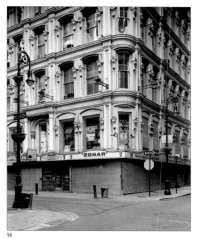

94

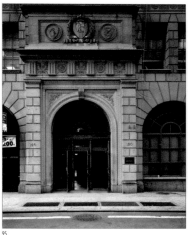

95

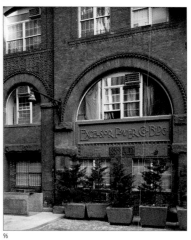

96

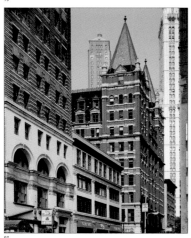

97

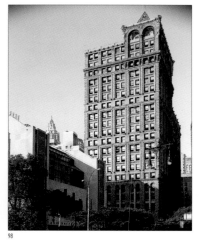

98

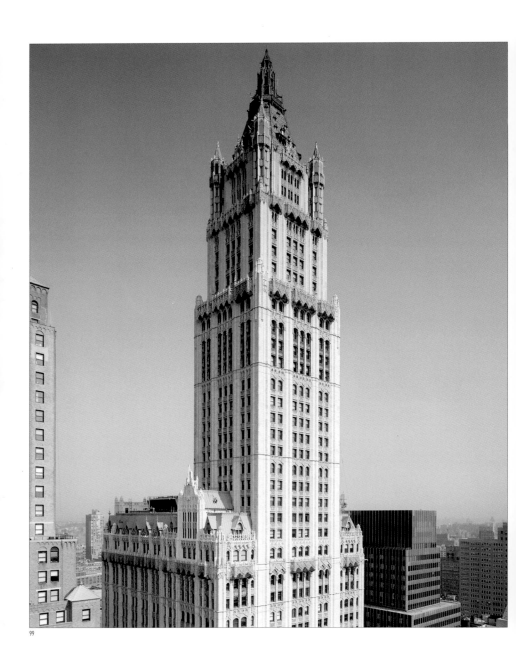

Woolworth Building *L*

233 Broadway
between Park Place and Barclay Street

1913, Cass Gilbert

For an idea of what the architect himself looked like, check out a gargoyle he placed in the lobby. He's the one hugging a model of the building, not far from his client, dime-store entrepreneur F. W. Woolworth, who is depicted counting his money. The Woolworth Building's lyrical Gothic style established a new benchmark for skyscraper architecture, replacing French Modern, which before then had been considered the only style appropriate for tall buildings. Much to the despair of New Yorkers looking for little necessities that they once found in Woolworth's stores, the "five-and-tens" have all vanished from the city's neighborhoods. At the time Mr. Woolworth died, six years after this building was finished, his empire extended to more than a thousand stores around the world and his fortune had grown to some $65 million, an impressive number of nickels and dimes in 1919. He was always proud to let it be known that he paid cash for his "Cathedral of Commerce." His rise to the role of merchant prince began in 1878 with a "five-cent" store in Utica, New York. When it failed, he moved to Lancaster, Pennsylvania, and expanded his inventory to include items that cost ten cents, and he was on his way. He opened his first New York store on Sixth Avenue at 17th Street in 1896.

NYC POLICE HEADQUARTERS

ONE POLICE PLAZA
BETWEEN PARK ROW, PEARL STREET,
AND AVENUE OF THE FINEST

1973, GRUZEN & PARTNERS

A ten-story cube cantilevered over a complex of buildings including a parking garage, detention facilities, and a pistol range, the triumph here is Police Plaza, which offers pedestrian access over Park Row from the Municipal Building. It arches past rows of locust trees, fountains, benches, and a monumental sculpture called *Five in One* created by Bernard Rosenthal.

UNITED STATES COURTHOUSE

40 CENTRE STREET AT FOLEY SQUARE

1936, CASS GILBERT

Finished by the architect's son, Cass Gilbert, Jr., after his father's death, this building is more than just a courthouse. It originally housed the U.S. District Attorney's offices, the U.S. District Court, the Circuit Court of Appeals, and even a training center for the Treasury Department's enforcers, all in a twenty-story office tower rising up from a five-story base to the stepped pyramid on the roof. The row of Corinthian columns at the entrance is angled in a gesture of neighborliness to the other courthouse next door.

NEW YORK COUNTY COURTHOUSE
(NEW YORK STATE SUPREME COURT)

60 CENTRE STREET AT FOLEY SQUARE

1927, GUY LOWELL

If you get summoned for jury duty, you won't report here but you'll probably wind up here. In New York State, the Supreme Court is where most cases get their first hearing. The steps leading up to the portico and past its Corinthian columns have probably been in more movies and TV shows than any other location in the city. It's illegal to shoot film inside, but the steps do the job when the scene calls for someone being hauled off to court.

ST. ANDREW'S CHURCH
(ROMAN CATHOLIC)

EAST OF FOLEY SQUARE
ON CARDINAL HAYES PLACE AT DUANE STREET

1939, MAGINNIS & WALSH AND ROBERT J. REILLY

Established in the mid-nineteenth century to minister to newly arriving immigrants, the predecessor of this charming church also served the needs of printers and newspaper people working in the neighborhood with a special mass at 2:30 in the morning.

100

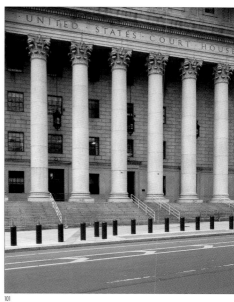

101

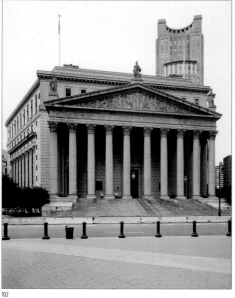

102

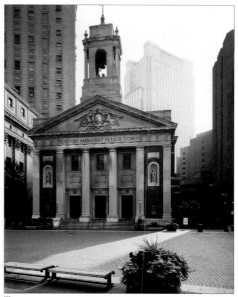

103

104

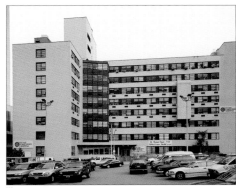

105

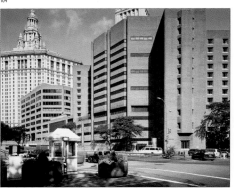

106

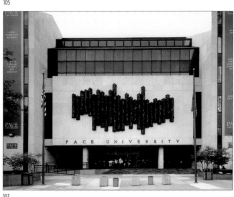

107

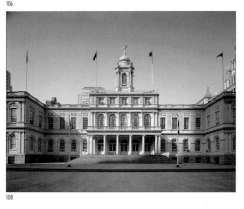

108

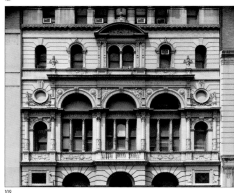

109

MURRAY BERGTRAUM HIGH SCHOOL

411 PEARL STREET AT MADISON STREET

1976, GRUZEN & PARTNERS

Financed by the sale of air rights for the equally brutal New York Telephone Company switching center to its east, this brown brick structure with narrow windows has all the earmarks of a prison, including the towers at the corners that house stairways and mechanical equipment.

BEEKMAN DOWNTOWN HOSPITAL

170 WILLIAM STREET
BETWEEN BEEKMAN AND SPRUCE STREETS

1971, SKIDMORE, OWINGS & MERRILL

Now part of New York Univerity Hospital, the original 150-bed facility was dedicated in 1953, and later absorbed by a larger building that closed off its courtyard on Gold Street. Beekman Downtown was the nearest hospital to the World Trade Center, and was where most of the early survivors were taken for care.

METROPOLITAN CORRECTIONAL CENTER

150 PARK ROW
BETWEEN PARK ROW, DUANE, AND PEARL STREETS

1975, GRUZEN & PARTNERS

Built as an annex to the Federal Courthouse on Foley Square, this is actually two buildings, one housing the U.S. Attorney's offices and the other a detention center with access to Police Headquarters. Critic Paul Goldberger took a tour of the detention cells and reported to his readers that they seemed to be more like new college dormitory rooms than prison cells.

PACE UNIVERSITY

NASSAU, FRANKFORT, GOLD, AND SPRUCE STREETS

1970, EGGERS & HIGGINS

Pace University, which also occupies the former New York Times Building at 41 Park Row, a landmark designed by George B. Post in 1889, was established in 1947 as a school for training certified public accountants. It became a university in 1973, and now offers degrees in such disciplines as publishing and computer sciences as well as psychology and law. It also has campuses in midtown Manhattan and Westchester County. This modern structure is dominated by a metal sculpture over the main entrance.

CITY HALL

CITY HALL PARK BETWEEN BROADWAY AND PARK ROW

1812, JOSEPH FRANCOIS MANGIN AND JOHN MCCOMB, JR.

The landmarked interior of this building, where the Mayor and the City Council report for work, is accented by a rotunda over a graceful pair of cantilevered staircases. For years, visitors were afraid to climb the steps, but when President Lincoln's body lay in state under them as it was being moved from Washington to Illinois, the only way to get a good look was to climb those stairs. When they didn't fall down, the office-holders upstairs began receiving more visitors.

HOME LIFE INSURANCE COMPANY BUILDING

253 BROADWAY
BETWEEN MURRAY AND WARREN STREETS

1894, NAPOLEON LE BRUN & SON

The top of this building is distinguished by a high mansard roof and a loggia behind Ionic columns. Its rusticated base is decorated with busy ornamentation and columns, but the middle is comparatively plain. Home Life Insurance, which built it as its headquarters, was among the first to guarantee insurability for prospective policy holders and the first to develop insurance plans to help families pay college tuition.

CRIMINAL COURTS BUILDING AND MEN'S HOUSE OF DETENTION

110

100 CENTRE STREET
BETWEEN LEONARD AND WHITE STREETS

1939, HARVEY WILEY CORBETT
AND CHARLES B. MEYERS

Usually called "the Tombs," the nickname of its predecessor, which resembled an Egyptian tomb, this building's façade more closely resembles Rockefeller Center, whose design was also worked on by Harvey Corbett. The prison contains cells for inmates awaiting their trials.

NEW YORK CITY CIVIL COURTHOUSE

111

111 CENTRE STREET AT WHITE STREET

1960, WILLIAM LESCAZE AND MATTHEW DEL GAUDIO

Jaded New Yorkers looking for something different in the way of evening entertainment often find their way here to listen to cases brought to small claims court. This is a unit of the Civil Court, created in the early 1960s by a merger of the city and municipal courts, which is responsible for lawsuits up to $25,000.

NEW YORK CITY FAMILY COURT

112

60 LAFAYETTE STREET
BETWEEN LEONARD AND FRANKLIN STREETS

1975, HAINES, LUNDBERG & WAEHLER

Once known as the Domestic Relations Court, this institution, now renamed Family Court, is technically a part of the New York State court system, handling juvenile and family-related matters such as divorces and child custody cases. Hearings held here are among the most emotionally charged of those held in any court, and its security staff is easily the busiest.

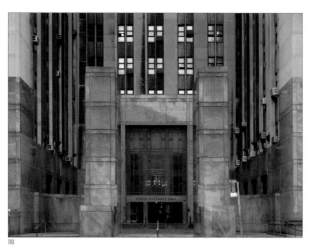

110

111

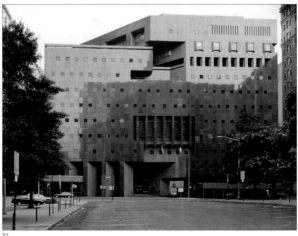

112

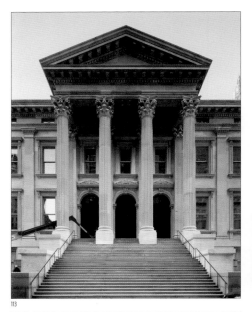

113

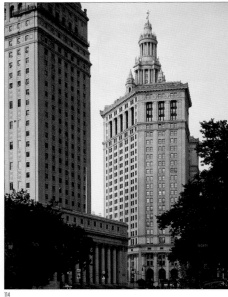

114

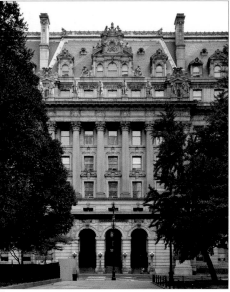

115

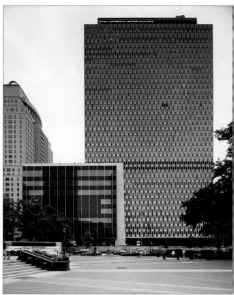

116

New York County Courthouse ℒ

52 CHAMBERS STREET
BETWEEN BROADWAY AND CENTRE STREET

1872, JOHN KELLUM AND THOMAS LITTLE

A monument to graft, but a beautiful one nonetheless, the so-called "Tweed Courthouse" cost as much to build as London's Houses of Parliament, with most of the money going into the pockets of Tammany boss William M. Tweed and his cronies. The building, which has been maligned and threatened over the years, is the future home of the Museum of the City of New York.

Municipal Building ℒ

ONE CENTRE STREET

1914, WILLIAM KENDALL OF McKIM, MEAD & WHITE

One of the problems with putting municipal offices in a skyscraper behind the diminutive City Hall is being careful not to overpower it, and this does the job very well. From some angles, it even seems to be embracing the true center of power. The tower at the top pays homage to City Hall's cupola, but in this case instead of featuring a statue of Justice, it is topped with Adolph A. Weinman's gilded *Civic Fame*, the largest statue in Manhattan. This, by the way, is where you go if you want to get married "at City Hall."

Surrogate's Court/Hall of Records ℒ

31 CHAMBERS STREET AT CENTRE STREET

1907, JOHN ROCHESTER THOMAS AND
HORGAN & SLATTERY

One of the nice things about New York is that you can tour the world without ever leaving town. Want to see the Paris Opera? Step into the lobby right here. When it was built, the Hall of Records was hailed as "the most Parisian thing in New York." Ironically, its designer, John Thomas, was possibly the only architect working in New York at the time who had never been to Paris.

Jacob K. Javits Federal Office Building

26 FEDERAL PLAZA, FOLEY SQUARE,
BETWEEN DUANE AND WORTH STREETS

1969, ALFRED EASTON POOR, KAHN & JACOBS
AND EGGERS & HIGGINS

With so many architects involved, you might wonder why they didn't produce something more pleasing. It may have been the client. The government built an addition around the corner on Broadway in 1977, and the results weren't much better. During his post-Presidential years in New York, Richard Nixon maintained an office here.

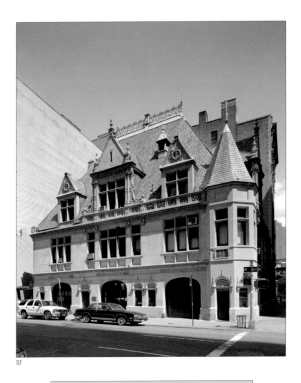

117

Engine Company No. 31

87 Lafayette Street at White Street

1895, Napoleon LeBrun & Sons

Now the Downtown Community Television Center, this fire station was built at a time when Lafayette Street was being widened in anticipation of making it a major connector between the meandering streets of downtown and the new grid pattern above them that had become the Manhattan standard in 1811. An echo of an early French Renaissance chateau, the building is just one example of the flair and dash of the city's early firehouses, and it is arguably the best by Napoleon LeBrun, who designed many of them. The LeBrun firm also designed the Metropolitan Life Tower, which rose above Madison Square in 1909.

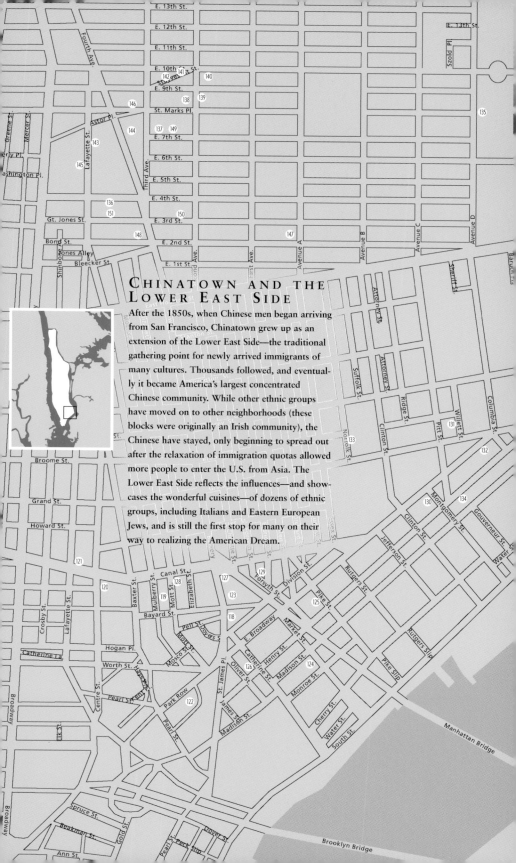

CHINATOWN AND THE LOWER EAST SIDE

After the 1850s, when Chinese men began arriving from San Francisco, Chinatown grew up as an extension of the Lower East Side—the traditional gathering point for newly arrived immigrants of many cultures. Thousands followed, and eventually it became America's largest concentrated Chinese community. While other ethnic groups have moved on to other neighborhoods (these blocks were originally an Irish community), the Chinese have stayed, only beginning to spread out after the relaxation of immigration quotas allowed more people to enter the U.S. from Asia. The Lower East Side reflects the influences—and showcases the wonderful cuisines—of dozens of ethnic groups, including Italians and Eastern European Jews, and is still the first stop for many on their way to realizing the American Dream.

EDWARD MOONEY HOUSE *L*

C. 1785–89

Built as the home of a prominent merchant, this Georgian-style house is the last survivor of a once-elegant neighborhood. The neighborhood deteriorated, and about fifty years after it was built, the house was turned into a brothel. For several years in modern times, it housed the busiest of all the offices of the Off-Track Betting Corporation, which has since relocated to larger quarters.

CHURCH OF THE TRANSFIGURATION *L*
(ROMAN CATHOLIC)

25 MOTT STREET

1801

Originally the Zion English Lutheran Church, this Georgian building is made of Manhattan Schist, the stone that underlies the whole island and is the bedrock that supports the skyscrapers. It is trimmed with brownstone and supports a copper spire that was added in the 1860s, at the same time that its impressive Gothic window frames were put in place. It became a Roman Catholic church in 1853, not long after the first Chinese immigrants arrived in the neighborhood.

HONG KONG BANK BUILDING

241 CANAL STREET AT CENTRE STREET

1983

Very few of New York's ethnic enclaves contain reminders of the lands the immigrants left behind them. We don't look for Greek temples in Astoria or English manor houses in Chelsea, but somehow it seems appropriate to bring a little of Chinese tradition into Chinatown. This is one of the better attempts. The ornamentation and tiles that embellish the façade of the red pagoda-style office building were imported from Taiwan.

254–260 CANAL STREET *L*

AT LAFAYETTE STREET

1857, ATTRIBUTED TO JAMES BOGARDUS

Resembling an Italian Renaissance palazzo, this is among the earliest examples of cast-iron architecture in New York, not to mention one of the largest. Its arched windows seem to go on forever, and because of the building's cast-iron construction, they probably could. The innovation freed builders from the constraints of massive masonry walls, and allowed them to create structures with open interiors and more light than ever before.

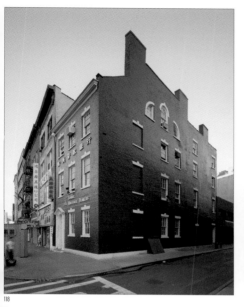

118

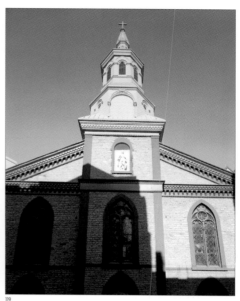

119

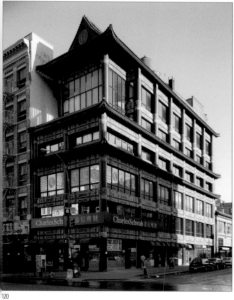

120

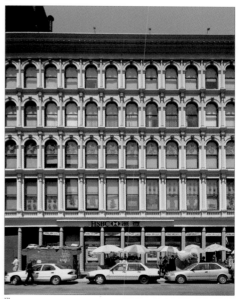

121

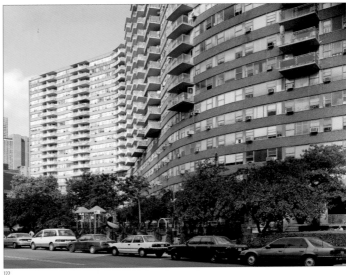

CHATHAM GREEN

185 PARK ROW
BETWEEN PEARL STREET AND ST. JAMES PLACE

1961, KELLY & GRUZEN

After the Third Avenue Elevated was torn
down in 1955, the eastern edge of Chinatown
became attractive to developers, and Chatham
Green was the first project to be realized. It is
a 21-story cooperative apartment building
with 450 apartments priced for middle-income
families, each of whom are guaranteed two dif-
ferent exposures. The serpentine structure has
no interior corridors, which have been sup-
planted by open galleries. Four years after
Chatham Green was ready for occupancy, the
same architects designed nearby Chatham
Towers, two 15-story buildings above a land-
scaped plaza. Each of them has 120 units, half
with terraces. It was the first apartment project
in the city to use exclusively drywall, rather
than plaster walls.

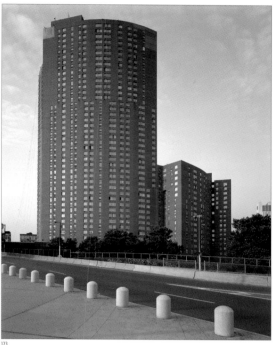

123

Confucius Plaza

Between the Bowery, Division Street,
Chatham Square, and the Manhattan Bridge

1976, Horowitz & Chun

This 6.5-acre site is packed to the limit with 762 apartments, a school that accommodates 1,200 students, 55,000 square feet of retail space and community rooms, a 7,500 square-foot day care center and a garage for 230 cars. It's all watched-over by a larger-than-life representation of the *Chinese Philosopher Confucius*, by sculptor Liu Shih. At its highest, the curving, stepped structure is 44 stories tall, tapering down to 19 stories at the edges. Its lower three floors project forward from the mass for a more comfortable transition to the 24,000 square-foot south-facing plaza. The building's unusual shape results in many north-facing apartments, but the views uptown more than compensate for the lack of sunshine.

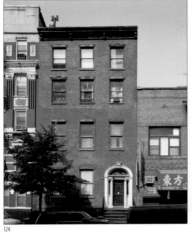

124

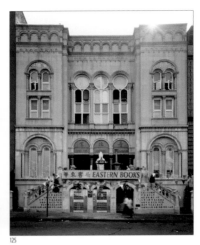

125

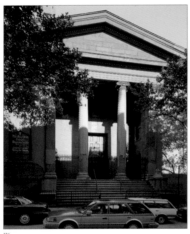

126

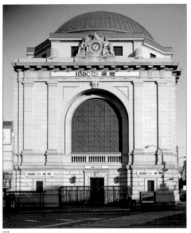

127

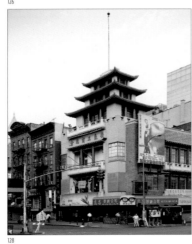

128

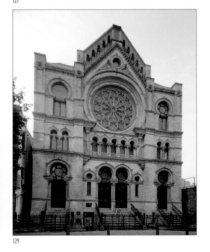

129

124
51 MARKET STREET ℒ

BETWEEN MONROE AND MADISON STREETS

1824

One of New York's most beautiful surviving examples of a Federal style row house, this was originally the home of William Clark, a grocer. A simple two-story house when the Clarks lived here, it was doubled to four several years later. The alteration didn't disturb its fabulous entrance, with the fanlight over the door. The style is quite modest for a New York house. It was popular during the first 35 years of the nineteenth century, after which a new style called Greek Revival replaced it.

125
SUNG TAK BUDDHIST TEMPLE ℒ

15 PIKE STREET
BETWEEN EAST BROADWAY AND HENRY STREET

1903

This is a symbol of a changing neighborhood— a former synagogue converted into a Buddhist temple. In this case, the conversion was something more than switching from one kind of house of worship to another. The temple fills most of the original sanctuary, but there are now apartments above it and stores on the street level.

126
MARINERS TEMPLE ℒ
(BAPTIST)

12 OLIVER STREET AT HENRY STREET

1845, ATTRIBUTED TO ISAAC LUCAS

Built as a fashionable Greek Revival church, this was a replacement for the original Oliver Street Baptist Church. The brownstone that clads the Temple is a local product, found in New Jersey and Connecticut, that became so common with home builders in the 1840s and '50s that every residence was called a "brownstone," even if it was made of brick. Its popularity stems from the fact that it was cheap and easy to cut.

127
HSBC BANK
(ORIGINALLY CITIZEN'S SAVINGS BANK)

51 BOWERY AT CANAL STREET

1924, CLARENCE W. BRAZER

This building's magnificent bronze dome was built as a Classical counterpoint to the now down-at-the-heels Manhattan Bridge approach across the street. That treasure, designed by Carrère & Hastings in 1915, has a grand arch and impressive colonnades that have been allowed to deteriorate over the years. The Department of Transporation has been promising to restore it, but other projects keep getting in the way.

128
CHINESE MERCHANT'S ASSOCIATION

85 MOTT STREET AT CANAL STREET

1958

The neighborhood known as Chinatown was already built when the first Chinese immigrants settled here in the 1850s, and there are still only a few architectural reminders of their former home. This attempt to remedy that problem is colorful, but as far from authentic Chinese architecture as the pagoda-inspired phone booths on every corner in the neighborhood.

129
CONGREGATION K'HAL ADATH JESHURUN ℒ
(SYNAGOGUE)

12–16 ELDRIDGE STREET
BETWEEN FORSYTH AND CANAL STREETS

1887, HERTER BROTHERS
RESTORATION, 1998, GEORGIO CAVAGLIERI

This was the first Orthodox temple in New York, as well as the most lavish. Its façade is mixture of Romanesque, Moorish, and Gothic styles. Unlike many other houses of worship on the Lower East Side, the K'Hal synagogue still serves its original purpose and has expanded its service to the Jewish community as an education center and resource for the study of the nineteenth-century immigrant experience.

Isaac Ludlum House

281 East Broadway off Montgomery Street

1829

This nearly intact but slightly dilapidated Federal-style house is currently an annex to the Henry Street Settlement around the corner. Along with other restored townhouses that are part of the Settlement's complex, it is a reminder of the character of the entire neighborhood in the early nineteenth century, when it was an outpost at the edge of the city.

Bialystoker Synagogue

7–13 Bialystoker Place
between Grand and Broome Streets

1826

Native stone called "Manhattan schist" is used in the façade of this nineteenth-century building that was built for the Willett Street Methodist Episcopal Church. It was converted to a synagogue in 1905 to serve a congregation that had been formed twenty-seven years earlier in Bialystok, a part of the Russian Empire that is now Poland, and that remained together after emigrating to New York.

Ritual Bathhouse

313 East Broadway at Grand Street

1904

Originally the Young Men's Benevolent Society, this building now serves Orthodox Jewish women who follow the requirement of a ritual bath, or *mikveh*, for purification and cleansing before marriage and monthly afterward. There are strict rules and guidelines involved, and the ritual can only be performed in a special location such as this.

Congregation Beth Hamedrash Hagodol (Synagogue)

60–64 Norfolk Street
between Grand and Broome Streets

1850, William F. Pedersen & Associates

Established in 1852, this congregation of Russian Orthodox Jews adopted the former Norfolk Street Baptist Church as its synagogue in 1885. The Gothic Revival building, with its iron fence, still has its original woodwork. The Baptist congregation, which had moved here from nearby Stanton Street, relocated to 46th Street, then to Park Avenue, when finally, in 1930, it became Riverside Church.

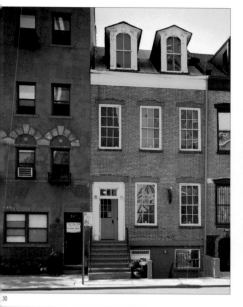

130

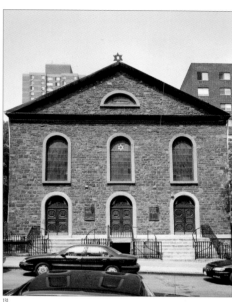

131

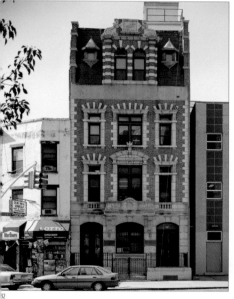

132

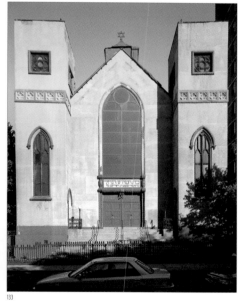

133

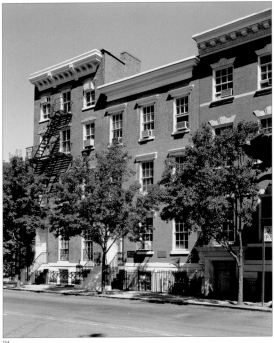

134

134

HENRY STREET SETTLEMENT

263, 265, AND 267 HENRY STREET,
BETWEEN MONTGOMERY AND GOUVERNEUR STREETS

1827 AND 1834.
NUMBER 267'S NEW FAÇADE, 1910, BUCHMAN AND FOX.
RESTORATION, 1996, J. LAWRENCE JONES ASSOCIATES

In 1893, Lillian Wald founded the "Nurse's Settlement" at 263 Henry Street to help Americanize the Eastern European Jewish immigrants on the Lower East Side. Later, as the Henry Street Settlement, it attracted the support of philanthropists Jacob Schiff and Morris Loeb, who bought the other two neighboring buildings and donated them to the effort. The structures are late Federal residences reflecting the character of this neighborhood in the early nineteenth century, when it was a semi-rural outpost at the edge of town.

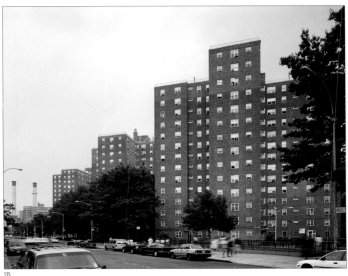

135

Jacob Riis Houses

East 6th to East 10th Street
east of Avenue D

1949, James MacKenzie, Sidney Strauss
and Walker & Gillette

These nineteen buildings, ranging from six to
fourteen stories, were placed at an angle to the
street grid to create an area that would serve as
a tree-lined park. It had badly deteriorated by
the 1960s, prompting the Parks Department to
turn it into a park with innovative play-
grounds, fountains, and an outdoor theater.
After its dedication by Lady Bird Johnson, the
Village Voice exulted that, "For once, the poor
of the city have the best of it." That was in
1966. Today, much of Riis Houses' plaza has
been destroyed because of what city officials
have deemed safety problems.

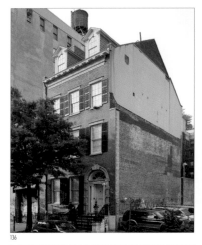

136

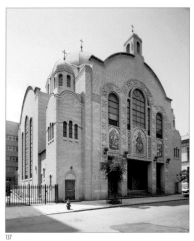

137

138

139

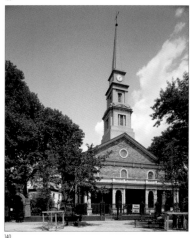

140

141

136
OLD MERCHANT'S HOUSE &

29 EAST 4TH STREET
BETWEEN THE BOWERY AND LAFAYETTE STREET

1832

This may be the only surviving Greek Revival house in the city with both its interior and exterior intact. It was the home of merchant Seabury Tredwell and remained in his family until its last surviving member died in 1933. The house and its furnishings were bought by George Chapman, who turned it into a public museum. It was faithfully restored in 1974, under the supervision of New York University architect Joseph Roberto.

137
ST. GEORGE'S UKRAINIAN CATHOLIC CHURCH

16–20 EAST 7TH STREET
BETWEEN COOPER SQUARE AND SECOND AVENUE

1977, APOLLINAIRE OSADACA

This is a glistening reminder of the Old Country for the more than 1,600 Ukranians who live in this part of the East Village. The church was established by Byzantine Rite Catholics at a former Baptist church on East 20th Street. When its first bishop, Soter Ortynsky, came here in 1907, his first mass in America was said there. The parish moved into this neighborhood in 1911.

138
OTTENDORFER BRANCH &
NEW YORK PUBLIC LIBRARY

135 SECOND AVENUE
BETWEEN ST. MARK'S PLACE AND EAST 9TH STREET

1884, WILLIAM SCHICKEL

This ornate brick and terra-cotta building was created as a free library for the large German community in the neighborhood by Anna Ottendorfer, whose first husband, Jacob Uhl, ran the successful German-language newspaper, *New Yorker Staats Zeitung*. After Uhl died, she married the paper's editor, Oswald Ottendorfer, and together they endowed this library, for which Ottendorfer personally selected the books.

139
STUYVESANT POLYCLINIC HOSPITAL &

137 SECOND AVENUE
BETWEEN ST. MARK'S PLACE AND EAST 9TH STREET

1884, WILLIAM SCHICKEL

At the time of its founding, this clinic, established to offer free outpatient care for the poor, was called the "Deutsches Dispensary." The name was changed after it was sold in 1906 to the German Polyklinik, but during World War I, anti-German sentiment forced it to change again, and although it was changed back after the war, it was renamed Stuyvesant Polyclinic, once and for all, during World War II.

140
ST. MARK'S-IN-THE-BOWERY CHURCH
(EPISCOPAL)

EAST 10TH STREET AT SECOND AVENUE

1828, ITHIEL TOWN

After St. Paul's Chapel on lower Broadway, this is Manhattan's second-oldest church building. It occupies the site of Peter Stuyvesant's private chapel, and he himself is buried in its churchyard. Once the centerpiece of a fashionable neighborhood, the church and its congregation deteriorated over the years, but both the structure and the people's faith were restored in a neighborhood renovation project that continued from 1975 through 1983.

141
RENWICK TRIANGLE

114–128 EAST 10TH STREET
AND 23–35 STUYVESANT STREET
BETWEEN SECOND AND THIRD AVENUES

1861, JAMES RENWICK, JR.

Although the façades of these sixteen Anglo-Italianate houses are all similar, their sizes vary to conform to the triangular shape of the overall building lot. Their widths range from sixteen to thirty-two feet and their depths, sixteen to forty-eight feet. Stuyvesant Street, the southern leg of the triangle, is the only Manhattan street that runs truly east to west geographically, as the compass defines it.

The Spirit of the '60s

The area bounded by 14th and Houston Streets, from Avenue D to the Bowery, had always been considered part of the Lower East Side, a neighborhood associated with immigrants. In the early 1950s Greenwich Village, which already enjoyed a tradition of welcoming bohemians and freethinkers, became the mecca of a brash artistic and literary community then dubbed "beatniks." But their destination came with a price tag. Some newcomers taken aback by the high rents of the Village took up residence on the Lower East Side, which they began to call the "East Village." The area soon had all the earmarks of the original Village over on the other side of Broadway.

Throughout the '60s the East Village was a hotbed of protest and provocative behavior, where radicalism became the order of the day, just as it had in Greenwich Village forty years earlier. And of course, what goes around comes around, as far as real estate is concerned. During the 1980s, the East Village became positively respectable after serious artists and people interested in changing, rather than just protesting, the system established themselves as community leaders.

142

STUYVESANT-FISH HOUSE

21 STUYVESANT STREET
BETWEEN SECOND AND THIRD AVENUES

1804

This larger-than-average Federal-style town-
house was built by Petrus Stuyvesant, the great
grandson of the Nieuw Amsterdam's Director
General, as a wedding gift for his daughter
Elizabeth when she married Nicholas Fish. The
land had been part of the original estate where
Stuyvesant spent his last days, after having
been recalled to the Netherlands to answer
charges that he had given away the colony to
the British. The authorities allowed the case to
die in committee and he was allowed to go
home again, free to grumble about the way
things were being run around here.

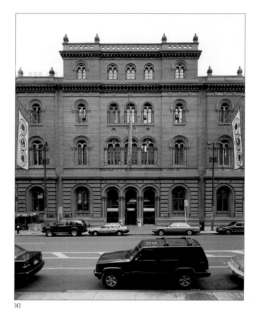

143

JOSEPH PAPP PUBLIC THEATER
(ORIGINALLY ASTOR LIBRARY)

425 LAFAYETTE STREET
BETWEEN EAST 4TH STREET AND ASTOR PLACE

1853, ALEXANDER SAELTZER.
ADDITIONS, 1869, GRIFFITH THOMAS
AND 1881, THOMAS STENT.
THEATER CONVERSION, 1976, GEORGIO CAVAGLIERI

This was New York's first major public library,
eventually combined with the Tilden Founda-
tion and the Lenox Library to create today's
New York Public Library. After the Hebrew
Immigrant Aid and Sheltering Society, which
had been here since 1921, moved to larger
quarters in 1965, Joseph Papp, the founder of
the New York Shakespeare Festival, convinced
the city to buy the Italian Renaissance Building
and lease it to his organization as theater
space. The conversion by Georgio Cavaglieri
carefully retains the original interior details
with a minimum of alteration.

COOPER UNION FOUNDATION BUILDING

144

COOPER SQUARE
EAST 7TH STREET TO ASTOR PLACE
FOURTH AVENUE TO THE BOWERY

1859, FREDERICK A. PETERSON

This is the oldest iron-framed building still stand-
ing in the United States, but these aren't ordinary
construction beams. Among his many talents,
Peter Cooper, the founder of this institution,
made the first rails for railroads. He rolled some
for this building, too, stretching them across
brick arches to support the massive brownstone
building, the dimensions of which were dic-
tated by the standard length of his rails. He
established Cooper Union as a free educational
institution that gives students the equivalent of
a college degree while stressing the practical
arts and trades. The only requirement then, as
now, was good moral character.

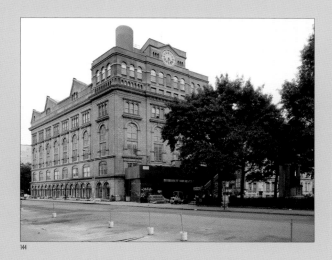

144

Renaissance Man

Few men in U.S. history have been as successful at so many different things as Peter Cooper. He began his career at the age of twenty-one by making equipment for cutting cloth used for uniforms during the War of 1812, and then he began looking for new worlds to conquer. He made his first fortune with a glue factory on the banks of Sunfish Pond, in the little village of Kip's Bay, between 31st and 34th Streets, but glue was only one item that he produced there. He turned out ink by the gallon and invented and manufactured isinglass, a shatterproof glass perfect for carriage windows. He also patented and produced an edible form of gelatin that was later marketed as Jell-O. Cooper dabbled in real estate and lost most of his fortune to swindlers when he tried to corner the market on land around Baltimore in anticipation of the building of the Baltimore and Ohio Railroad. He tried to recoup his losses by opening iron mines there, but the steam locomotives of the new railroad weren't equipped to haul ore. Undaunted, Cooper designed and built an engine capable of transporting iron, and he became a millionaire all over again—by building both locomotives for the railroads and the rails themselves.

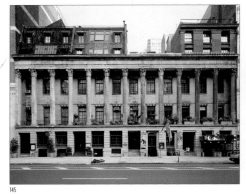

145

146

147

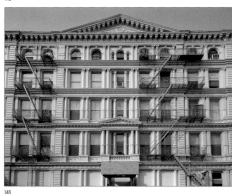

148

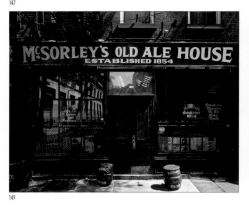

149

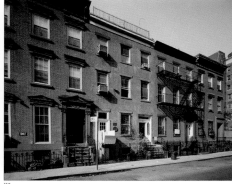

150

LaGrange Terrace ℒ

428–434 Lafayette Street
between East 4th Street and Astor Place

1833, Seth Geer,
after plans by Alexander Jackson Davis

Often called Colonnade Row, this is all that is left of a beautiful row of nine marble Greek Revival townhouses. Five of the originals were destroyed and the other four have fallen into neglect. Critics laughed when Geer built residences so far removed from the city, but when he sold them at the then outrageous price of $25,000 apiece to Cornelius Vanderbilt and John Jacob Astor, Geer had the last laugh.

William Wollman Hall
Cooper Union School of Engineering

51 Astor Place between Third and Fourth Avenues

1961, Voorhees, Walker, Smith, Smith & Haines

The engineering school, Cooper Union's largest component, is located across Astor Place from the main building. The buff brick structure is five stories high along Fourth Avenue, and drops to four along its eastern elevation. Its entrance is in a one-story projection where the two wings intersect, and covered walkways above street level and set back from the Third Avenue corner form a kind of raised courtyard.

First Houses ℒ

29–41 Avenue A at East 3rd Street

1935, Frederick L. Ackerman

This was the first public housing project in the United States. Every third house on the site was demolished to provide light and air for the remaining tenements, which were then rebuilt using bricks salvaged from their destroyed neighbors. Among the amenities missing from later projects are the stores that were included in this one. The development had 122 units, each equipped with a refrigerator, a stove, and a bathroom with hot running water, renting for $6 a room.

Bouwerie Lane Theater ℒ

330 Bowery at Bond Street

1874, Henry Englebert

Built to be a bank, this building was abandoned for half a century until 1963 when it became an off-Broadway theater, resurrecting an old tradition of the Bowery as a theater district. In the 1800s it was lined with concert saloons and minstrel theaters and it was the site of the Great Bowery Theater, America's largest, in the 1820s.

McSorley's Old Ale House

15 East 7th Street
between Cooper Square and Second Avenue

1854

Although there are some naysayers, McSorley's claims to be oldest continuously-operating saloon in New York. The main attraction here are steins of the house ale, sold two at a time. Until 1970, when the law said that they had to allow women to belly up to the bar, this was strictly a male preserve. And law or no, the proprietors have refused to add a ladies' room.

30–38 East 3rd Street

off Second Avenue

1830

This quintet of row houses are still as charming as they ever were. The larger tenement buildings that are usually associated with the Lower East Side first appeared a year or two after these, and others like them, were built. After the 1840s, this area was known as "Kleindeutschland,"—Little Germany—for its heavy concentration of German immigrants.

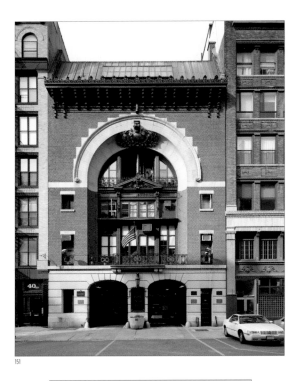

151

ENGINE COMPANY NO. 33

44 GREAT JONES STREET
BETWEEN THE BOWERY AND LAFAYETTE STREET

1899, FLAGG & CHAMBERS

Built as the headquarters of the New York City
Fire Department, this perfect example of the
French Beaux Arts style was the creation of
Ernest Flagg, who designed several of the city's
firehouses. The street is called "Great Jones" to
avoid confusion with the block-long Jones
Street in Greenwich Village between Bleecker
and West Fourth Streets, or nearby Jones Alley,
connected to it via Shinbone Alley south of
Bond Street.

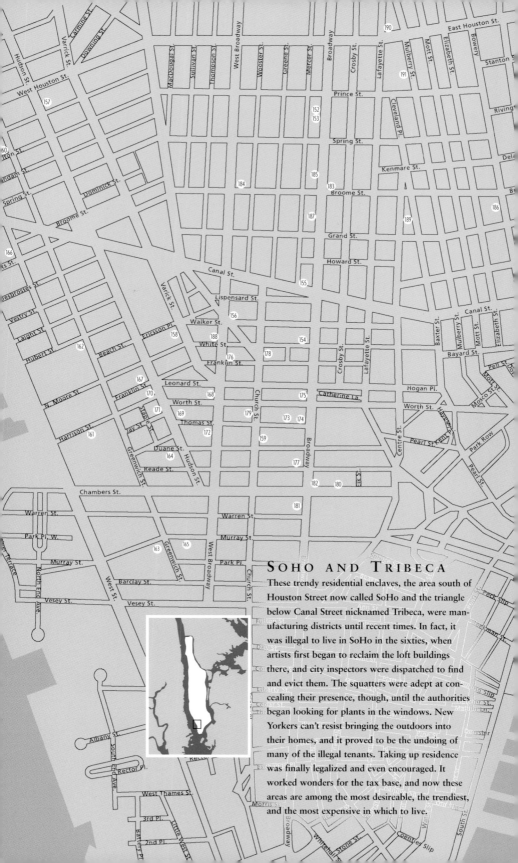

SOHO AND TRIBECA

These trendy residential enclaves, the area south of Houston Street now called SoHo and the triangle below Canal Street nicknamed Tribeca, were manufacturing districts until recent times. In fact, it was illegal to live in SoHo in the sixties, when artists first began to reclaim the loft buildings there, and city inspectors were dispatched to find and evict them. The squatters were adept at concealing their presence, though, until the authorities began looking for plants in the windows. New Yorkers can't resist bringing the outdoors into their homes, and it proved to be the undoing of many of the illegal tenants. Taking up residence was finally legalized and even encouraged. It worked wonders for the tax base, and now these areas are among the most desireable, the trendiest, and the most expensive in which to live.

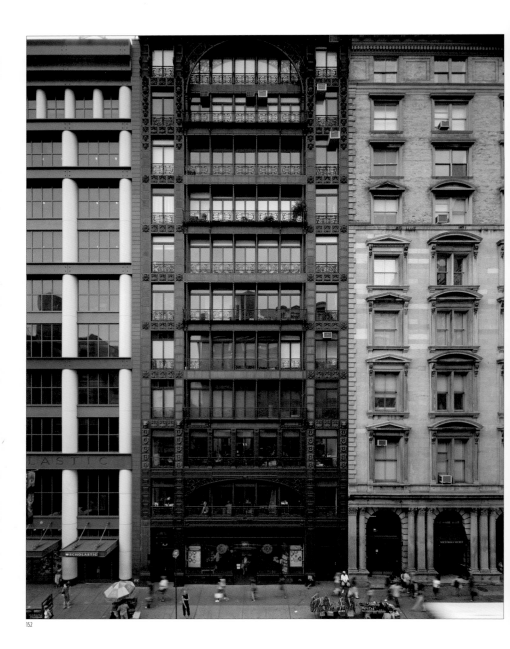

152

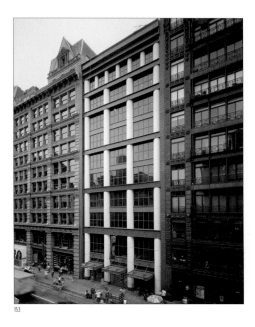

153

561 BROADWAY

BETWEEN SPRING AND PRINCE STREETS

1904, ERNEST FLAGG

This is often called the "Little Singer Building" because it set the stage for the same architect's Singer Tower on Broadway at Liberty Street for the same client, the Singer Sewing Machine Company. The forty-seven-story tower is only a memory, having been torn down in 1970, but thankfully we still have this delightful twelve-story version. Among the innovations here is the first successful fireproofing of an iron structure with brick and terra-cotta. Iron plates bolted together form the vertical elements, but an unusual amount of glass and delicate wrought-iron tracery give the façade a feeling of airiness. The intricately carved ironwork continues up to the cornice in a tour de force that had never before been seen in a New York building. These days, we'd call it a "curtain wall," but that term and its concept were still fifty years in the future when Ernest Flagg created the Little Singer Building.

SCHOLASTIC BUILDING

557 BROADWAY BETWEEN PRINCE AND SPRING

2001, ALDO ROSSI AND GENSLER ASSOCIATES

Scholastic Publishers moved here from a 19th-century loft building further up Broadway, providing an impressive new New York home for Harry Potter, Clifford the Big Red Dog, and the Babysitter's Club. The world's largest publisher and distributor of children's books, the company also publishes 35 school-based magazines, and its products include software that helps youngsters learn how to read. Its divisions run the gamut from television programming to teaching via the Internet, and it has a presence in nearly every school across the United States.

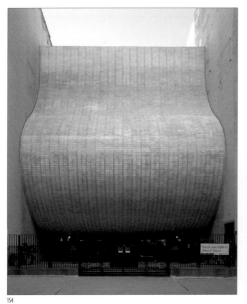

154

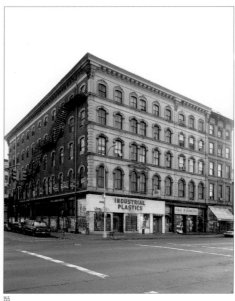

155

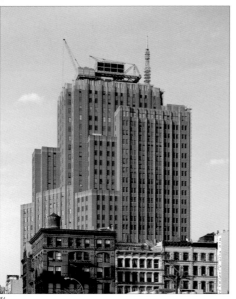

156

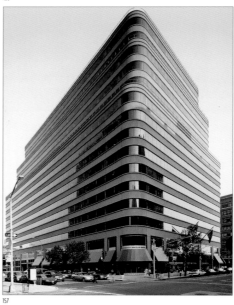

157

CIVIC CENTER SYNAGOGUE

47-49 WHITE STREET
BETWEEN BROADWAY AND CHURCH STREETS

1967, WILLIAM N. BREGER ASSOCIATES

A ribbon-like wall of marble tiles hides a wonderful garden behind this modern addition to a street of nineteenth-century cast-iron buildings. Many of the early buildings in this former shopping district were either faced with marble or used it to enhance iron and other materials. The stone, known as Tuckahoe marble, was quarried in nearby Westchester County.

ARNOLD CONSTABLE STORE

307–311 CANAL STREET AT MERCER STREET
1856

When it was a dry goods emporium, this building also faced Mercer and Howard Streets, and, although the façades are similar on all three sides, only the Canal Street elevation is faced with marble, while the other two are brick. The change in Canal Street's retail climate over the years hasn't been kind to this building, and no trace of its cast-iron front entrance remains.

AT&T HEADQUARTERS

32 SIXTH AVENUE
BETWEEN WALKER AND LISPENARD STREETS

1932, VOORHEES, GMELIN & WALKER

An expansion of an earlier office building, this huge Art Deco structure once housed the biggest long-distance telephone center in the world. Its landmarked lobby has ceramic tile walls with marble and bronze trim. There is a tile map of the world on one wall, and the ceiling is covered with glass mosaics celebrating telephone communications to far-away continents.

SAATCHI & SAATCHI
D.F.S. COMPTON WORLD HEADQUARTERS

375 HUDSON STREET
BETWEEN KING AND WEST HOUSTON STREETS

1987, SKIDMORE, OWINGS & MERRILL,
LEE HARRIS POMEROY & ASSOCIATES,
EMERY ROTH & ASSOCIATES

It's a long way from Madison Avenue, but this is the home of one of the world's biggest advertising agencies, as well the book publisher Penguin Putnam. It is a late addition to a neighborhood of massive buildings, most of which were built on land leased from Trinity Church as the center of the city's printing industry.

FIRST PRECINCT, NYPD

16 ERICSSON PLACE AT VARICK STREET

1912, HOPPIN & KOEN

This lavish Renaissance palace for New York's Finest features a large stable on the Varick Street side for their horses. It is now the First Precinct, even though the stone carving over the front door identifies it as the Fourth. Its designation was changed when the First moved across town from its original location at 100 Old Slip, now the Police Museum.

STATE INSURANCE FUND

199 CHURCH STREET
BETWEEN THOMAS AND DUANE STREETS

1955, LORIMER RICH ASSOCIATES

Actually, this office building isn't as unattractive as its stainless steel canopy might suggest. Its base is made of pleasing red granite, and its upper stories are faced with glazed white brick. It could be worse. The Insurance Fund was created in 1910 to support workers' claims for job-related injuries, which both employers and insurance companies resisted. New York was the first state to provide such coverage.

CHARLTON-KING-VANDAM HISTORIC DISTRICT

KING STREET BETWEEN SIXTH AVENUE AND VARICK STREET

1820–1849

This tiny Historic District, of which these Greek Revival and Federal style row houses are a part, was the site of Richmond Hill, a 1776 Georgian mansion that overlooked the Hudson River. It served as George Washington's headquarters, then as the official residence of Vice President John Adams, who moved there in 1789. Aaron Burr bought Richmond Hill four years later. Burr sold the estate to John Jacob Astor, who leveled the hill and divided the property into twenty-five-foot building lots for many of the houses that are here now.

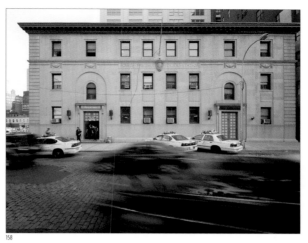

158

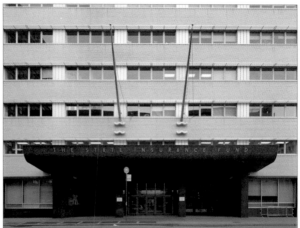

159

160

161

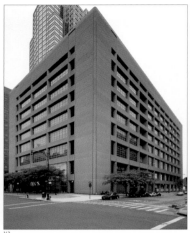

162

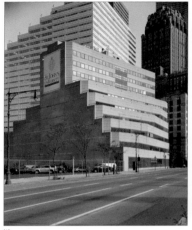

163

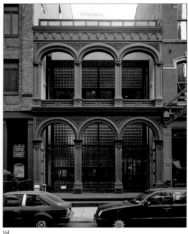

164

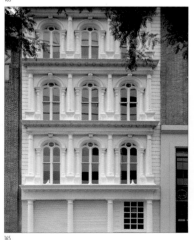

165

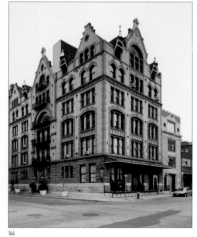

166

161

HARRISON STREET ROW

25–41 HARRISON STREET AT GREENWICH STREET

1796–1828, RESTORATION BY OPPENHEIMER & BRADY

A charming reminder of the first time Tribeca was considered a great place to live, these nine Federal-style houses were rehabilitated and made part of the Independence Plaza housing complex in the 1960s. Three of them, including nos. 25 and 27, both designed by John McComb, Jr., were moved around the corner from Washington Street.

162

SHEARSON-LEHMAN PLAZA

390 GREENWICH STREET, HUBERT STREET TO WEST STREET

FAULKNER INFORMATION SERVICES,
1986, SKIDMORE, OWINGS & MERRILL
SMITH BARNEY (TRAVELLERS GROUP),
1989, KOHN PEDERSON FOX

This pair of buildings seems to be at odds with one another, and together they seem to be battling the whole neighborhood. The newer, taller one became the focus of neighborhood protests against the illuminated Travellers umbrella logo on its uptown façade, but the real bone of contention just might be the loss of the park that the building replaced.

163

COLLEGE OF INSURANCE

101 MURRAY STREET
BETWEEN GREENWICH AND WEST STREETS

1983, HAINES LUNDBERG WAEHLER

Among the many superlatives applied to New York City, one rarely hears that the city has more colleges and universities than any other urban center in the country. Among them is this unusual one, the College of Insurance, founded in 1962, housed inside a pink pile of orderly steps. The blank wall on the downtown side hints at future expansion, but then where will the students park their cars?

164

172 DUANE STREET

BETWEEN HUDSON AND GREENWICH STREETS

1872, JACOB WEBER
REMODELED, 1994, V. POLINELLI

Cast-iron arches from the original building frame an elegant and modern new one built of glass block. Originally the Weber Cheese Company, one of hundreds of such companies in this neighborhood, whose merchants were commonly-known as the "big butter and egg men," it is now the home of the law firm of Lovinger Mahoney Adelson.

165

75 MURRAY STREET

BETWEEN WEST BROADWAY AND GREENWICH STREET

1858, JAMES BOGARDUS

Here is one of the earliest examples of cast-iron architecture by pioneer James Bogardus. Like all the others, the building's floors and roofs are supported by wood beams on brick bearing walls but the façade is made up of sections of pre-fabricated cast-iron that were assembled on the site like an Erector set.

166

FLEMING SMITH WAREHOUSE

451–453 WASHINGTON STREET AT WATTS STREET

1892, STEPHEN DECATUR HATCH

The first building in Tribeca to be converted to residential use is a fascinating combination of Romanesque and Flemish Renaissance design, with fanciful gables and dormers. The date of its construction and the initials of its original owner are wrought in metal on the central gable. Many buildings in the western section of Tribeca are similar masterpieces, with brick and stone façades and bold metal trim, and most were built for companies dealing in fresh produce.

108 HUDSON STREET

AT FRANKLIN STREET, 1895

The unusual columns flanking the entrance of this baroque hulk were designed to match the rusticated façade of this former loft building that has, like so many of its neighbors, been converted into apartments. The term "rustication" refers to the practice of dressing the façades of stone buildings with deeply grooved joints. In many buildings, although not here, the stones are roughened as well, to achieve a "rustic" effect.

175 WEST BROADWAY 𝓛

BETWEEN LEONARD AND WORTH STREETS

1877, SCOTT & UMBACH

TriBeCa, short for the "triangle below Canal Street," gets its character from former manufacturing buildings like this. Although many of the structures in the district bounded by Church, Cortlandt, and Canal Streets have become the epitome of loft living, the master plan that defined its boundaries, created in 1958 by the Downtown-Lower Manhattan Association, called for reserving the triangle as downtown's only manufacturing district.

WESTERN UNION BUILDING 𝓛

60 HUDSON STREET AT WORTH STREET

1930, VOORHEES GMELIN & WALKER

This is one of several architectural treasures created by Ralph Walker. Western Union virtually controlled communication by telegraph at the time it was built, and his design for its corporate headquarters reflected its power with several different shades of brick, lightening in hue as the structure rises. The building's lobby also has landmark status, where the orange brick walls reach up to a matching barrel-vaulted ceiling of Guastavino tile. The building provides office space for several different companies today.

REGENT WALL STREET HOTEL

6 HARRISON STREET AT HUDSON STREET

1884, THOMAS R. JACKSON

Formerly a branch of the New York Mercantile Exchange, whose main headquarters was at 55 Wall Street, it's now the Regent Wall Street Hotel. This powerful brick structure with its impressive tower was built as a statement of solidity to local merchants who relied on it for their financial needs. It was redesigned in 1987 as office space.

HOUSE OF RELIEF

67 HUDSON STREET AT JAY STREET

1893, CADY, BERG & SEE

Originally an outpost of New York Hospital, which was located on 15th Street at the time, this was a turn-of-the-century version of today's hospital emergency rooms, built to serve lower Manhattan. Now a residential building, it still, appropriately, includes several doctors' offices.

155 WEST BROADWAY
(NOW NEW YORK CITY SUPREME COURT)

AT THOMAS STREET

1865, JARDINE, HILL & MURDOCK

A frequent destination of Manhattanites summoned for jury duty, this building has a double effect on the local streetscape. On West Broadway, it is a handsome Anglo-Italianate building, while the façade around the corner on Thomas Street is just plain brick. Jurors can adjourn to a gourmet lunch across the street at the trendy Odeon, a gentrified former cafeteria.

167

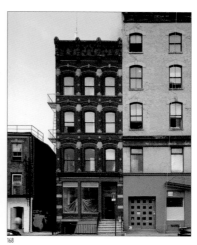

168

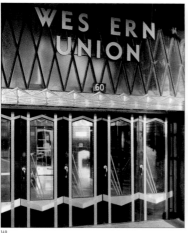

169

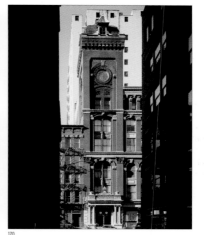

170

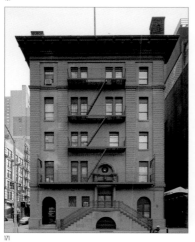

171

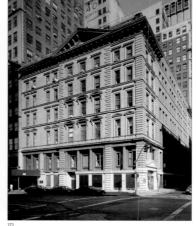

172

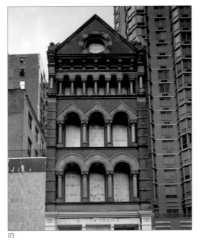

173

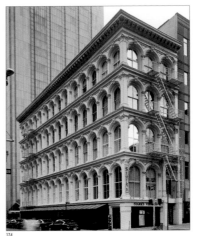

174

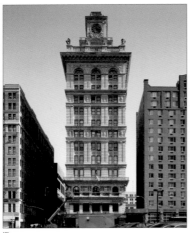

175

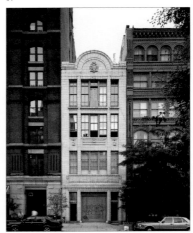

176

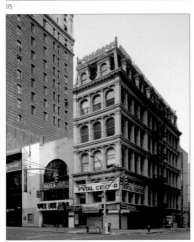

177

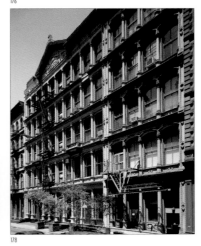

178

8 THOMAS STREET

BETWEEN BROADWAY AND CHURCH STREET

1876, J. MORGAN SLADE

Originally an emporium built for David S. Brown, a manufacturer of laundry and toilet soaps, this loft apartment building combines several different architectural styles. Its banded stone arches are Venetian Gothic and its cast-iron ground floor borrows from French styles. All together, it is classified as Victorian Gothic, and there is no finer example of it anywhere in New York.

319 BROADWAY

AT THOMAS STREET

1870, D. & J. JARDINE

Originally one of a pair of Italianate cast-iron buildings that once guarded the western entrance of Thomas Street and were known as "the Thomas Twins," this survivor was once the headquarters of the Metropolitan Life Insurance Company and also the home of the New York Life Insurance Company before it moved into its own building further down on Broadway in 1899.

N.Y. LIFE INSURANCE COMPANY BUILDING
(NOW NEW YORK CITY OFFICES)

346 BROADWAY AT LEONARD STREET

1899, S. D. HATCH AND McKIM, MEAD & WHITE

As Hatch's eastern addition to an earlier building on the Broadway side was completed and the insurance company moved into it, Stanford White went to work on a building to replace the one they had just left. Its distinctive clock tower eventually became the Clock Tower Gallery for the display of avant-garde art. New York Life moved uptown to the former site of White's original Madison Square Garden in 1928.

DEPARTMENT OF WATER SUPPLY, GAS, AND ELECTRICITY

226 WEST BROADWAY
BETWEEN FRANKLIN AND WHITE STREETS

1912, AUGUSTUS D. SHEPARD, JR.

Originally built as the Fire Department's High Pressure Services headquarters, the iconography on this slender building's glazed terra-cotta façade includes representations of fire hydrants, hoses, valves, couplings, and other tools of the firefighter's trade. It is crowned in its central pediment by a fine rendering of the official seal of the City of New York.

287 BROADWAY

AT READE STREET

1872, JOHN B. SNOOK

Built as a speculative building, the original owner gussied up this cast-iron French Second Empire structure with a gorgeous mansard roof enhanced with intricate iron filigree. He also made it more attractive for prospective tenants by installing one of the first passenger elevators in the city. Unfortunately, fashion has long since passed this section by, and, like many of its neighbors, all the glories of 287 Broadway are far above street level.

36–57 WHITE STREET

BETWEEN CHURCH STREET AND BROADWAY

1861–65, VARIOUS ARCHITECTS,
INCLUDING JOHN KELLUM & SON

This row includes the Woods Mercantile Buildings (46–50), built of Tuckahoe marble with cast-iron storefronts. In the 1850s and '60s, blocks like this one, off Broadway above City Hall, were part of New York's most fashionable shopping district. This block included the upscale saddlery company run by James and Samuel Condict, at no. 55. Architect John Kellum also designed the nearby "Tweed" Courthouse.

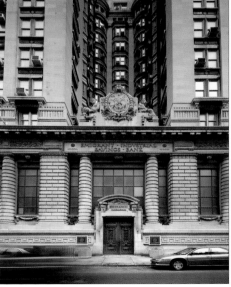

AT&T LONG LINES BUILDING

CHURCH STREET
BETWEEN THOMAS AND WORTH STREETS

1974, JOHN CARL WARNECKE & ASSOCIATES

This pile of pink granite doesn't have a window in sight because the electronic equipment inside can't stand the heat. On the other hand, the heat generated by the machines themselves is enough to warm its 29 eighteen-foot-high floors. This building is also certified safe from nuclear fallout, and it has enough food and energy supplies to remain sealed off for two weeks no matter what happens outside.

179

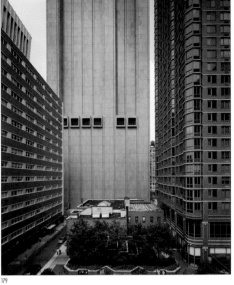

EMIGRANT INDUSTRIAL SAVINGS BANK
(NOW CITY OFFICES)

51 CHAMBERS STREET
BETWEEN BROADWAY AND ELK STREET

1912, RAYMOND ALMIRALL

The Emigrant Savings Bank was founded in 1850 by the Irish Emigrant Society, with a boost from Roman Catholic Bishop John Hughes, to encourage saving habits among new arrivals from Ireland. By the time this structure, the third building on this same site, was built, it was the most successful savings bank in the city. It flaunted the distinction with this Beaux Arts confection. It is New York's first building designed with an H-shaped plan, giving daylight to nearly all of the office space. The interior is landmarked and worth a visit, even if it is now occupied by the Department of Motor Vehicles.

180

BROADWAY-CHAMBERS BUILDING ℒ

277 BROADWAY AT CHAMBERS STREET

1900, CASS GILBERT

This was Cass Gilbert's first commission in New York, and one of the first to use steel-frame construction. The base is pink granite, the shaft is red and beige brick, the capital is colorful terra-cotta, and the cornice is beautifully weathered copper, all of it working in graceful harmony. It is located a few blocks up Broadway from Gilbert's other contribution to the neighborhood, the Woolworth Building.

181

280 BROADWAY ℒ

AT CHAMBERS STREET

1846, JOHN B. SNOOK

Now City offices, this Italianate marble palace was the first department store in New York. Its owner, A. T. Stewart, drew crowds of shoppers here until 1862, when he began luring them to a store farther uptown and turned the old emporium into a warehouse. More floors were added and, from 1919 through 1952, the building served as headquarters for the *New York Sun*, whose publishers placed a clock over the entrance bearing the newspaper's slogan, "The Sun: It Shines for All."

182

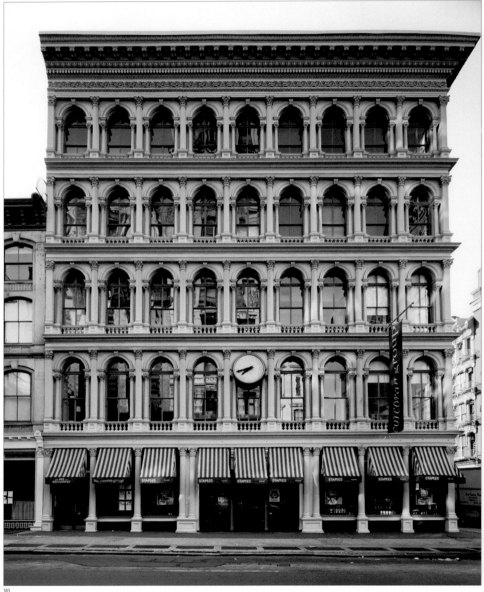

◆ SOHO AND TRIBECA ◆

184

183

E. V. Haughwout Building

488–492 Broadway at Broome Street

1857, John Gaynor
Restored, 1999, Joseph Pell Lombardi

One of the most impressive cast-iron buildings in the city, its Venetian Renaissance façade came from the catalogue of Daniel Badger's Iron Works, a local firm that made cast-iron panels that architects mixed and matched to create the effect they wanted. Cast-iron was especially appropriate for retail stores like this one because its strength allowed large open spaces for show windows. Eder V. Haughwout sold cut glass, silverware, clocks, and chandeliers in his cast-iron palace, and he made it more attractive to his customers by installing the first commercial elevator ever to appear in a store.

184

Kenn's Broome Street Bar

363 West Broadway at Broome Street

1825

No, this bar hasn't been dispensing drinks for 175 years. It just looks like it has. It's the kind of place people expect to find when they stroll through landmark districts. The three-story brick Federal-style house it occupies was originally a private home, built in the days when this part of the neighborhood, now known as SoHo, was an elite residential enclave. The ground floor has been extensively altered, and the floors above have obviously seen better days. The dormer jutting out of its sloping roof could use some loving restoration if anyone hopes it to last many more years.

New Era Building

491 Broadway between Broome and Spring Streets

1897, Buchman & Deisler

A gorgeous example of the Art Nouveau style, this copper-roofed gem was built as a retail store for Jeremiah C. Lyons, who expanded his business here at a time when others were moving uptown and taking fashionable customers with them. Within a few more years, the neighborhood became home to dealers in waste paper and marginal manufacturing enterprises, in spite of the presence of wonderful buildings like this one.

Bowery Savings Bank ℒ

130 Bowery between Grand and Broome Streets

1895, McKim, Mead & White

This building is the reason why so many bank buildings all over the country are designed in the Classical style. Stanford White was a master of that style and once he produced this impressive example of it, nothing else would do for the bankers of America. The majestic interior of this L-shaped bank is a symphony of marble mosaic floors, marble tellers' cages, and massive columns rising up to coffered ceilings with huge cast-iron skylights.

Roosevelt Building

478–482 Broadway
between Grand and Broome Streets

1874, Richard Morris Hunt

This cast-iron building was built for Roosevelt Hospital, which inherited the site from James H. Roosevelt (Theodore Roosevelt's uncle), who lived and practiced law here in the 1850s. While most architects used cast-iron to imitate stone, Richard Morris Hunt let the iron speak for itself here in such elements as the curved screen-work above the fourth floor windows and the narrow columns that take full advantage of the iron's strength. When the building was new, these iron elements were painted in at least a half-dozen different colors instead of the dull gray paint other designers used to make their iron buildings look like stone.

2 White Street ℒ

at West Broadway

1809, Gideon Tucker

A no-nonsense Federal-style house with a dormered gambrel roof, this was probably a store with the owner's living quarters in its upper stories. The truly remarkable thing about it is that such a modest building has survived at all, and in such wonderful condition. At the time it was built, Tribeca was a completely residential neighborhood, but it turned industrial before once again becoming a great place to live.

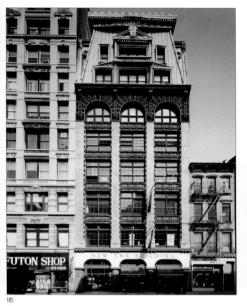

185

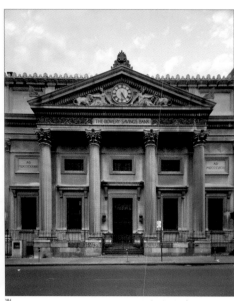

186

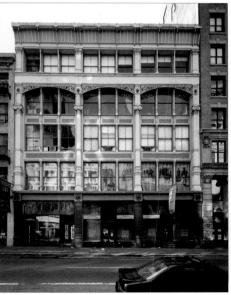

187

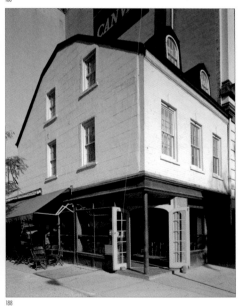

188

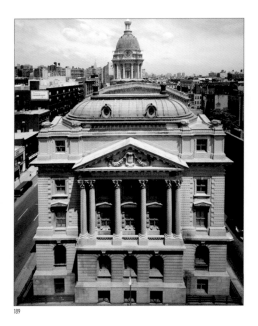

189

POLICE BUILDING APARTMENTS 𝓛

189

240 Centre Street

1909, Hoppin & Koen
Apartment conversion, 1988,
Ehrenkranz Group & Eckstut

The grand scale and baroque detail of this building make it a standout in a neighborhood of lofts and tenements—but of course the effect was intentional: It was originally the headquarters of the New York City Police Department. This was the place where gangsters in 1930s movies went when they were sent "downtown." The department moved even further downtown in 1973, and this magnificent building stood forlornly empty for fifteen years before it was converted into luxury apartments favored by models and actors.

PUCK BUILDING 𝓛

190

295–309 Lafayette Street at East Houston Street

1886 and 1893 Albert Wagner

A Massive Romanesque Revival building with repeated round-arched arcades and intricate brickwork, the Puck Building is actually two separate structures. When Lafayette Street was extended through the block in the early 1890s, two bays of the original building were removed and its entire west wall was destroyed. Herman Wagner, a close relative of the original architect, designed the new Lafayette Street elevation as a seamlessly perfect match to the previous work, moving the main entrance over to the new section. The signature sculpture of Shakespeare's Puck that stood over the original main entrance was duplicated rather than moved. The building was extensively rehabilitated in 1984 as office, gallery, and party space, and also serves as the exterior shot of Grace's design office in the TV sit-com *Will and Grace*.

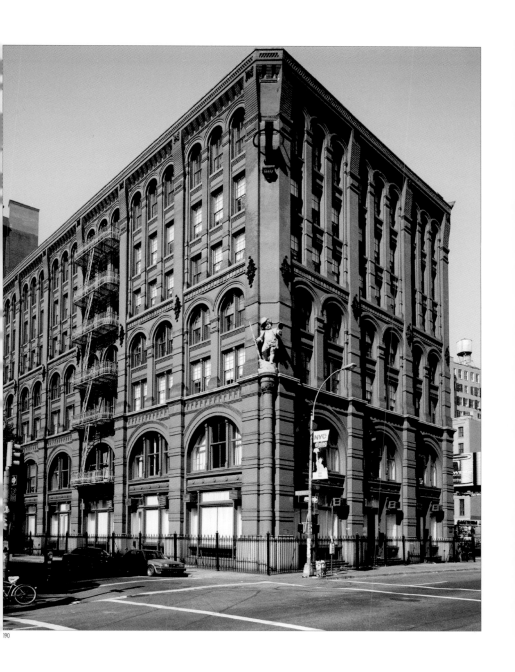

190

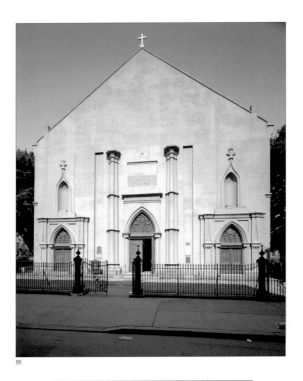

191

St. Patrick's Old Cathedral
(Roman Catholic)

260–264 Mulberry Street at Prince Street

1815, Joseph Mangin

At the time this building was dedicated—and
welcomed its first bishop, Rt. Rev. John Con-
nolly—there were 16,000 Catholics in New
York and only one Catholic church, St. Peter's
on Barclay Street. The mother church of the
Archdiocese is now St. Patrick's on Fifth
Avenue at 50th Street, and this has become just
a parish church, although it is designated as an
"old" cathedral. The complex includes a very
fine rectory and churchyard, and a convent
and school for girls, which was originally an
orphanage.

GREENWICH VILLAGE

On New Year's Eve in 1916, a band of self-styled "Bohemians" climbed to the top of the arch in Washington Square and, after firing cap pistols and releasing balloons, declared the Village a "free republic, independent of uptown." By "uptown," they apparently meant the rest of America, because their proclamation included an appeal to President Wilson for Federal protection as a small country. They needn't have bothered. Greenwich Village has been a place apart since colonial times, a gathering place for free spirits of all kinds, and it still is. Even the streets refuse to follow the rigid grid of the rest of Manhattan. The good news is that you don't need a passport to meander the streets, taking in the diversity of beautiful architecture—including many landmark townhouses—and sampling the restaurants, shops, cafés, and nightlife.

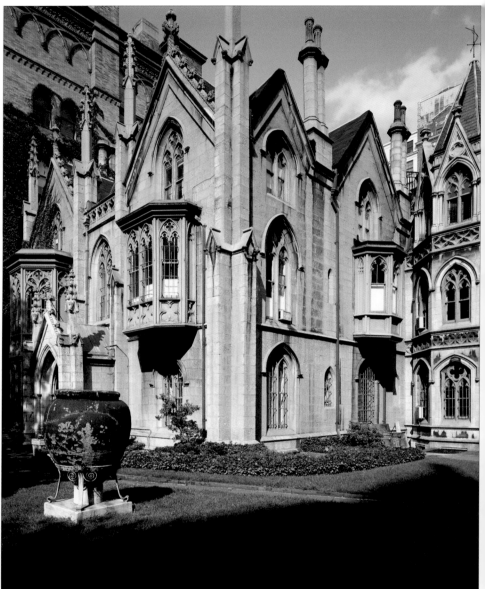

GRACE CHURCH
(EPISCOPAL)

800 BROADWAY AT 10TH STREET

1846, JAMES RENWICK, JR.

The huge urn that stands in front of the rectory to the north of Grace Church is a relic from ancient Rome, a gift to a former rector from one of his parishioners. The church, along with the rectory and other buildings in the complex—including the school behind it on Fourth Avenue—were designed by another parishioner, James Renwick, Jr. Renwick was also the architect of New York's St. Patrick's Cathedral and Washington's Smithsonian Institution, the latter when he was just twenty-three years old. The church, one of the country's most elegant Gothic-style structures, is famous as the spiritual home of some of the city's most influential families, but it also pioneered community outreach among New York's churches in 1876, by establishing Grace Chapel on East 14th Street (now Immaculate Conception Church) to offer classes in English and other services to new immigrants. The parish built a mission house on the Lower East Side several years later, and today it maintains a homeless shelter within its original complex. The wife of the architect was a descendant of Henry Brevoort, who refused to sell his garden on this site to allow Eleventh Street to push through, and then held out against the surveyors of Broadway, forcing the bend in the thoroughfare that makes Grace Church's marble steeple visible all the way down to Houston Street.

NEW YORK MERCANTILE EXCHANGE

628–639 BROADWAY

1882, HERMAN J. SCHWARZMANN
AND BUCHMAN & DEISLER

The busy cast-iron façade of this former financial institution that is now a retail store is decorated with reliefs of roses and lilies, and its delicate columns are ridged to represent bamboo. One of the great advantages of cast-iron is that the material can be made to resemble anything that a designer can imagine. Few buildings in the city are as imaginatively decorated as this one by the chief architect of the 1876 Centennial Exposition in Philadelphia.

ONE FIFTH AVENUE

AT EAST 8TH STREET

1929, HELMLE, CORBETT & HARRISON
AND SUGARMAN & BERGER

New York's enthusiasm for skyscrapers during the Roaring Twenties spilled over to apartment buildings, and One Fifth Avenue was among the first to take advantage of the trend. Twenty-seven stories tall, it has only one connected neighbor, which allows it to soar as a virtual freestanding tower above Washington Square Park. The lobby is unmistakably residential in a grand way, with a symphony of Doric elements.

FIRST PRESBYTERIAN CHURCH

48 FIFTH AVENUE
BETWEEN WEST 11TH AND WEST 12TH STREETS

1846, JOSEPH C. WELLS

The British architect who designed this Gothic Revival church used Oxford University's Magdalen College as his model. The Church House next door was built in 1960, following designs by Edgar Tafel that closely reflect the church itself. The chapel, built in 1894, was designed by McKim, Mead & White.

FORBES MAGAZINE BUILDING

60–62 FIFTH AVENUE AT WEST 12TH STREET

1925, CARRÈRE & HASTINGS AND SHREVE & LAMB

Originally the headquarters of the Macmillan Publishing Company, this building is now the home of *Forbes* Magazine and its sister publications. The eclectic Forbes Gallery located here reflects the interests of the late Malcolm Forbes, who collected a range of artifacts from toy boats and soldiers to Fabergé eggs.

LOCKWOOD DE FOREST HOUSE

7 EAST 10TH STREET
BETWEEN UNIVERSITY PLACE AND FIFTH AVENUE

1887, VAN CAMPEN TAYLOR

Now New York University's Center for Jewish Student Life, the façade of this charming house is intricately carved teakwood evoking an East Indian temple. Its original owner was an artist who worked in India and founded a school there to revive the ancient art of wood carving.

HEMMERDINGER HALL

100 WASHINGTON SQUARE
BETWEEN WAVERLY AND WASHINGTON PLACES

1895, ALFRED ZUCKER

This is the main building of New York University. It stands on the site of a massive Gothic building that housed the entire university when it was built in 1837, six years after the founding of what has become the largest private university in the country.

193

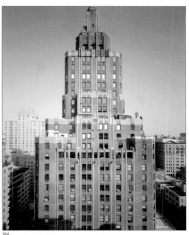

194

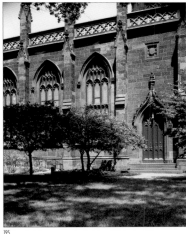

195

196

197

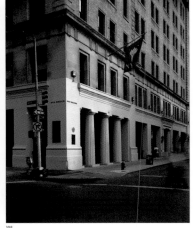

198

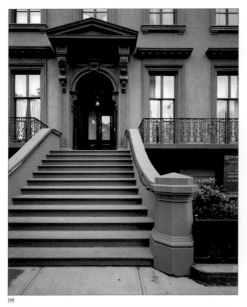

199

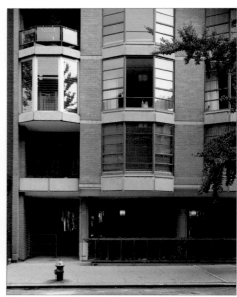

200

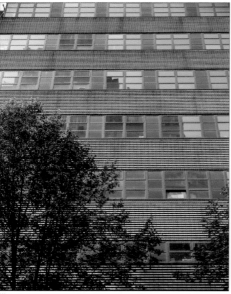

201

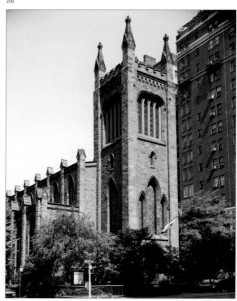

202

SALMAGUNDI CLUB

47 FIFTH AVENUE
BETWEEN EAST 11TH AND EAST 12TH STREETS

1853

This handsome Italianate mansion was once part of a row of similar houses along this lower Fifth Avenue block. It was built for Irad Hawley, president of the Pennsylvania Coal Company. The Salmagundi Club, which mounts art exhibitions in its magnificent interior, moved here in 1917, fifty-four years after its founding as one of the country's oldest artists' clubs, with a membership that included Louis Comfort Tiffany, John La Farge, and Stanford White. Its name is said to have come from a strange French salad with unlikely ingredients that was appropriated by Washington Irving for a magazine that satirized life in New York.

BUTTERFIELD HOUSE

37 WEST 12TH STREET
BETWEEN FIFTH AND SIXTH AVENUES

1962, MAYER, WHITTLESLEY & GLASS

A rare example of an apartment house that respects the neighborhood above the developer's bottom line, Butterfield House actually consists of two buildings, one a seven-story structure on 12th Street that complements its neighboring residential buildings, and the other, twelve stories high, rising among the loft buildings on 13th Street. The space between them is a glass-enclosed corridor through a landscaped courtyard.

THE NEW SCHOOL FOR SOCIAL RESEARCH

66 WEST 12TH STREET
BETWEEN FIFTH AND SIXTH AVENUES

1930, JOSEPH URBAN

Founded in 1919 as an intellectual center for adults, the New School evolved into a university in the 1930s as a haven for intellectuals escaping Nazi Germany. Its major commitment is still to adult education, and it offers a broad range of innovative programs. This building, one of New York's earliest examples of the International Style, was designed by Joseph Urban, who was well known as a designer of theaters and stage sets.

CHURCH OF THE ASCENSION
(EPISCOPAL)

FIFTH AVENUE AT WEST 10TH STREET

1841, RICHARD UPJOHN
ALTERED, 1889, MCKIM, MEAD & WHITE

At the time this church was built, Episcopalians were divided between advocates of "High Church" and "Low Church," and the rector of this parish was a firm believer in the latter. To make sure that his church couldn't accommodate higher ritual, he insisted that the rectory should be placed behind it on the lot, which limited the size of the area around the altar. Stanford White's alterations changed the simplicity of the interior with an altar mural and stained glass by John La Farge, and an altar relief by Augustus Saint-Gaudens.

203

204

205

WASHINGTON MEWS

BEHIND 1–13 WASHINGTON SQUARE NORTH,
BETWEEN FIFTH AVENUE AND UNIVERSITY PLACE

Originally called "Stable Alley" when it served the Washington Square mansions, these former carriage houses were converted to private homes in 1916. The residences on the south side were rebuilt in 1939 when some of the original houses on the square were turned into apartments. The house on the southeast corner, at University Place, is New York University's Maison Française, remodeled in 1957 in the style of a French country bistro.

MACDOUGAL ALLEY

OFF MACDOUGAL STREET BETWEEN WEST 8TH STREET
AND WASHINGTON SQUARE NORTH

1850s

Although overshadowed by the bulky apartment building at 2 Fifth Avenue, this dead-end street is still a charming city-escape. The houses, which were originally stables for homes on 8th Street and Washington Square, have been remodeled in a variety of styles.

127–131 MACDOUGAL STREET

BETWEEN WEST 3RD AND WEST 4TH STREETS

1829

This row of tiny Federal houses was built for Aaron Burr who, among his other activities, dabbled in real estate. The iron pineapples at the entrance to no. 129 are a symbol of hospitality that began in Nantucket when the masters of whaling ships brought home souvenirs from their South Seas adventures, including pineapples, which they placed on the newell posts outside their front doors as a signal that they were home and eager to receive visitors.

CABLE BUILDING

611 BROADWAY AT HOUSTON STREET

1894, MCKIM, MEAD & WHITE

This building was originally the headquarters of the Broadway Cable Traction Company whose cars, like the ones in San Francisco today, were propelled by cables that moved in slots under the street. One of the company's powerhouses was located forty feet under this eight-story building that was built to keep noise and vibration to a minimum. New York's cable cars, which were once the only way to go along Broadway and Third Avenue, were replaced by streetcars at the beginning of the twentieth century.

UNIVERSITY VILLAGE

BLEECKER STREET TO WEST HOUSTON STREET
WEST BROADWAY TO MERCER STREET

1966, I. M. PEI & PARTNERS

Like its neighbor, Washington Square Village, on the other side of Bleecker Street, the huge slab buildings of this development, a third of which house NYU staff members, turns its back to the street. Peeking out from the interior plaza is a thirty-six-foot concrete version of a two-foot metal construction by Pablo Picasso called *Portrait of Sylvette*, which was executed by Norwegian sculptor Carl Nesjar in close collaboration with Picasso himself.

THE ATRIUM

160 BLEECKER STREET
BETWEEN SULLIVAN AND THOMPSON STREETS

1896, ERNEST FLAGG

This was originally Mills House No. 1, a residential hotel built for working-class bachelors who couldn't afford to live alone. It was constructed as two twelve-story blocks, each containing 750 bedrooms and common toilets to serve them. All of the bedrooms had windows overlooking the street or a large interior courtyard, and the building also included smoking rooms, reading rooms, lounges, and restaurants. The price for all of this, including elevator service, was twenty cents a night. It was converted to apartments (with considerably higher rents) in 1976.

ELMER HOLMES BOBST LIBRARY AND STUDY CENTER

70 WASHINGTON SQUARE SOUTH AT WEST BROADWAY

1972, PHILIP JOHNSON AND RICHARD FOSTER

A 150-foot red sandstone tower rising straight up from the sidewalk and spilling forty feet into West Broadway, which was narrowed to make room for it, this is NYU's library and a welcoming place for its students. The interior is a grand 100-foot-square atrium, surrounded by glass-enclosed floors.

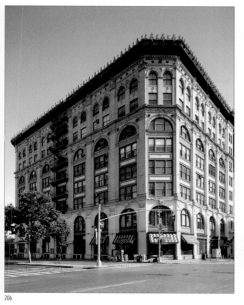

206

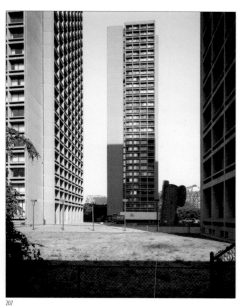

207

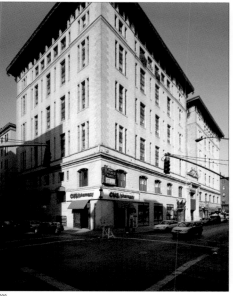

208

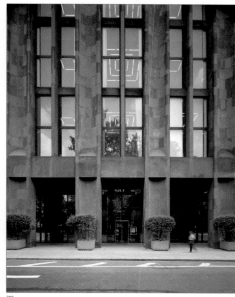

209

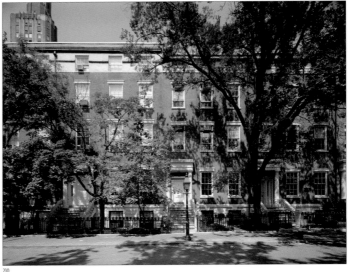

1–13 WASHINGTON SQUARE NORTH

BETWEEN FIFTH AVENUE AND UNIVERSITY PLACE

1833

This row of Greek Revival houses was built on land owned by Sailor's Snug Harbor, an institution founded to serve the needs of retired seamen, which drove a hard bargain with the developer. The contract stipulated that the houses should be set back at least twelve feet from the street, that they should be at least three stories high, and that they should be built of stone or brick. The brickwork, which alternates long and short bricks in each row, is called Flemish Bond, and was only used in the most expensive houses. The entranceways include marble columns and carved wooden colonettes, another symbol of gracious living. The interiors of nos. 7–13, off Fifth Avenue, were gutted and converted to apartments in 1939 in an attempt by Sailor's Snug Harbor to boost its income. The row is now owned by New York University.

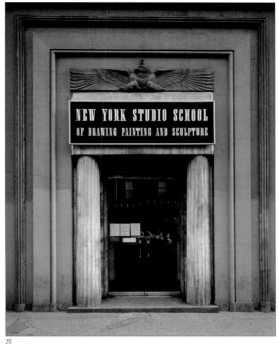

211

211

NEW YORK STUDIO SCHOOL OF DRAWING, PAINTING AND SCULPTURE

8 WEST 8TH STREET BETWEEN FIFTH AVENUE
AND MACDOUGAL STREET

1838

This Art Deco building with peeling paint was once the home of Gertrude Vanderbilt Whitney, a member of not one but two of New York's wealthiest families. An accomplished sculptor, she converted a stable in MacDougal Alley behind this building into a studio and gallery in 1907. It ultimately became the Whitney Museum of Art. The collection was moved from here in 1949, to a spot adjoining the Museum of Modern Art before moving again in the 1960s, to Madison Avenue at 75th Street.

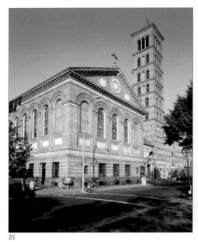

212

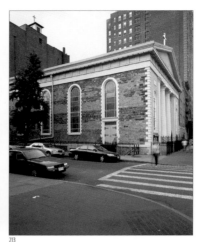

213

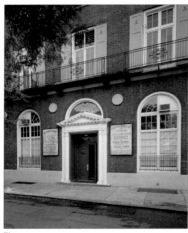

214

215

216

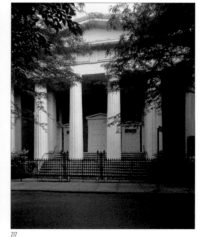

217

212

JUDSON MEMORIAL CHURCH
(BAPTIST)

55 WASHINGTON SQUARE SOUTH

1893, McKIM, MEAD & WHITE

Designed by Stanford White, this Italian Renaissance church and the adjoining bell tower are built of Roman brick and terra-cotta. As he often did, White called on the best artists of the day to embellish his work and the interior is lighted by stained glass windows executed by John La Farge. The tower once held an orphanage, but now houses the history department, among others, for New York University.

213

ST. JOSEPH'S CHURCH
(ROMAN CATHOLIC)

365 SIXTH AVENUE AT WASHINGTON PLACE

1834, JOHN DORAN

The front of this church, with arched windows that were added in an 1885 reconstruction after a fire nearly destroyed the building, is covered with smooth painted stucco. But along the Washington Place side, the native stone façade is a reminder of its origins as a country church.

214

GREENWICH HOUSE

29 BARROW STREET BETWEEN
WEST 4TH STREET AND SEVENTH AVENUE

1917, DELANO & ALDRICH

Founded in 1902 by Mary Kingsbury Simkhovitch to respond to the needs of children growing up in a neighborhood with a population of 975 people per acre, the city's first neighborhood association still operates from this neo-Federal building. Its programs range from day care to drug counseling to activities for the elderly.

215

18 WEST 11TH STREET

BETWEEN FIFTH AND SIXTH AVENUES

1845
ALTERED, 1978, HARDY HOLZMAN PFEIFFER ASSOCIATES

This was once part of a row of Greek Revival houses that all looked similar. It was destroyed in 1970 when a group of radicals' bomb-making project went awry and leveled it. It took another eight years to rebuild it in this modern style.

216

56 WEST 10TH STREET

BETWEEN FIFTH AND SIXTH AVENUES

1832

A small, dormered Federal townhouse, this is one of the oldest houses in the neighborhood and one of the most charming along a block that offers plenty of competition. The doorway, with its fluted Ionic colonettes and leaded windows—along with the wrought-iron handrails and newell post—is typical of the Federal Style, which arrived in New York in about 1800, later than in post-Revolutionary Boston and Philadelphia.

217

VILLAGE COMMUNITY CHURCH

143 WEST 13TH STREET
BETWEEN SIXTH AND SEVENTH AVENUES

1847, SAMUEL THOMPSON

Originally the 13th Street Presbyterian Church, this Greek Revival building is now a condominium apartment house called Portico Place. The Doric columns that form the portico and the pediment above them are in fact made of wood and not stone, as they appear to be.

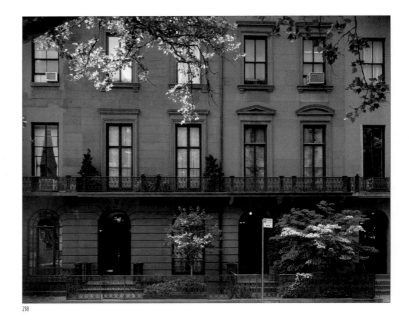

218

RENWICK TERRACE

20–38 West 10th Street
between Fifth and Sixth Avenues

1858, attributed to James Renwick, Jr.

This row of apartments was inspired by London's rows of townhouses called "terraces." These Anglo-Italianate houses were the first to break with the tradition of brownstones with high stoops (a term that comes from the Dutch word for "step," popularized by the Dutch who placed their living quarters above the street as protection against floods). The appeal to early tenants was the fact that it was difficult to tell where one unit began and another left off, so that visitors might assume that it was a single, very large mansion.

JEFFERSON MARKET LIBRARY

425 Sixth Avenue at West 10th Street

1877, Vaux & Withers
Restoration, 1967, Georgio Cavaglieri

A flamboyant Victorian Gothic structure designed by Calvert Vaux, the architect of the buildings and bridges of Central Park, this building stood empty and abandoned for twenty-two years before being converted into a branch of the New York Public Library in 1967. Its conversion was the result of a long battle by Greenwich Villagers, led by architectural activist Margot Gayle, to save the clocktower. Originally the Jefferson Market Courthouse, it stands on the site of one of the city's major food markets of the early nineteenth century. The courthouse itself also adjoined a large jail, which was replaced in 1931 by the massive Art Deco Women's House of Detention. The detention center was demolished in 1974 and replaced by a neighborhood garden called the Jefferson Market Greening.

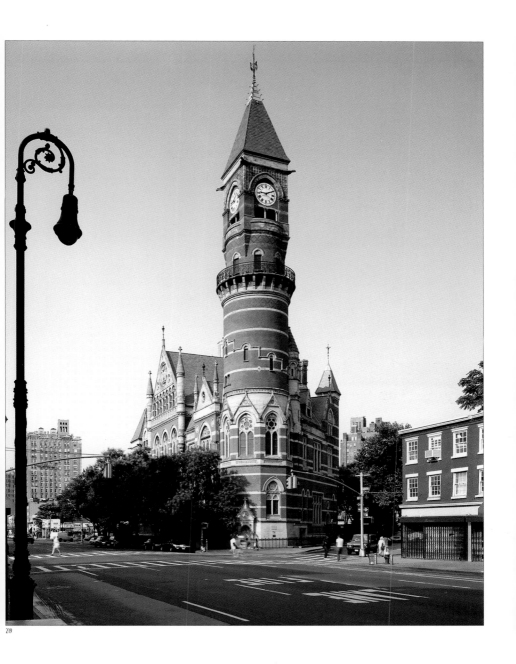

GAY STREET

BETWEEN CHRISTOPHER STREET AND WAVERLY PLACE

1833–44

The row of Federal houses on the west side of this short street were built in 1833, and their Greek Revival neighbors on the east side were added after 1844. Its residents in the 1850s were mainly working class people, but its most famous resident was Ruth McKenney, who lived at 14 Gay Street in the 1930s and wrote of her experiences as a Greenwich Village Bohemian in *My Sister Eileen*, which became the hit Broadway musical, *Wonderful Town*.

PATCHIN PLACE

WEST 10TH STREET BETWEEN SIXTH AND GREENWICH AVENUES

1848

Like Milligan Place around the corner on Sixth Avenue, this charming oasis was originally built as boarding houses for the men who worked at the Brevoort House Hotel on Fifth Avenue. Among its later residents were poets John Masefield and e. e. cummings, as well as novelists Theodore Dreiser and Djuna Barnes, and activist John Reed.

37 BANK STREET

BETWEEN WAVERLY PLACE AND WEST 4TH STREET

1837

Built for a leather merchant, this is one of Greenwich Village's most outstanding Greek Revival houses. Three and one-half stories high with a low stoop and a classic doorway, its cornice with garlanded bull's-eye windows, make it one of the city's architectural gems. This entire block of Bank Street is among the finest in the Village.

4–10 GROVE STREET

BETWEEN BEDFORD AND HUDSON STREETS

1834, JAMES N. WELLS

These houses are among the last survivors of the early Federal-Style homes that dominated the city in the first quarter of the nineteenth century. The wrought iron work (including the boot scrapers) is all original, as are the paneled doorways. Later, houses in the style eliminated the dormer windows from the top floor, which was reserved for the use of the servants and the family's children.

WHOLESALE MEAT MARKET

555 WEST STREET AT GANSEVOORT STREET

1908, BERNSTEIN & BERNSTEIN

This building was created to serve a farmers' market organized along this block. After conversion to a Fire Department pumping station, it was altered again to anchor the city's wholesale meat district, bounded by 14th Street and Ninth Avenue, Gansevoort Street, and the Hudson River.

MacDOUGAL-SULLIVAN GARDENS

BETWEEN MacDOUGAL AND SULLIVAN STREETS WEST HOUSTON AND BLEECKER STREETS

1844–1850

Created from tenement rows in the early 1920s, this was a project of William Sloane Coffin's Hearth and Home Corporation, created to lure the middle-class into the neighborhood. The company bought all the buildings on the block and renovated them and then combined their backyards into a private park.

220

221

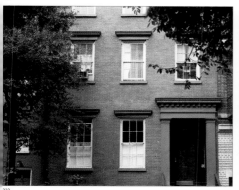

222

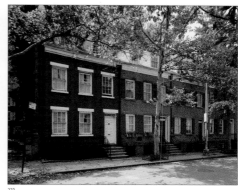

223

224

225

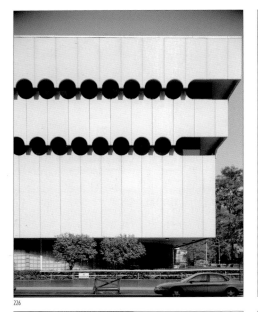

226

St. Vincent's Hospital

36 Seventh Avenue at Greenwich Ave.

1987, Ferenz, Taylor, Clark & Associates

St. Vincent's was founded by the Sisters of Charity in 1849 and moved to this location from the Lower East Side seven years later. It has been jointly administered by the Order and the Roman Catholic Archdiocese of New York since 1975. It is designated a "level one" trauma center and an AIDs center by New York State. It is a teaching affiliate of the New York Medical College, and houses a large school of nursing. This rather eccentric building contains the offices of its affiliated physicians.

Westbeth
(formerly Bell Labs)

155 West Street
between Washington, West, and Bethune Streets

1898, Cyrus W. Eidlitz
Converted, 1969, Richard Meier & Associates

As a research facility of the Bell Telephone Company, this complex of thirteen clustered buildings witnessed history being made. These walls saw the development of such things we take for granted as the coaxial cable, the transistor, and digital breakthroughs that made desktop computers possible, not to mention direct-access long-distance telephone dialing and the first transmission of television pictures. All that, and more, happened right here before the company moved to New Jersey and the complex was transformed into artists' studios and housing.

70 PERRY STREET

BETWEEN WEST 4TH AND BLEECKER STREETS

1867, WALTER JONES

This French Second Empire–style mansion was built by Walter Jones, its original owner, who was also the architect. Except for the similar mansard roof on its neighbor, no. 72, it is unique to this block. Although it is twenty feet wide, like all its neighbors, its proportions make it seem larger than the others. Although a grand house, Jones built it as a rental property and lost it through foreclosure in 1871. The next owner, who bought it at auction and also preferred to rent it to others, sold it to Albert Messinger in 1896. Although he himself was a real estate agent, Messinger made it his home until 1912.

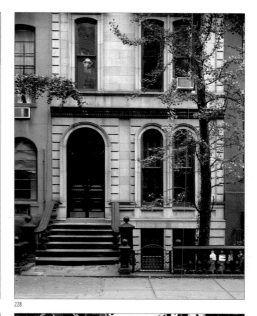

228

167 PERRY STREET ℒ

AT WEST STREET

1986, WILLIAM MANAGHAN

After the West Side Highway was demolished in the late 1970s, Greenwich Village was able to expand to the west after having been walled off from the Hudson River for some forty years, and this low-rise apartment complex was among the first to take advantage of the opportunity. The highway was torn down in slow stages after a loaded dump truck fell through a pothole and crashed down into the street below in December of 1973.

229

230

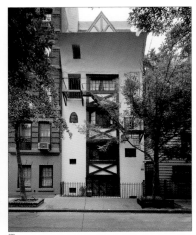

231

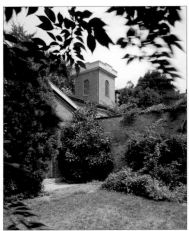

232

233

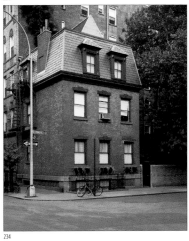

234

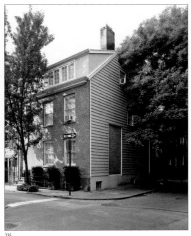

235

230

18 AND 20 CHRISTOPHER STREET

BETWEEN GAY STREET AND WAVERLY PLACE

1827, DANIEL SIMONSON

Both of these Federal-style houses have gambrel roofs, with an echo carried out in the huge dormers that were added later. The storefronts, possibly the most charming to be found anywhere in New York, were another later addition to what was originally a pair of residential buildings. Their show windows and doorways are sheltered under unusual hoods.

231

"TWIN PEAKS"

102 BEDFORD STREET BETWEEN
GROVE AND CHRISTOPHER STREETS

1830

This wood-frame house was altered in 1925 by Clifford Reed Daily, who said it was his intention to turn the Village's "desert of mediocrity" into something more hospitable to creativity. It became a half-timbered version of a house in Nuremberg, thanks to funding provided by financier Otto Kahn. On the day it was formally dedicated, movie star Mabel Normand was hoisted up to one of the peaks to break a bottle of Champagne on its ridge.

232

CHURCH OF ST. LUKE-IN-THE-FIELDS
(EPISCOPAL)

485 HUDSON STREET
BETWEEN BARROW AND CHRISTOPHER STREETS

1822, ATTRIBUTED TO CLEMENT CLARKE MOORE

Formerly St. Luke's Chapel of Trinity Parish, this country church was severely damaged by a fire in 1981 and restored four years later by Hardy Holzman Pfeiffer Associates. The church property originally included fourteen townhouses along Hudson Street, six of which are still standing, along with the rectory at the edge of the charming lot behind the church building.

233

GROVE COURT

10–12 GROVE STREET
BETWEEN BEDFORD AND HUDSON STREETS

1854

This charming enclave of small attached brick houses, sheltered by arching shade trees, was originally built as a series of homes for people who worked on the nearby Hudson River piers. At different times in its history, Grove Court was known as "Mixed Ale Alley" and "Pig's Alley." This block of Grove Street is one of the quietest anywhere in New York, and it is even quieter back there on the other side of that iron gate.

234

39 AND 41 COMMERCE STREET

AT BARROW STREET

1831 AND 1832, D. T. ATWOOD

A local legend that walking tour guides perpetuate is that this pair of elegant houses, separated by a courtyard, was built by a sea captain for his two daughters who wouldn't speak to each other. City records indicate that they were actually built for a milk dealer, but do not reveal why they were built as a pair.

235

ISAACS-HENDRICKS HOUSE

77 BEDFORD STREET AT COMMERCE STREET

1799

We usually think of Greenwich Village as a place to revisit New York's past, yet this is the oldest house still standing there, and it was built when the city was already more than 175 years old. Remodeled several times over its long life, it was originally a farmhouse, and the area behind it along Commerce Street was a farmyard, filled with pigs and ducks, geese and chickens. The barnyard area was eventually replaced by a brewery.

6 St. Luke's Place

LEROY STREET
BETWEEN HUDSON STREET AND SEVENTH AVENUE SOUTH

1880s

When this elegant row of brick and brownstone Italianate townhouses was built in the 1880s, their addresses were on Leroy Street. But when James J. Walker, the city's mayor from 1926 until 1932, lived at no. 6, his girlfriend, Betty Compton, lived at the other end of the block. To remove the connotation from the public's mind, he used his powers and Tammany Hall connections to rename its eastern end St. Luke's Place. It was the only bow he ever made to anything resembling propriety. In those days, when mayors lived in their own houses, they were the only homes allowed to have lampposts at the bottom of their stoops. It made it easier to track down the mayor in his own surroundings.

61 Morton Street

BETWEEN HUDSON AND BEDFORD STREETS

One of the most fascinating streets in Greenwich Village, this block of Morton Street has buildings in a range of styles and heights, from five- to six-story nineteenth-century residences to six- to eight-story buildings added in the twentieth century. The south side has four fine Italianate houses and others on the street range from Greek Revival to Italianate, all of them showing signs of loving care.

U.S. Federal Archive Building

666 GREENWICH STREET

1899, WILLOUGHBY J. EDBROOKE,
WILLIAM MARTIN AIKEN, JAMES KNOW TAYLOR

This huge structure, in a style architectural historian Henry Hope Reed has called "Roman Utilitarian," was originally built as a warehouse for cargo passing through customs. After ships stopped berthing at the nearby Morton Street pier, it was converted to a storehouse for federal records including, in pre-computer days, all the income tax returns filed in the Eastern District. It was converted to an apartment/office building in 1988 with the help of the New York Landmarks Conservancy, an organization that provides technical and financial help for landmark preservation and reuse.

"Narrowest House"

75 BEDFORD STREET
BETWEEN MORTON AND COMMERCE STREETS

1873

Often called the "Edna St. Vincent Millay House" because it was one of the poet's several homes in the Village, this structure is only nine-and-a-half feet wide. Before it was built, there was an alley here leading to a brewery yard in back (the former brewery is now the Cherry Lane Theater), which is now a courtyard.

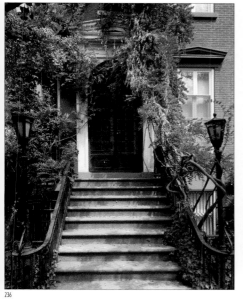

236

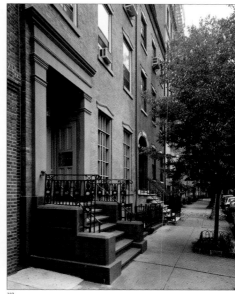

237

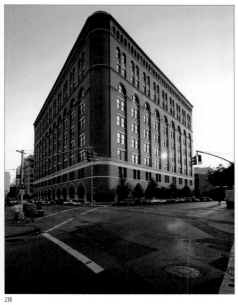

238

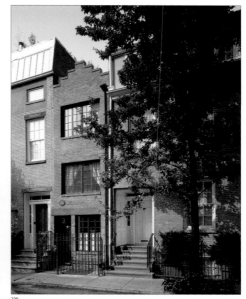

239

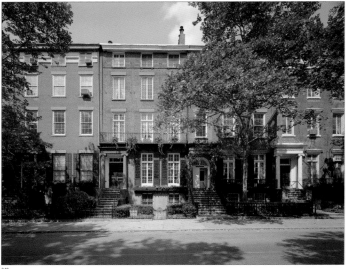

240

19–26 WASHINGTON SQUARE NORTH

BETWEEN FIFTH AVENUE AND MACDOUGAL STREET

1829–1839

In the early nineteenth century, Washington Square was surrounded on three sides by rows of elegant houses like these, but, except for the north side, they have all been destroyed. This block lost several of its original mansions in 1952 when the nineteen-story apartment building went up around the corner at 2 Fifth Avenue. When plans for its construction were announced seven years earlier, Greenwich Villagers rose up in arms and even convinced City Planning Commissioner Robert Moses, a man not known for his sense of history or aesthetics, that tearing down the houses was a bad idea. He blocked it by ruling that buildings facing Washington Square North could not be higher than double the width of the street. Another developer proposed limiting the bulk of the apartment house along the square with a five-story annex that would be in a modernized version of Greek Revival.

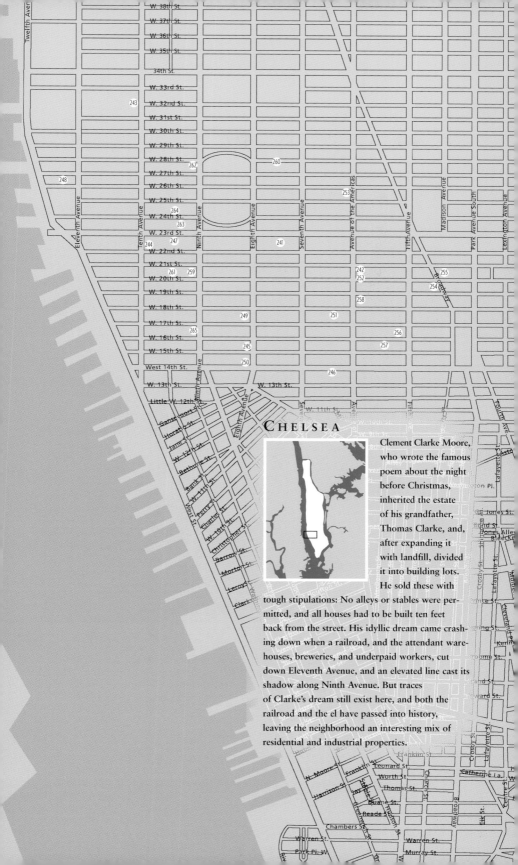

W. 38th St.
W. 37th St.
W. 36th St.
W. 35th St.
34th St.
W. 33rd St.
W. 32nd St.
W. 31st St.
W. 30th St.
W. 29th St.
W. 28th St.
W. 27th St.
W. 26th St.
W. 25th St.
W. 24th St.
W. 23rd St.
W. 22nd St.
W. 21st St.
W. 20th St.
W. 19th St.
W. 18th St.
W. 17th St.
W. 16th St.
W. 15th St.
West 14th St.
W. 13th St.
W. 13th St.
Little W. 12th St.
W. 11th St.

Twelfth Avenue
Eleventh Avenue
Tenth Avenue
Ninth Avenue
Eighth Avenue
Seventh Avenue
Avenue of the Americas
Fifth Avenue
Madison Avenue
Park Avenue South
Lexington Avenue

243
248
264
263
244 247
261 259
265
249
250
245
246
262
260
253
241
242
252
258
251
254 255
256
257

Gansevoort St.
Horatio St.
Jane St.
Bethune St.
Bank St.
W. 12th St.
Perry St.
Charles St.
W. 10th St.
Christopher St.
Barrow St.
Morton St.
Leroy St.
Clark St.
West St.

CHELSEA

Clement Clarke Moore, who wrote the famous poem about the night before Christmas, inherited the estate of his grandfather, Thomas Clarke, and, after expanding it with landfill, divided it into building lots. He sold these with tough stipulations: No alleys or stables were permitted, and all houses had to be built ten feet back from the street. His idyllic dream came crashing down when a railroad, and the attendant warehouses, breweries, and underpaid workers, cut down Eleventh Avenue, and an elevated line cast its shadow along Ninth Avenue. But traces of Clarke's dream still exist here, and both the railroad and the el have passed into history, leaving the neighborhood an interesting mix of residential and industrial properties.

ton Pl.
Jones St.
Bond St.
Jones Alley
Bleecker
Crosby St.
Lafayette St.
Mercer St.
Greene St.
Spring St.
Kenn
Broome St.
Grand St.
ward St.
Lafayette St.
Crosby St.
Franklin St.
Leonard St.
Catherine La.
W. Moore St.
Franklin St.
Worth St.
Harrison St.
Thomas St.
Duane St.
Hudson St.
Reade St.
Chambers St.
Warren St.
Park Pl. W.
Warren St.
Murray St.

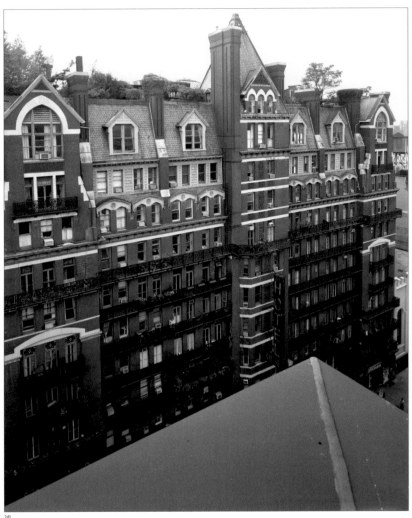

241

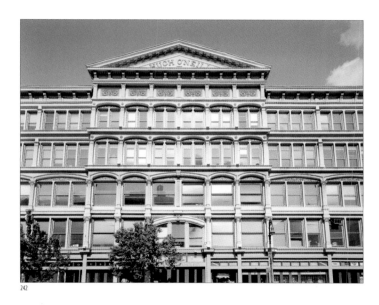

242

CHELSEA HOTEL

222 WEST 23RD STREET
BETWEEN SEVENTH AND EIGHTH AVENUES,

1885, HUBERT, PIRSSON & CO.

This building was originally a forty-unit cooperative apartment building, among the city's first. It became a 250-unit hotel in 1905, and, although transients are welcome, most of its tenants are permanent residents. Its early guests included actresses Sarah Bernhardt and Lillian Russell, and writers O'Henry and Mark Twain. In later years it has attracted such writers as Arthur Miller, Dylan Thomas, and Brendan Behan, and composer Virgil Thompson, who lived here for nearly fifty years. The lobby and stairways are crowded with original works by such artists as Larry Rivers and Patrick Hughes, who were habitual hotel guests.

HUGH O'NEILL DRY GOODS STORE

655–671 SIXTH AVENUE
BETWEEN WEST 20TH AND WEST 21ST STREETS

1876, MORTIMER C. MERRITT

Hugh O'Neill, the man who built this huge store, was the P. T. Barnum of the retail trade, and was known as "The Fighting Irishman of Sixth Avenue." While other merchants catered to the upper-middle class, O'Neill concentrated on the working class, holding almost unbelievable sales at prices his competitors couldn't dream of matching. He was the first to offer merchandise below cost as "loss leaders" to lure customers into his store, making sure that the customers would come by mounting aggressive advertising campaigns.

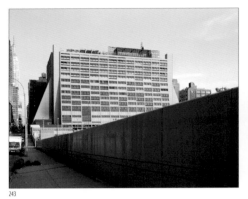

243

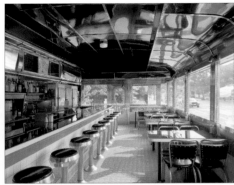

244

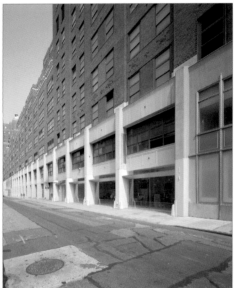

245

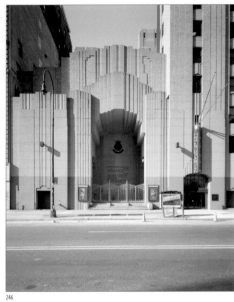

246

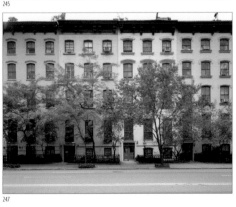

247

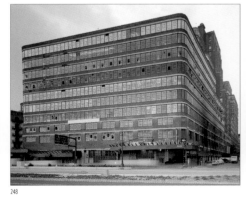

248

WESTYARD DISTRIBUTION CENTER

TENTH AVENUE
BETWEEN WEST 31ST AND WEST 33RD STREETS

1970, DAVIS, BRODY & ASSOCIATES

Originally intended to serve as a warehousing and manufacturing facility, this building turned out to be more attractive as office space and is now home to the *New York Daily News*, among other companies. Built over railroad yards and a Lincoln Tunnel ramp, its façades slope back for the first eight floors, then rise up straight for five more, creating an effect *Architectural Digest* called, "a pyramid that changed its mind."

EMPIRE DINER

210 TENTH AVENUE AT 22ND STREET

1943
ALTERED, 1976, CARL LAANES

Not always this empty, the Empire Diner is a very busy place in the wee hours of the morning, when partygoers gather to catch their breath after a long night on the town. Restored with a stainless steel exterior and shiny black and chrome accents on the inside, it is a reminder of what fast food was all about fifty years ago.

PORT OF NEW YORK AUTHORITY BUILDING

111 EIGHTH AVENUE
BETWEEN WEST 15TH AND WEST 16TH STREETS

1932, ABBOTT, MERKT & CO.

What is now called the Port Authority of New York and New Jersey was simply the Port of New York Authority, when the agency built this structure it called Union Inland Terminal No. 1. It replaced seventy-eight individual buildings with fifteen floors of warehouse space, loading docks, showrooms, and its own offices. The agency moved to the World Trade Center, which it also built, in the 1970s.

SALVATION ARMY CENTENNIAL MEMORIAL TEMPLE

120 WEST 14TH STREET
BETWEEN SIXTH AND SEVENTH AVENUES

1930, VOORHEES, GMELIN & WALKER

Built to mark the hundredth anniversary of the birth of the organization's founder, William Booth, this Art Deco citadel is also the national headquarters of the Salvation Army. The Army, which was established in the slums of London in 1878, arrived in New York two years later, and consisted of a missionary accompanied by seven women "soldiers."

428–450 WEST 23RD STREET

BETWEEN NINTH AND TENTH AVENUES

1860s

In the years just before the Civil War, rows of Anglo-Italianate brownstone houses like these lined street after street in Manhattan, as New Yorkers began building homes that they hoped would reflect their affluence and social status. This surviving row is often overlooked in the shadow of London Terrace on the other side of 23rd Street, which itself replaced a row almost exactly like this one.

STARRET-LEHIGH BUILDING

WEST 26TH TO WEST 27TH STREETS
ELEVENTH TO TWELFTH AVENUES

1931, CORY & CORY, WITH YASURO MATSUI

This nineteen-story warehouse was built for the Lehigh Valley Railroad, whose trains pulled into the ground floor where elevators waited to carry the loaded freight cars up to the floors above. Each floor sprawls over 124,000 square feet of space under 20-foot ceilings. The building was included in the Museum of Modern Art's 1932 International Exposition of Modern Architecture, which gave its name to the International Style.

JOYCE THEATER

175 EIGHTH AVENUE
BETWEEN WEST 18TH AND WEST 19TH STREETS

1942, SIMON ZELNIK
CONVERTED 1982,
HARDY HOLZMAN PFEIFFER ASSOCIATES

Formerly the Elgin movie theater, this building was the sort of place kids in small-town America would have characterized as "the itch." In its new configuration, sparkly clean, of course, it has since become one of New York's foremost dance venues.

THE NEW YORK SAVINGS BANK℄

81 EIGHTH AVENUE AT 14TH STREET

1897, R. H. ROBERTSON

Now a carpet showroom, this Classical building joins with its neighbor across 14th Street, the former New York County Savings Bank, as a gateway to Chelsea and Greenwich Village. The bank across the street, also a landmark, has been converted to an Off-Broadway theater.

128 WEST 18TH STREET

BETWEEN SIXTH AND SEVENTH AVENUES

1865

Five of the buildings in this block have been given Landmark status, each of them originally a stable built to serve the residents of the surrounding streets. At the time they were built, just after the Civil War, the entire block consisted only of housing for horses and carriages.

249

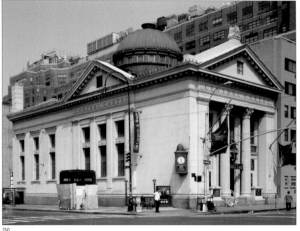

250

251

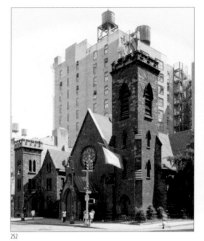

252

253

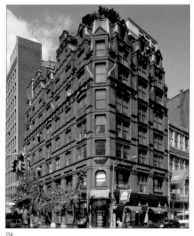

254

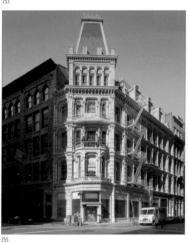

255

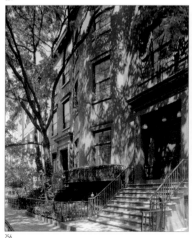

256

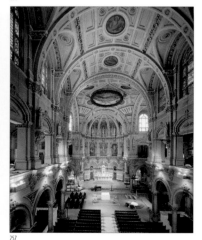

257

CHURCH OF THE HOLY COMMUNION

252

(EPISCOPAL)

49 WEST 20TH STREET AT SIXTH AVENUE

1846, RICHARD UPJOHN

This was the prototype for Gothic Revival church buildings across the United States in the nineteenth century. It was also an early example of a "free" church, which abolished pew rentals. After the neighborhood became less fashionable, the parish consolidated with Calvary and St. George's Church and the building was transformed to secular purposes, including a popular disco.

COOGAN BUILDING

253

776 SIXTH AVENUE AT 26TH STREET

1876, ALFRED H. THORP

James J. Coogan, who owned this building, also owned the land in upper Manhattan known as "Coogan's Bluff," site of the Polo Grounds. Its architect, Alfred H. Thorp, once proposed a "girdle road" around Manhattan, a viaduct with a rail line and a boulevard on top and housing and stores at its base. The idea didn't fly, but it planted the seed for elevated railroads.

GORHAM SILVER COMPANY BUILDING

254

889–891 BROADWAY AT WEST 19TH STREET

1884, EDWARD H. KENDALL

This Queen Anne structure is one of New York's earliest mixed-use buildings. Its first two floors served as Gorham's retail store, but the rest was used as bachelor apartments. It had become an entirely commercial building by 1912, when remodeling by John H. Duncan removed its corner tower and added dormers to the roof. Today it is a cooperative apartment building with stores at the sidewalk level.

LORD & TAYLOR BUILDING

255

901 BROADWAY AT EAST 20TH STREET

1870, JAMES H. GILES

Established in 1826 as a small shop on Catherine Street, Lord & Taylor moved twice before settling here in 1871. After continuing its march uptown to Fifth Avenue and 39th Street in 1914, the Broadway façade of its grand French Second Empire emporium was rebuilt and its ground floor was altered yet again in the 1990s when the neighborhood began showing signs of life again.

17 WEST 16TH STREET

256

BETWEEN FIFTH AND SIXTH AVENUES

1840s

Most of the row houses in the blocks off Fifth Avenue north of 14th Street were torn down in the late nineteenth century, but this block managed to survive, and these seven Greek Revival houses are a reminder of what was lost. Margaret Sanger moved her pioneering birth control clinic to no. 17 in 1930.

CHURCH OF ST. FRANCIS XAVIER

257

(ROMAN CATHOLIC)

40 WEST 16TH STREET
BETWEEN FIFTH AND SIXTH AVENUES

1887, PATRICK CHARLES KEELY

The Jesuits who founded this church and its adjoining school were French, English, and Irish priests who came to New York from Kentucky to establish St. John's College, now Fordham, in the Bronx. The church's heavy Baroque exterior only hints at the Baroque extravaganza inside.

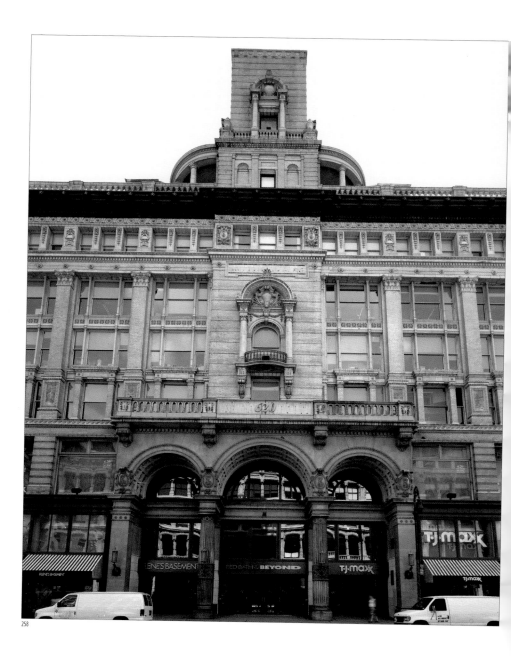

SIEGEL-COOPER DRY GOODS STORE

632 SIXTH AVENUE
BETWEEN WEST 18TH AND WEST 19TH STREETS

1896, DeLemos & Cordes

Its original owner, master merchant Henry Siegel, advertised this as "The Big Store: A City in Itself," and even such a designation was an understatement. Its biggest crowd-pleaser was a marble terrace on the main floor with a replica in marble and brass of Daniel Chester French's statue, *The Republic*, a hit at the recent Chicago World's Fair. Jets of water accented by ever-changing colored lights played around the pedestal, making it impossible to miss and "Meet me at the fountain," meant only one thing to New Yorkers in the 1890s. Siegel's store was among the first of its kind to sell food, and he pioneered the concept of giving away free samples to build sales. He also hired demonstrators to push everything from sheet music to can openers. The store was among the first to be air-cooled, and the first to hire women as sales clerks. Changing habits among shoppers took them out of this neighborhood and, by World War I, Siegel-Cooper was converted into a military hospital. Retailing has come back to the corner of Sixth Avenue and West 18th Street, but it isn't the same somehow. The statue that graced the fountain has been relocated to the Forest Lawn Cemetery in Glendale, California.

GENERAL THEOLOGICAL SEMINARY
(EPISCOPAL)

NINTH AVENUE BETWEEN
WEST 20TH & WEST 21ST STREETS

1883–1900, CHARLES C. HAIGHT

The buildings around the interior quadrangle can be seen from 20th Street, but a close-up look is best. Access is through the forbidding building on Ninth Avenue housing the seminary's library. Its most famous faculty member was Clement Clarke Moore, who taught biblical languages here, but is more fondly remembered as the author of "A Visit from St. Nicholas." You know the one: "'Twas the Night before Christmas ...'"

FASHION INSTITUTE OF TECHNOLOGY

WEST 26TH TO WEST 28TH STREETS
BETWEEN SEVENTH AND EIGHTH AVENUES

1958–88, VARIOUS ARCHITECTS

The institution occupying these eight buildings evolved from the Central Needle Trades High School in 1944, into a four-year college of the State University of New York. It offers degrees in various disciplines associated with the fashion trade, from pattern-making to photography and merchandising. Its alumnae roster, a "who's who" of the fashion business, includes Calvin Klein and Norma Kamali.

CUSHMAN ROW

406–418 WEST 20TH STREET
BETWEEN NINTH AND TENTH AVENUES

1840

These beautiful Greek Revival houses were built by dry goods merchant turned real estate speculator, Don Alonzo Cushman. He built extensively in Chelsea, becoming a millionaire in the process, and went on to found the Greenwich Savings Bank. "Don" was his first name, not his title.

CHURCH OF THE HOLY APOSTLES
(EPISCOPAL)

300 NINTH AVENUE AT 28TH STREET

1854, MINARD LAFEVRE
TRANSEPT, 1858, RICHARD UPJOHN & SON

This building was severely damaged in a 1990 fire that destroyed some of its priceless windows by William Jay Bolton, America's first stained glass maker, several of which have thankfully survived. Always a socially active church, it opened a soup kitchen in 1982, and has since become the largest such facility in the city. The day after the fire, the kitchen opened as usual in the gutted church and served more than 900 meals.

LONDON TERRACE

WEST 23RD TO WEST 24TH STREETS
NINTH TO TENTH AVENUES

1930, FARRAR & WATMAUGH

There are fourteen buildings and 1,670 apartments in this sixteen-story complex arranged around an interior courtyard. Its swimming pool was once the largest in Manhattan, and its roof deck had all the attributes of the deck of an ocean liner. The first tenants here, who moved in at the height of the Great Depression, were provided with housekeeping services, three restaurants, and shops along the ground-floor level.

437–459 WEST 24TH STREET

BETWEEN NINTH AND TENTH AVENUES

1850, PHILO BEEBE

This row of twelve houses, which have landscaped front yards, was built as housing for merchants and tradesmen. It marks the northern boundary of the estate of Thomas Clarke, which extended between Eighth Avenue and the Hudson River, down to what is now Nineteenth Street. A former British army officer, Clarke named his holdings "Chelsea" after the London home for retired soldiers.

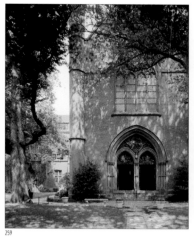

259

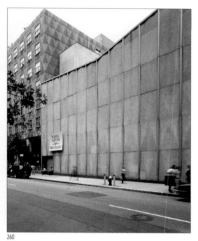

260

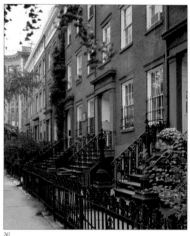

261

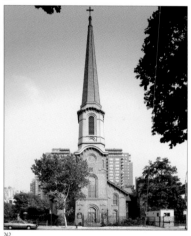

262

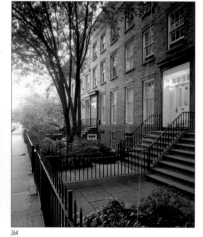

263

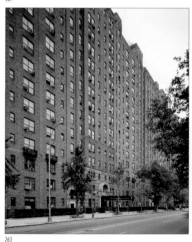

264

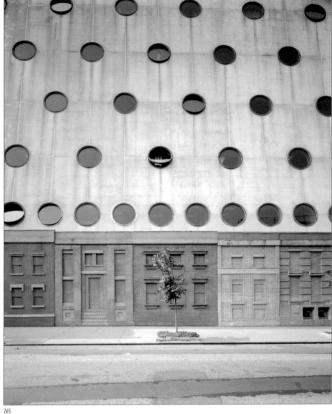

265

NATIONAL MARITIME UNION, JOSEPH CURRAN ANNEX

100 NINTH AVENUE
BETWEEN WEST 16TH AND WEST 17TH STREETS

1966, ALBERT C. LEDNER & ASSOCIATES

The building that serves the Maritime Union is appropriately nautical, its façade pierced with round porthole-like windows. The façade itself is sloped like the hull of a ship, but evocations of seafaring life probably had little to do with it. Instead, zoning laws seem to have entered into the equation, placing the emphasis on sky-exposure planes of tall buildings. Housing the union's medical and recreation facilities, the Curran Annex reflects the style of its headquarters' building on Seventh Avenue at Thirteenth Street, designed by the same New Orleans-based architect.

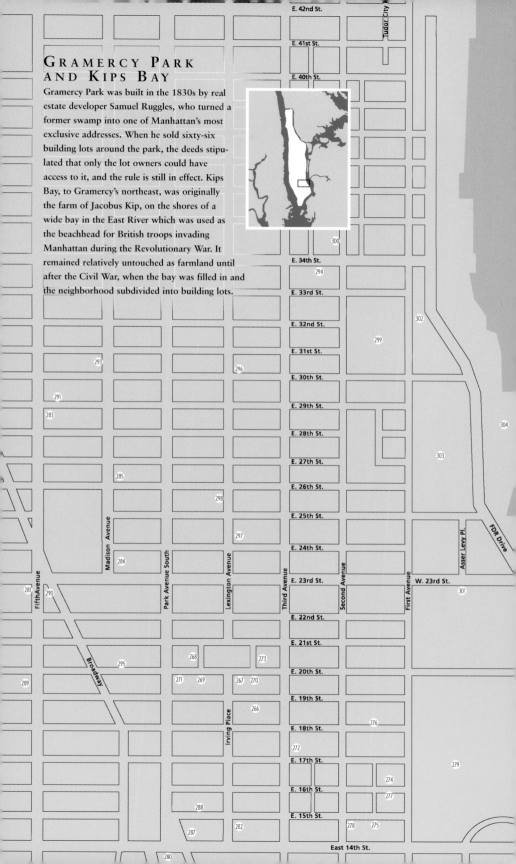

GRAMERCY PARK AND KIPS BAY

Gramercy Park was built in the 1830s by real estate developer Samuel Ruggles, who turned a former swamp into one of Manhattan's most exclusive addresses. When he sold sixty-six building lots around the park, the deeds stipulated that only the lot owners could have access to it, and the rule is still in effect. Kips Bay, to Gramercy's northeast, was originally the farm of Jacobus Kip, on the shores of a wide bay in the East River which was used as the beachhead for British troops invading Manhattan during the Revolutionary War. It remained relatively untouched as farmland until after the Civil War, when the bay was filled in and the neighborhood subdivided into building lots.

E. 42nd St.
E. 41st St.
E. 40th St.
E. 34th St.
E. 33rd St.
E. 32nd St.
E. 31st St.
E. 30th St.
E. 29th St.
E. 28th St.
E. 27th St.
E. 26th St.
E. 25th St.
E. 24th St.
E. 23rd St.
E. 22nd St.
E. 21st St.
E. 20th St.
E. 19th St.
E. 18th St.
E. 17th St.
E. 16th St.
E. 15th St.
East 14th St.

W. 23rd St.

Tudor City
Madison Avenue
Park Avenue South
Lexington Avenue
Third Avenue
Second Avenue
First Avenue
Fifth Avenue
Broadway
Irving Place
Asser Levy Pl.
FDR Drive

281 290 289 283 291 293 285 284 295 271 269 268 273 267 270 266 272 288 287 282 280 298 297 296 294 300 299 302 303 304 301 276 274 277 279 278 275

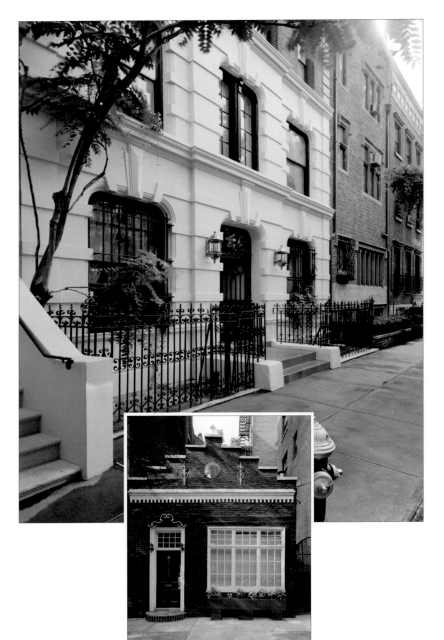

266

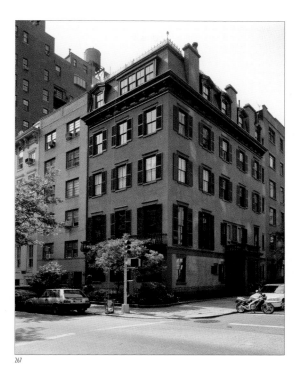

267

"THE BLOCK BEAUTIFUL"

EAST 19TH STREET
BETWEEN THIRD AVENUE AND IRVING PLACE

RENOVATED 1909, FREDERICK J. STERNER

Frederic Sterner was an early-20th-century society architect, known for his design of houses. In this case, he redesigned the façades of all the houses and former stables lining a single block and called it "beautiful." People still do, although "charming" is a word more often heard, especially from admirers of the tiny carriage houses that have become one-story townhouses, more like dollhouses than functional city residences.

STUYVESANT FISH HOUSE

19 GRAMERCY PARK AT IRVING PLACE

1845

This house, whose mansard roof was added in 1860, was once owned by Stuyvesant Fish, president of the Illinois Central Railroad. His wife, Mary, whom everyone knew as "Mamie," inherited the mantle of Queen of New York Society from Mrs. William Astor, and made this her headquarters. In 1931, after years of neglect, it became the home of the city's most successful public relations man, Benjamin Sonnenburg, who, after furnishing it with fine art and antiques, began hosting the city's most glittering parties here, mixing the crème of politics, business, society, and the arts in gatherings of 20 to 200 guests nearly every night of the week.

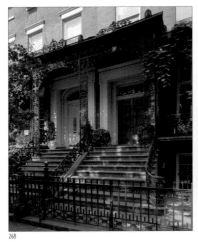

268

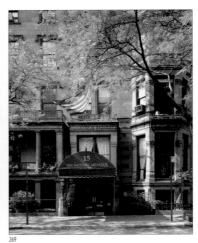

269

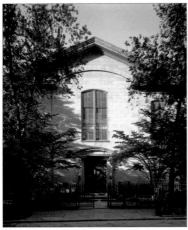

270

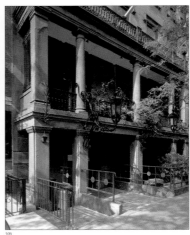

271

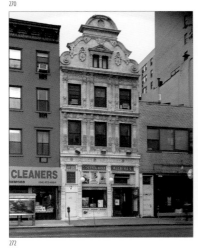

272

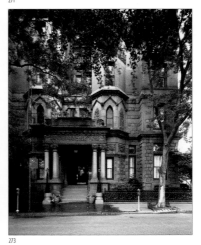

273

268

3 AND 4 GRAMERCY PARK WEST

BETWEEN EAST 20TH AND EAST 21ST STREETS

1846

The beautiful cast-iron verandas on this pair of houses are attributed to Alexander Jackson Davis, one of the most highly respected architects of the early nineteenth century. Although they suggest New Orleans or Charleston, here in New York they have become symbols of Gramercy Park itself. Across the street in the park is an apartment house for birds, purple Martins specifically, an amenity once found in every park in the city.

269

NATIONAL ARTS CLUB ℒ

15 GRAMERCY PARK SOUTH
BETWEEN PARK AVENUE SOUTH AND IRVING PLACE

1884, VAUX & RADFORD

A Victorian Gothic façade alive with representations of birds, plants, and animals native to New York State and busts of famous writers covers this pair of houses combined into a single mansion by former New York Governor Samuel J. Tilden. A major benefactor of the New York Public Library, Tilden won the popular vote in the 1876 presidential election, but lost in the Electoral College to Rutherford B. Hayes.

270

BROTHERHOOD SYNAGOGUE ℒ

28 GRAMERCY PARK SOUTH
BETWEEN IRVING PLACE AND THIRD AVENUE

1869, KING & KELUM
REMODELED, 1975, JAMES STEWART POLSHEK & PARTNERS

Originally the Friends' Meeting House, this building was abandoned after the two feuding branches of Quakers sorted out their differences and settled down together on Stuyvesant Square. In spite of its landmark status, it was slated to be torn down by an apartment house developer in 1975, but at literally the last minute, the Brotherhood Synagogue bought the building and sensitively transformed it from a meeting house to a temple.

271

THE PLAYERS ℒ

16 GRAMERCY PARK SOUTH
BETWEEN PARK AVENUE SOUTH AND IRVING PLACE

1845
REMODELED, 1889, STANFORD WHITE

This was a simple Gothic Revival brownstone until actor Edwin Booth bought it to convert it into an actors' club. Stanford White added the two-story porch, the great wrought-iron lanterns, and the graceful iron railings. Booth's statue, in the character of Hamlet, by Edmond T. Quinn, stands across the street in Gramercy Park.

272

SCHEFFEL HALL

190 THIRD AVENUE
BETWEEN EAST 17TH AND EAST 18TH STREETS

1894, WEBER & DROSSER

Depending on your generation, you might think of this as Fat Tuesday's or Joe King's Rathskeller or the German-American Club, but you can't think of it without remembering the good times you had there. Built as a biergarten for the pleasure of its predominantly German neighbors, it became a destination of choice for college students in the 1920s, who came for the Dixieland music and the generous steins of beer.

273

34 GRAMERCY PARK EAST

AT 21ST STREET

1883, GEORGE W. L. C. DA CUNHA

Originally a hotel, then one of the city's earliest cooperative apartment houses, this spectacular building in the Queen Anne style has hardly changed since the day it was built, from its beautiful tiled lobby to the antique hydraulic elevator that still gets you to the top floor in fashion.

FRIENDS MEETING HOUSE AND SEMINARY ℒ
(QUAKER)

226 EAST 16TH STREET AT STUYVESANT SQUARE

1860, CHARLES T. BUNTING

This austere red brick building was built by a branch of the Quakers called Hicksites who held to the original practices of their faith, as opposed to the so-called Orthodox Quakers who had adopted some new doctrines from evangelical Christians. The two groups, which split in 1828, came together again in 1958 and kept this building as their principal meeting house in the city.

OLD STUYVESANT HIGH SCHOOL ℒ

345 EAST 15TH STREET
BETWEEN FIRST & SECOND AVENUES

1907, C. B. J. SNYDER

Founded in 1904 to prepare immigrant children for science careers, Stuyvesant has evolved into one of America's most prestigious high schools, open only to students who can pass a tough entrance examinaton. They routinely win the Westinghouse Science Award, an honor that pits them against the Bronx High School of Science, itself one of the country's best. The school moved from here to a new building at West and Chambers Streets in 1992.

326, 328, AND 330 EAST 18TH STREET ℒ

BETWEEN FIRST AND SECOND AVENUES

1853

This trio of tiny houses is set back behind landscaped front yards, a rarity in Manhattan, which makes it easier to admire the details of their cast-iron porches. What is really amazing about them is how they managed to survive, intact for all these years. This block was the last outpost of genteel civilization at the eastern edge of the infamous Gashouse District well into the twentieth century.

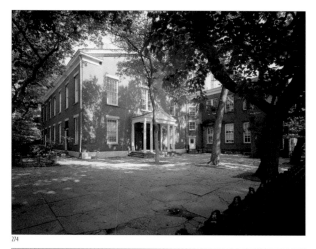

274

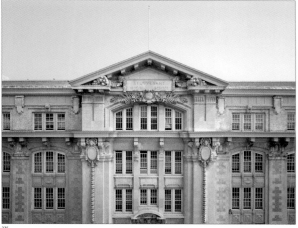

275

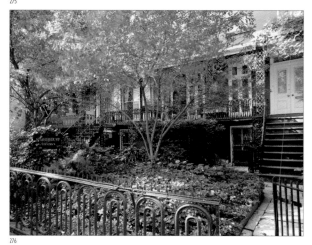

276

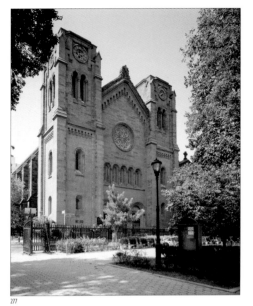

277

SAINT GEORGE'S CHURCH

(Episcopal)

East 16th Street at Stuyvesant Square

1856, Blesch & Eidlitz

One of America's first Romanesque Revival churches, this institution is remembered as J. P. Morgan's church. As a vestryman and warden, he made sure nothing happened here that didn't meet with his approval. Its organ, the favorite of E. Power Biggs, who made recordings on nearly every major pipe organ in the world, was designed by Dr. Albert Schweitzer. St. George's parish has merged with Calvary Church on Park Avenue South at 21st Street as a single unit.

277

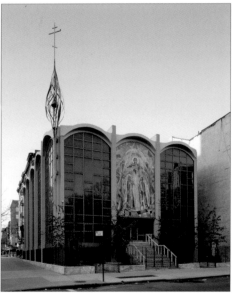

278

ST. MARY'S CATHOLIC CHURCH OF THE BYZANTINE RITE

246 East 15th Street at Second Avenue

1964, Brother Cajetan J.B. Baumann

The mosaics and stained glass windows of this modern concrete structure make it a standout in the daytime and even more of one at night when the light shining through the windows makes it glow. The church overlooks Stuyvesant Square, once part of Peter Stuyvesant's farm, which was given to the city in 1837. The only park in the city cut exactly in half by an avenue, its western two acres are graced by a bronze sculpture of its namesake, created in 1936 by Gertrude Vanderbilt Whitney, the founder of the Whitney Museum.

278

279

STUYVESANT TOWN

EAST 14TH STREET TO EAST 20TH STREET
FIRST AVENUE TO AVENUE C

1947, IRWIN CLAVAN AND GILMORE CLARKE

The Metropolitan Life Insurance Company replaced eighteen blocks of slums with these thirty-five middle-income high-rise buildings creating a suburb in the city for returning World War II veterans. Rents originally averaged $76.50 a month for the 8,755 apartments, but have since risen with inflation to about $1,000. In 2001, it was announced that rents for new vacancies in the now destablized units would go up to between $2,100 and $4,200 a month.

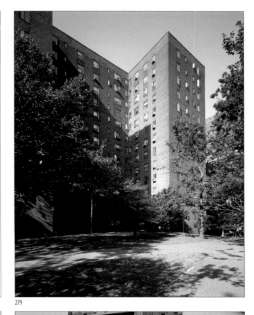

279

280

ONE UNION SQUARE SOUTH

14TH STREET BETWEEN FOURTH AVENUE AND BROADWAY

1999, DAVIS BRODY BOND AND
SCHUMAN LICHTENSTEIN CLAMAN & EFRON
ARTWALL, KRISTIN JONES AND
ANDRE AND ANDREW GINZEL

If you hear something you like in a movie at one of the fourteen theaters in this building, you might find a recording of the soundtrack at the Virgin Megastore here. There are also 240 apartments here, so some people can do all that without technically ever leaving home. Judgment on the beauty of the building's "Artwall" façade, facing up the length of Park Avenue South, is probably best left to the eye of the beholder.

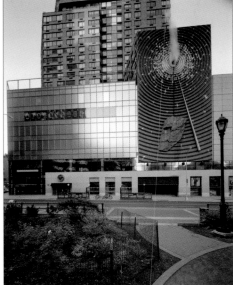

280

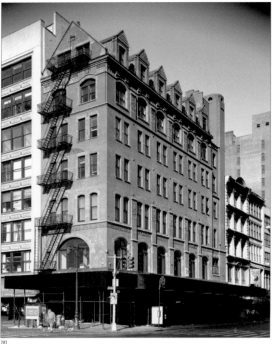

281

281

WESTERN UNION TELEGRAPH BUILDING

186 FIFTH AVENUE AT 23RD STREET

1884, HENRY J. HARDENBERGH

Completed during the same year as Hardenbergh's Dakota apartment house and twenty-three years before his Plaza Hotel, this building isn't as celebrated as either of them, although it deserves to be. When it was built, its neighbor across 23rd Street was the Fifth Avenue Hotel, since replaced by the Toy Center. It was the city's most luxurious in the mid-19th century, and headquarters of the state Republican machine. Its boss, Senator Thomas Platt, schemed there to get rid of Governor Theodore Roosevelt by engineering the Vice-Presidential nomination for him. Less than a year later, T.R. was President and in Platt's hair more than ever.

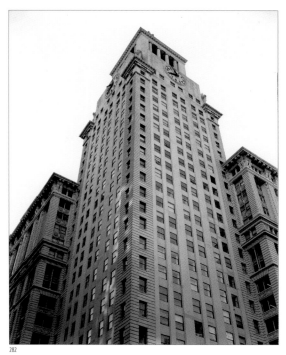

282

CON EDISON BUILDING

4 IRVING PLACE AT 14TH STREET

1915, HENRY J. HARDENBERGH
TOWER, 1926, WARREN & WETMORE

This building was created as the home of the
Consolidated Gas Company, which joined with
the Edison Electric Company to become known
as Consolidated Edison. It was built in stages as
the company grew, and the tower was installed
as a memorial to its employees who died in
World War I. This is the site of two historic
buildings: the "Wigwam," home of Tammany
Hall, and the Academy of Music, a lavish
opera house that for thirty years was a Mecca
for high society patronizing visiting opera
singers. It was also the home of the New York
Philharmonic Orchestra, which performed in
an annex on Irving Place at 15th Street.

MARBLE COLLEGIATE CHURCH *L*
(DUTCH REFORMED)

FIFTH AVENUE AT 29TH STREET

1854, SAMUEL A. WARNER

Established in 1628 in Nieuw Amsterdam, this is the oldest religious congregation in the city. The name "Collegiate" refers to its system of operating under co-equal pastors. The most famous of this church's pastors was Dr. Norman Vincent Peale, who became a pastor here in 1932 and brought a new theology of optimism with him. His book, *The Power of Positive Thinking*, was a runaway best-seller in the 1950s, and he lured thousands to this church, where he preached until his death in 1993.

METROPOLITAN LIFE INSURANCE COMPANY *L*

ONE MADISON AVENUE AT 23RD STREET

1909, NAPOLEON LEBRUN & SONS

The tower rising above the Met's complex of offices was originally much more richly ornamented but sadly, it was savaged during a 1964 restoration. The extension along 23rd Street to Park Avenue South was built in 1913, on the site of McKim, Mead & White's Madison Avenue Presbyterian Church, which was only seven years old when it was demolished. The tower, at 700 feet, topped the old Singer Tower as the tallest building in the world.

NEW YORK LIFE INSURANCE COMPANY *L*

51 MADISON AVENUE
EAST 26TH TO EAST 27TH STREET

1928, CASS GILBERT

This full-block building with a gilded pyramid twenty-six floors above the street fills the site of the original Madison Square Garden. The company, which acquired the site through foreclosure on Stanford White's old Garden, moved here from lower Broadway after its rival, the Metropolitan Life Insurance Company, established Madison Square as the center of the insurance industry.

SERBIAN ORTHODOX CATHEDRAL OF ST. SAVA *L*

15 WEST 25TH STREET
BETWEEN FIFTH AND SIXTH AVENUES

1855, RICHARD UPJOHN

Originally Trinity Chapel, this complex, consisting of a brownstone church, a former school used as a parish house, and a clergy house, was bought by the Serbian community in 1942. All that's missing here is a churchyard, but a monument at the corner of Fifth Avenue and 25th Street marks the last resting place of Major General William Worth (for whom Fort Worth, Texas is named). Except for Grant's Tomb, it is the only burial site directly on a Manhattan street.

ZECKENDORF TOWERS

ONE IRVING PLACE, BETWEEN EAST 14TH
AND EAST 15TH STREETS, TO UNION SQUARE

1987, DAVIS, BRODY & ASSOCIATES

The tower above the Con Ed Building on Irving Place at 14th Street has been hidden behind this massive development of apartments, offices, and stores. The complex replaced the more neighborhood-friendly S. Klein's on the Square, the original of several discount clothing stores in the area, where shoppers pawed through huge bins of clothing looking for a bargain and hoping it would fit.

CENTURY ASSOCIATION *L*

109–111 EAST 15TH STREET
BETWEEN UNION SQUARE EAST AND IRVING PLACE

1869, GAMBRILL & RICHARDSON

Now the Century Center for the Performing Arts, this is the oldest clubhouse building in New York. It is one of several locations the club has occupied, culminating with their present building at 7 West 43rd Street. The association was founded in 1846 by William Cullen Bryant and others to encourage interest in arts and letters. Its name was suggested by the fact that membership was limited to one hundred artists and authors, and their patrons.

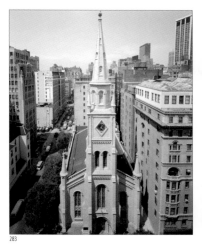

283

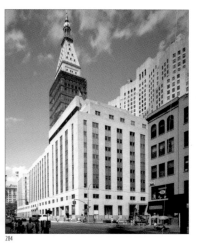

284

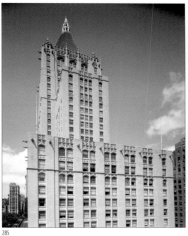

285

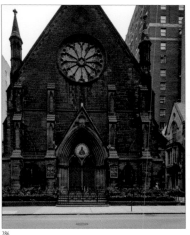

286

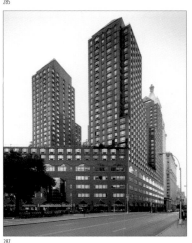

287

288

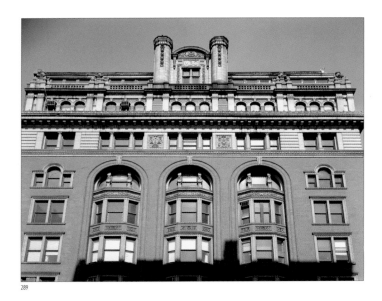

289

METHODIST BOOK CONCERN

150 FIFTH AVENUE AT WEST 20TH STREET

1888–90, EDWARD H. KENDALL

This loft building was the home of one of the country's largest publishers of religious books in the late nineteenth century. It also served as the New York headquarters of the Methodist Church. There were so many publishers of religious tracts and books in this neighborhood (the Presbyterian Building on the other side of 20th Street is an example), that it was known as "Pater Noster Row" in the 1890s. After the area began coming back to life a century later, it became a publishing center all over again as secular publishers flocked downtown to take advantage of the vast open space that buildings like this have to offer. Compared to its uptown counterparts, the rent is a bargain, too.

FLATIRON BUILDING

175 FIFTH AVENUE AT 23RD STREET

1903, DANIEL H. BURNHAM & CO.

This may be the most photographed building in New York, not just because its composition makes it so photogenic, but because, since the 1960s, the neighborhood around it has harbored a large concentration of photographers. Although only 23 stories, it was the first really tall building north of City Hall, and it has symbolized skyscraper style ever since it was built. Its formal name is the Fuller Building, but the unusual shape gave it its more popular name. The shape was dictated by the variation in Manhattan's grid pattern caused by Broadway's march uptown on an east-west diagonal. One of the earliest buildings in New York supported by a steel cage, its heavy limestone walls, which appear to be supporting the building, give it a sturdy look in spite of its slim profile.

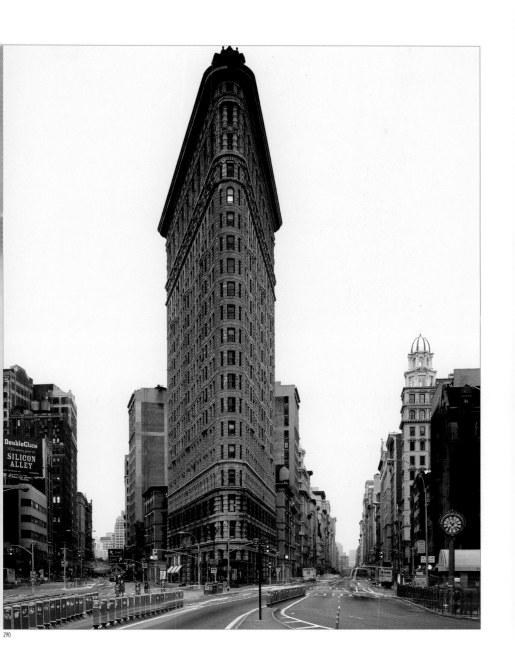

290

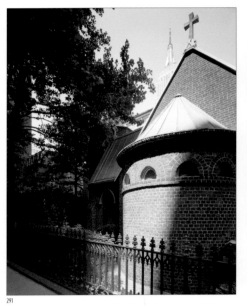

291

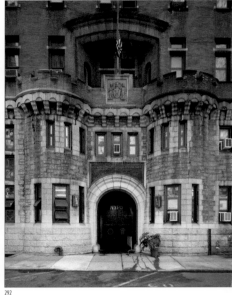

292

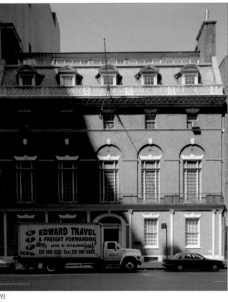

293

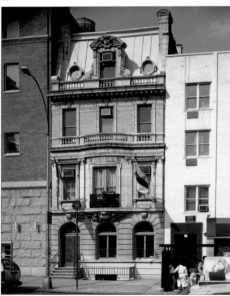

294

LITTLE CHURCH AROUND THE CORNER *L*
(EPISCOPAL)

ONE EAST 29TH STREET
BETWEEN FIFTH AND MADISON AVENUES

1850

When the famous actor Joseph Jefferson died, his friends approached the rector of the Church of the Incarnation on Madison Avenue to arrange the funeral. "We don't accept actors," he informed them, "but there is a little church around the corner that does." From that day on, the Church of the Transfiguration's original name was forgotten.

23RD PRECINCT, NYPD

138 WEST 30TH STREET
BETWEEN SIXTH AND SEVENTH AVENUES

1907, R. THOMAS SHORT

Now the Police Department's Traffic Control Division, this midtown fortress was designed by the architect of the fanciful Alwyn Court on 58th Street at Seventh Avenue, created with his partner, H.S.S. Harde. The firm also designed the Red House on West 85th Street, and 4 East 66th Street at Madison Avenue, and the Studio Building on West 77th Street off Central Park West.

AMERICAN ACADEMY OF DRAMATIC ARTS *L*

120 MADISON AVENUE
BETWEEN EAST 30TH AND EAST 31ST STREETS

1908, MCKIM, MEAD & WHITE

Designed by Stanford White with interiors by Elsie de Wolfe, this was originally the Colony Club, New York's first retreat for socially prominent women. It became the home of the American Academy of Dramatic Arts, the oldest professional acting school in the English-speaking world, in 1963.

ESTONIAN HOUSE *L*

243 EAST 34TH STREET
BETWEEN SECOND AND THIRD AVENUES

1899, THOMAS A. GRAY

This Beaux Arts clubhouse was built for the Civic Club by Frederick Goddard, a philanthropist dedicated to providing uplift in the lives of people living between 23rd and 42nd Street on the East Side. The Goddard family sold the building to the Estonian Educational Society in 1946.

THEODORE ROOSEVELT BIRTHPLACE 𝓛

28 EAST 20TH STREET
BETWEEN BROADWAY AND PARK AVENUE SOUTH

REPLICATED 1923, THEODATE POPE RIDDLE

Now a National Historic Site, this house is not where young Teddy Roosevelt spent his boyhood, but it is a very close facsimile. The original house was demolished while Roosevelt was still alive. After demolishing the uncle's house next door, the Women's Roosevelt Memorial Association commissioned Theodate Pope Riddle, one of America's first female architects, to reconstruct the late president's birthplace as it had been in 1865, when Teddy Roosevelt was seven years old.

TOURO COLLEGE 𝓛

160 LEXINGTON AVENUE AT EAST 30TH STREET

1909, HARVEY WILEY CORBETT

This building was originally the New York School of Applied Design for Women, established in 1892 to teach ornamental design to underprivileged women. Harvey Wiley Corbett, who was on its faculty, created this inspiring classical temple, which includes casts from the Parthenon frieze, with the help of his students. Touro College is a non-sectarian school, but it requires its liberal arts students to earn credits in Jewish and Hebrew studies.

BARUCH COLLEGE

LEXINGTON AVENUE
BETWEEN EAST 24TH AND 25TH STREETS

2001, KOHN PEDERSON FOX ASSOCIATES

This seventeen-story building is organized around a series of stacked atriums meant to substitute for traditional college quadrangles. It contains 102 classrooms, 14 research labs, 36 computer labs, some 500 offices, 2 auditoriums, a food court, a bookstore, a pool, and a basketball court, housing about half of the campus of Baruch College, a unit of the City University of New York.

69TH REGIMENT ARMORY 𝓛

68 LEXINGTON AVENUE
BETWEEN EAST 25TH AND EAST 26TH STREETS

1906, HUNT & HUNT

This ribbed and buttressed building, which makes no attempt to hide the dimensions of the huge drill hall inside, is famous not as an armory but as a landmark in the art world. It was the site of the 1919 International Exhibition of Modern Art, also called the "Armory Show," which introduced modern art to America with more than 1,600 works by such artists as Picasso and Van Gogh, Cézanne, Gauguin, and Matisse.

KIPS BAY PLAZA

EAST 30TH TO EAST 33RD STREETS
FIRST TO SECOND AVENUES

1963, I. M. PEI & ASSOCIATES

These two twenty-one-story concrete slabs set parallel to each other contain 1,136 apartments. Although they completely ignore their surrounding neighborhood, their placement creates a pleasing interior park for the people who live in the midst of the isolation they create, even if it does cancel out one of the best reasons for living in the city in the first place, the joy of people-watching.

ST. VARTAN CATHEDRAL
(ARMENIAN ORTHODOX)

620 SECOND AVENUE
BETWEEN EAST 34TH AND EAST 35TH STREETS

1967, STEINMANN & CAIN

This is a bit of old Armenia writ large on Second Avenue. An adaptation of the small Romanesque churches of Asia Minor, its gold dome dominates the streetscape for several blocks uptown. The ten-foot bronze sculpture, *Descent from the Cross*, in the cathedral's plaza is by Reuben Nakian. It is an abstract translation of the Rubens painting, *Descent from the Cross*, in Antwerp.

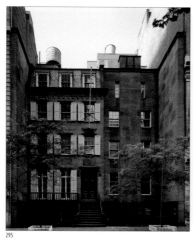

295

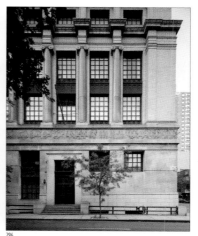

296

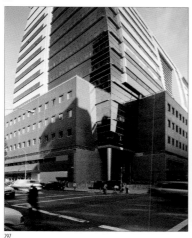

297

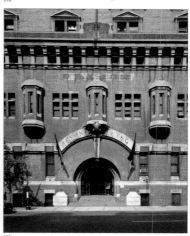

298

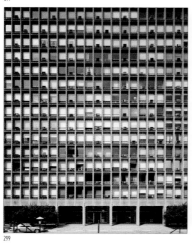

299

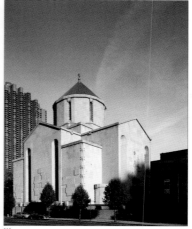

300

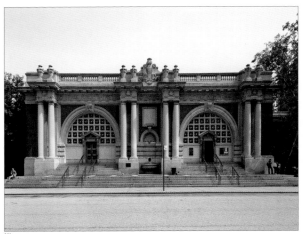

301

302

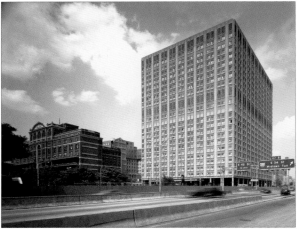

303

PUBLIC BATHS ℒ

EAST 23RD STREET AT ASSER LEVY PLACE
BETWEEN FIRST AVENUE AND FDR DRIVE

1906, ARNOLD W. BRUNNER
AND WILLIAM MARTIN AIKEN

Back when this was a neighborhood of densely packed slums, most of which lacked running water, the city built this structure to cope with the sanitary problems. Appropriately modeled after the baths of ancient Rome, it was converted to a recreation center with a swimming pool in 1990.

MT. SINAI-NYU MEDICAL CENTER

FIRST AVENUE BETWEEN 30TH AND 34TH STREETS

1950, SKIDMORE, OWINGS & MERRILL

A constantly expanding complex, these buildings house New York University's medical school and complete the long row of medical insitutions that line First Avenue from the Veteran's Affairs Medical Center on 24th Street for half a mile up to 34th Street. The neighborhood to the west also includes the Cabrini Medical Center and Beth Israel Hospital.

BELLEVUE HOSPITAL CENTER

462 FIRST AVENUE AT 27TH STREET

1908–39, MCKIM, MEAD & WHITE

Established in 1736, this is the oldest municipal hospital in the United States, and one of the largest. Until the 1950s, when it had 2,700 beds, it was by far the biggest hospital in New York before being eclipsed by mergers of other large medical institutions. Among the "firsts" in Bellevue's history are the first cesarean section performed in the United States, the first use of hypodermic syringes, and the first hospital-owned ambulance service.

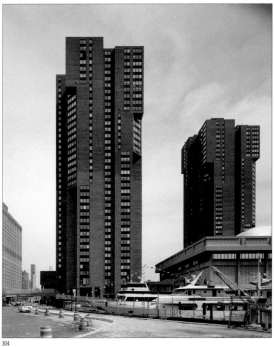

304

WATERSIDE

FDR DRIVE
BETWEEN EAST 25TH AND EAST 30TH STREETS

1974, DAVIS, BRODY & ASSOCIATES

This development includes 1,600 apartment
units in four towers on a platform over the East
River. Nearly 400 of them are designated for
moderate-income families and many have rents
set at public housing levels. The rest of the com-
plex is rented according to tenants' income fol-
lowing a complicated rate system. Realization
of this project was a long time coming. The
original plans were developed in 1963, but the
first families didn't begin moving in until 1974.

MIDTOWN

The visitors you see poring over maps in hotel lobbies rarely stray from this part of Manhattan, extending roughly between the Empire State Building and Central Park. It may be that they don't have time to wander any further because there is so much for them to see and do right here, from Times Square to the United Nations, from Rockefeller Center to the exclusive Fifth-Avenue boutiques. This is the beaten path for a very good reason. If you haven't seen Midtown Manhattan, you haven't seen the world. But it isn't just a mecca for tourists. It is a working, teeming business district, and most of the interesting faces that compete with the buildings for your attention belong to native New Yorkers hurrying to work. Even the most jaded local can't resist looking up at the marvelous surroundings once in awhile.

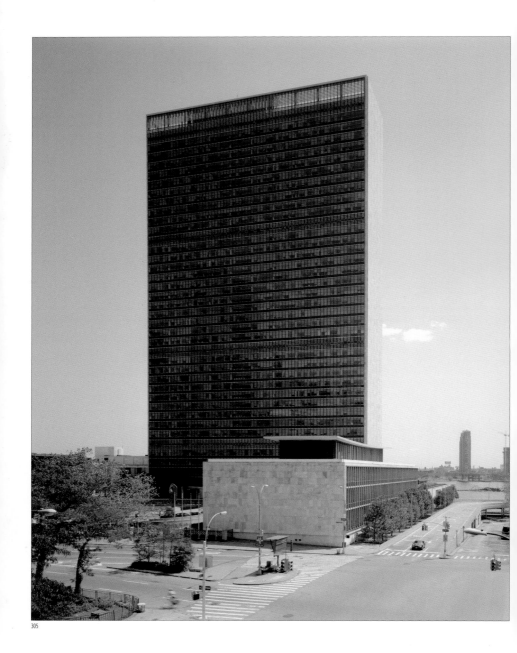

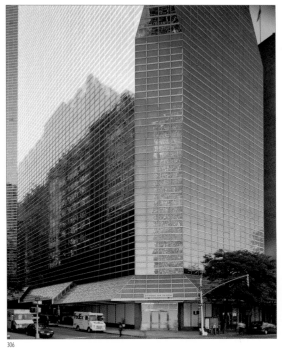

306

UNITED NATIONS HEADQUARTERS

UNITED NATIONS PLAZA (FIRST AVENUE)
BETWEEN EAST 42ND AND EAST 48TH STREETS

1953, INTERNATIONAL ARCHITECTS,
WALLACE K. HARRISON, CHAIRMAN

This international zone in the heart of the city was built on land donated by John D. Rockefeller, Jr. It is dominated by the 544-foot slab building housing the Secretariat, flanked by the General Assembly Building to its north, the Conference Building on the east, and the Library at the 42nd Street end. The complex extends out onto a platform over the FDR Drive, and a tunnel diverts First Avenue traffic away from it. The UN's gardens and the General Assembly lobby are open to the public, and tours of the other buildings are available.

I UNITED NATIONS PLAZA

FIRST AVENUE AT EAST 44TH STREET

1976 AND 1983, KEVIN ROCHE
JOHN DINKELOO & ASSOCIATES

The first combination hotel/office building ever attempted in New York, critics despised no. 1 UN Plaza, a thirty-nine-story structure sheathed in blue-green glass. The *Times'* Paul Goldberger complained that the glass façade "hides what is going on inside," and the *AIA Guide* sniffed that it looked like "folded graph paper." But in spite of its critics, the public loved the place and it was duplicated seven years later by the identical no. 2 UN Plaza.

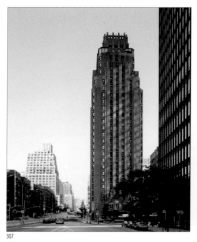

307

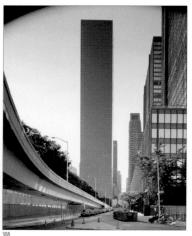

308

309

310

311

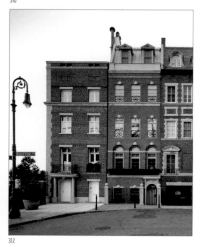

312

307
BEEKMAN TOWER *L*

FIRST AVENUE AT EAST 49TH STREET

1928, JOHN MEAD HOWELLS

This was built as the Panhellenic Tower, an apartment hotel for women college graduates belonging to Greek letter sororities. It was an architectural landmark from the very beginning, hailed as a perfect example of vertical force. It is now an apartment building.

308
TRUMP WORLD TOWER

845 UNITED NATIONS PLAZA AT EAST 47TH STREET

2001, COSTAS KONDYLIS

After the United Nations complex was built, the city fathers reserved a block-long space, called Dag Hammarskjöld Plaza, around the corner on the south side of 47th Street, as the only place where protest demonstrations could be held. In the years since, every grievance imaginable has been aired there, but few of the protests were as impassioned as those mounted by residents of this upscale neighborhood protesting Donald Trump's plan to build this building, which he claims is the world's tallest apartment house.

309
FORD FOUNDATION BUILDING *L*

321 EAST 42ND STREET
BETWEEN FIRST AND SECOND AVENUES

1967, KEVIN ROCHE, JOHN DINKELOO & ASSOCIATES

This L-shaped building is built around a 130-foot-high "greenhouse," whose plant life rotates with the seasons. It is a terraced garden with seventeen full-grown trees and thousands of plants, including aquatic plants growing in a peaceful pool. The architects said that they had a proper environment for the building's staff in mind, but even if you aren't lucky enough to work here, you are free to visit the gardens on weekdays.

310
TUDOR CITY *L*

EAST 40TH TO EAST 43RD STREETS
BETWEEN FIRST AND SECOND AVENUES

1928, FRED F. FRENCH

Apart from "prewar," the most common pitch in classified ads for apartments is "walk to work," which first appeared in print for the 3,000 apartments in this twelve-building complex. One thing the ads didn't mention was that in the 1920s this neighborhood was mainly tenements and slaughterhouses, which is why these buildings face inward and there are almost no river views.

311
THE CORINTHIAN

345 EAST 37TH STREET
BETWEEN FIRST AND SECOND AVENUES

This apartment tower replaced the East Side Airline Terminal, built to complement the one at Ninth Avenue and 42nd Street and to cut the time it took airport buses (they called them "limos" back then) to get to the Queens Midtown Tunnel and the airports on the other side. The problem was that passengers still had to cut through crosstown traffic to catch their bus.

312
SUTTON PLACE

BETWEEN YORK AVENUE AND FDR DRIVE
EAST 53RD TO EAST 59TH STREETS

1920s

This charming neighborhood was originally developed in 1875 by Effingham B. Sutton. It was allowed to deteriorate until after the First World War, when Mrs. William K. Vanderbilt moved here and it was instantly transformed into an enclave of expensive townhouses and exclusive apartment buildings.

BEAUX ARTS APARTMENTS 𝓛

307 AND 310 EAST 44TH STREET
BETWEEN FIRST AND SECOND AVENUES

1930, RAYMOND HOOD AND KENNETH MURCHISON

These two buildings face each other across the street, a space visualized as a kind of courtyard. They were originally intended to contain double-story artists' studios, but instead have one-room apartments with traditional studios on the top two floors. Each of the small apartments was designed to feature a small bathroom and a serving pantry, as well as a pair of "Murphy beds" that fold into closets during the day.

SNIFFEN COURT HISTORIC DISTRICT 𝓛

EAST 36TH STREET
BETWEEN LEXINGTON AND THIRD AVENUES

1864

This is the city's smallest historic district. It is made up of ten two-story round-arched stables that were converted in the 1920s into homes for World War I veterans who came back with new brides and thought they would feel more at home in surroundings like this.

VILLARD HOUSES 𝓛

451–455 MADISON AVENUE
BETWEEN EAST 50TH AND EAST 51ST STREETS

1884, FAÇADE, JOSEPH WELLS, INTERIOR, STANFORD WHITE

This U-shaped group of six houses was built for Henry Villard, an immigrant who went on to control the Northern Pacific Railroad, among others. His own house occupied the entire south wing, but he only lived in it for three years. The Palace Hotel was built above the houses in 1980, and the south wing became part of its entrance. The north wing is a bookstore and exhibition space for the Municipal Arts Society.

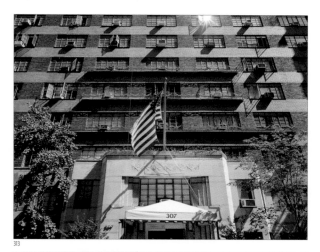

313

314

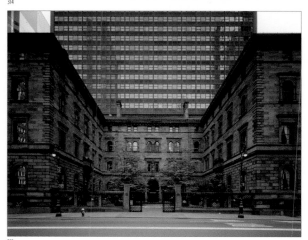

315

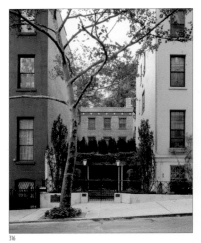

316

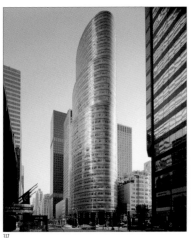

317

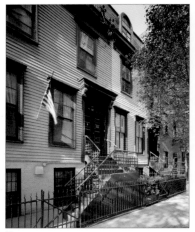

318

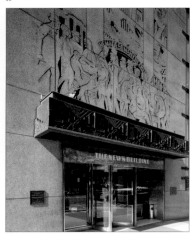

319

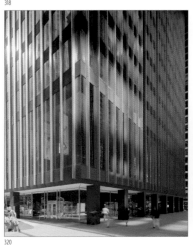

320

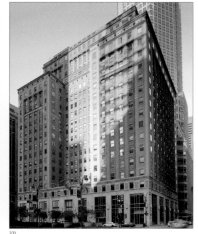

321

316

152 EAST 38TH STREET \mathcal{L}

BETWEEN LEXINGTON AND THIRD AVENUES

1858

That little charmer peeking out from between its taller neighbors was originally built with a deep front yard, as were other long-gone houses around it. When it was remodeled in 1934, a low wall was built at the front of the lot and it was refaced with stucco. Not much else was changed—except, of course, for the neighborhood around it.

317

885 THIRD AVENUE

BETWEEN EAST 53RD AND EAST 54TH STREETS

1986, JOHN BURGEE AND PHILIP JOHNSON

Office buildings are generally named for their principal tenant, but this one is called the "Lipstick Building" because of its brown and pink telescoping tiers. The name stuck quickly, even before the first tenants moved in, but none of them are in the cosmetics business.

318

312 AND 314 EAST 53RD STREET \mathcal{L}

BETWEEN FIRST AND SECOND AVENUES

1886

A reminder that this part of midtown isn't all office towers, only one of these two wood-frame houses has been given Landmark status. But they stand here together as a very rare example of a time when mansard-roofed residences like these could be found in every corner of the city. Looking at the neighborhood that has grown up around them, it is hard to believe that the East 50s was a long haul to the office at one point in time.

319

DAILY NEWS BUILDING \mathcal{L}

220 EAST 42ND STREET
BETWEEN SECOND AND THIRD AVENUES

1930, HOWELLS & HOOD

Among Raymond Hood's considerable talents was his ability to give buildings a character all their own, and this is Hood at his pinnacle. Its original tenant, the *New York Daily News*, has since moved over to the far West Side, but the spectacular lobby in this building, intended as an educational exhibit for the newspaper, is still intact. Its centerpiece is the world's largest interior globe, whose details are constantly updated.

320

J. P. MORGAN CHASE BUILDING

410 PARK AVENUE
BETWEEN EAST 47TH AND EAST 48TH STREETS

1960, SKIDMORE, OWINGS & MERRILL

This 53-story tower rising straight up from Park Avenue actually begins at the second floor, as do many in this neighborhood that were built above the tracks and railroad yards serving neaby Grand Central Terminal. Union Carbide, its original tenant, moved out to suburban Connecticut in the 1980s. The Chase Manhattan Bank merged with J. P. Morgan & Co. and changed its name in 2001.

321

POSTUM BUILDING \mathcal{L}

250 PARK AVENUE
BETWEEN EAST 46TH AND EAST 47TH STREETS

1925, CROSS & CROSS

This is the last survivor of a long row of similar buildings that once formed an orderly street line from Grand Central Terminal up to the Racquet & Tennis Club at 53rd Street. The original intent was to create a conservative link between the commercialism of lower Park Avenue and the large apartment houses to the north.

GENERAL ELECTRIC BUILDING *L*

1931, CROSS & CROSS

This building was the original home of Radio Corporation of America and became the General Electric Building when RCA moved over to Rockefeller Center to a structure that is now known as the GE Building. They're both buildings any company could be proud of. The Art Deco, almost Gothic, crown at the top of this one, intended to suggest radio waves, is a marvelous addition to the skyline, but this building is especially notable for its relationship to St. Bartholomew's Church behind it. Cross & Cross sensitively designed this spire using materials and colors compatible with the church and treated the rear façade so that it recedes into the background, forming a backdrop for its low neighbor.

TURTLE BAY GARDENS *L*

226–247 EAST 49TH STREET
AND 227–247 EAST 48TH STREET

REMODELED, 1920, EDWARD C. DEAN
AND LAWRENCE BOTTOMLEY

In an effort to reclaim what was then a run-down neighborhood, Charlotte Martin bought these twenty houses and renovated them into single-family houses and apartments. The façades were all redone and the yards behind them were combined into an Italian Renaissance common garden. Among the people who have lived here are Katharine Hepburn, Mary Martin, Tyrone Power, and Stephen Sondheim. Writer E. B. White, a longtime resident, immortalized a tree in its garden, which he said, "symbolizes the city: life under difficulties, growth against odds, sap-rise in the midst of concrete, and the steady reaching for the sun."

CHANIN BUILDING *L*

122 EAST 42ND STREET AT LEXINGTON AVENUE

1929, SLOAN & ROBERTSON

There is enough fascinating detail on this façade to keep you busy for days, and there is even more in the lobby. Above the storefronts, black marble and bronze frame a frieze telling the story of evolution from one-celled creatures to fish and birds. The piers above it are embellished with sea serpents, and the terra-cotta panels at the fourth floor have a busy pattern of flowers. Inside, the theme is the "City of Opportunity," with bas-reliefs and grilles that tell the story of how a humble man can become rich and powerful by sheer will. That man was Irwin Chanin, who built this architectural treasure.

MOBIL BUILDING

150 EAST 42ND STREET
BETWEEN LEXINGTON AND THIRD AVENUES

1955, HARRISON & ABRAMOVITZ

At the time it was built, this was the largest office building erected since Rockefeller Center. It was originally the Socony-Vacuum Building, named for its principal tenant, which became known as Socony-Mobil the year it moved here. The stamped stainless steel panels that make up its façade prompted architecture critic Lewis Mumford to write that it makes the building look like it is "coming down with the measles."

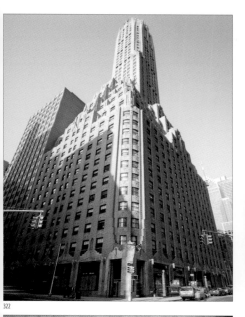

322

323

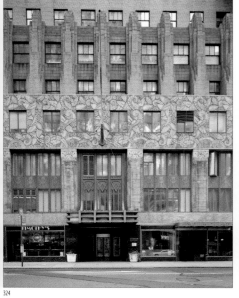

324

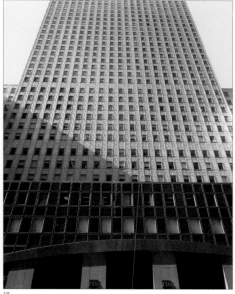

325

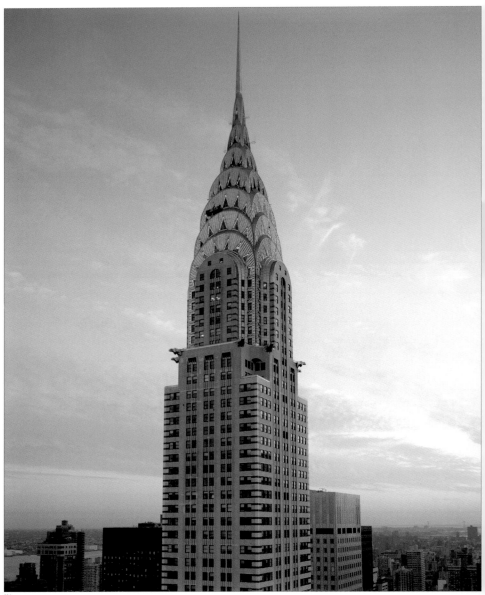

Chrysler Building

405 Lexington Avenue at 42nd Street

1930, William Van Alen

Every New Yorker's favorite skyscraper, this wasn't built as offices for Chrysler Motors, but as a monument to its owner, Walter P. Chrysler, and that meant it had to be the world's tallest building. The earliest sign of a race to the sky came when J. E. R. Carpenter, architect of the Lincoln Building on 42nd Street facing Vanderbilt Avenue, announced that he was going up to fifty-five floors. William Van Alen, Chrysler's architect, countered by announcing fifty-six stories. Then, when Carpenter topped that with plans for a sixty-three-story building, Van Alen went to sixty-five. But it was only a bluff. Carpenter never intended to go above fifty-four floors. However, Van Alen had a fiercer competitor in his former partner, H. Craig Severance, who said his building for the Bank of the Manhattan Company (now the Trump Building), in the financial district, would be the world's tallest. Van Alen countered by adding more floors to his with the blessing of his client, who knew a good publicity stunt when he saw one. The last straw was Severance's addition of a lantern to the top of the bank building, and then a flagpole on top of it, after the Chrysler Building's crown had gone as far as it could go. Van Alen countered the affront by secretly building a 185-foot stainless steel spire inside his building's fire shaft, and, as Severance was topping off his downtown building, he hoisted what he called the "Vertex" into position. The result was that Chrysler's sevety-seven-story monument was the world's tallest building, only to be topped by the Empire State Building in less than a year.

327

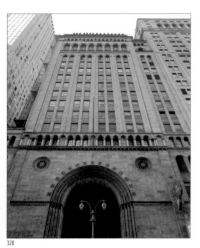

328

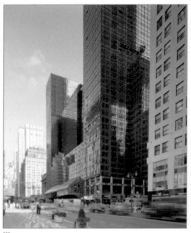

329

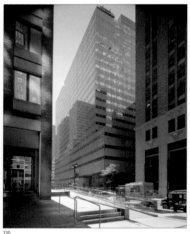

330

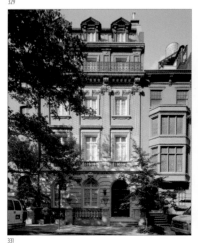

331

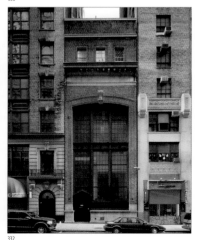

332

GEORGE S. BOWDOIN STABLE ℒ

327

149 EAST 38TH STREET
BETWEEN LEXINGTON AND THIRD AVENUES

1902, RALPH S. TOWNSEND

This former carriage house is guarded by carved bulldogs that share the Dutch gable with with horses wearing wreaths around their necks. When a railroad ran down the center of Park Avenue, these blocks east of it, "the wrong side of the tracks," were filled with stables set at a discrete remove from their owners' homes. Unlike other similar stable areas, though, many of the East Side's service buildings made their own elegant statements.

BOWERY SAVINGS BANK ℒ

328

110 EAST 42ND STREET
BETWEEN PARK AND LEXINGTON AVENUES

1923, YORK & SAWYER

This is a Roman basilica with rich ornamentation, including a rooster symbolizing punctuality (possibly in making payments on loans) and a squirrel as a symbol of thrift. The monumental arch at the entrance leads to a banking room that qualifies as one of the city's greatest interiors. When the bank stopped operating, this wonderful space became a catering hall, run by Giuseppe Cipriani, who has also taken over the space in the Rainbow Room at Rockefeller Center.

GRAND HYATT HOTEL

329

125 EAST 42ND STREET AT LEXINGTON AVENUE

1920, WARREN & WETMORE
REBUILT, 1980, GRUZEN & PARTNERS WITH DER SCUTT

Part of the New York Central Railroad's scheme for a "terminal city" over its tracks was the construction of several hotels. This one, with direct access to the terminal itself, was named the "Commodore," in honor of Cornelius Vanderbilt, the railroad's founder, who earned this title as owner of the world's largest steamboat fleet. Its conversion to a more modern glass-enclosed structure was one of Donald Trump's first major projects in Manhattan.

PARK AVENUE ATRIUM

330

466 LEXINGTON AVENUE
BETWEEN EAST 45TH AND EAST 46TH STREETS

1984, EDWARD DURRELL STONE

This was originally Grand Central Palace, an exposition hall built as part of the Grand Central Terminal complex. While the most popular annual event was the flower show, it is better remembered by veterans of World War II who were summoned here for physical examinations by their local draft board. Its conversion to an office building left the open space inside and redesigned it as an atrium with glass elevators riding up and down its sides.

JAMES F. D. LANIER HOUSE ℒ

331

123 EAST 35TH STREET
BETWEEN PARK AND LEXINGTON AVENUES

1903, HOPPIN & KOEN

This outstanding Beaux Arts townhouse, which replaced two smaller houses for banker James Lanier, is by the architect of the Police Headquarters Building on Centre Street and several of the mansions on Riverside Drive.

ANDY WARHOL'S "FACTORY"

332

19 EAST 32ND STREET AND 22 EAST 33RD STREET
BETWEEN PARK AND MADISON AVENUES

REMODELED 1983

This building, which also has an entrance on Madison Avenue, was originally a substation for the Edison Electric Company. Artist Andy Warhol used it as a studio, office space, and a gathering place for a wide array of artists, actors, models, and musicians throughout the sixties and seventies. Lou Reed's *Velvet Underground* was considered the "house band" and parties there often turned into "happenings."

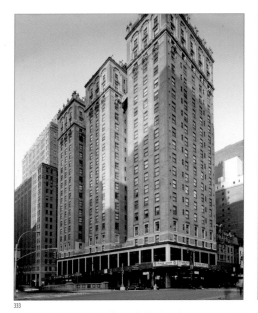

333

VANDERBILT HOTEL

4 PARK AVENUE
BETWEEN EAST 33RD AND EAST 34TH STREETS

1913, WARREN & WETMORE

Now an office building, about all that remains as a reminder of the original hotel is the landmarked Della Robbia Bar, once known as "The Crypt," a space vaulted with Guastavino tiles reminiscent of the Oyster Bar in Grand Central Terminal, conceived by the same architect. He added colorful ceramic ornament to this space.

333

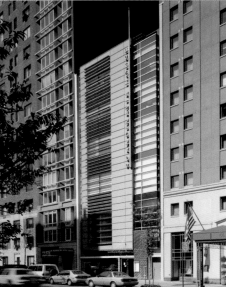

334

SCANDINAVIA HOUSE

56 PARK AVENUE
BETWEEN EAST 37TH AND EAST 38TH STREETS

2000, POLSHEK PARTNERSHIP

Also known as the Nordic Center in America, Scandinavia House is the headquarters of the American-Scandinavian Foundation, which promotes the cultures and traditions of Denmark, Finland, Iceland, Norway, and Sweden through special exhibitions, film screenings, and other events. Its gift shop is one of the best and most unusual of all the museum shops in the city. The building itself is worth a visit for anyone who admires the design accomplishments of the Northern Europeans.

334

335

PHILIP MORRIS HEADQUARTERS

120 PARK AVENUE AT 42ND STREET

1982, ULRICH FRANZEN & ASSOCIATES

This headquarters building of the tobacco and food conglomerate includes the downtown branch of the Whitney Museum. It stands at the edge of Pershing Square, a little park that never was. When the Grand Union Hotel at 100 East 42nd Street at Park Avenue was torn down in 1914, the city reserved its site for a plaza named for General John J. Pershing, commander of the American forces in World War I. The plot sat empty until 1920 when the city fathers sold it to a developer who built a twenty-four-story building there and named it the Pershing Square Building. The name also lives on in a plaque on the viaduct over 42nd Street.

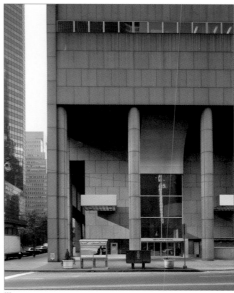

335

336

23 PARK AVENUE 🄻

AT 35TH STREET

1898, McKIM, MEAD & WHITE

Originally the J. Hampden and Cornelia Van Rensselaer residence, this brownstone palazzo was the headquarters of the Advertising Club for many years before it was converted into condominium apartments. The Italianate style, of which this is an impressive example, came into prominence in New York with the mass quarrying of brownstone in New Jersey and Connecticut. It is very easily worked, and it allowed architects to duplicate Classical stone carving without the availability of many fine Italian craftsmen.

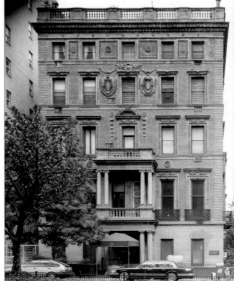

336

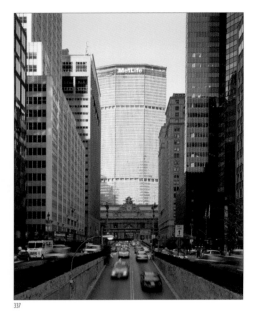

337

MET LIFE BUILDING

200 PARK AVENUE

1963, EMERY ROTH & SONS
WITH PIETRO BELLUSCHI AND WALTER GROPIUS

This behemoth was originally conceived as the ultimate revenue producer for the railroad that owned the site. In its planning stages as the Grand Central City Building, it became the subject of heated controversy while it was still on the drawing boards. In spite of the bitter criticism, most of its space was leased before construction actually began to Pan American World Airways, which added a heliport to the roof. Before the newly named Pan Am Building was finished, an unprecedented ninety-three percent of its space had been rented. As the tenants were moving in, the *New York Times* editorialized, "We have gained the world's largest office building. We have lost some of the world's most impressive views." The world also lost Pan Am, the airline, in 1992, and the building was acquired by the Metropolitan Life Insurance Company.

GRAND CENTRAL TERMINAL ℒ

EAST 42ND STREET BETWEEN LEXINGTON AND VANDERBILT AVENUES

1913, REED & STEM AND WARREN & WETMORE
INTERIOR RESTORATION, 1998, BEYER BLINDER BELLE

More than just a pretty face, this Beaux-Arts masterpiece is also an engineering triumph. Charles Reed of the St. Paul firm of Reed & Stem conceived the "elevated circumferential plaza" to carry Park Avenue around it. He also borrowed an idea from Stanford White's original Madison Square Garden for interior ramps to speed the flow of passengers. The trains arrived on a two-level fan of tracks south of 49th Street. He designed a bridge over them strong enough to support a neighborhood of skyscrapers. Reed also designed a terminal building, but work had barely begun when Whitney Warren was hired to design another, which is the building that exists today.

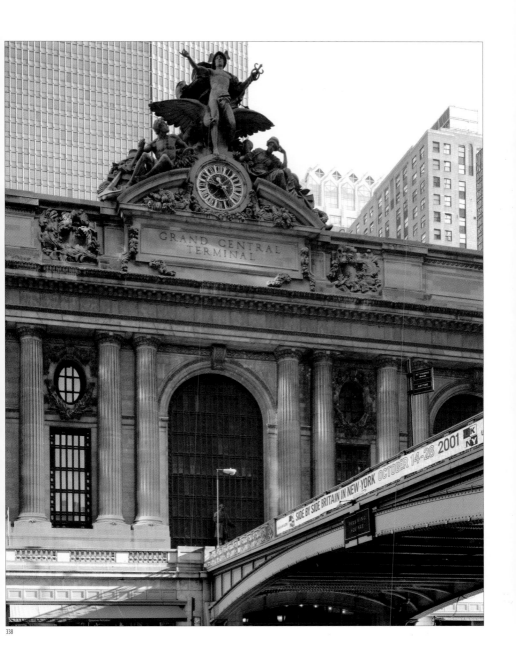

WALDORF-ASTORIA HOTEL 𝒧

301 PARK AVENUE
BETWEEN EAST 49TH AND EAST 50TH STREETS

1931, SCHULTZE & WEAVER

This grand hotel replaces the combined Waldorf and Astoria Hotels that were torn down to make way for the Empire State Building. References to its predecessors live on in its Empire Room and Peacock Alley. The three-story Grand Ballroom can comfortably accommodate 6,000 people, but it was strained to its limit the night the hotel opened and 20,000 guests showed up. Those who came by car arrived via a covered driveway that runs right through the building. This, among other more obvious amenities, has made the hotel a favored destination of security-conscious world leaders since the beginning.

HELMSLEY BUILDING 𝒧

230 PARK AVENUE
BETWEEN EAST 45TH AND EAST 46TH STREETS

1929, WARREN & WETMORE

When the New York Central Railroad built Grand Central Terminal, it also built this palatial thirty-five story building straddling Park Avenue for its offices. Its north elevation paid homage to the cornice line of buildings marching up the Avenue before rising up to the impressive tower with a cupola that could be seen for miles. Two arcades allow pedestrians to walk under the building at the sidewalk level, and two larger portals carry vehicles up and around the terminal. The pedestrian paths once continued on up Park Avenue itself, but they were removed to make more room for cars.

ST. BARTHOLOMEW'S CHURCH 𝒧
(EPISCOPAL)

PARK AVENUE
BETWEEN EAST 50TH AND EAST 51ST STREETS

1919, BERTRAM G. GOODHUE

High on the list of New York's wealthiest and most fashionable churches, this building was built on the original site of a brewery that had been turning out beer here for nearly sixty years. It replaces the parish's former church on Madison Avenue at 44th Street, and the entrance portal, designed by Stanford White with sculptures by Daniel Chester French and Philip Martiny, was reinstalled here on Park Avenue. In the 1980s, the church proposed replacing its adjacent parish house with an office tower, but after a long court battle, a decision by the United States Supreme Court saved the beautiful low-rise building.

CONSULATE GENERAL OF POLAND 𝒧

233 MADISON AVENUE AT EAST 37TH STREET

1906, C. P. H. GILBERT

This extravagant mansion, now restored as the Polish Consulate, was built by Captain Raphael De Lamar, who was master of his own ship at the age of twenty-three, and eventually struck it rich in the Colorado gold fields. His New York house had two elevators, one for the servants and the other for De Lamar and his ten-year-old daughter (his wife had divorced him). While the house had an elaborate ballroom, it was never used. The Captain was described as "aloof" and uninterested in entertaining.

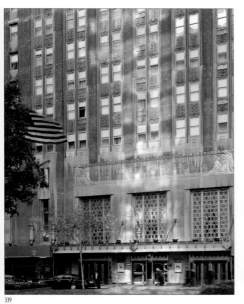

339

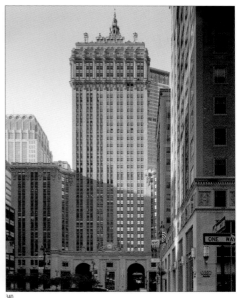

340

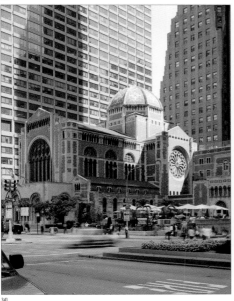

341

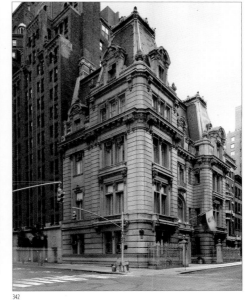

342

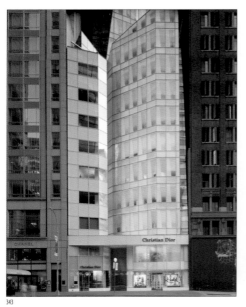

343

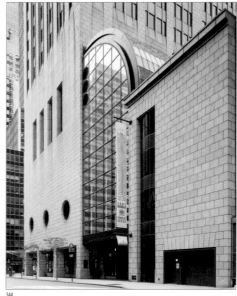

344

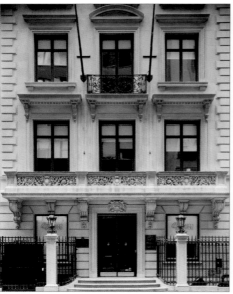

345

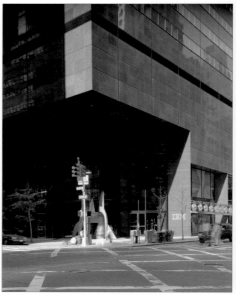

346

343

LVMH

19 East 57th Street
BETWEEN MADISON AND FIFTH AVENUES

1999, CHRISTIAN DE PORTZAMPARC

This building, which houses the offices of Louis Vuitton and Moet Hennessy, is among the most fascinating structures built in New York in recent decades. The folded panes of its sleek glass curtainwall provide a wonderful counterpoint to its more serious-minded neighbors. Like the products of its owners, the building's plan was imported from France, and nothing was lost in its translation to 57th Street.

344

SONY BUILDING

550 MADISON AVENUE
BETWEEN EAST 55TH AND EAST 56TH STREETS

1984, PHILIP JOHNSON AND JOHN BURGEE
SONY ENTERTAINMENT CENTER, 1994,
GWATHMEY SIEGEL & ASSOCIATES

When this building was built as AT&T's headquarters, all heads turned to its roof, which was adorned by what could only be described as a "Chippendale" pediment. But there is more to this building than that. Its stone cladding, the first seen in New York in some thirty years, was a welcome change from glass-walled structures.

345

BANCO DI NAPOLI

4 East 54th Street
BETWEEN FIFTH AND MADISON AVENUES

1900, MCKIM, MEAD & WHITE

Once the residence of William H. Moore, a Chicago lawyer and a founder of the National Biscuit Company and U.S. Steel, among other giant corporations, this house was built for millionaire playboy W. E. D. Stokes, who had married one of the great beauties of the day after falling in love with her photograph in a store window. Unfortunately, a few years after one of the most lavish weddings in New York's history, they were divorced before this, their dream house, was finished.

346

IBM BUILDING

590 MADISON AVENUE AT EAST 57TH STREET

1983, EDWARD LARRABEE BARNES ASSOCIATES

International Business Machines, the electronic equipment manufacturer headquartered in New York since 1924, moved to a building on this site in 1938. Although it later moved its headquarters to Armonk, in Westchester County, its New York City operations kept growing, making this larger building necessary. It includes an indoor park on the 57th Street side, connecting it with Nike Town and Trump Tower to its west.

CROWN BUILDING

347

730 FIFTH AVENUE AT WEST 57TH STREET

1921, WARREN & WETMORE

Originally the Hecksher Building and later the Genesco Building, this was the first tall office structure in the Fifth Avenue retail district and the first skyscraper built following the dictates of the 1916 zoning law, which set out unprecedented restrictions on the massing of such buildings. Its silhouette was intended to serve as a friendly backdrop to the Vanderbilt mansion, which stood on the opposite corner of West 57th Street.

FIFTH AVENUE PRESBYTERIAN CHURCH

348

705 FIFTH AVENUE AT WEST 55TH STREET

1875, CARL PFEIFFER

This is the third location of this church since its founding in the late eighteenth century, built to keep pace with the northward population migration. The church's plain brownstone façade doesn't prepare you for its wonderful Victorian Gothic sanctuary, constructed on two levels with no right angles.

TRUMP TOWER

349

725 FIFTH AVENUE AT EAST 56TH STREET

1983, DER SCUTT, WITH SWANKE, HADEN CONNELL

A multilevel shopping mall with high-end luxury apartments over the stores, the Trump Tower is very high on the list of must-see attractions among out-of-town visitors who are dazzled by the liveried attendants, the grand piano just inside the entrance, and the spectacular waterfall, as well as by the prices they encounter when they explore the shops themselves.

HENRI BENDEL ℒ

350

712 FIFTH AVENUE

1908, ADOLF S. GOTTLIEB
AND 714 FIFTH AVENUE, 1909, WOODRUFF LEEMING
COMBINED AND REDESIGNED, 1991, BEYER BLINDER BELLE

Long a fixture around the corner on West 57th Street, when Bendel's expanded and moved here, it discovered, to everyone's surprise, that the painted-over windows on the second floor of the uptown building they merged with were rare examples of glass by René Lalique.

ROCKEFELLER APARTMENTS ℒ

351

17 WEST 54TH STREET
BETWEEN FIFTH AND SIXTH AVENUES

1937, HARRISON & FOUILHOUX

Commissioned by Nelson Rockefeller, this pair of simple but elegant buildings filled some of the land still owned by the family after Rockefeller Center was built. The rest of the parcel was donated to the Museum of Modern Art and to the New York Public Library, which used its slice for the Donnell Library on West 53rd Street.

ST. THOMAS CHURCH ℒ
(EPISCOPAL)

352

FIFTH AVENUE AT WEST 53RD STREET

1913, CRAM, GOODHUE & FERGUSON

This limestone neo-Gothic building makes perfect use of its cramped corner site. Inside, the magnificent reredos behind the altar, among the city's best, regularly serves as a backdrop for St. Thomas' boys choir, arguably the best in America. A small doorway on the downtown side, next to the main entrance, is called "the bride's door," and is loosely identified by the scrollwork over it, to the right of the figure of Christ, in the form of a dollar sign.

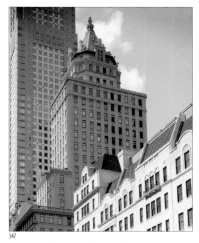

347

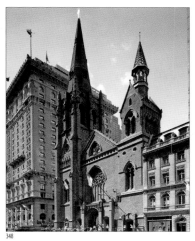

348

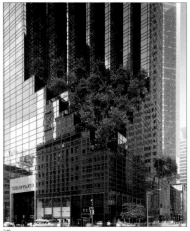

349

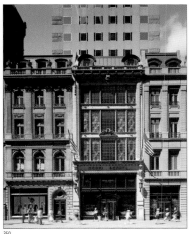

350

351

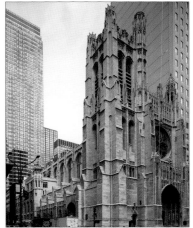

352

St. Regis-Sheraton Hotel

2 East 55th Street at Fifth Avenue

1904, Trowbridge & Livingston

The brassy doorman's shelter and the cab-call sign next to the entrance are just the beginning. The real treat is inside this luxurious hotel, among them Maxfield Parrish's mural of Old King Cole over the bar, moved here from the old Knickerbocker Hotel in Times Square. When this hotel was built, the area west of the lobby, now retail stores, was a grand dining room that opened onto the Fifth Avenue sidewalk in the warmer months.

Scribner's Bookstore ℒ

597 Fifth Avenue
between East 48th and East 49th Streets

1913, Ernest Flagg

The interior of this store has landmark status, which is why Benetton, the current occupant, has changed little here except the displays of merchandise. Charles Scribner's Sons, publishers of such authors as Ernest Hemingway and F. Scott Fitzgerald, was acquired by the Macmillan Company in 1984, and the wonderful bookstore it had operated here was closed.

University Club ℒ

One West 54th Street at Fifth Avenue

1899, Charles McKim of McKim, Mead & White

This High Renaissance Italian palazzo is nine stories tall, but it is divided into three equal parts by high arched windows to make it appear to be a three-story building, closer in scale to its Italian precedents. The lowest of the levels is the lounge, whose ceilings are visible from the sidewalk. The other two main sections house the library and the dining room. The building's focal point is its library that, at 13,000 volumes, is the largest collection of any private club in America.

Tiffany's

727 Fifth Avenue at East 57th Street

1940, Cross & Cross

This famous jeweler dismissed the retail trade's march up Fifth Avenue until 1940, when it moved from its former location in a McKim, Mead & White palace at 48th Street into this new granite and limestone structure. The nine-foot Atlas clock over the entrance, which became the company's trademark in 1853, has accompanied the company to six different locations. Created by Frederick Metzler, whose main business was carving figureheads for ships, the clock has earned a reputation over the years as the city's most accurate timepiece.

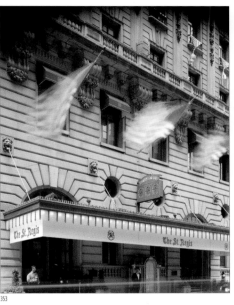

353

354

355

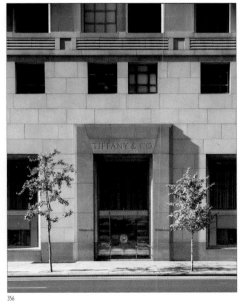

356

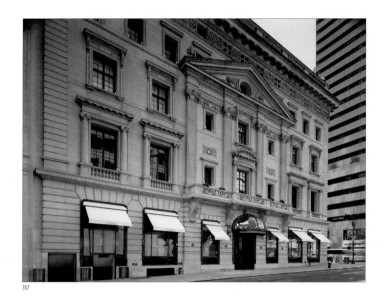

357

CARTIER'S 🔏

357

651 FIFTH AVENUE AT EAST 52ND STREET

1905, ROBERT W. GIBSON

The Vanderbilts once ruled these Fifth Avenue blocks with three elabrate mansions on its west side. To insure that commerce wouldn't intrude, William K. Vanderbilt sold the land at the corner of 52nd Street to fellow millionaire Morton F. Plant, with the stipulation that it be used for a residence for twenty-five years. After the Vanderbilts themselves moved on, Plant asked to have the covenant lifted. Instead, Vanderbilt bought the house for $1 million, much more than it was worth at the time, and rented it to Cartier's for $50,000 a year, far and away the highest rent anywhere on Fifth Avenue.

358

BRITISH EMPIRE BUILDING AND LA MAISON FRANÇAISE 🔏

610 AND 620 FIFTH AVENUE BETWEEN WEST 49TH AND WEST 50TH STREETS

1933, ASSOCIATED ARCHITECTS

Among John D. Rockefeller, Jr.'s goals in building Rockefeller Center was to encourage foreign trade and he built this pair of buildings for the British and French governments. The landscaped space between them, leading from Fifth Avenue down to the sunken plaza in front of the RCA Building, was called the "Channel Gardens." Gardens were a key part of the original plan for the complex, and the roofs of these two buildings, along with several of the others, are formally landscaped.

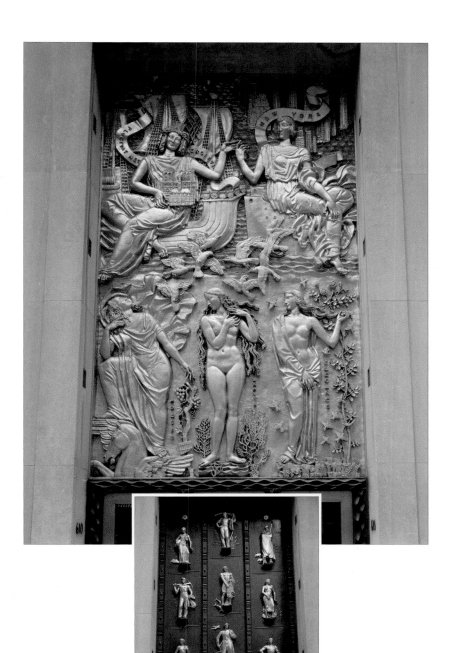

358

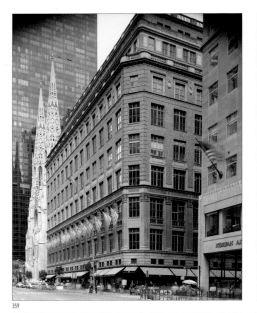

359

Saks Fifth Avenue

611 Fifth Avenue
between East 49th and East 50th Streets

1924, Starret & Van Vleck

Almost as soon as this giant department store was completed, its owner, Adam Gimbel, began redesigning it, first expanding its show windows along Fifth Avenue, and then hiring architect Frederick Kielser to design displays for them. It marked the first time that retailers did much more than haphazardly fill their windows with whatever happened to be on sale at the time. Naturally, other stores followed his lead, much to the delight of window-shoppers all over the city.

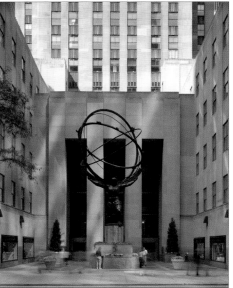

360

360

International Building

630 Fifth Avenue
between West 50th and West 51st Streets

1934, Associated Architects

Lee Lawrie's fifteen-foot bronze statue, *Atlas*, perfectly matches the form and function of the International Building. The sphere on the figure's shoulders is twenty-one feet in diameter and was made transparent because the artist didn't want it to obstruct views from the building or to cast unwanted shadows. Among Lee Lawrie's other contributions to Rockefeller Center are the limestone panels and glass screens over the entrance to 30 Rockefeller Plaza.

St. Patrick's Cathedral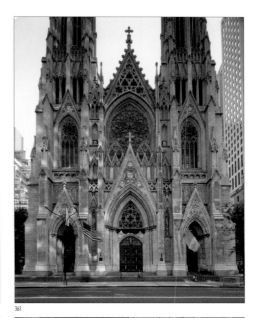
(Roman Catholic)

FIFTH AVENUE
BETWEEN EAST 50TH AND EAST 51ST STREETS

1878, JAMES RENWICK, JR.

The Catholic Church bought this plot of land in 1828 intending to use it as a cemetery, but the plan was abandoned when gravediggers hit solid rock just below the surface. In 1850, Archbishop John Hughes announced plans to build a cathedral here and work began eight years later. It was dedicated in another twenty-one years at a cost more than double the original estimate, but consecrated in 1910 completely debt-free. The Archbishop's (Cardinal's) Residence on the Madison Avenue side was finished in 1880 and the towers were put in place in 1888. The Lady Chapel behind the High Altar, designed by Charles T. Matthews, was added in 1906.

361

Associated Press Building

50 ROCKEFELLER PLAZA
BETWEEN WEST 50TH AND WEST 51ST STREETS

1938, ASSOCIATED ARCHITECTS

This is the home of the Associated Press, founded in 1848 to augment the newsgathering operations of several New York City newspapers. Today it serves more than 1,700 American newspapers and some 8,500 abroad. The stainless steel plaque over the entrance was created by sculptor Isamu Noguchi. Its overall theme is "the march of civilization," expressed by a group of five men with a reporter's notebook, a telephone, a camera, a wirephoto machine, and a teletype machine.

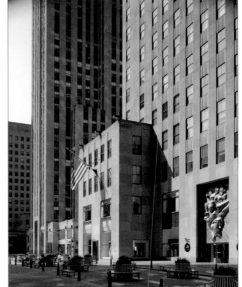

362

363
THE PLAZA HOTEL

GRAND ARMY PLAZA
FIFTH AVENUE AT 59TH STREET

1907, HENRY J. HARDENBERGH

The day this French Renaissance hotel opened in 1907, a line of automobiles gathered at the Fifth Avenue entrance to help the partygoers get home. They were New York's very first taxis, so-called because of a taxi-meter that recorded the time it took to get from here to there and how much the ride cost. In the years since, history has been made in all sorts of ways here, prompting a long-running advertising campaign that claimed, "Nothing Unimportant Ever Happens at the Plaza."

364
BERGDORF GOODMAN

FIFTH AVENUE
BETWEEN WEST 57TH AND WEST 58TH STREETS

1928, BUCHMAN & KAHN

The William K. Vanderbilt mansion, one of the most lavish in the city's history, originally stood on this site. After it was torn down in 1926, its elaborate wrought iron gates were moved up to the entrance of Central Park's Conservatory Gardens on Fifth Avenue at 105th Street. This complex is actually seven different buildings joined by an arcade and a common façade, built to serve a variety of retail operations. Its principal tenant is Bergdorf Goodman, a women's specialty shop. In its early days, no merchandise was displayed in the individual salons. After a customer made her wishes known, the garments were displayed for her on living models.

365
GENERAL MOTORS BUILDING

767 FIFTH AVENUE
BETWEEN EAST 58TH AND EAST 59TH STREETS

1968, EDWARD DURRELL STONE

This was the site of the elegant Savoy Plaza Hotel, demolished to make way for a massive office building. Among its attractions is the F. A. O. Schwarz toy store and the windowed studios used for CBS's early-morning television show. It was recently remodeled by the ubiquitous Donald Trump, who created condominium offices inside and covered the useless plaza below the Fifth Avenue sidewalk.

366
ALGONQUIN HOTEL

59–61 WEST 44TH STREET
BETWEEN FIFTH AND SIXTH AVENUES

1902, GOLDWIN STARRETT

Decorated with comfortable eighteenth-century English and American furnishings, this hotel has always been a center of literary and theatrical life. It is most famous as the meeting place of the Algonquin Roundtable, a group of intellectuals who met here for lunch every day in the 1920s and traded witticisms and insults well into the afternoon. The group included newspaper columnists like Franklin P. Adams, and magazine writers such as Dorothy Parker and Robert Benchley. Actors and other artists, Douglas Fairbanks and Harpo Marx among them, were often invited to match wits with the regulars.

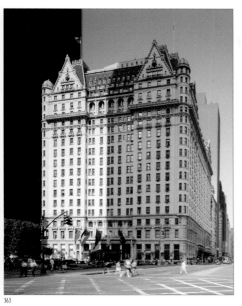

363

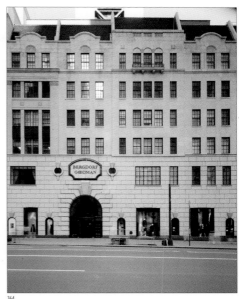

364

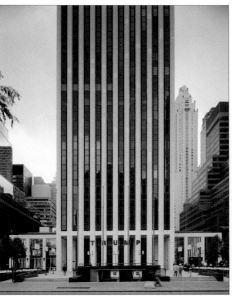

365

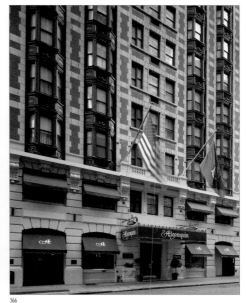

366

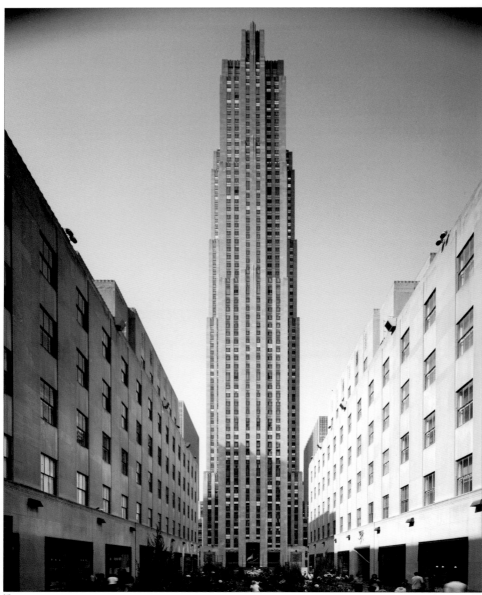

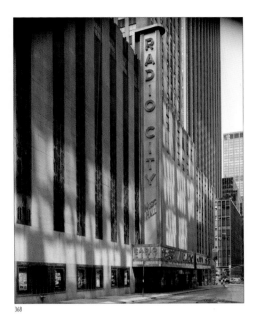

368

RCA Building 𝓛

30 Rockefeller Plaza
between West 49th and West 50th Streets

1933, Associated Architects

In 1929, after he had assembled parcels of land extending from 48th to 51st Streets between Fifth and Sixth Avenues as a site for the new home of the Metropolitan Opera, John D. Rockefeller, Jr. was informed that the Great Depression had made it impossible for the opera company to move, and he was stuck with all that property, whose value was profoundly compromised. His response was to build this complex of office buildings, stores, and theaters. Its centerpiece is this monumental skyscraper, leased to the Radio Corporation of America, owner of, among other things, the National Broadcasting Company, whose studios and offices are in this building. RCA was acquired by General Electric in 1986, and the building's name was officially changed to the GE Building.

Radio City Music Hall 𝓛

Sixth Avenue at 50th Street

1932, Samuel ("Roxy") Rothafel

This 6,200-seat temple to the performing arts was originally intended to be a variety playhouse, but when ticket-buyers didn't respond, it was quickly transformed into a movie theater with stage shows. Because of its reputation for family entertainment, the decline in the quality of films that could be shown here resulted in an announcement in 1978 that the Rockettes had kicked up their heels for the last time and the theater would be torn down. It was saved in the nick of time by the state's Urban Development Corporation, has undergone extensive renovation, and although movies with stage shows are a thing of the past, it still presents traditional Easter and Christmas shows, live rock concerts, and similar events.

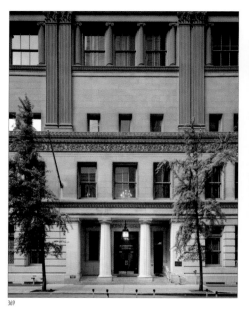

369

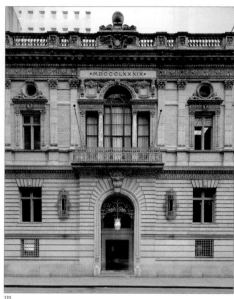

370

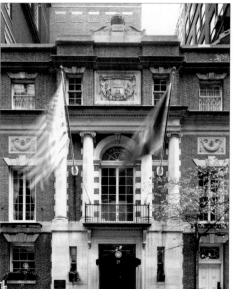

371

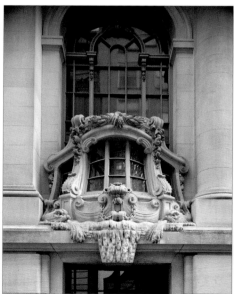

372

ASSOCIATION OF THE BAR OF THE CITY OF NEW YORK

42 WEST 44TH STREET
BETWEEN FIFTH AND SIXTH AVENUES

1896, CYRUS L. W. EIDLITZ

Organized in 1870 by lawyers who were shocked by the excesses of Tammany Hall and its boss, William Marcy Tweed, the association's original membership went through rigid screening and was charged high fees to ensure that only the best lawyers in town were represented. By the time it moved here in 1896, the association was still an exclusive club with about 1,400 members, however, today, about a third of the lawyers in the city are members. They are free to use the impressive reference library, which contains nearly half a million books.

CENTURY ASSOCIATION CLUBHOUSE

7 WEST 43RD STREET
BETWEEN FIFTH AND SIXTH AVENUES

1891, MCKIM, MEAD & WHITE

A club dedicated to the advancement of the arts, this palace represents a collaboration between Stanford White and his partner, Charles F. McKim. Older members were opposed to the $150,000 cost of the land here, and appalled by the $160,000 fee charged by their fellow members to design the building. But the annual dues only went up $15 a year, to $50, and membership began to grow by leaps and bounds. The only negative note was that the association was closed to women, and society decorator Elsie de Wolfe, who could have used the connections, was forbidden to go beyond the gallery in the entrance hall.

HARVARD CLUB

27 WEST 44TH STREET
BETWEEN FIFTH AND SIXTH AVENUES

1915, MCKIM, MEAD & WHITE

This Colonial Revival structure is intended to recall the early buildings on the campus of Harvard University in Cambridge, Massachusetts. Charles F. McKim, the principal architect, had studied at Harvard and later designed several of its buildings. He specified dark red "Harvard brick" for this New York outpost, built for the university's alumni. The view of the second-floor interior through the high windows on the 45th Street side are well worth a walk around the corner.

NEW YORK YACHT CLUB

37 WEST 44TH STREET
BETWEEN FIFTH AND SIXTH AVENUES

1900, WARREN & WETMORE

This is a club for well-heeled gentleman sailors and yachtsmen. At the time it was built, its members ran a fleet of more than 150 ocean-worthy sailboats and an equal number of steam-powered yachts. The roster included William K. Vanderbilt's 312-foot Valiant and J.P. Morgan's 304-foot Corsair II. The club held, and successfully defended, the America's Cup from 1851, before finally losing it to an Australian vessel in 1983. The bay windows were designed to resemble the sterns of ships that Dutch seamen originally called "jachts."

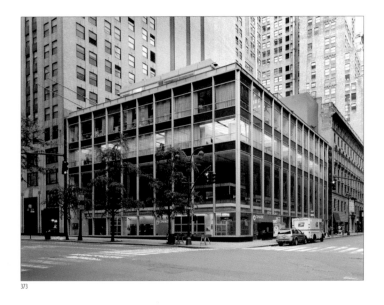

373

MANUFACTURERS TRUST COMPANY

373

510 FIFTH AVENUE AT WEST 43RD STREET

1954, GORDON BUNSCHAFT
OF SKIDMORE, OWINGS & MERRILL

Now a branch of the Chase Manhattan Bank, this glass building represented a breakthrough in bank design and on the day it opened, 15,000 people went through its doors for a better look at what they could easily see from the sidewalk. Bank officials claimed that this new image took them away from an era when security was the most important message into one that made them appear more friendly and open. But to cover their bets, they also installed a highly visible safe deposit vault in the front window. Proof that the new look could be profitable, more depositors opened new accounts in its first year here than at any of the bank's branches during any year in the bank's history.

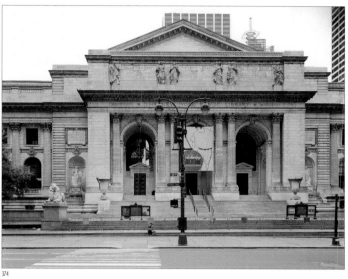

374

New York Public Library

FIFTH AVENUE
BETWEEN WEST 40TH AND WEST 42ND STREETS

1911, CARRÈRE & HASTINGS

One of the world's most important libraries is housed in one of the city's most impressive buildings, a Beaux-Arts masterpiece inside and out. Its collection contains some 49.5 million items, including more than 18 million books. None of it is allowed to leave the building, but materials can be examined by selecting an item from a computerized data base. The volume is retrieved from underground stacks and delivered in minutes. Library cardholders (anyone who lives, works, or is a student in New York State is eligible) can borrow items from eighty branches. Those lions lounging on the steps are by Edward C. Potter, who also fashioned the lionesses outside the Morgan Library.

AMERICAN STANDARD BUILDING ℒ

40 WEST 40TH STREET
BETWEEN FIFTH AND SIXTH AVENUES

1924, HOOD & FOUILHOUX

Originally the American Radiator Building, this is now the Bryant Park Hotel. It is a simple but powerful design in black and gold by the master, Raymond Hood, who had supported himself in his early career by designing radiator covers for the company then known as the American Radiator and Standard Sanitary Company. He apparently liked his former employer because when the company commissioned this building as a showroom and offices, Hood never batted an eye at their demand that it be designed and constructed in thirteen months. After delivering on their demand, he said that, "I had exactly the sort of client an architect desires."

HSBC BANK TOWER

452 FIFTH AVENUE AT 40TH STREET (ℒ)

1983, ATTIA & PERKINS
INCORPORATING THE KNOX HAT BUILDING,
1902, JOHN H. DUNCAN

If New York men wear a hat at all, it is usually a baseball cap. But that hasn't always been the case, and at the turn of the last century, enough of them bought headgear to make men like Edward M. Knox able to afford impressive buildings like this one for their showrooms. New York was the country's largest supplier of men's hats in the early nineteenth century, and Knox was at the top of the heap with factories in Brooklyn and lower Manhattan, whose output was exported all over the world. His former store and the tower that encloses it was redeveloped by Republic National Bank and is now occupied by its successor, HSBC.

390 FIFTH AVENUE ℒ

AT 36TH STREET

1906, MCKIM, MEAD & WHITE

One of several Classical emporiums along this stretch of Fifth Avenue, this building was the home of Gorgam Silversmiths, the first company to sell sterling silver in America. Like most Fifth Avenue retailers, the company moved here from Broadway in the teens, the district known as "Ladies' Mile." It was replaced at this location by Russeks, a furrier, which kept the building intact. Unfortunately, that can't be said for the current occupants.

GERARD APARTMENTS ℒ

123 WEST 44TH STREET
BETWEEN SIXTH AND SEVENTH AVENUES

1894, GEORGE KEISTER

In 1893, Charles Frohman built the Empire Theater on Broadway at 41st Street, and the area above it, then called Longacre Square, became the new theater district. This apartment hotel, originally called the Hotel Gerard, was among the first, and certainly the tallest, to take advantage of the trend. Before its name was changed to Gerard Apartments, it was known as the 1-2-3 Hotel, and better known for its ground-floor restaurant, Café Un-Deux-Trois. The building's gables, dormers, and bow windows make it one of the best shows in the Theater District.

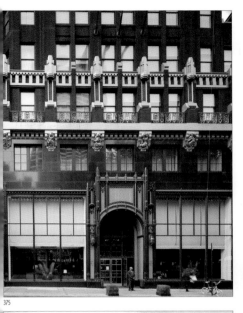

375

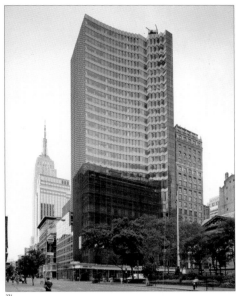

376

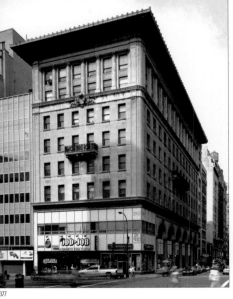

377

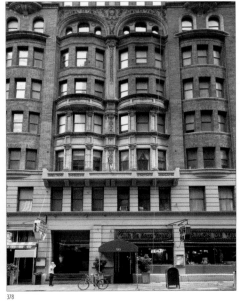

378

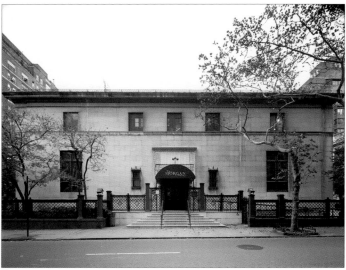

379

Pierpont Morgan Library *ℒ*

33 East 36th Street
between Park and Madison Avenues

1906, McKim, Mead & White

J. P. Morgan was one of the most active art collectors of his time. Both his house at 36th Street and Madison Avenue and his house in London were overflowing, so in order to consolidate his collection of rare books and priceless manuscripts, he built this wondertful building in what had been a garden behind his house. The exterior is made from blocks of stone laid without mortar, fitted so closely together that a knife blade couldn't be inserted between them. The interior contains three grand rooms: an elaborate entrance rotunda, a library to its east lined with three tiers of books, and Morgan's study on the west side. It was Morgan's intention that his library would make his collection permanently available for "the pleasure of the American people," and this core building is exactly as he left it.

Empire State Building *ℒ*

350 Fifth Avenue
between West 33rd and West 34th Streets

1931, Shreve, Lamb & Harmon

Although its height of 1,250 feet no longer qualifies it as the world's tallest building, this tower still offers the best skyscraper views in this or any other city. It was dedicated at the height of the Great Depression and its 2 million square feet of space remained half empty for a dozen years, until wartime prosperity helped fill the empty offices. Officially, the Empire State Building is 102 stories tall, but only eighty-five floors are rentable commercial space. The rest is an observation deck and a cupola that was intended for use as a mooring mast for dirigibles, and served as a perch for the great ape, "King Kong," in the movie of the same name.

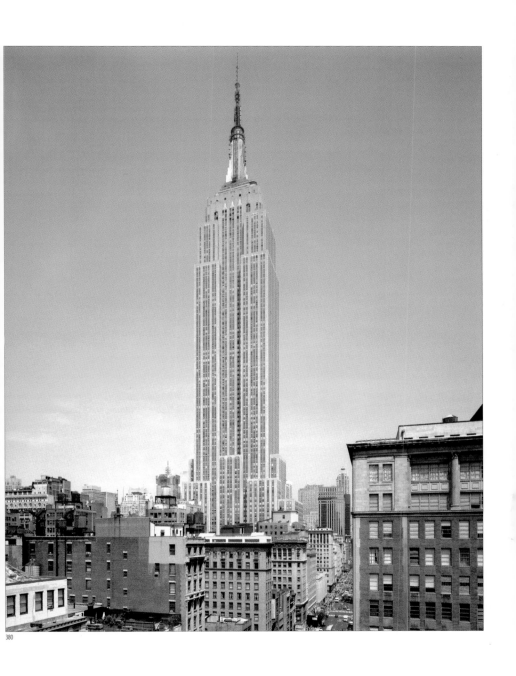

380

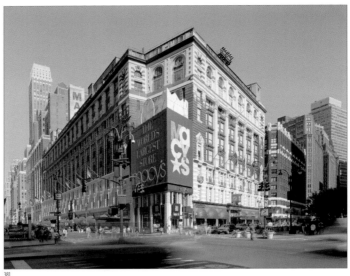

381

Macy's

34TH–35TH STREETS
BETWEEN BROADWAY AND SEVENTH AVENUE

BROADWAY BUILDING, 1902, DE LEMOS & CORDES
ADDITIONS, 1924–31, ROBERT D. KOHN

The original department store building, whose entrance on Broadway forms the backdrop at the end of Macy's Thanksgiving Day Parade, contains 800,000 square feet of space, but as other department stores began expanding, the company built a 400,000 square-foot addition so as to maintain its status as the "World's Largest Store." It might have been a bit bigger, but the store's major competitor, Henry Siegel, secretly bought a thirty- by fifty-foot plot on the 34th Street corner and built a thriving little store there. After all these years, that plot is still not owned by Macy's, but the store leases space on the roof for a giant billboard directing customers to its entrances around the corner.

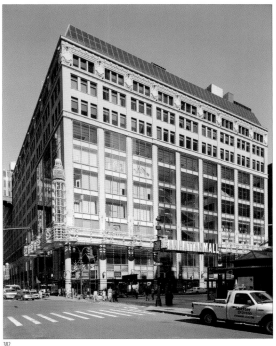

382

382

MANHATTAN MALL

1275 BROADWAY
BETWEEN WEST 32ND AND WEST 33RD STREETS

1912, D. H. BURNHAM & CO.
CONVERTED, 1989, RTKL ASSOCIATES

When Gimbel's department store closed its doors here in 1986, the suburbs moved in. The store's original building was gutted and enclosed in glass, then hung with garish electric signs to create a multi-level shopping mall complete with a "food court" on the top floor. Among the reminders of the original store is a fascinating two-level bridge across 32nd Street that once served to move merchandise across from a receiving facility housed in a separate building. The store's upper three stories are also relatively intact as a kind of memorial to better days in Greeley Square.

383

COLLECTOR'S CLUB 𝓛

22 EAST 35TH STREET
BETWEEN MADISON AND PARK AVENUES

1902, McKIM, MEAD & WHITE

This elegant Georgian townhouse with medieval bow windows was built for Thomas B. Clarke, an art dealer and collector. It was sold to the Collector's Club, whose members are generally more interested in stamps than art, in 1937.

384

CHURCH OF THE INCARNATION 𝓛
(EPISCOPAL)

205 MADISON AVENUE AT 35TH STREET

1864, EMLEN T. LITTEL

This church building contains some of the most important ecclesiastical art in the country, including stained glass windows by William Morris and Louis Comfort Tiffany, sculpture by Augustus Saint-Gaudens and Daniel Chester French, and murals by John La Farge.

385

HOTEL MARTINIQUE 𝓛

53 WEST 32ND STREET AT BROADWAY

1900, HENRY J. HARDENBERGH

A Holiday Inn by the architect of the original Waldorf-Astoria and Plaza Hotels, this opulent building was converted into a homeless shelter before being returned to use as an urban motel. It was originally one of several hotels in the neighborhood that thrived during the days of rail travel, when visitors arrived at nearby Pennsylvania Station and didn't want to wander too far to find a place to sleep.

386

W.R. GRACE BUILDING

1114 SIXTH AVENUE AT WEST 43RD STREET

1974, SKIDMORE, OWINGS & MERRILL

Designed by the master architect Gordon Bunshaft, this building will never qualify as a masterpiece. It doesn't hold a candle to the same firm's 9 West 57th Street, both of which get around the zoning laws with a sloping façade rather than setbacks. The Grace Building, which replaced the Stern Brothers department store, took advantage of zoning requirements to get a Sixth Avenue address by including a rather dull plaza behind it.

387

BRYANT PARK STUDIOS

80 WEST 40TH STREET AT SIXTH AVENUE

1902, CHARLES A. RICH

These days, the word "studio" defines a one-room apartment, but a century ago it meant double-height apartments with huge windows like the ones in this building, built to catch the north light from Bryant Park across the street. Built for painter A. A. Anderson, who had just come home from Paris, it included space for other artists like himself to live and work, but his own apartment was the most lavish of them all, filled with exotic architectural details to be used as backgrounds for the portraits that were his specialty.

388

THE LAMB'S CLUB 𝓛

130 WEST 44TH STREET
BETWEEN SIXTH AND SEVENTH AVENUES

1905, McKIM, MEAD & WHITE

Now the Manhattan Church of the Nazarene and the Lamb's Theater, this clubhouse was built for the actors' fraternity. The group, founded in 1874, is still active and holds its meetings, which it calls "lambastes," at the Women's National Republican Club on 51st Street across from Rockefeller Center.

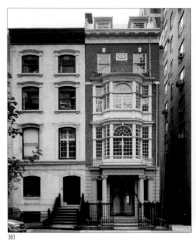

383

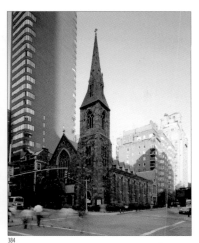

384

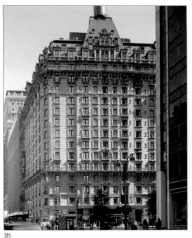

385

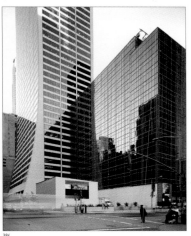

386

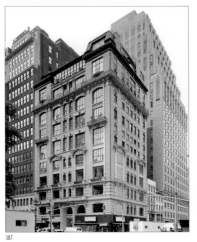

387

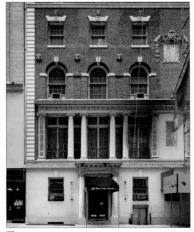

388

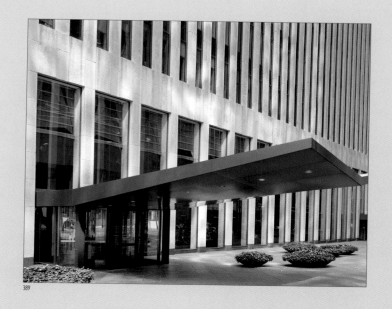

389

A Rose by Any Other Name

*After the Sixth Avenue elevated line was torn down in
1939, the city's visionaries began making plans to turn the
now sun-splashed avenue into an international trading
zone. Mayor Fiorello LaGuardia put his stamp of approval
on the idea by changing the name of Sixth Avenue to
Avenue of the Americas, in hopes of attracting Latin
American businesses, but not much else was done to push
the idea forward. To this day, not even native New Yorkers
have accepted the new name, and they go right on calling
it Sixth Avenue. As Mayor LaGuardia had himself pointed
out, "When I make a mistake, it's a beaut!"*

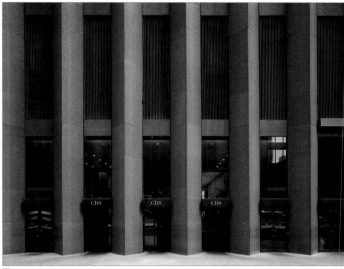

390

EXXON BUILDING

1251 SIXTH AVENUE
BETWEEN WEST 49TH AND WEST 50TH STREETS

1971, HARRISON, ABRAMOVITZ & HARRIS

After Rockefeller Center began expanding westward in the 1960s, the swath along Sixth Avenue changed dramatically from 47th to 51st Streets with overpowering buildings, some of which rise above useless plazas below the sidewalk level. This was the second of the buildings in Rockefeller Center East, after the Time-Life Building on the other side of 50th Street. The fifty-four-story building, with 2.1 million square feet of space, replaced several smaller ones, including a hotel and fourteen restaurants.

CBS BUILDING

51 WEST 52ND STREET AT SIXTH AVENUE

1965, EERO SAARINEN & ASSOCIATES

Placed in the center of the site above a plaza, this building soars thirty-eight stories without a single setback. The 490-foot tower was one of New York's first skyscrapers built in reinforced concrete rather than around a steel frame, which allowed Saarinen to alternate the structural columns with deep-set gray-tinted glass, giving the building a feeling of solidity that earned its nickname, "Black Rock." Its interiors were as carefully designed as the exterior, and when the Columbia Broadcasting System moved here from its former home at 485 Madison Avenue, its chairman, William S. Paley, decreed that employees were forbidden to decorate their desks with personal photographs or their children's artwork. Art on the walls and in the corridors was all selected by the decorator and nothing else was permitted. All desks, each of which had a company-approved ashtray but little else, were to be swept clean of work-related materials at the end of the business day.

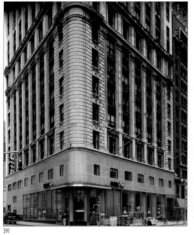

391

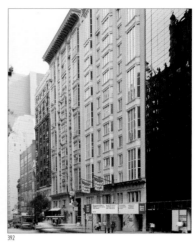

392

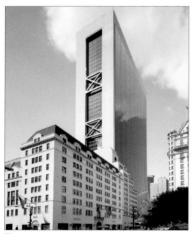

393

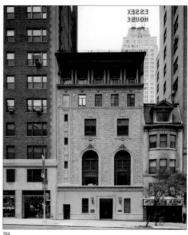

394

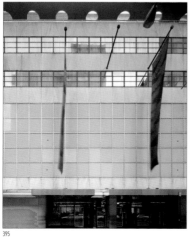

395

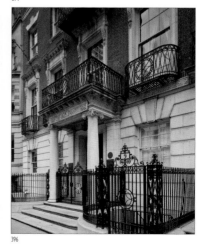

396

MUTUAL OF NEW YORK INSURANCE COMPANY BUILDING

391

1740 BROADWAY
BETWEEN WEST 55TH AND WEST 56TH STREETS

1950, SHREVE, LAMB & HARMON

This building's main attraction, for those in the know, is the high mast on the roof, which reveals the time, temperature, and a weather forecast all in one quick glance. If the star on top is green, it's going to be a nice day, but if it is white, expect snow. A moving ribbon of light on the mast itself predicts rising or falling temperatures. The building was originally designed before World War II, but its plans were put on hold for the war's duration.

130 WEST 57TH STREET

392

BETWEEN SIXTH AND SEVENTH AVENUES

1908, POLLARD & STEINEM

This apartment building was designed as artists' studios, with a grand array of bay windows, and matches its next-door neighbor, also designed by Pollard & Steinem, and also a landmark.

9 WEST 57TH STREET

393

BETWEEN FIFTH AND SIXTH AVENUES

1974, SKIDMORE, OWINGS & MERRILL

Designed by Gordon Bunshaft, this swooping, tapered shaft was created to comply with zoning laws while avoiding conventional setbacks. It was castigated by architecture critics, who called it everything from a glass ski jump to a "bell-bottom building." But its owner, Sheldon Solow, didn't care a bit because even before construction had begun, he had already leased 500,000 square feet of it to Avon Products.

COLUMBIA ARTISTS MANAGEMENT

394

165 WEST 57TH STREET
BETWEEN SIXTH AND SEVENTH AVENUES

1917, GEORGE AND HENRY BOEHM

Originally a school of dance operated by Louis H. Chalif, this concert and recital space is known as CAMI Hall, and provides a showcase for the clients of the musicians' talent agency, Columbia Artists Management.

MUSEUM OF MODERN ART

395

11 WEST 53RD STREET
BETWEEN FIFTH AND SIXTH AVENUES

1939, PHILIP GOODWIN AND EDWARD DURELL STONE

This is one of New York's best buildings in the International style, which was introduced to America, and the world, at one of its own exhibitions in 1912. Housing one of the world's most important collections of modern art, the museum owns paintings by such giants as Picasso, Van Gogh, Matisse, and Monet, as well as sculpture by Constantine Brancusi, Henry Moore, and Alexander Calder.

U.S. TRUST COMPANY

396

9–11 WEST 54TH STREET
BETWEEN FIFTH AND SIXTH AVENUES

1898, McKIM, MEAD & WHITE

Built as a residence for James Junius Goodwin, whose business partner was J. P. Morgan, this double house is one of the best examples of a Colonial Revival house ever designed by McKim, Mead & White, who were the acknowledged masters of the style. The buildings were sensitively converted into a bank in 1981, by the architectural firm of Haines, Lundberg, Waehler.

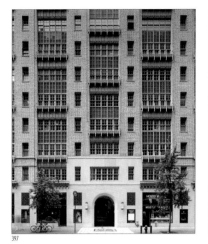

397

RODIN STUDIOS ℒ

200 WEST 57TH STREET
BETWEEN SEVENTH AVENUE AND BROADWAY

1917, CASS GILBERT

This former artists' studio apartment building is now used as office space. Its French Gothic façade tips its hat to the Art Students League across the street, and is also a smaller cousin to the same architect's Woolworth Building.

397

398

NEW YORK ATHLETIC CLUB

CENTRAL PARK SOUTH AT SEVENTH AVENUE

1930, YORK & SAWYER

Along with 300 bedrooms, meeting rooms, and dining rooms, this twenty-one-story limestone Renaissance clubhouse has gymnasiums, squash and handball courts, a running track, and a swimming pool on the fourth floor directly above the lobby. Its 500-seat main dining room on the tenth floor includes a west-facing loggia for alfresco dining. The tower contains a solarium with views in every direction through quartz-glass windows.

398

399

RUSSIAN TEA ROOM

150 WEST 57TH STREET
BETWEEN SIXTH AND SEVENTH AVENUES

FAÇADE 1873, JOHN G. PRAGUE,
ALTERED, 1927 AND 2000, HARMAN JABLIN ARCHITECTS

This restaurant, which former owner Faith Stewart-Gordon advertised as "slightly to the left of Carnegie Hall," began its life as a meeting place for Russian emigrés. Its original decor evoked a pre-revolutionary Russian Christmas. After the flamboyant restaurateur Warner LeRoy bought the place, he hired Harman Jablin Architects to make it into an attraction as unique as his Tavern on the Green.

399

400
ART STUDENTS LEAGUE ℒ

215 WEST 57TH STREET
BETWEEN BROADWAY AND SEVENTH AVENUE

1892, HENRY J. HARDENBURGH

This was the first headquarters of the American Fine Arts Society, which it funded through an agreement with the Art Students League and the Architectural League to share exhibition space. Once it opened, it became the scene of every major art and architectural exhibition held in the city.

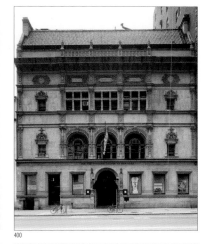

400

401
ALWYN COURT ℒ

180 WEST 58TH STREET AT SEVENTH AVENUE

1909, HARDE & SHORT
RESTORATION, 1981, BEYER BLINDER BELLE

This apartment building's façade is covered with elaborately carved terra-cotta panels designed to lure tenants who weren't so sure they wanted to abandon apartment hotels. It incorporated all the trappings of hotel living, if not the services, including expensive wood paneling in all of its fourteen-room units. Each offered five baths and a central vacuum cleaning system, but the biggest incentive was closet space. Even hotels didn't have that.

401

402
CARNEGIE HALL ℒ

156 WEST 57TH STREET AT SEVENTH AVENUE

1891, WILLIAM B. TUTHILL

Built by steel magnate Andrew Carnegie as a home for the Oratorio Society, the New York Philharmonic's opening night concert here was conducted by Pyotr Ilich Tchaikovsky. One of the most acoustically perfect concert halls in the world, it was nearly demolished after the Philharmonic moved up to Lincoln Center, but was saved by violinist Isaac Stern and others who convinced the city to buy it.

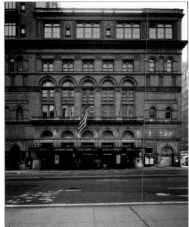

402

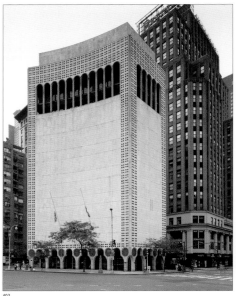

403

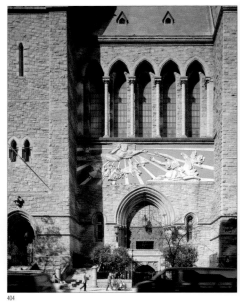

404

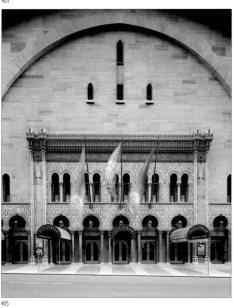

405

406

403

GALLERY OF MODERN ART

2 COLUMBUS CIRCLE
BETWEEN BROADWAY AND EIGHTH AVENUE

1965, EDWARD DURRELL STONE

This marble building, reviled by many for its stark and eccentric exterior, was built to house an art gallery funded by Huntington Hartford, was bought by the Gulf+Western Company, whose offices overlooked it across Columbus Circle, and who donated it to the city as an office for the Department of Cultural Affairs. Now that both G+W and Cultural Affairs have moved on, this gleaming structure's future is uncertain.

404

CHURCH OF ST. PAUL THE APOSTLE
(ROMAN CATHOLIC)

COLUMBUS AVENUE AT 60TH STREET

1885, JEREMIAH O'ROURKE

In order for a church building to qualify as a cathedral, it must have a "cathedra," the seat of a bishop. This church, built for the Paulist Fathers, doesn't have one, which makes it a basilica, although it is much bigger than many cathedrals. Its interior is embellished with the work of Stanford White, John La Farge, and Bertram Goodhue.

405

CITY CENTER 55TH STREET THEATER

135 WEST 55TH STREET
BETWEEN SIXTH AND SEVENTH AVENUES

1924, H. P. KNOWLES

This was originally the Mecca Temple of the Masonic Ancient and Accepted Order of Nobles of the Mystic Shrine, which helps explain its Moorish architectural style. The city turned it into a performing arts center in the early 1940s, and it became home to the New York City Ballet and the New York City Opera. After they were moved to Lincoln Center, it became a leading venue for a variety of dance companies. The sixty-nine-story tower next door, called CitySpire, was built using air rights from this building, making it solvent for years to come.

406

SHERATON CENTER

SEVENTH AVENUE
BETWEEN WEST 52ND AND WEST 53RD STREETS

1962, MORRIS LAPIDUS & ASSOCIATES

When it was built as the Americana Hotel, this was the biggest reinforced-concrete structure in New York. It replaced the massive, Italianate Manhattan Storage and Warehouse building that had stood here for more than sixty-five years. Sheraton also operates the former City Squire motel on the other side of Seventh Avenue, which adds to its presence as a hotel district at the edge of Times Square.

407

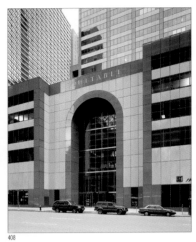

408

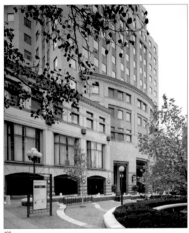

409

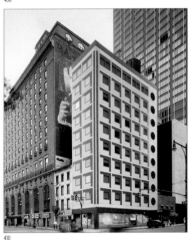

410

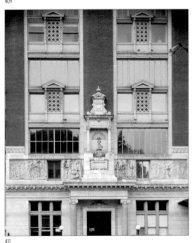

411

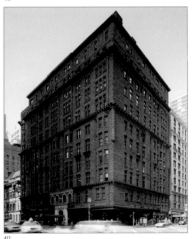

412

BRILL BUILDING

1619 BROADWAY, BETWEEN WEST 49TH AND 50TH STREETS

1931

This building, which for many years housed Jack Dempsey's restaurant, was the ultimate location of Tin Pan Alley, an aggregation of music publishers and song writers that blossomed on West 28th Street between Broadway and Sixth Avenue in the 1890s. It earned its name from the tinny sound of pianos being played by song-pluggers trying to sell sheet music. The business, which kept New York at the forefront of popular music for nearly a century, faded in the 1960s with the advent of rock 'n' roll.

EQUITABLE CENTER

787 SEVENTH AVENUE
BETWEEN WEST 51ST AND WEST 52ND STREETS

1986, EDWARD LARRABEE BARNES ASSOCIATES

A huge public atrium dominated by a Roy Lichtenstein mural and a sculpture-filled galleria make this office building a sensitive neighbor to nearby Rockefeller Center. It was designed by the same architects as the former Union Carbide Building (now J. P. Morgan Chase) on Park Avenue, built at the same time, and the buildings bear striking similarities.

WORLDWIDE PLAZA

EIGHTH TO NINTH AVENUES
WEST 49TH TO WEST 50TH STREETS

1989, SKIDMORE, OWINGS & MERRILL

Built on the site of the second incarnation of Madison Square Garden, this complex of office and apartment buildings was the subject of a Public Television documentary exploring the problems of building construction, and there were plenty of them as these massive buildings went up, covering an entire city block. The site was a parking lot for more than twenty years before the project got underway.

830 EIGHTH AVENUE

AT WEST 50TH STREET

Long before World Wide Plaza was built across the avenue, this tiny plot was a valuable piece of real estate because of its location in sight of Madison Square Garden. The building went up during the long period when the Garden site was a parking lot, and presumably the land's value had dropped. But it's still no excuse for anything as banal as 830 Eighth Avenue, which looks like it was built from pieces of a children's construction set.

GAINSBOROUGH STUDIOS 𝓛

222 CENTRAL PARK SOUTH
BETWEEN BROADWAY AND SEVENTH AVENUE

1908, CHARLES W. BUCKHAM

In the early twentieth century, when apartment houses first sprang up in the city, artists were usually forbidden to work in them and had to rent separate studios. A host of buildings with high-ceilinged duplexes and north-facing windows accomodated them, and this was the most elegant of them all. The bust of Sir Thomas Gainsborough over the door indicated that serious creativity was possible with the landlord's blessing.

THE OSBORNE 𝓛

205 WEST 57TH STREET AT SEVENTH AVENUE

1899, JAMES E. WARE

Don't let the heavy-handed stone exterior fool you, it's the interiors that matter here, and you can get a taste of its luxurious detail with a peek into the lobby through the front door. This was one of several early apartment houses built on standard-size city lots, and all of them suffered from cramming too much into too little space. In spite of their touches of elegance, they were often shrugged off as "tenements for the rich."

413

ONE TIMES SQUARE

WEST 42ND STREET
BETWEEN BROADWAY AND SEVENTH AVENUE

1905, CYRUS L. W. EIDLITZ

Spend a couple of minutes in Times Square and you're sure to hear someone say, "That's where they drop the ball on New Year's Eve." Yes, it is. They've been doing it every year since 1904, when *The New York Times* first moved into this building. The *Times* relocated around the corner to West 43rd Street in 1913, but didn't sell the building to Allied Chemical until forty-three years later. The new owner stripped its limestone façade and replaced it with marble, nearly all of which is now hidden behind super billboards that bring in more rent than the office space inside. There are two subcellars under the subway station here that once housed the paper's presses, but almost nobody remembers that they are down there.

The Great White Way

Electric advertising signs arrived in New York in 1891, when flashing lights on a building at Madison Square announced the opening of a housing development at Brooklyn's Manhattan Beach. By 1918, they had come to be regarded as an eyesore, and the city passed a law restricting outdoor advertising to non-residential neighborhoods. But even by then, Times Square was already filled with what advertisers called "spectaculars," and before long, it was so brightly lit that it became known as "The Great White Way."

Although citizens' groups still railed against the garish signs, the City Fathers turned a blind eye to them until 1992, when the state legislature passed a law requiring more of them. Officials in both New York and Albany had been wrestling with the problem of what to do to stem the decay of Times Square for more than fifteen years, and by the time they had what seemed to be a workable plan in place, the office market went sour, and developers tried to abandon their commitment. The lawmakers agreed to let them off the hook in return for a promise to attract new retail and entertainment businesses to the area. The hardest part of the agreement, as far as the developers were concerned, was a new law that required at least one illuminated sign of no less than 1,000 square feet for every fifty feet of building frontage along Broadway and Seventh Avenue, between 42nd and 50th Streets. The builders were angry at first, because their dream included attracting financial institutions into the neighborhood they had always shunned, and they believed that bankers would balk at all the glitz. What they didn't realize, but found out quickly enough, was that the rent for the advertising space could bring in more money than the office space did. And they never would have predicted that the biggest sign of all is outside the Nasdaq Exchange—right in the middle of Times Square.

MARIOTT MARQUIS HOTEL

1531–1549 BROADWAY
BETWEEN WEST 45TH AND WEST 46TH STREETS

1985, JOHN PORTMAN

It is generally conceded that out-of-towners make the best New Yorkers, but this building seems to be an exception to the rule. John Portman, fresh from his successes in Atlanta and Chicago, built this hotel without a thought to the fact that New Yorkers are pedestrians, and the entrance is set well back off the street across automobile driveways. The lobby is on the eighth floor, but the ride up there in glass-enclosed elevators makes up for the inconvenience.

REUTERS BUILDING

3 TIMES SQUARE
BETWEEN WEST 42ND AND WEST 43RD STREETS

2001, FOX & FOWLE

The corner of Seventh Avenue and 42nd Street was once the site of the Victoria Theater where showman Willie Hammerstein promoted such attractions as the Cherry Sisters, which he billed a "the world's worst act." After architect Stanford White was shot dead over the affections of showgirl Evelyn Nesbitt, Hammerstein paid her $3,500 a week to appear on his stage here as "The Girl in the Red Velvet Swing." Today the site is the home of one of the world's largest news-gathering organizations.

ABC STUDIOS

1500 BROADWAY, BETWEEN 43RD AND 44TH STREETS

ALTERED, 1999

This building, whose lower floors are covered with miles of neon and digital message boards, was originally the Claridge Hotel, used as a location for the film, *Midnight Cowboy*. Its Broadway façade was once adorned by a huge sign advertising Camel cigarettes that featured a man continuously blowing smoke rings onto the street below. These days, its sidewalks are filled every morning with people hoping a camera will catch them watching a broadcast of ABC's *Good Morning America*.

ASTOR PLAZA

1515 BROADWAY
BETWEEN WEST 44TH AND WEST 45TH STREETS

1970, KAHN & JACOBS, WITH DER SCUTT

Those crowds of screaming teenagers on the sidewalk outside this building are hoping for a glimpse of their heroes through the windows of the MTV studios upstairs. This fifty-story tower replaced the late-lamented Astor Hotel, demolished before there was a landmark law to save it.

414

415

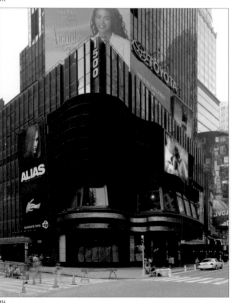

416

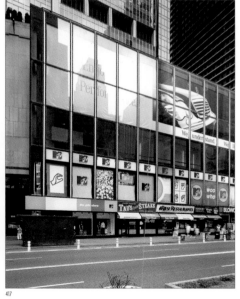

417

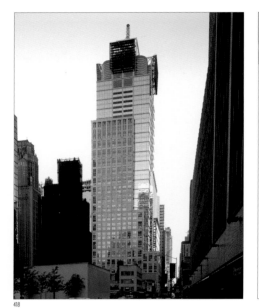

418

CONDÉ NAST BUILDING

4 TIMES SQUARE AT BROADWAY

1999, FOX & FOWLE

With a glitzy façade on the Times Square side, this home of the publisher of *The New Yorker*, *Vogue*, and *House and Garden* presents a different, more conservative face to the east and Sixth Avenue. Among its tenants is the NAS-DAQ Exchange, which anchors the 43rd Street corner with the biggest advertising sign in Times Square. That corner was once an outpost of Coney Island's pride, Nathan's Famous Hot Dogs.

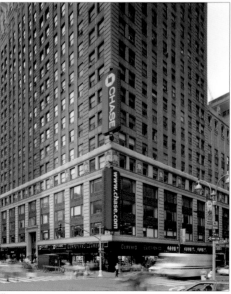

419

419

PARAMOUNT BUILDING

1501 BROADWAY
BETWEEN WEST 43RD AND WEST 44TH STREETS

1927, RAPP & RAPP

Architectural historian Andrew Dolkart has suggested that the mountain that is the trademark of Paramount Pictures Corporation was the inspiration for the massiveness of its headquarters. It is topped by a four-faced clock whose numbers are stars, also part of the Paramount symbol, and a huge glass globe above it represents the company's world-wide reach. The building once included the legendary Paramount Theater, converted to office space in 1967.

LYCEUM THEATER ♫

149–157 WEST 45TH STREET
BETWEEN SIXTH AVENUE AND BROADWAY

1903, HERTS & TALLANT

This is the oldest New York Theater still in use and the first to have landmark status. It was built by producer Daniel Frohman, who included the innovation of a Green Room where performers could relax, and a lavish apartment for the producer. Frohman fell on hard times in the Great Depression and the Lyceum was threatened with demolition by his creditors. It was saved from the wrecker's ball in 1939.

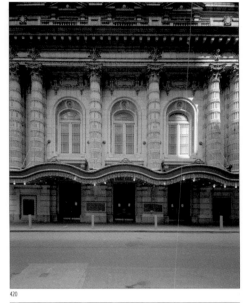

420

CANDLER BUILDING

220 WEST 42ND STREET
BETWEEN SEVENTH AND EIGHTH AVENUES

1914, WILLAUER, SHAPE & BREADY

This building was originally built by Asa Candler (owner of the Coca-Cola Company at the time) for his own offices. It is now the home of SFX Entertainment, which produces and promotes concert and theatrical tours across the country. The basement floor was once a branch of the Exchange Buffet, affectionately known to its customers as the "eat-'em and beat-'em," because patrons told the cashier what they had eaten as they were leaving and paid on an honor system.

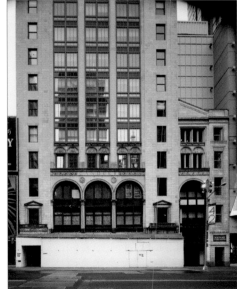

421

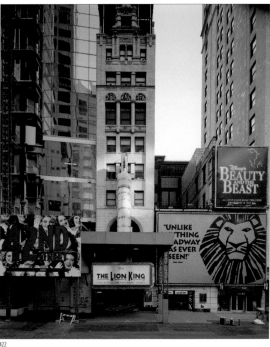

422

New Amsterdam Theater ℒ

214 West 42nd Street
between Seventh and Eighth Avenues

1903, Herts & Tallant
Restoration, 1997, Hardy Holtzman Pfeiffer and
Walt Disney Imagineering

Once the home of the Ziegfeld Follies, this wonderful Art Nouveau theater became a movie palace in the 1930s and then deteriorated into virtual ruin. In the 1990s, the Walt Disney Company invested $8 million in resurrecting it, and began the inexorable march of Disney across what had become one of the city's seediest neighborhoods. The Disney magic worked, and dozens of other companies moved in, too, creating the "New" Times Square.

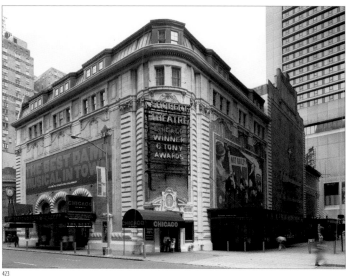

423

SHUBERT ALLEY

BETWEEN WEST 44TH AND WEST 45TH STREETS
WEST OF SEVENTH AVENUE

Anchored by the Booth Theater at 45th Street and the Sam S. Shubert Theater on 44th, this little passageway has access to the offices of the Shubert Organization, which owns these and dozens of other theaters in the district. The Booth, designed in 1913 by Henry B. Herts, was named for actor Edwin Booth. The Shubert, which Herts designed in the same year, stands as a memorial to the man who founded the theatrical empire that his brothers, Lee and J. J., inherited and have run since his death. Both theaters are landmarked inside and out.

St. James Theater ℒ

246–256 West 44th Street
between Broadway and Eighth Avenue

1927, Warren & Wetmore

Built by Abraham Erlanger as a playhouse for musicals, Rodgers & Hammerstein's *Oklahoma!* opened here in 1943 and ran for more than six years. It was followed in 1951 by *The King and I*, and then in 1964 by *Hello, Dolly.* The most successful show of 2001, *The Producers*, added to its distinguished history.

Times Square Theater

217 West 42nd Street
between Seventh and Eighth Avenues

1920, DeRosa and Pereira

Back when 42nd Street was the center of the action in the theater district, the Times Square was where the action could be found. Built by entrepreneurs Arch and Edgar Selwyn, it was the home of such hits in the 1920s as *Gentlemen Prefer Blondes*, *The Front Page*, and *Private Lives*. It was converted to a movie theater, as many of its neighbors were, in 1933, and is now being revitalized as part of a master plan called "42nd Street Now!"

Virginia Theater ℒ

245 West 52nd Street
between Broadway and Eighth Avenue

1925, C. Howard Crane

The Theater Guild opened this as the Guild Theater, a showcase for innovative theatrical art with the works of such giants as Eugene O'Neill and George Bernard Shaw. It became a radio theater in 1943 and was later sold to the federally funded American National Theater and Academy, which often leased it to commercial producers.

Lunt-Fontanne Theater ℒ

205 West 46th Street
between Broadway and Eighth Avenue

1910, Carrère & Hastings

This theater was built by producer Charles Dillingham, one of Broadway's most important producers, who flaunted his status by hiring the best architects of the day to design what he called the Globe Theater. His fortunes turned in the 1930s and he lost the theater, which was converted into a movie house. It was restored in 1958 and renamed in honor of the acting couple, Alfred Lunt and Lynne Fontanne, who reopened it as a legitimate theater in a production of *The Visit*.

Winter Garden Theater ℒ

1634–1646 Broadway
between West 50th and West 51st Streets

1911, William A. Swasey

The musical *Cats* set a Broadway record here in a space built for horses. Back when what is now Times Square was called Longacre Square, it was a center for trading horseflesh, and this was among its biggest sales arenas. In its first dozen years as a theater, it was home to an annual review called *The Passing Show*. Barbra Streisand appeared here in *Funny Girl*, followed two years later by *Mame*, starring Angela Lansbury.

Actor's Studio ℒ

432 West 44th Street
between Ninth and Tenth Avenues

1859
Restored 1995, Davis Brody & Associates

Founded in 1947 by Elia Kazan, Robert Lewis, and Cheryl Crawford, the studio was where Lee Strasberg introduced the "Method," made famous by Marlon Brando. After Strasberg died in 1982, Ellen Burstyn and Al Pacino became the studio's leaders and six years later, Frank Corsaro became its artistic director. Its present home is the former Seventh Associate Presbyterian Church.

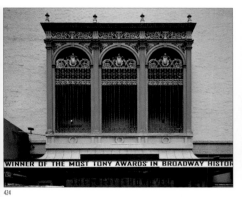

424

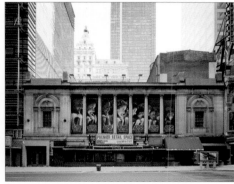

425

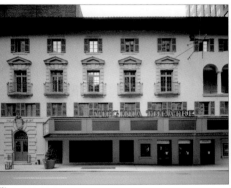

426

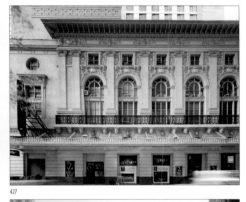

427

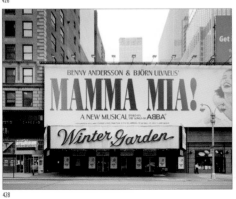

428

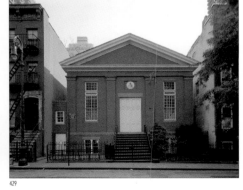

429

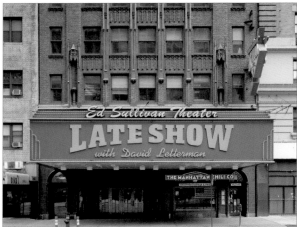

430

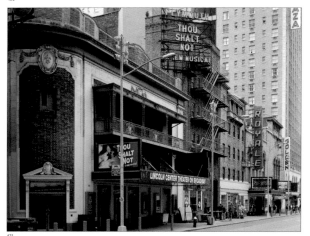

431

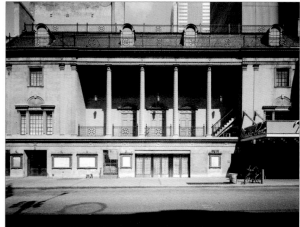

432

ED SULLIVAN THEATER \mathscr{L}

1697–1699 BROADWAY
BETWEEN WEST 53RD AND WEST 54TH STREETS

1927, HERBERT J. KRAPP

Now well known as David Letterman's home base, this theater is named for Ed Sullivan, whose *Toast of the Town* was broadcast from here in the early days of television. It was built by Arthur Hammerstein and named for his father, the first Oscar Hammerstein. He lost it four years after it was built, but it reopened with a blockbuster show that included appearances by Jerome Kern and George Gershwin.

236–256 WEST 45TH STREET

BETWEEN BROADWAY AND EIGHTH AVENUE

1918–27, ALL BY HERBERT J. KRAPP

These four theaters were built between 1918 and 1927. In its early days, The Plymouth specialized in works by Ibsen and Tolstoy; The Royale is where Mae West appeared in *Diamond Lil*; and The John Golden's first big hit was *Tobacco Road* in 1933. The Imperial is the crown jewel of the quartet, having housed such hit shows as *Annie Get Your Gun* (1946) and *Fiddler on the Roof* (1964).

MUSIC BOX THEATER \mathscr{L}

239–247 WEST 45TH STREET
BETWEEN BROADWAY AND EIGHTH AVENUE

1920, C. HOWARD CRANE AND GEORGE KIEHLER

The Music Box was built by songwriter Irving Berlin and producer Sam H. Harris. The musical *Of Thee I Sing*, the first ever to win a Pulitzer Prize, opened here in 1931 and during the Depression, when scores of theaters went dark, it kept this one thriving. Playwright George S. Kaufman saw many of his hits produced at the Music Box, and William Inge's *Picnic* won the Pulitzer Prize here in 1952.

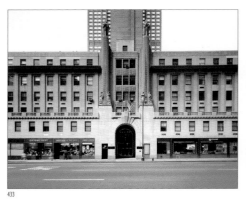

433

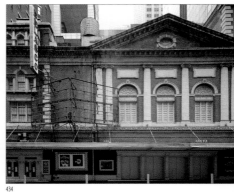

434

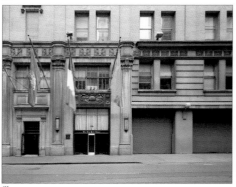

435

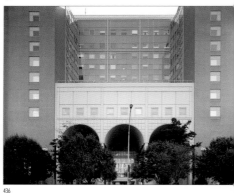

436

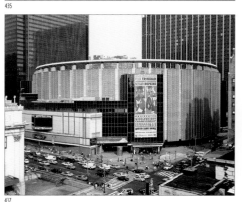

437

438

433

HEARST MAGAZINE BUILDING ℒ

951–969 EIGHTH AVENUE AT WEST 57TH STREET

1928, JOSEPH URBAN

This is a skyscraper waiting to happen, and plans have already been drawn and approved for it. It was built by William Randolph Hearst to house his seven magazines. The base is six stories high, but he planned a taller building above it, a scheme that died in the Great Depression. Hearst was convinced that the theater district would eventually move to Columbus Circle and invested heavily in real estate around it with eager anticipation.

434

BELASCO THEATER ℒ

111 WEST 44TH STREET
BETWEEN SIXTH AND SEVENTH AVENUES

1907, GEORGE KEISTER

Built by producer and consummate showman David Belasco, this theater had the most sophisticated lighting system of its day, as well as a huge elevator stage. It also included luxurious apartments for Belasco and his headliners.

435

NEW YORK TIMES BUILDING ℒ

229 WEST 43RD STREET
BETWEEN SEVENTH AND EIGHTH AVENUES

1913, LUDLOW & PEABODY

Known to its owners as "the Annex," this building was built to handle the expansion that made the original Times Tower around the corner obsolete. The newspaper moved its basement printing plant out of here in 1996 and moved to new plants in Edison, New Jersey, and College Point, Queens. The paper is in the process of building a new skyscraper for the rest of its operations a few blocks down Eighth Avenue.

436

ST. LUKE'S-ROOSEVELT HOSPITAL ℒ

TENTH AVENUE
BETWEEN WEST 58TH AND WEST 59TH STREETS

1990, SKIDMORE, OWINGS & MERRILL
WILLIAM J. SYMS OPERATING THEATER, 1892,
W. WHEELER SMITH

Opened at this location in 1871 as Roosevelt Hospital, this institution merged with St. Luke's Hospital in 1979. The adjacent operating theater was built to give students an opportunity to witness surgical techniques. It was incorporated into a condominium apartment building in 1997.

437

MADISON SQUARE GARDEN CENTER

WEST 31ST TO WEST 33RD STREETS
SEVENTH TO EIGHTH AVENUES

1968, CHARLES LUCKMAN ASSOCIATES

This mammoth structure, with twenty-nine stories of office space, is what replaced the late, lamented Penn Station. It is the third version of the storied Garden, which began on Madison Square in 1879, followed by an incarnation on Eighth Avenue at 50th Street in 1925. The main arena here has 20,000 seats, and there are another thousand in a theater space on the Eighth Avenue side, as well as a large rotunda used as exhibition space.

438

PORT AUTHORITY BUS TERMINAL

EIGHTH AVENUE
BETWEEN WEST 40TH AND WEST 42ND STREET

1950, PORT AUTHORITY OF NEW YORK AND NEW JERSEY

This is the biggest bus terminal in the world, serving commuter buses from New Jersey as well as long-distance bus lines, which enter and exit the terminal through a system of ramps that lead directly to the Lincoln Tunnel. There is also a huge parking facility on the roof for those who prefer to make the trip in their own cars.

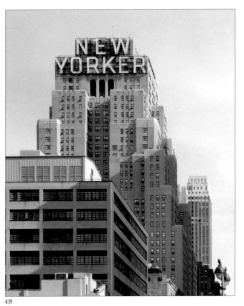

439

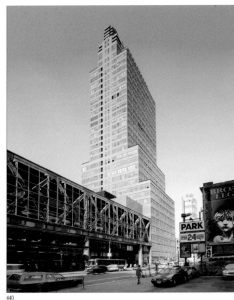

440

441

442

NEW YORKER HOTEL

481 EIGHTH AVENUE
BETWEEN WEST 34TH AND WEST 35TH STREETS

1930, SUGARMAN & BERGER

Now owned by the Unification Church, the New Yorker was, with 2,503 guest rooms, one of the city's biggest when it was built. An early advertisement boasted that its bell boys were "as snappy-looking as West Pointers," that it had a radio in every room with a choice of four stations, that its barber shop had twenty-five chairs and its laundry 150 employees. The ad also mentioned ninety-two "telephone girls," and kitchens "as clean as a model private home kitchen."

McGRAW-HILL BUILDING ℒ

330 WEST 42ND STREET
BETWEEN EIGHTH AND NINTH AVENUES

1931, RAYMOND HOOD

Metallic bands of green, silver, and gold encircle the lower floors of this building and continue inside the lobby. The horizontal bands also continue in blue-green terra-cotta all the way to the top of the thirty-five-story tower. The McGraw-Hill Publishing Company moved from here to its new building in Rockefeller Center in the late 1960s, and its former headquarters and printing plant became a general-use office building.

FILM CENTER BUILDING ℒ

630 NINTH AVENUE
BETWEEN WEST 44TH AND WEST 45TH STREETS

1929, ELY JACQUES KAHN

The lobby here is an Art Deco extravaganza with pink marble circles and black marble stripes on the terrazzo floor, and patterns of orange and blue tiles arrayed among alternating stripes of black and white marble. It is the work of Ely Jacques Kahn, who, along with Raymond Hood and Ralph Walker, established the style that changed the face of New York buildings in the 1930s.

THE PIANO FACTORY

452–458 WEST 46TH STREET
BETWEEN NINTH AND TENTH AVENUES

1888

Before the era of phonographs and radios, no self-respecting home was considered fully furnished without a piano in the living room, and dozens of New York companies helped fill the need. Among them was the Wessell, Nickel & Gross Company, which made sounding boards in this factory that was converted to luxury apartments in 1980.

443
GENERAL POST OFFICE ✒

EIGHTH AVENUE
BETWEEN WEST 31ST AND WEST 33RD STREETS

1913, McKIM, MEAD & WHITE

Soon to be converted into the "new" Penn Station, this building was designed to complement the old one that stood across Eighth Avenue. In this "city that never sleeps," all of the post offices are closed at night except this one. It's especially busy at midnight on April 15, the deadline for postmarks on tax returns.

444
JACOB K. JAVITS CONVENTION CENTER

ELEVENTH TO TWELFTH AVENUES
BETWEEN WEST 34TH AND WEST 37TH STREETS

1986, I. M. PEI & PARTNERS

This is the ultimate glass box, with glass covering 1.8 million square feet of floor space—enough to accommodate six simultaneous events and 85,000 people at one time in its exposition halls and meeting rooms. More than 3 million visitors pass through its doors every year for events that include the Auto Show and the Boat Show.

445
PASSENGER SHIP TERMINAL

TWELFTH AVENUE
BETWEEN WEST 48TH AND WEST 52ND STREETS

1976, PORT AUTHORITY OF NEW YORK
AND NEW JERSEY

No sooner had these modern piers been built than the great ocean liners stopped making regular runs between New York and Europe. Now the *Queen Elizabeth 2* and some cruise ships berth here, but the piers are more often used as exposition space.

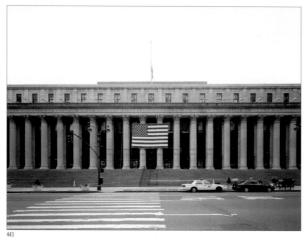

443

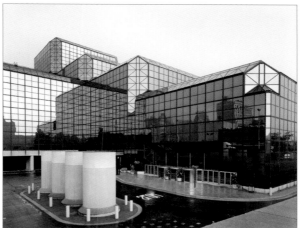

444

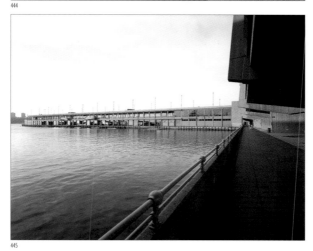

445

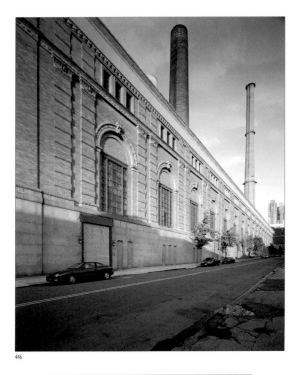

446

IRT POWERHOUSE

ELEVENTH AVENUE AT WEST 58TH STREET

1904, McKIM, MEAD & WHITE

Located close to the Hudson River to facilitate delivery of coal to fire its generators, this station provided all the power to run the city's original subway, the Interborough Rapid Transit Company. The reason behind its elaborateness was the fear that a factory-like structure would be a blight on the neighborhood. Architect Stanford White placed the conveyors for bringing in the fuel and removing the ashes discretely underground. He also designed its smokestacks to look like tapered Classical columns. Although they have become obscured by grime over the years, the basement is built of pink granite supporting buff brick walls. The ornamentation, most of which has been removed, is buff terra-cotta.

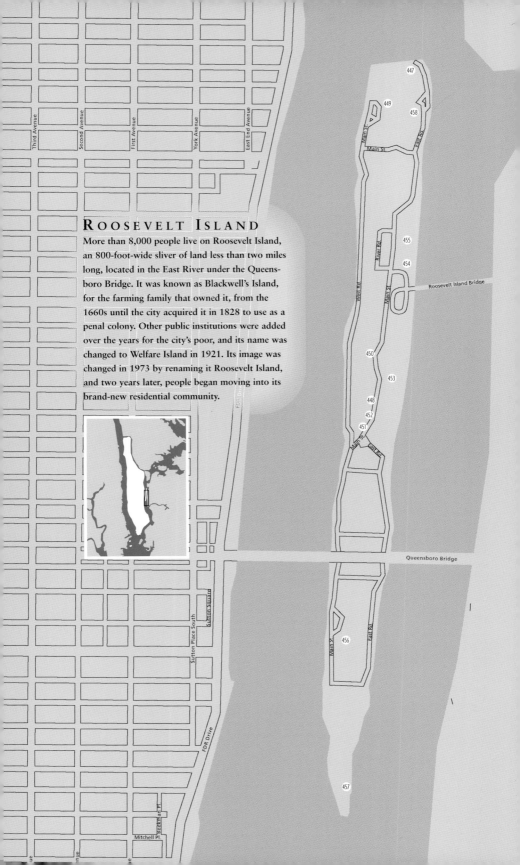

ROOSEVELT ISLAND

More than 8,000 people live on Roosevelt Island, an 800-foot-wide sliver of land less than two miles long, located in the East River under the Queensboro Bridge. It was known as Blackwell's Island, for the farming family that owned it, from the 1660s until the city acquired it in 1828 to use as a penal colony. Other public institutions were added over the years for the city's poor, and its name was changed to Welfare Island in 1921. Its image was changed in 1973 by renaming it Roosevelt Island, and two years later, people began moving into its brand-new residential community.

Third Avenue

Second Avenue

First Avenue

York Avenue

East End Avenue

FDR Drive

Sutton Place South

Sutton Square

Beekman Pl.

Mitchell Pl.

Main St

East Rd

River Rd

West Rd

Main St

Roosevelt Island Bridge

Queensboro Bridge

447

449

458

455

454

450

453

448

452

451

456

457

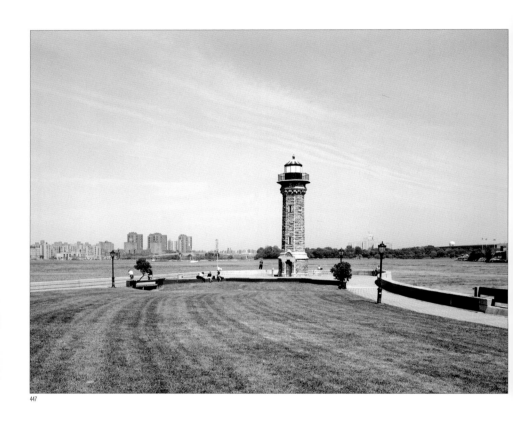

447

LIGHTHOUSE 𝓛

NORTHERN TIP OF ROOSEVELT ISLAND

1872, JAMES RENWICK, JR.

This fifty-foot granite lighthouse was said to have been built by an inmate of the Lunatic Asylum, who left this inscription on it: "This is the work/ Was done by/ John McCarthy/ Who built this light/ House from top to bottom/ To all ye who do pass by may/ Pray for his sould when he dies." Whether or not this is really the work of John McCarthy is anybody's guess, but there was an asylum inmate by that name who had been allowed to build a small fort on this spot because he was afraid of an attack by the British. It was torn down when the light-house was built. Although not an official Sea-mark, the tower overlooks Hell Gate, a narrow strait that connects Long Island Sound to the East River. The powerful tide surge that runs through it, along with underwater rocks, made it the most treacherous spot in all the water-ways around New York. It was widened and deepened in the late nineteenth century, but mariners navigating it still need to keep their wits about them.

448

449

450

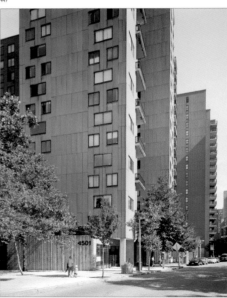

451

448

ISLAND HOUSE

551–575 MAIN STREET, ROOSEVELT ISLAND

1975, JOHANSEN & BHAVNANI

This upscale Roosevelt Island apartment build-
ing has an indoor swimming pool overlooking
the East River, with New York Hospital as a
backdrop. The views of Manhattan from the
island's west side are obviously the best it has
to offer, and buildings like this one, that take
advantage of them, are the most expensive.

449

BIRD S. COLER HOSPITAL

NORTHERN END OF ROOSEVELT ISLAND

1954

This is a 1,890-bed New York City hospital for
the chronically ill, planned in the 1930s, but
delayed by World War II. In spite of its mod-
ern, well-lit facilities, it still had an air of gloom
about it when it was built in the midst of the
island's abandoned buildings.

450

EASTWOOD

510–580 MAIN STREET, ROOSEVELT ISLAND

1976, SERT, JACKSON & ASSOCIATES

When the State Urban Development Corpora-
tion turned the near-derelict Welfare Island
into a residential community called Roosevelt
Island in 1971, this apartment block contain-
ing 1,000 units was designated for low- to mid-
dle-income tenants. Higher-priced apartments
on the other side of the brick-paved street face
Manhattan, while these overlook a Queens
industrial neighborhood.

451

RIVERCROSS

505–541 MAIN STREET, ROOSEVELT ISLAND

JOHANSEN & BHAVNANI

Although most of the buildings on Roosevelt
Island contain rental apartments, those in this
luxury building are co-ops. The view from here
across the East River is of Rockefeller Univer-
sity. Of the three upscale buildings on the
island, it is closest to the Tram and the subway
station deep under it.

GOOD SHEPARD ECUMENICAL CENTER \mathcal{L}

543 MAIN STREET, ROOSEVELT ISLAND

1889, FREDERICK CLARKE WITHERS

Originally the Episcopal Chapel of the Good Shepard, this little country church was built to serve the inmates of the various public institutions that were here when this was known as Welfare Island. The two porches marked separate entrances for men and women.

JAMES BLACKWELL FARMHOUSE \mathcal{L}

BLACKWELL PARK, MAIN STREET, ROOSEVELT ISLAND

1804
RESTORED 1973, GEORGIO CAVAGLIERI

This simple farmhouse was the home of the Blackwell family that once owned this entire island. It was named for them until 1828, when the city bought it as the site of a prison.

MOTORGATE

EAST SIDE OF ROOSEVELT ISLAND

1974, KALLMANN & McKINNELL

It is forbidden to drive a car on Roosevelt Island, but certainly not to own one. Automobiles reach this huge garage facility across the Roosevelt Bridge from Queens. Electric buses transport their drivers from the garage to their apartments. Most Roosevelt Islanders come and go via the tramway that parallels the Queensboro Bridge, or through a subway station built in 1989.

AVAC BUILDING

NORTH OF MOTORGATE, ROOSEVELT ISLAND

1975, KALLMANN & McKINNELL

The letters stand for Automated Vacuum Collection. Using a system developed for Disney World, all of the refuse from all of Roosevelt Island's buildings is vacuumed through tunnels to this place where it is sorted, compacted, and shipped off to the Sanitation Department.

GOLDWATER MEMORIAL HOSPITAL

900 MAIN STREET, ROOSEVELT ISLAND

1939, BUTLER & KOHN, YORK & SAWYER

Originally the Welfare Hospital for Chronic Diseases, the design of this building is intended to give its long-term patients maximum sunshine and soothing river views.

SMALLPOX HOSPITAL \mathcal{L}

SOUTHERN TIP OF ROOSEVELT ISLAND

1856, JAMES RENWICK, JR.

When this institution was first established, it consisted of wooden shacks for the quarantine of smallpox victims. Although vaccination made the disease less common, there were still epidemics during the nineteenth century, making this large facility necessary. An even larger smallpox hospital was built on North Brother Island, near Rikers Island off the Bronx shore, in 1886, and this one was converted to nurse's housing before being completely abandoned, and left to rot, in the 1950s.

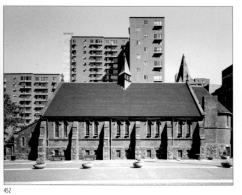

452

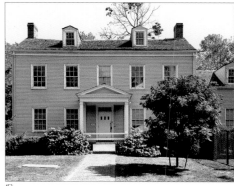

453

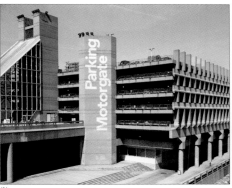

454

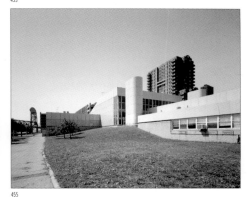

455

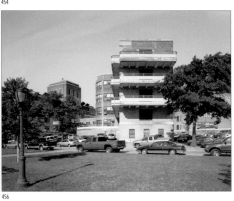

456

457

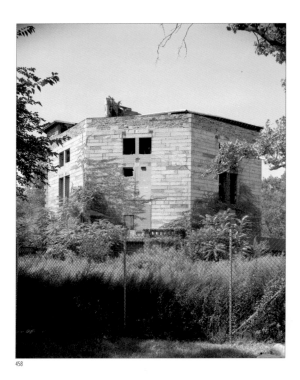

458

Octagon Tower 𝓛

NORTHERN END OF ROOSEVELT ISLAND

1839, ALEXANDER JACKSON DAVID

This was originally part of the New York City
Lunatic Asylum, built to relieve overcrowding
at Bellevue Hospital. The patients, supervised
by inmates from the island's penitentiary,
worked on a small farm here and were put to
work building the seawalls that made the island
bigger. It was believed that hard work was ther-
apeutic, and everything possible was done to
keep the residents busy. The tower, which orig-
inally had an impressive dome, was the center-
piece of a larger structure. Its two wings were
torn down to make room for the transforma-
tion of the island into a residential community,
but there are plans to restore it, eventually, as
part of what is called Octagon Park.

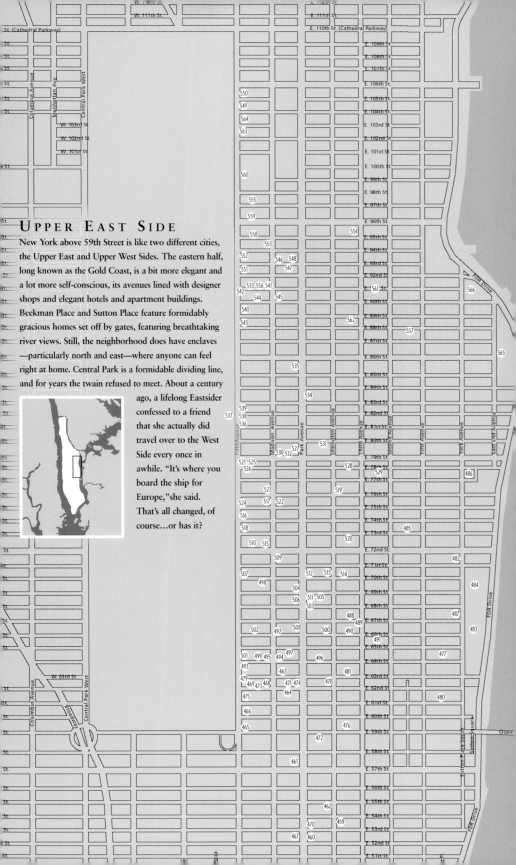

UPPER EAST SIDE

New York above 59th Street is like two different cities, the Upper East and Upper West Sides. The eastern half, long known as the Gold Coast, is a bit more elegant and a lot more self-conscious, its avenues lined with designer shops and elegant hotels and apartment buildings. Beekman Place and Sutton Place feature formidably gracious homes set off by gates, featuring breathtaking river views. Still, the neighborhood does have enclaves —particularly north and east—where anyone can feel right at home. Central Park is a formidable dividing line, and for years the twain refused to meet. About a century ago, a lifelong Eastsider confessed to a friend that she actually did travel over to the West Side every once in awhile. "It's where you board the ship for Europe," she said. That's all changed, of course…or has it?

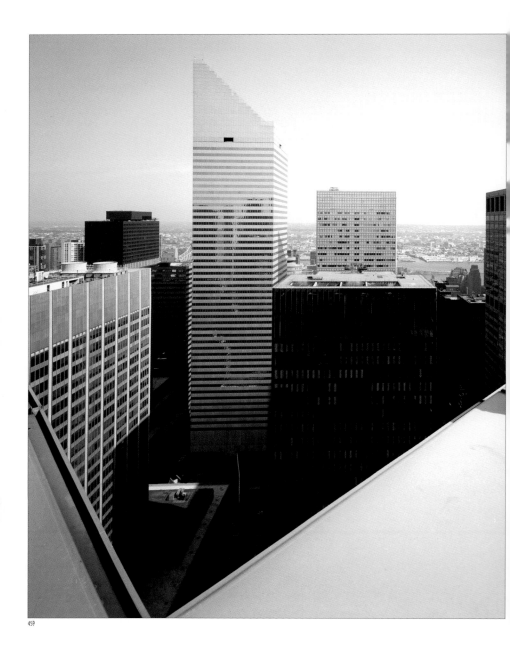

459

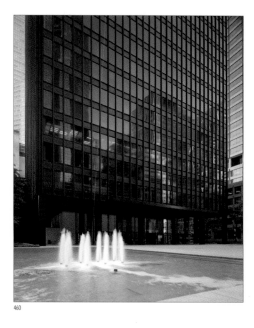

460

459

CITICORP CENTER

LEXINGTON AVENUE,
BETWEEN EAST 53RD AND EAST 54TH STREETS

1978, HUGH STUBBINS & ASSOCIATES

The cost of the site for this building came to $40 million, making it Manhattan's most expensive real estate, and there was one holdout at that: St. Peter's Lutheran Church, which refused to sell its building. Citibank agreed to pay the church $9 million and to build them a new building as part of its development. The tower itself rests on columns that give it an openness at ground level, and allows light and air to penetrate its market area on the first three levels as well as allowing breathing space to the church at the 54th Street corner. The tower's distinctive sloping roof was originally intended to be a solar collector that would power the air-conditioning system, but it was never installed. What was installed up there is a 400-ton concrete block riding on rails, called a "tuned mass damper," which slows the building's tendency to sway in high winds.

460

SEAGRAM BUILDING

375 PARK AVENUE
BETWEEN EAST 52ND AND EAST 53RD STREETS

1958, LUDWIG MIES VAN DER ROHE
WITH PHILIP JOHNSON

This masterful example of the International style has been imitated literally hundreds of times around the city, but never once equaled. One of its best features is the plaza in front. Nobody was quite sure why it worked so well, including the architect himself, but urban planning consultant William H. Whyte put his finger on it. It was the steps, he said, "they are the best of any office building." In 1960, a tax assessor measured the ninety-foot Seagram Plaza and concluded that the city was being cheated out of something like $300,000 a year in tax revenues because of all that wasted space. The city's lawyers agreed and the tax law was changed to take "prestige value" into account along with rentable space.

461
RITZ TOWER

109 EAST 57TH STREET AT PARK AVENUE

1925, EMERY ROTH AND CARRÈRE & HASTINGS

This forty-story apartment hotel has setbacks on all four sides that guarantee light and air in every apartment, not to mention a host of terraces and balconies, a novelty when it was built in 1925. Most of the apartments on the upper floors are duplexes with double-height living rooms, stretching for forty feet along the outside wall. Many of them are as high up as 500 feet in the air, a feat that was impossible to even imagine back in those days.

462
CENTRAL SYNAGOGUE

652 LEXINGTON AVENUE AT EAST 55TH STREET

1872, HENRY FERNBACH

Recently restored after a disastrous fire, this Moorish structure, based on the Dohany Street Synagogue in Budapest, is the oldest continually used synagogue in New York. It is the fifth house of worship of Congregation Ahawath Chesed, formed by immigrants from Bohemia in 1846 on the Lower East Side. The synagogue took its present name in 1920.

463
BANK OF NEW YORK

706 MADISON AVENUE AT EAST 63RD STREET

1922, FRANK EASTON NEWMAN

This neo-Federal bank branch seems out of place on bustling Madison Avenue, but that may be the point. Its serenity not only calls attention to itself, but calls out to potential depositors looking for a quiet retreat, or possibly an infusion of cash to finish a shopping spree.

464
40 EAST 62ND STREET

BETWEEN MADISON AND PARK AVENUES

1910, ALBERT JOSEPH BODKER

The image of starving artists working in cold, drafty garrets flies out the window in elegant surroundings like this. But this building was built with artists in mind. It is an eight-story neo-Medieval structure with endless floor-to-ceiling bay windows and a richly ornamented base that its builders hoped would appeal to artists. It undoubtedly did, but although rents were relatively low in 1910, it's hard to believe a "starving artist" could really come near the place—then or now.

465
SHERRY-NETHERLAND HOTEL

781 FIFTH AVENUE AT EAST 59TH STREET

1927, SCHULTZE & WEAVER, BUCHMAN & KAHN

This hotel's original restaurant at the back of the lobby was placed on a lower level with high ceilings to make it appear larger, but it was actually much smaller than a guest might expect from the world's tallest apartment hotel. The reason was Prohibition. Since a bar would have been illegal, the management encouraged its guests to rely on room service and the availability of bootleg liquor.

466
METROPOLITAN CLUB

1–11 EAST 60TH STREET AT FIFTH AVENUE

1894, McKIM, MEAD & WHITE

Organized by J. P. Morgan and others, this was intended to be "the club of clubs," a distinction already claimed by its rival, the Union Club. One way the Metropolitan hoped to attract the cream of New York society, at the expense of the competition, was by including a dining room for women in the bowels of the clubhouse, in hopes that the wives of these prospects would exert the necessary pressure.

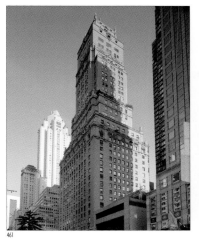

461

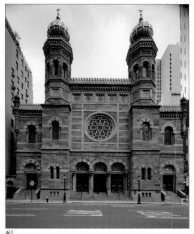

462

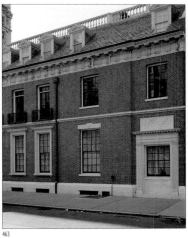

463

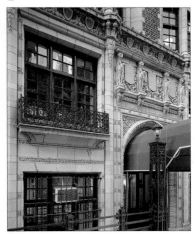

464

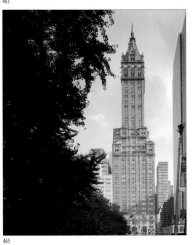

465

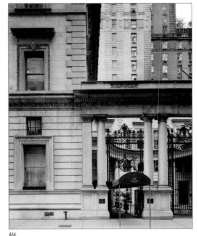

466

RACQUET AND TENNIS CLUB ℒ

370 PARK AVENUE
BETWEEN EAST 52ND AND EAST 53RD STREETS

1918, McKIM, MEAD & WHITE

When this building was built, both Charles McKim and Stanford White were dead and William Rutherford Mead had retired, leaving their tradition to W. S. Richardson, who was true to the legacy in his fashion. Although far from the firm's best work, it is still head and shoulders above just about everything else built in New York in 1918. The indoor tennis courts are behind the blind arches at the top of the façade.

HERMÈS

691 MADISON AVENUE AT EAST 62ND STREET

1928, McKIM, MEAD & WHITE

This little bandbox was originally Louis Sherry's restaurant. It was altered for use as stores in 1950, and then again, in 1986, as the local flagship of *The Limited*, a women's wear store. Now *Hermès* has turned it into a little bit of Paris on Madison Avenue.

KNICKERBOCKER CLUB ℒ

2 EAST 62ND STREET AT FIFTH AVENUE

1915, DELANO & ALDRICH

This exclusive men's club, affectionately known as the "Nick," was founded by August Belmont and others who believed that the existing clubs were getting too liberal for their taste. Until 1963, it shared its garden with an almost identical townhouse on the 61st Street corner. It was the home of Mrs. Marcellus Hartley Dodge, who actually lived in New Jersey but kept her former home as a base for shopping trips.

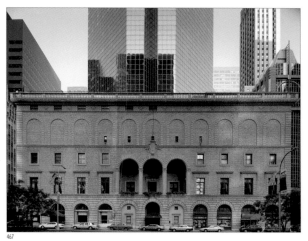

467

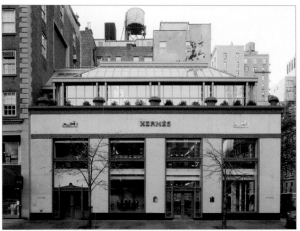

468

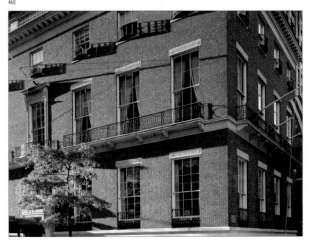

469

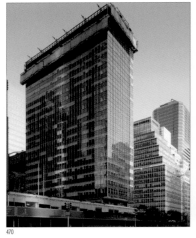

470

471

472

473

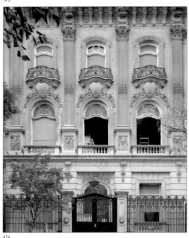

474

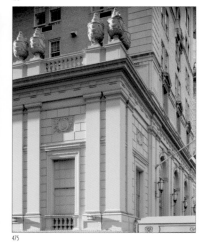

475

LEVER HOUSE

390 PARK AVENUE
BETWEEN EAST 53RD AND EAST 54TH STREETS

1952, GORDON BUNSHAFT OF
SKIDMORE, OWINGS & MERRILL

Although the glass-walled United Nations Secretariat was under construction when Lever House was finished, this is New York's first all-glass building, and still one of the most beautiful. Among the problems nobody anticipated was how to wash those windows, few of which can be opened. It was an especially vexing issue for the tenant who gave the building its name, the prominent purveyor of soap.

ASSISIUM SCHOOL

36 EAST 63RD STREET
BETWEEN MADISON AND PARK AVENUES

1930, CROSS & CROSS

This building, which was converted to a school in 1941 by the Missionary Sisters of the Third Order of St. Francis, was originally the Hangar Club, an organization of aeronautical enthusiasts. Although its name suggests that its interiors might have been designed along the lines of an airplane hangar, it actually had all the intimacy of an English gentleman's club.

GALLERIA

119 EAST 59TH STREET
BETWEEN PARK AND LEXINGTON AVENUES

1975, DAVID KENNETH SPECTER AND PHILIP BIRNBAUM

This is a mixed-use office/apartment tower, each independent with separate elevator and electrical systems and other basic services. The tower, which is almost invisible from the sidewalk, has a dramatic impact on the skyline in this area, especially when seen from uptown. It rests on an eight-story base that includes an attractive public galleria connecting it to 58th Street.

COLONY CLUB

564 PARK AVENUE AT EAST 62ND STREET

1915, DELANO & ALDRICH

When the Colony outgrew its quarters on Madison Avenue at 30th Street, it commissioned this building, that not only included more bedrooms but a whole floor for servants and a special area for the enjoyment of members' pets. There is a huge swimming pool in the basement as well as mineral baths worthy of the best European spas. There is also an oak-paneled gymnasium further up, and a squash court on the floor above it.

EDITH AND ERNESTO FABBRI HOUSE

11 EAST 62ND STREET
BETWEEN FIFTH AND MADISON AVENUES

1900, HAYDEL & SHEPARD

This house was built by Mrs. Elliot F. Shepard, née Vanderbilt, for her daughter, Edith and her new husband, Ernesto Fabbri. After living here for a few years, the Fabbris moved to Paris, where he had been offered a job at his uncle's bank. Soon afterward, Mrs. Fabbri's cousin, Alfred Gwynne Vanderbilt, leased the house for what he characterized as a "bachelor's hall." It is now the residence of the Japanese Representative to the United Nations.

HOTEL PIERRE

795 FIFTH AVENUE AT EAST 61ST STREET

1930, SCHULTZE & WEAVER

Former chef Charles Pierre had a loyal following when he built this hotel, and in spite of the Depression, it flourished as a symbol of optimism among New Yorkers who could still afford a night on the town. The lobby and lounge are in the rear, accessed through the 61st Street entrance. Its double-height dining room extends for 100 feet along Fifth Avenue, half a level above the street to take advantage of the Central Park views.

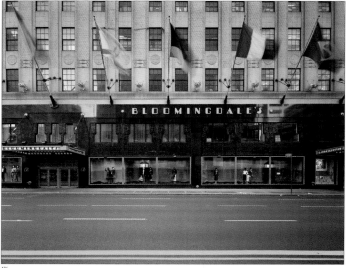

476

BLOOMINGDALE'S

LEXINGTON, THIRD AVENUES;
EAST 59TH, EAST 60TH STREETS

1930, STARRETT & VAN VLECK

One of the reasons why it is so hard to find
your way around in this fashionable depart-
ment store is that it is actually two buildings
superimposed on one another. It was the result
of the store's expansion that began with a small
dry-goods store on Third Avenue, and contin-
ued a little bit at a time between 1872 and
1927, reaching its peak with the even bigger
annex on the Lexington Avenue side that swal-
lowed its predecessors three years later. The
store, once called "The Great East Side
Bazaar," was founded by Lyman and Joseph
Bloomingdale, and its name has nothing to do
with the old Bloomingdale neighborhood on
the Upper West Side.

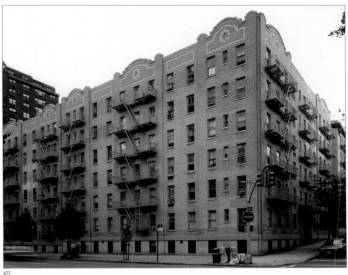

477

477

CITY AND SUBURBAN HOMES ℒ

FIRST AVENUE ESTATES, EAST 64TH
TO EAST 65TH STREETS, FIRST TO YORK AVENUES

1898, JAMES E. WARE

The City and Suburban Homes Company was
a limited-profit company formed to improve
the living conditions of wage earners, the
majority of whom were forced to live in sub-
standard tenements. This was its second proj-
ect, a collection of six-story walk-up apartment
houses designed to provide light and air into
every unit. They were called "estates," and
compared to existing tenements they were,
although the name didn't fool anyone.

BARBIZON HOTEL

140 EAST 63RD STREET AT LEXINGTON AVENUE

1927, MURGATROID & OGDEN

This was originally the Barbizon Club for Women, built as a refuge for young women new to the big city and its predatory men. Among its architectural charms is the rooftop, which originally included a restaurant and a solarium. Gothic arches edging a walkway up there framed some of the city's most dramatic views, and provided inspiration for painter Georgia O'Keeffe and photographer Samuel Gottscho (yes, men were welcome, at least on the roof).

NEW YORK ACADEMY OF SCIENCES

2 EAST 63RD STREET
BETWEEN FIFTH AND MADISON AVENUES

1920, STERNER & WOLFE

Originally built as a residence for William Ziegler, Jr., president of the Royal Baking Company, this is now the headquarters of an organization dedicated to such sciences as biology, chemistry, geology, and astronomy. It sponsors research and interacts with the scientific community. Among its other activities is the Junior Academy of Sciences, which encourages high school students to participate in scientific projects.

ABIGAIL ADAMS SMITH MUSEUM

421 EAST 61ST STREET, BETWEEN FIRST AND YORK AVENUES

1799

This is the headquarters of the Colonial Dames of America, which restored and furnished the building's nine period rooms to form a charming colonial museum. Originally a carriage house, it was part of a twenty-acre estate owned by Colonel William S. Smith and his wife, Abigail, the daughter of President John Adams. The main house, destroyed by fire, was converted into a fashionable resort hotel called the Mount Vernon.

CYRIL AND BARBARA RUTHERFORD HATCH HOUSE ℬ

153 EAST 63RD STREET
BETWEEN LEXINGTON AND THIRD AVENUES

1919, FREDERICK J. STERNER

This townhouse, with a beautiful interior courtyard, was commissioned by Mrs. William K. Vanderbilt's daughter, Barbara Rutherford and her husband Cyril Hatch. When they were divorced three years later, it was sold to theatrical producer Charles Dillingham, and in 1940, it became the home of Louise Hovick, better known as stripper Gypsy Rose Lee. In the 1980s, it was the home of painter Jasper Johns.

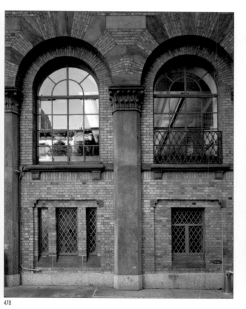

478

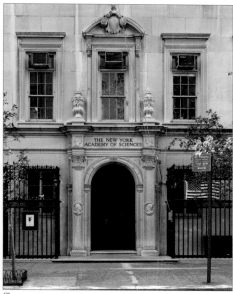

479

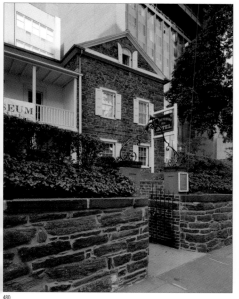

480

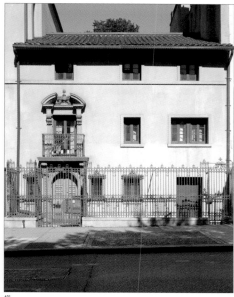

481

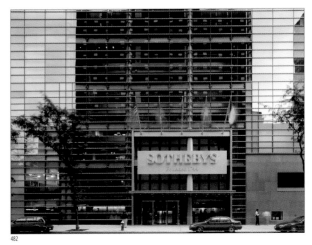

482

483

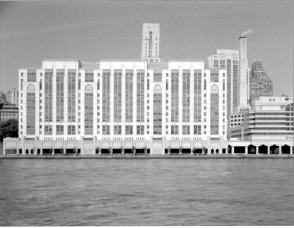

484

SOTHEBY'S

1334 YORK AVENUE AT 72ND STREET

EXPANDED AND REMODELED, 1999, KOHN PEDERSON FOX

The auction house moved into this former Eastman Kodak building in 1980, and then went right to work making it bigger and better. Sotheby's traces its history back to 1744, when a London bookseller began auctioning rare books. Today, its auctions include rarities of every kind from baseball memorabilia to estate jewelry, art and antiques, and, yes, rare books. It conducts auctions worldwide, even on the Internet, but this is the center of the action.

ROCKEFELLER UNIVERSITY

1230 YORK AVENUE
BETWEEN EAST 63RD AND EAST 68TH STREETS

1910, YORK & SAWYER

Founded in1901 by John D. Rockefeller, this has become one of the world's most important research centers. Nineteen Nobel laureates have been associated with it. Unlike other universities, senior professors work directly with students in laboratory settings. There are no academic courses, and students don't pay tuition. On the contrary, they are paid a small annual stipend.

NEW YORK PRESBYTERIAN HOSPITAL- NEW YORK-CORNELL MEDICAL CAMPUS

YORK AVENUE
BETWEEN EAST 68TH AND EAST 71ST STREETS

1932, SHEPLEY, BULLFINCH & ABBOTT

New York Hospital was established in 1771 as a facility for charity cases. It became associated with Cornell University's Medical College in 1912, and began planning this building fifteen years later.

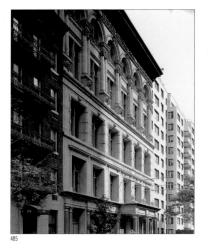

485

BOHEMIAN NATIONAL HALL

321 EAST 73RD STREET
BETWEEN FIRST AND SECOND AVENUES

1897, WILLIAM C. FROHNE

Toward the end of the nineteenth century, this neighborhood was filled with Czech and Slovak immigrants, and this ornate structure was built as a meeting place for them. It included a restaurant and club rooms, a rifle range and bowling alley, as well as a huge ballroom. The children of the immigrants came here to study their parents' native language and culture.

485

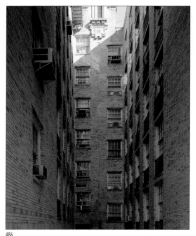

486

CHEROKEE APARTMENTS

EAST 77TH TO EAST 78TH STREETS
EAST OF YORK AVENUE

1911, HENRY ATTERBURY SMITH

Also called East River Houses, these four buildings originally housed 384 working-class families in units with rare cross-ventilation. Tunnels lined in Guastavino tile connected the interior courtyards to the street, and glass pergolas sheltered the stairways, which were left open to maximize air circulation. Every apartment also had a wrought-iron balcony, an amenity that was rare even in contemporary luxury apartments.

486

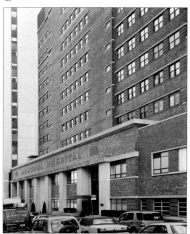

487

MEMORIAL SLOAN-KETTERING CANCER CENTER

1275 YORK AVENUE
BETWEEN EAST 67TH AND EAST 68TH STREETS

1938, JAMES GAMBLE ROGERS

Originally established on the West Side in 1884, this is the country's oldest hospital devoted exclusively to treating cancer patients, and was the first to use radiation therapy. A cancer research laboratory originally funded by General Motors Chairman Alfred P. Sloan, and his fellow GM executive Charles F. Kettering joined what was then called Memorial Hospital in 1960.

487

488

MILAN HOUSE

115 East 67th Street and 116 East 68th Street

1931, Andrew J. Thomas

This pair of eleven-story apartment blocks is separated by a mid-block Italianate courtyard, one of the finest "secret gardens" in the city. These buildings caught the eye of John D. Rockefeller, Jr., who was considering the renovation of his townhouse on West 54th Street but changed his mind in favor of the Rockefeller Apartments, loosely based on this pair.

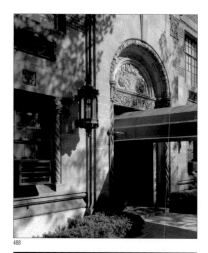

488

489

KENNEDY CHILD CARE STUDY CENTER 𝓛

149–151 East 67th Street

1890, Buchman & Deisler and Brunner & Tryon

In order to encourage growth of the Upper East Side in the 1860s, the city gave land in the area to such institutions as museums, schools, and hospitals. This section, originally designated Hamilton Square, running between Fifth and Third Avenues and 66th to 69th Streets, was given to several of them, including Mount Sinai Hospital, which built a complex of buildings here that included modern laboratories, a nursing school, and this building, which served as its outpatient department.

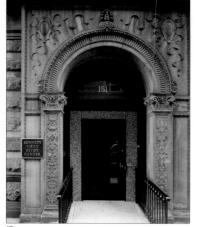

489

490

131–135 East 66th Street 𝓛

between Lexington and Third Avenues

1906, Charles A. Platt

This artists' cooperative with double-height studio space coupled with duplex apartments, was designed by Charles A. Platt, a well-known society architect, who moved here himself after collaborating with the designers of the similar building next door to make certain that the neighborhood would be worthy of his presence.

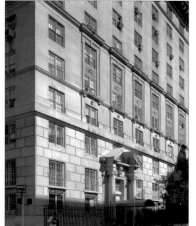

490

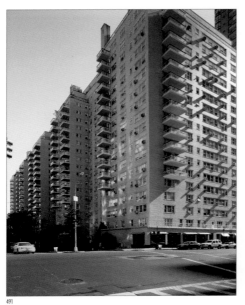

491

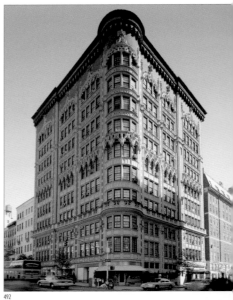

492

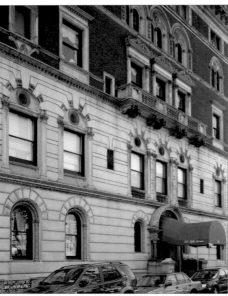

493

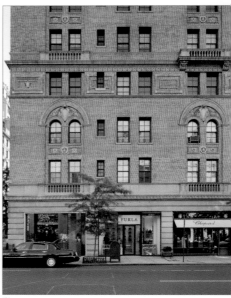

494

Manhattan House

200 East 66th Street
between Second and Third Avenues

1950, Skidmore, Owings & Merrill,
and Mayer & Whittlesey

The Third Avenue elevated was still rumbling past when this nineteen-story apartment house was built, and the noise would continue for another six years. It is famous as New York's first "white brick" apartment house, even though its bricks are actually gray. Following this, hundreds of apartments were faced with white brick, not only because it was cheap, but because public housing was built with red brick. Besides, builders noted, it looked like marble.

45 East 66th Street

at Madison Avenue

1908, Harde & Short

The firm of Harde & Short designed several lavishly decorated New York apartment buildings, including the Red House on the Upper West Side, and Alwyn Court near Carnegie Hall. This ten-story structure brought their style to the Upper East Side, but in keeping with East Side tradition, it was not given a name, only a street address. It is such a standout on the Madison Avenue streetscape that it probably doesn't need one.

Edward J. Berwind House

2 East 64th Street at Fifth Avenue

1896, Nathan Clark Mellin

Among the most fascinating "cottages" in Newport, Rhode Island, is The Elms. When its owner, Edward J. Berwind, came home at the end of the season, this was where he came. Although it has been converted to apartments so that we can't see how he actually lived here, it's a good bet that it was in solid comfort. Berwind was a big name in the coal business, and although he had long since made his fortune, his comfortable future was guaranteed in 1917, when he secured the contract to fuel all of the Navy's ships during World War I.

The Verona

32 East 64th Street at Madison Avenue

1908, William E. Mobray

As if to accentuate the fact that the east and west sides of Manhattan are two distinct entities, buildings east of Central Park are usually identified just by their addresses while their western counterparts are invariably given names. This an exception to the rule and considering its excellent homage to Italy, the name "Verona" is richly deserved. The kitchens and pantries overlooking a courtyard here are served by separate elevators for servants and tradesmen. Residents and their guests use passenger elevators that lead directly to foyers in each apartment.

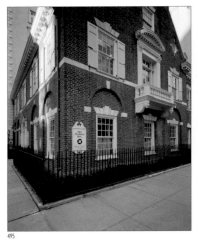

495

496

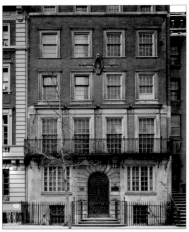

497

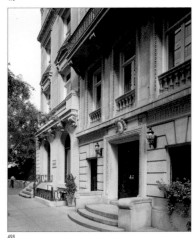

498

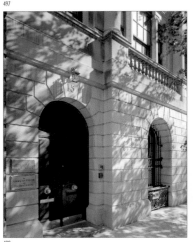

499

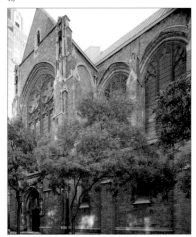

500

495

J. P. MORGAN-CHASE BANK

726 MADISON AVENUE AT EAST 64TH STREET

1933, MORRELL SMITH

Like its neighbor down the avenue, the Bank of New York, this neo-Georgian branch bank building is out of scale with its neighbors, but right on the money when it comes to charm. As a branch of the Bank of the Manhattan Company, it was originally furnished with reproductions of colonial museum pieces, including hooked rugs.

496

EDWARD DURRELL STONE HOUSE

130 EAST 64TH STREET
BETWEEN PARK AND LEXINGTON AVENUES

1878, JAMES E. WARE

This house once looked just like its next-door neighbor to the west, but when architect Edward Durrell Stone moved here in 1956, he pushed the front out to the sidewalk and faced it with the terrazzo grille that is similar to his design of the American Embassy in New Delhi.

497

SARA DELANO ROOSEVELT MEMORIAL HOUSE ℒ

47–49 EAST 65TH STREET
BETWEEN MADISON AND PARK AVENUES

1908, CHARLES A. PLATT

This pair of houses was built by Mrs. James Roosevelt. She herself lived in the eastern half, while her son, Franklin D. Roosevelt, lived in its twin with his wife, Eleanor. This was where FDR recovered from polio, confined to a fourth-floor bedroom for more than a year in 1921 and 1922. The houses are now owned by Hunter College.

498

EAST 70TH STREET

BETWEEN FIFTH AND MADISON AVENUES

1910–1911

Five of these outstanding townhouses are landmarks. They were built on land formerly owned by James Lenox, whose impressive library on the site of the Frick Collection was incorporated into the New York Public Library.

499

KOSCIUSKO FOUNDATION

15 EAST 65TH STREET
BETWEEN FIFTH AND MADISON AVENUES

1917, HARRY ALLAN JACOBS

This mansion was built for Van Alen, whose mother-in-law, Mrs. Astor, lived around the corner. The Foundation, which moved here in 1945, is a Polish-American cultural institution providing scholarships to students of Polish heritage, and supporting student exchanges between Poland and the United States. It was named for Tadeusz Kosciusko, a hero of the Revolutionary War battle of Saratoga.

500

CHURCH OF ST. VINCENT FERRER ℒ
(ROMAN CATHOLIC)

LEXINGTON AVENUE AT EAST 66TH STREET

1918, BERTRAM G. GOODHUE

This church complex, built by the Dominican Order, includes a Victorian Gothic priory, a school, and a neo-Gothic Holy Name Society building. After St. Patrick's Cathedral, this is the number-one choice for society weddings.

501
TEMPLE EMANU-EL
(SYNAGOGUE)

840 FIFTH AVENUE AT EAST 65TH STREET

1929, ROBERT D. KOHN, CHARLES BUTLER,
CLARENCE STEIN, AND MAYERS, MURRAY & PHILIP

Before the synagogue was built, this was the site of the Astor mansion, which made the Upper East Side a fashionable neighborhood. The temple, whose sanctuary seats 2,500, is ornamented with beautiful stained glass and mosaics. To get the full effect of their beauty, visit here as the sun is setting. As the light streams through the west-facing windows, a special glow is cast on everything inside.

502
REPUBLIC OF POLAND MISSION TO THE UNITED NATIONS

9 EAST 66TH STREET
BETWEEN FIFTH AND MADISON AVENUES

1912, ERNEST FLAGG

This airy townhouse was built for the architect's brother-in-law, Charles Scribner, of the family of publishers. Ernest Flagg also designed a house for his other brother-in-law, Arthur Scribner, at 39 East 67th Street. The flamboyant house next door to this one, 5 East 66th Street, was designed by Richard Howland Hunt for William J. Schiefflin, heir to his family's wholesale drug business.

503
AMERICAS SOCIETY

680 PARK AVENUE AT EAST 68TH STREET

1912, MCKIM, MEAD & WHITE

When this house, the residence of financier Percy Pyne, was built, the magazine *Architecture* reported that, "so few of New York residences appear like homes that, when one finds a house like this, one feels as if a day of Thanksgiving should be proclaimed." It was the home of the U.S.S.R. Delegation to the United Nations when Soviet Prime Minister Nikita Khruschev arrived for a UN session in 1960 and traded barbs with New Yorkers on the sidewalk from a second-floor window.

504
UNION CLUB

101 EAST 69TH STREET AT PARK AVENUE

1932, DELANO & ALDRICH

This is New York's oldest men's club, and most of the others were spun off by its members who disagreed with its policies. While many of those upstart clubs are dedicated to sports and other special interests, the Union still sticks to its roots as a gentleman's club of the old school. This building provides its members all of the comforts of home, and then some. It was one of the first buildings in the city with central air-conditioning.

505
SPANISH INSTITUTE

684 PARK AVENUE
BETWEEN EAST 68TH AND EAST 69TH STREETS

1926, MCKIM, MEAD & WHITE

This is the last of the magnificent row of townhouses in this block, built in what had been the garden of Percy Pyne's house next door, for his daughter and son-in-law, Oliver D. and Mary Pyne Filley. Both this and the Pyne house were in the process of demolition in 1965, when the Marquesa de Cuevas, a Rockefeller heiress, bought and donated them to the organizations that occupy them today.

506
HUNTER COLLEGE

695 PARK AVENUE, BETWEEN EAST 68TH
AND EAST 69TH STREETS AND LEXINGTON AVENUE

1913, C. B. J. SNYDER

Originally the Normal College of the City of New York, Hunter also operates a high school, providing its education students with hands-on experience in the classroom. Named for its first president, Hunter is now part of the City University of New York. It accepted only women before 1964, but today the sexes are equally represented in the student body, which has risen to more than 20,000.

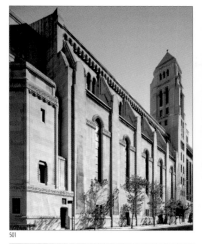

501

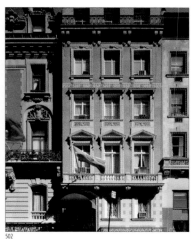

502

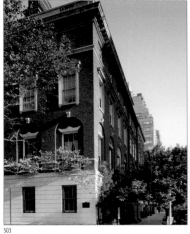

503

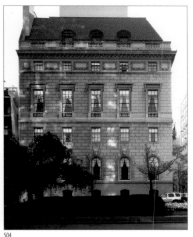

504

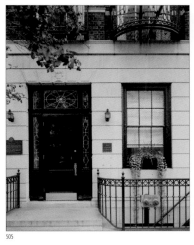

505

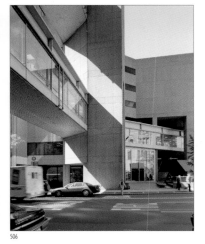

506

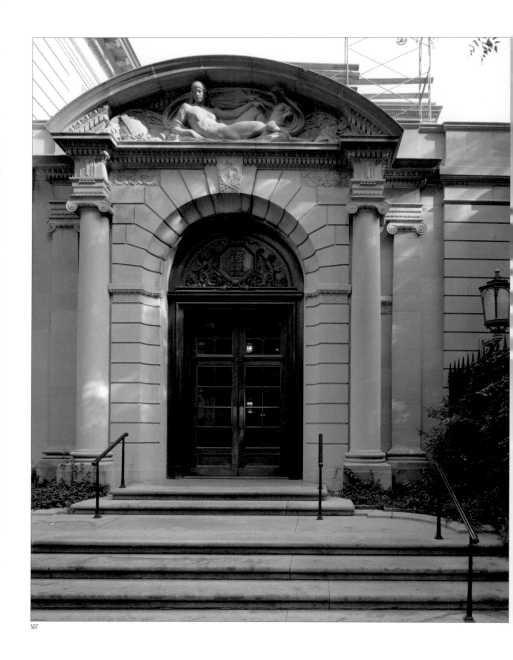

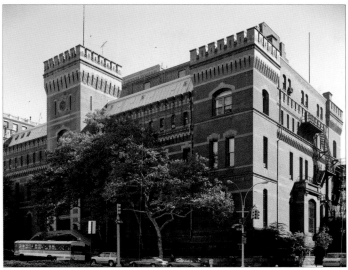

508

Frick Collection 𝒟

ONE EAST 70TH STREET AT FIFTH AVENUE

1914, CARRÈRE & HASTINGS

When steel magnate Henry Clay Frick first arrived in New York, he took a carriage ride through Central Park, past the mansion of his arch-rival, Andrew Carnegie. He resolved to build a mansion for himself, "... that will make Andy's look like a miner's shack," and this was the result. Frick was already one of the country's premier art collectors, thanks to the salesmanship of dealer Joseph Duveen, who steered him to architect Thomas Hastings for a building worthy of his collection. The dealer also recommended interior decorator Elsie de Wolfe to select antique furnishings from his own warehouse. After Mrs. Frick died in 1931, Duveen oversaw the mansion's transformation into a major art gallery.

Seventh Regiment Armory 𝒟

640 PARK AVENUE
BETWEEN EAST 66TH AND EAST 67TH STREETS

1879, CHARLES W. CLINTON

The Seventh Regiment was formed as a successor to the city's volunteer militias by some of New York's most prominent men, who personally paid for their own weapons and uniforms. In 1874, the city presented them with this site and, in the tradition of the regiment, its members paid for the armory. They engaged such designers as Louis Comfort Tiffany and Stanford White to create the first-floor public rooms and individual company rooms upstairs. The huge drill shed, extending out to Lexington Avenue, is modeled after the train shed in the original Grand Central Terminal. It is used today by the New York National Guard, but is also famous as the location of the annual antiques show and similar public events that require such an immense amount of open space.

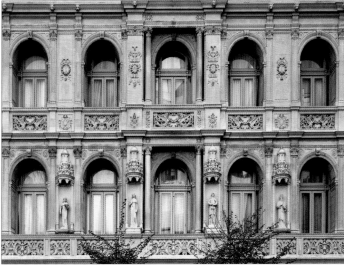

509

POLO/RALPH LAUREN

867 MADISON AVENUE AT 72ND STREET

1898, KIMBALL & THOMPSON

If Ralph Lauren had started from scratch, he couldn't have built a building that suits his image quite like this one does. It was built for Gertrude Rhinelander Waldo, but in spite of its charming personality, she chose to live across the street with her sister rather than move into her new home because her husband, former police commissioner Francis Waldo, died before it was finished. While it was being built, Mrs. Waldo toured Europe, picking up art objects to furnish it, but never unpacked the things she bought. Her mansion stood empty until 1920, when it was converted into retail space. It was returned to its original glory in 1984, when Ralph Lauren brought his boutique here.

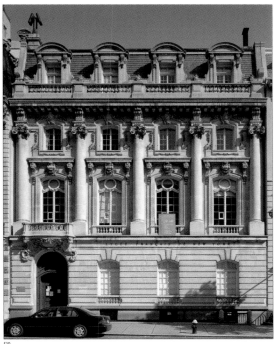

510

Lycée Français de New York

9 EAST 72ND STREET
BETWEEN FIFTH AND MADISON AVENUES

1899, FLAGG & CHAMBERS
1896, CARRÈRE & HASTINGS

Appropriate for a French school (which has since decided to move elsewhere), these two buildings are as reminiscent of Paris as any others in New York, not to mention that they may be the most beautiful townhouses in the city. The one on the left, no. 7, was built as a home for businessman Oliver Jennings, and its neighbor was intended as the home of furniture store heir, Henry T. Sloan. He and his wife were divorced less than two years after they moved into it. Publisher Joseph Pulitzer bought it and later sold it to banker James Stillman.

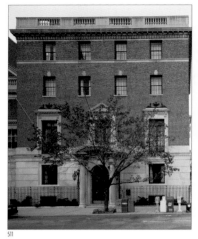

511

512

513

514

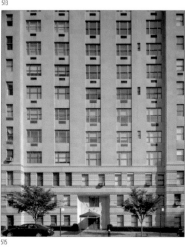

515

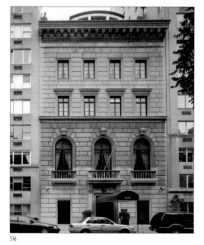

516

ISTITUTO ITALIANO DI CULTURA

686 PARK AVENUE
BETWEEN EAST 68TH AND EAST 69TH STREETS

1919, DELANO & ALDRICH

This house was built as the residence of William Sloane, president of the W. & J. Sloane furniture store. Today it houses the cultural division of the Italian Consulate, which has been located in the mansion next door since 1952. All of the impressive mansions on this wonderful block were built right after the railroad tracks that had previously run down the center of what is now Park Avenue were covered.

ASIA SOCIETY

725 PARK AVENUE AT EAST 70TH STREET

1981, EDWARD LARRABEE BARNES ASSOCIATES

This institution was organized in 1957 to encourage relations between Asia and the West. The building contains galleries displaying art from Japan, China, Tibet, and India, among other places. Most of its exhibitions are drawn from its own collections, which include the Mr. & Mrs. John D. Rockefeller III Collection of Asian Art. It also presents concerts and dance programs, as well as film screenings.

PAUL MELLON HOUSE

125 EAST 70TH STREET
BETWEEN PARK AND LEXINGTON AVENUES

1966, H. PAGE CROSS

This townhouse was built for Paul Mellon, a financier, philanthropist, and major art collector. One of the very few townhouses built over the previous half-century, its design was dictated by an old covenant that requires new building to be set back ten feet from the sidewalk. That was apparently no problem, because this French-inspired yellow stucco house is made all the more interesting by its high-walled front garden.

ATTERBURY HOUSE

131 EAST 70TH STREET

1871
ALTERED, 1911, GROSVENOR ATTERBURY

After Charles Lamed Atterbury bought this townhouse, he hired his son to expand and remodel it. The young architect went on to design the Metropolitan Museum's American Wing. Grosvenor Atterbury also designed the British-influenced Forest Hills Gardens, and he was responsible for the remodeling of an Eighth Street brownstone into the first home of the Whitney Museum.

19 EAST 72ND STREET

AT MADISON AVENUE

1937, ROSARIO CANDELLA AND MOTT B. SCHMIDT

Although a solid example of modern architecture, what makes this address important is the building it replaced, McKim, Mead & White's massive German Renaissance house for Charles L. Tiffany, the jeweler. When the elder Tiffany commissioned the project, his only request was that it should be big, and he left the details to the architect, Stanford White, and his son, Louis Comfort Tiffany, who also designed an apartment for himself in the building.

FRENCH CONSULATE

934 FIFTH AVENUE
BETWEEN EAST 74TH AND EAST 75TH STREETS

1926, WALKER & GILLETTE

Although new apartment buildings had replaced most of the Fifth Avenue mansions by the mid-1920s, making them passé, there was still room for one more, or least millionaire Charles E. Mitchell thought so when he built this one. It has the distinction of being the last mansion on the avenue, and it is every bit as beautiful as its predecessors that were destroyed in the name of progress.

980 MADISON AVENUE

BETWEEN EAST 75TH AND EAST 76TH STREETS

1950, WALKER & POOR

This building originally housed the auction galleries of Parke-Bernet, which merged with Sotheby's in 1964. The auction house is now on East 72nd Street and York Avenue, but its real estate division is still located in this building. The bronze allegorical sculpture on its façade by Wheeler Williams, representing Venus and Manhattan, symbolizes enlightenment brought to the city through the arts of distant lands.

927 FIFTH AVENUE

AT EAST 74TH STREET

1917, WARREN & WETMORE

This was one of the early apartment houses built to keep pace with a growing demand for a Fifth Avenue address in the years leading up to World War I. The pace slowed during the war and the hard times that followed it, but by 1920, architects and builders were busy again trying to create buildings like this one on a larger scale. The Fifth Avenue Association tried to nip the trend in the bud by forcing a zoning restriction limiting heights along this stretch of the avenue to seventy-five feet. It was overturned by the courts in 1923, and the limit went back up to 150 feet.

ST. JEAN BAPTISTE CHURCH ℒ
(ROMAN CATHOLIC)

1067–1071 LEXINGTON AVENUE AT EAST 76TH STREET

1914, NICHOLAS SERRACINO

This church, which would be very much at home in Rome, was built for the French-Canadian community that dominated the neighborhood after the turn of the last century. It replaces an earlier one on the same site, and was funded by streetcar millionaire Thomas Fortune Ryan because, it was said, he had been forced to stand during mass one day at the smaller original. The building is especially notable for its Corinthian portico and its twin towers. Its French-style organ is among the best anywhere in New York, and its musical programs are among the city's most popular.

EAST 73RD STREET

BETWEEN LEXINGTON AND THIRD AVENUES

Every one of the charming houses on this block was originally a stable or carriage house. When the Upper East Side was developing into an enclave for the wealthy, these blocks east of Park Avenue were literally the other side of the tracks because of the railroad running down the center of the avenue. But it was the right side for housing horses, and their owners made sure their digs were classy. Near the close of the nineteenth century, there were about 5,000 stables of all types in the city, and its population of horses was close to 74,000. The less wealthy kept theirs in large communal stables, predecessors of today's parking garages.

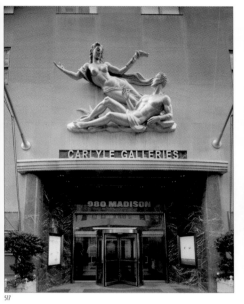

517

518

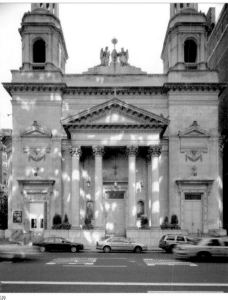

519

520

521

521

NYU Institute of Fine Arts

ONE EAST 78TH STREET AT FIFTH AVENUE

1912, HORACE TRUMBAUER

This freestanding mansion was built by James B. Duke, the founder of the American Tobacco Company. It replaced the former Henry H. Cook house, which was said to have been the best-built house ever demolished in New York, but Duke had something better in mind. It is finished in marble on all four sides, and contains thirty rooms, including eight bedrooms, each with its own full bath, and another twelve for the comfort of the servants. When Duke died in 1925, his thirteen-year-old daughter Doris inherited $50 million and became one of New York's first "poor little rich girls." Mrs. Duke continued to live here until 1957, when she gave her $1.6 million mansion to New York University and moved to the Stanhope Hotel.

522

WHITNEY MUSEUM OF AMERICAN ART

945 MADISON AVENUE AT EAST 75TH STREET

1966, MARCEL BREUER & ASSOCIATES

Before he began this project, architect Marcel Breuer, a member of the Bauhaus group, announced that his Whitney Museum would reflect the vitality of the street. But somehow that objective got lost at the drawing board. He wound up designing a structure separated from the street by what is best described as a moat, complete with a simulated drawbridge at the entrance. Nevertheless, this is an art museum and it's what's inside that counts. The highly innovative gallery space inside the Whitney makes it possible to showcase modern American art without any fussy distractions from the building itself.

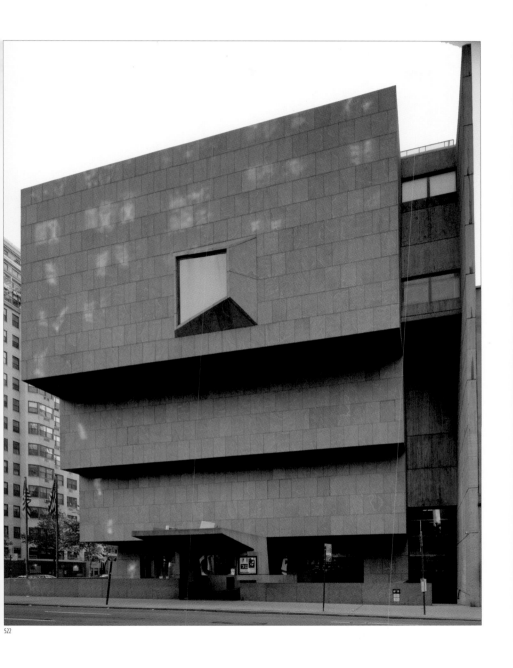

522

523

524

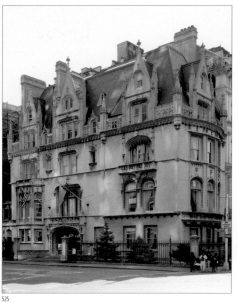

525

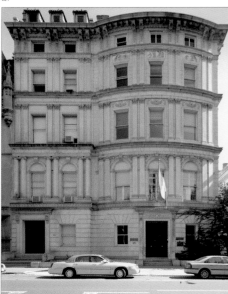

526

HOTEL CARLYLE

35 EAST 76TH STREET AT MADISON AVENUE

1929, BIEN & PRINCE

The tower on this hotel, which the architect said was inspired by Westminster Cathedral in London, has become symbolic of the fashionable Upper East Side. These are actually two buildings, a forty-story apartment hotel on the south side, and a seventeen-story apartment building overlooking 77th Street. This was the hotel of choice for Presidents Harry S. Truman and John F. Kennedy, and its bar is the New York performing space of singer Bobby Short, who was here to serenade those Presidents and is still going strong.

HARKNESS MANSION ℒ

ONE EAST 75TH STREET AT FIFTH AVENUE

1908, JAMES GAMBLE ROGERS

Standard Oil heir Edward S. Harkness was every inch a gentleman. He insisted on only the best for this house, and didn't flinch at the cost of imported marble and the highest quality materials throughout—but he wasn't above some simple economies. The basement has a huge refrigerator opening onto a moat so that, when the temperature goes down, the doors can be opened to conserve electricity. When his widow died in 1950, she left this house to the Commonwealth Fund, which had been established by her mother-in-law "for the welfare of mankind." The house next door, no. 4, was transformed by their daughter, Rebekah Harkness, into a home for her ballet company, which she disbanded ten years after investing $20 million to bring it to life.

UKRAINIAN INSTITUTE ℒ

2 EAST 79TH STREET

1899, C. P. H. GILBERT

This French chateau, complete with a moat, was built for Isaac D. Fletcher, a self-made man who had become president of the New York Coal Tar Company and the Barrett Manufacturing Company. He commissioned C. P. H. Gilbert to build him a mansion that resembled William K. Vanderbilt's home down Fifth Avenue at 58th Street, and the architect succeeded brilliantly. Fletcher filled the house with one of the city's finest art collections, including a French Impressionist painting of this house. When he died, he left 251 paintings and $3 million to take care of them to the Metropolitan Museum.

CULTURAL SERVICES, EMBASSY OF FRANCE

972 FIFTH AVENUE
BETWEEN EAST 78TH AND EAST 79TH STREETS

1909, McKIM, MEAD & WHITE

This house was commissioned by Oliver Whitney as a wedding gift for his nephew, Harry Payne Whitney, and his bride, the former Gertrude Vanderbilt. Payne Whitney was the son of William C. Whitney, of the family of financiers, who was one of America's foremost horse-breeders. When the elder Whitney died in 1904, he owned no fewer than ten mansions in the city.

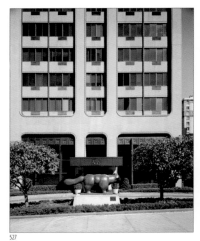

527

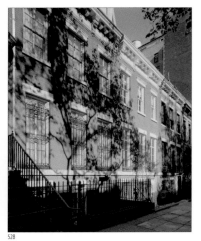

528

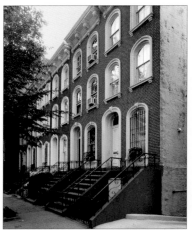

529

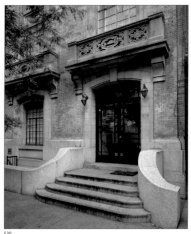

530

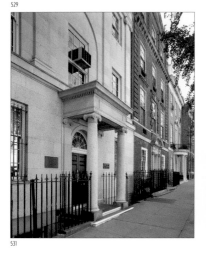

531

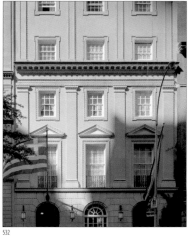

532

PARK 900

900 PARK AVENUE, AT EAST 79TH STREET

1973, PHILIP BIRNBAUM

A slab that is set back from both Park Avenue and 79th Street, this twenty-eight story tower rises straight up from a landscaped plaza, removing it from the normal building wall on both sides. What is more, the fact that Park Avenue slopes at this point forces the plaza below grade, creating a barrier to tenants and visitors alike.

157–165 EAST 78TH STREET ℒ

BETWEEN LEXINGTON AND THIRD AVENUES

1861, HENRY ARMSTRONG

Brick Italianate row houses like these were fashionable in 1850s, and these five, all that remain of eleven on the block, were built as speculative houses to catch the growing wave of middle-class New Yorkers eager to relocate to the Upper East Side.

208–218 EAST 78TH STREET ℒ

BETWEEN SECOND AND THIRD AVENUES

1865, WARREN AND RANSOM BEMAN

These six Italianate houses were once part of a row of fifteen identical buildings. They were built as speculative housing, and, reflecting an attempt to squeeze more of them into the block, they are each only about thirteen feet wide, compared to the city's standard of twenty-five-foot building lots.

ISELIN HOUSE ℒ

59 EAST 79TH STREET
BETWEEN MADISON AND PARK AVENUES

1909, FOSTER, GADE & GRAHAM

Built for lawyer John H. Iselin, this is one of four adjacent landmarked houses that made this block one of the city's most fashionable addresses in the years before the First World War. It is an unusual combination of French Renaissance and Classical styles that harmonize wonderfully.

130 EAST 80TH STREET ℒ

BETWEEN PARK AND LEXINGTON AVENUES

1916–1930

This row of Georgian houses is the work of Cross & Cross and Mott B. Schmidt. It includes the former home of Vincent Astor (no. 130 at the far right) now occupied by the Junior League of the City of New York, which was formed in 1901 to enlist debutantes in helping to improve social conditions among the poor.

GREEK CONSULATE GENERAL ℒ

67–69 EAST 79TH STREET
BETWEEN MADISON AND PARK AVENUES

1908, CARRÈRE & HASTINGS

This Parisian townhouse was built by the prominent lawyer George Rives, one of the city's most active supporters. He served on the boards of Columbia University, the New York Public Library, and New York Hospital. He was also on the board of the New York City Rapid Transit Corporation at the time it was building the city's first subway.

533

Otto Kahn House ℒ

One East 91st Street at Fifth Avenue

1918, J. Armstrong Stenhouse
and C. P. H. Gilbert

This Italian Renaissance palazzo, which is now the Convent of the Sacred Heart and a boarding school, was built for Otto H. Kahn, a member of Kuhn, Loeb & Company and an expert on railroad financing at a time when investing in railroads was bigger than technology is today. He made an indelible mark on the city as chairman of the Metropolitan Opera, a post he held for twenty-three years, beginning in 1908. He was also active in luring influential foreign dance and theatrical companies to New York and making it their number one American destination, and he supported such American companies as the Theater Guild and the Provincetown Players.

534

Church of St. Ignatius Loyola ℒ
(Roman Catholic)

980 Park Avenue at East 84th Street

1900, Schickel & Ditmars

This huge church was erected on the foundations of an earlier church dedicated to St. Laurence O'Toole, the patron saint of the Irish immigrants who settled in this neighborhood when it was still a factory district, and when Park Avenue was the right-of-way for a railroad whose smoke-belching trains established a quality-of-life standard for people who had never heard the term "air pollution."

535

DeKoven House ℒ

1025 Park Avenue
between East 85th and East 86th Streets

1912, John Russell Pope

The original owner of this Elizabethan house, Reginald DeKoven, was a songwriter, and he included an old English minstrel gallery at the back of the Great Hall, a baronial room behind the huge bay windows overlooking Park Avenue. All of the woodwork, the fireplaces, and the plaster ceilings were modeled after English manor houses and inns.

536

998 Fifth Avenue ℒ

At 81st Street

1912, McKim, Mead & White

This building marks an end, and a beginning, of the Fifth Avenue streetscape. It was the first luxury apartment house built on the avenue above 59th Street, and it put an end to the practice of building individual townhouses. At the time, New Yorkers still weren't sure it was a good idea to share their roof with other families, but McKim, Mead & White softened the blow by filling only half the block front, and arranging the apartments, which rented for $25,000 a year, so that only servants' quarters would overlook the courtyard.

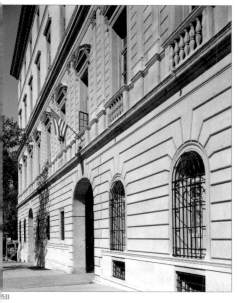

533

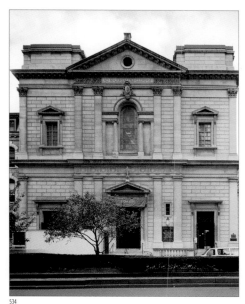

534

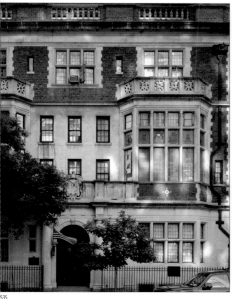

535

536

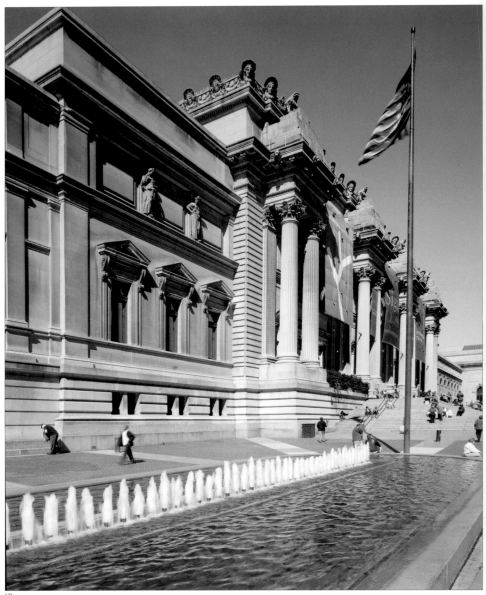

METROPOLITAN MUSEUM OF ART

FIFTH AVENUE
BETWEEN EAST 80TH AND EAST 84TH STREETS

1870, CALVERT VAUX AND JOSEPH WREY MOULD,
RICHARD MORRIS HUNT

This great building was begun in the 1870s based on designs by Calvert Vaux and Jacob Wrey Mould, who created most of the buildings and architectural features of Central Park. The core building for the museum has long since been swallowed up by a host of later wings, including the elegant central façade and the East Wing, which contains the inspiring Main Hall. They were designed in 1902 by Richard Morris Hunt. The original building is exposed at the southeast wall of the Lehman Wing, which was added in 1975. Among the other additions are the Thomas J. Watson Library, housing 150,000 books, built on the west side in 1964, and the Sackler Wing, whose centerpiece is the ancient Egyptian Temple of Dendur, opened in 1978. The Great Hall was altered and restored in 1970. The biggest museum in the western hemisphere, the Met attracts more than six million visitors a year to its eighteen diverse departments. Its holdings include more than 3.3 million treasures, and in spite of almost continuous expansion, there still isn't enough space to display them all.

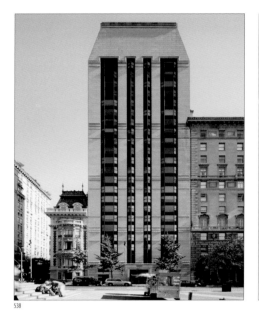

538

1001 Fifth Avenue

BETWEEN EAST 81ST AND EAST 82ND STREETS

1980, JOHNSON/BURGEE
WITH PHILIP BIRNBAUM & ASSOCIATES

When plans were announced for this high-rise mess, the developers assured their critics that it would blend right in among its elegant neighbors. What they delivered was a fake mansard roof that doesn't even bother to hide the props that hold it up. This is a good lesson to watch not what developers say, but what they do.

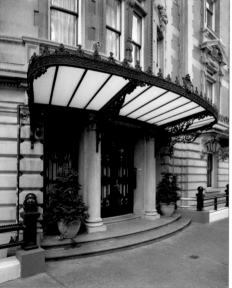

539

539

Duke House ℒ

1009 FIFTH AVENUE AT 82ND STREET

1901, WELCH, SMITH & PROVOT

This Beaux Arts townhouse was built as a speculative venture, but it wasn't on the market very long before it was sold to Benjamin Duke, a director of the American Tobacco Company. Various members of the Duke family have lived here over the years since then.

NATIONAL ACADEMY OF DESIGN *L*

1083 FIFTH AVENUE
BETWEEN EAST 89TH AND EAST 90TH STREETS

1915, TURNER & KILIAN AND OGDEN CODMAN, JR.

This institution was formed in 1896 by Samuel
F. B. Morse and others as an association to pro-
mote artistic design, with membership limited
to professional artists. This building was once
the home of Collis P. Huntington, whose wife,
the brilliant sculptor Anna Hyatt Huntington,
was a member of the Academy. It houses a
major art school and gallery space for chang-
ing exhibitions of the work of its members.

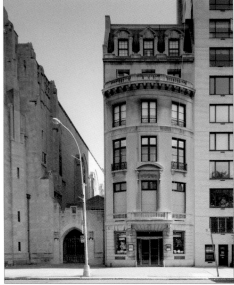

540

CONSULATE OF THE RUSSIAN FEDERATION *L*

9 EAST 91ST STREET
BETWEEN FIFTH AND MADISON AVENUES

1903, CARRÈRE & HASTINGS

When Mr. & Mrs. William J. Sloane built a
house for their daughter, Adele, they also built
this one next door for their younger daughter,
Emily, and her husband, John Henry Hammond.
When young Hammond was told of their inten-
tions, he protested that "I am not going to be
considered a kept man," but he accepted the
gift anyway. Their son, John, was a famous jazz
promoter and when he invited Benny Good-
man to play at one of the musicales that were
common in the mansion's music room, his
mother wouldn't hear of it unless the clarinetist
promised to confine himself to Mozart. Good-
man later became her son-in-law when he mar-
ried John's sister, Alice.

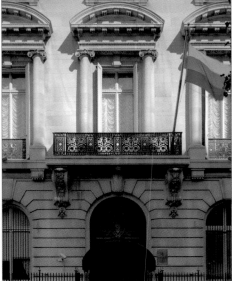

541

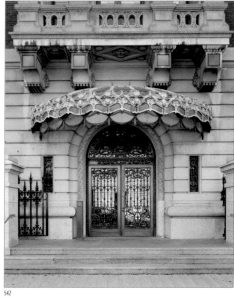

542

COOPER-HEWITT MUSEUM 𝓛

2 EAST 91ST STREET AT FIFTH AVENUE

1903, BABB, COOK & WILLARD

In 1898, when Andrew Carnegie bought this plot of land at the highest point along Fifth Avenue, nobody would even think of building a mansion north of the Metropolitan Museum, and that was what the steel baron liked about it. He hired an agent to secure options on this and other nearby lots and swore him to secrecy so that the sellers wouldn't know who their new neighbor would be and raise their prices accordingly. Carnegie then ordered his architects to give him the "most modest, plainest and most roomy house in New York," adding, "building a grand palace is foreign to our tastes." The result was a plain Georgian mansion, but it certainly wasn't modest. The house was converted, but little changed, to the Smithsonian's National Museum of Design in 1977.

SOLOMON R. GUGGENHEIM MUSEUM 𝓛

1071 FIFTH AVENUE
BETWEEN EAST 88TH AND EAST 89TH STREETS

1959, FRANK LLOYD WRIGHT

Built to house the vast collection of non-objective paintings assembled by minerals millionaire Solomon R. Guggenheim, this is Frank Lloyd Wright's only New York building, other than a residence on Staten Island. His involvement in the project began in 1943, but the building itself did not become a reality until sixteen years later. As completed, it contains a ramp coiling at a five-percent grade five times around the ninety-five-foot-high rotunda. The *Times*'s art critic, John Canaday, proclaimed, "the pictures disfigure the building and the building disfigures the pictures." The paper's architecture critic, Ada Louise Huxtable, on the other hand, felt that, "Mr. Wright has given us an impressive demonstration of modern construction in reinforced concrete at its most imaginative."

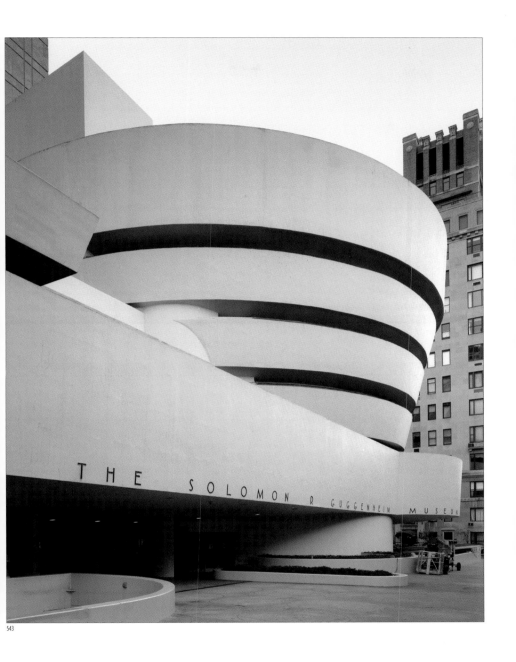

543

9–17 EAST 90TH STREET ℒ

BETWEEN FIFTH AND MADISON AVENUES

1903–28

This wonderful mix of houses ranges from Colonial Revival to Beaux Arts to neo-Federal and neo-Georgian, without a single dissenting note. It is one of the most beautiful blocks here in Carnegie Hill.

1261 MADISON AVENUE ℒ

AT 90TH STREET

1901, BUCHMAN & FOX

When this elegant Beaux Arts apartment house was built, similar elegance had not yet quite arrived in the neighborhood, which was filled with middle-class housing and tenements. Its builders knew their day would come.

1321 MADISON AVENUE ℒ

AT EAST 93RD STREET

1891, JAMES E. WARE

This Queen Anne-style brick-faced house with a pyramid roof at the corner was built as the anchor for a row of five brownstone-fronted houses, all of which have since disappeared. Its entrance on the street side is set above an impressive high stoop made of stone.

544

545

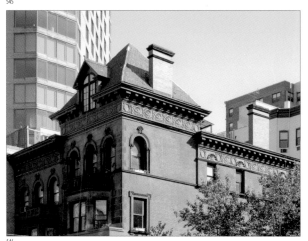

546

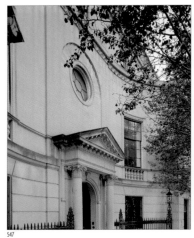

547

548

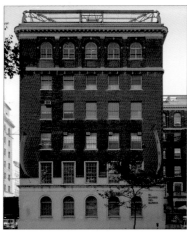

549

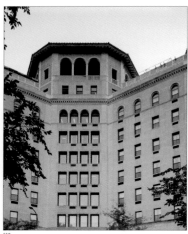

550

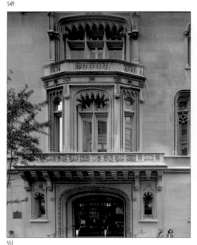

551

552

547
SMITHERS ALCOHOLISM CENTER ℬ

56 EAST 93RD STREET
BETWEEN MADISON AND PARK AVENUES

1931, WALKER & GILLETTE

This was the last palace to be built on the Upper East Side. It was the home of stockbroker William Loew, one of the lucky few to survive the Depression. After Loew died, it became the home of showman Billy Rose, and is now an addiction treatment center affiliated with St. Luke's-Roosevelt Hospital.

548
RUSSIAN ORTHODOX SYNOD OF BISHOPS

67–76 EAST 93RD STREET
BETWEEN MADISON AND PARK AVENUES

1928–31, DELANO & ALDRICH

This complex of neo-Federal houses was owned by George F. Baker, Jr., the chairman of the First National Bank (now Citibank), who enlarged it and added to it. It was converted for use as a Russian Orthodox Church in 1958.

549
EL MUSEO DEL BARRIO

1230 FIFTH AVENUE
BETWEEN EAST 104TH AND EAST 105TH STREETS

This is the northernmost of the institutions along "Museum Mile." The East Harlem neighborhood, bounded by Fifth and Third Avenues, East 120th and East 96th Streets, was largely an Italian enclave before Puerto Ricans began settling here in the 1920s, calling it *El Barrio*, "the neighborhood." After World War II, other Latin American groups settled here, too, and this museum is a showcase for the art of their combined cultures.

550
TERENCE CARDINAL COOKE HEALTH CARE CENTER

1240–1248 FIFTH AVENUE
BETWEEN EAST 105TH AND EAST 106TH STREETS

1921, YORK & SAWYER

This facility was converted into a nursing home by the Roman Catholic Archdiocese of New York in 1979. It was originally the Flower Fifth Avenue Hospital, a teaching facility associated with the New York Medical College.

551
THE JEWISH MUSEUM ℬ

1109 FIFTH AVENUE AT 92ND STREET

1908, C. P. H. GILBERT

This was originally the home of Felix and Frieda Warburg, whose fortune was made through the Wall Street firm of Kuhn, Loeb & Company. Among its original furnishings was a pipe organ that was outfitted with piano rolls, much like the band organs on carousels. Mrs. Warburg gave the house to the Jewish Museum in 1944, and it has since been expanded to more than twice its original size in a seamless reconstruction.

552
INTERNATIONAL CENTER OF PHOTOGRAPHY ℬ

1130 FIFTH AVENUE AT EAST 94TH STREET

1915, DELANO & ALDRICH

This Georgian Revival House was built by Willard Straight, a diplomat and financier whose specialty was Far Eastern Affairs. He was a founder of the magazines *The New Republic* and *Asia*. The house became the headquarters of the National Audubon Society and later the International Center of Photography, founded in 1974 by photojournalist Cornell Capa. The center is in the process of moving to larger quarters on Sixth Avenue at 43rd Street.

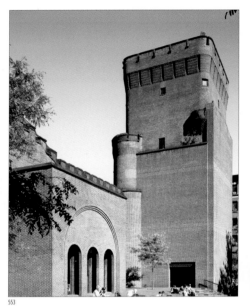

553

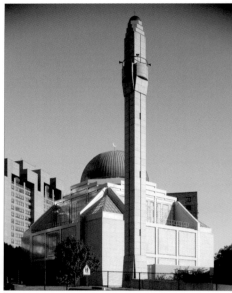

554

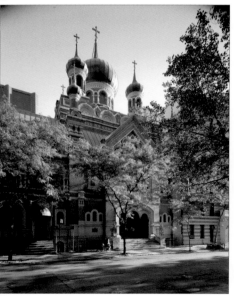

555

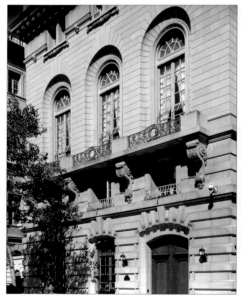

556

SQUADRON A ARMORY FAÇADE

MADISON AVENUE
BETWEEN EAST 94TH AND EAST 95TH STREETS

1895, JOHN ROCHESTER THOMAS

When the armory was demolished in 1966 to make way for the new Hunter College High School, this portion of its battlemented façade was preserved to be used as a very unusual entrance to the school's playground, and a memorial to the massive building that once filled an entire block.

ISLAMIC CULTURAL CENTER
(MOSQUE)

201 EAST 96TH STREET AT THIRD AVENUE

1991, SKIDMORE, OWINGS & MERRILL

At a time when other religions were reporting declining memberships, Islam was growing by leaps and bounds in the city. Although there have been Muslims in New York since colonial times, their numbers started to grow in the early part of the twentieth century as immigrants began arriving from Eastern Europe for the first time. After the United Nations moved to New York, delegates from Islamic countries, led by the Pakistani delegation, formed the Islamic Center, which planned and eventually built this impressive mosque. The building, which combines the traditional dome and minaret with modern touches, is angled on the site to face Mecca. Financing for the building was largely arranged by Kuwaiti interests.

ST. NICHOLAS CATHEDRAL
(RUSSIAN ORTHODOX)

15 EAST 97TH STREET
BETWEEN FIFTH AND MADISON AVENUES

1902, JOHN BERGENSEN

Russian immigrants established their Orthodox religion in New York in the early years of the twentieth century, and this elaborate Victorian structure, with its traditional onion-shaped domes, was among the first visible signs that they were here to stay. Mass is still said here in Russian.

DUCHENE RESIDENCE SCHOOL

7 EAST 91ST STREET
BETWEEN FIFTH AND MADISON AVENUES

1902, WARREN, WETMORE & MORGAN

When Andrew Carnegie began selling off his excess buildings lots, he sold this mid-block site to Mr. & Mrs William J. Sloane with the understanding that only a one-family house could be built between it and the Fifth Avenue corner, leaving a seventeen-foot swath of undeveloped land to ensure light and air for the freestanding mansion they themselves would build. The mansion is now part of the Convent of the Sacred Heart, which occupies the corner house that was eventually built.

CHURCH OF THE HOLY TRINITY \mathcal{L}
(EPISCOPAL)

316–332 EAST 88TH STREET
BETWEEN FIRST AND SECOND AVENUES

1897, BARNEY & CHAPMAN

This church is a memorial to her mother and father by Serena Rhinelander, and was built on land that had been owned by her family for almost a century before it was built in 1879. It is part of a complex that includes a rectory and parish house as well as the beautiful church itself, with a unique belltower overlooking a quiet garden court.

HOUSE OF THE REDEEMER \mathcal{L}

7 EAST 95TH STREET
BETWEEN FIFTH AND MADISON AVENUES

1916, EGISTO FABBRI AND GROSVENOR ATTERBURY

When Edith Vanderbilt Fabbri and her husband came home from Paris, they abandoned their former mansion on East 62nd Street and built this Italian Renaissance house, marked by the Fabbri family crest in the courtyard's iron gate. Mrs. Fabbri gave the property to the Episcopal Church in 1949, and it is now used as a center for retreats.

LUCY DREXEL DAHLGREN HOUSE \mathcal{L}

15 EAST 96TH STREET
BETWEEN FIFTH AND MADISON AVENUES

1916, OGDEN CODMAN, JR.

Ogden Codman, Jr., one of the most important residential architects in the early twentieth century and an unabashed Francophile, designed this house as a twin to his own a few doors down the street. Lucy Dahlgren was a busy heiress, too busy to be bothered with running a house like this, and it became the residence of Pierre Cartier, the founder of the jewelry firm that bears his name.

MT. SINAI HOSPITAL CENTER

FIFTH AVENUE
BETWEEN EAST 98TH AND EAST 102ND STREETS

ORIGINAL BUILDING, 1904, ARNOLD W. BRUNER
ANNENBERG BUILDING, 1976, SKIDMORE, OWINGS & MERRILL

Central Park strollers can't miss the hulking thirty-one story tower rising behind this gate. It houses the hospital's School of Medicine. Its façade is Cor-ten steel, protected from further corrosion by a thin coating of rust, which, along with its windows of dark-tinted glass makes it a forbidding presence in this huge complex.

RUPPERT TOWERS

EAST 90TH TO EAST 92ND STREETS
BETWEEN SECOND AND THIRD AVENUES

1976, DAVIS & ASSOCIATES

This huge apartment complex and its similar neighbor, Yorkville Towers, are on a site once occupied by a brewery owned by Jacob Ruppert, who also owned the New York Yankees. Although his sideline makes Colonel Ruppert the best-remembered of the men who ran some 125 breweries in New York and Brooklyn in the 1870s, his operation ranked eighth among all the competitors.

148–156 EAST 89TH STREET \mathcal{L}

BETWEEN LEXINGTON AND THIRD AVENUES

1887, HUBERT, PIRSSON & CO.

These six Queen Anne houses are the survivors from a row of ten that were built as speculative housing by William Rhinelander on land that his family acquired in 1812. The houses are connected by a continuous mansard roof that is punctuated by dormers and gables, and a series of chimneys.

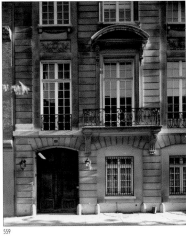

557

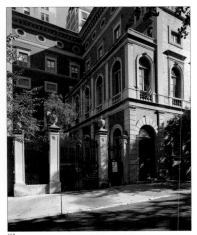

558

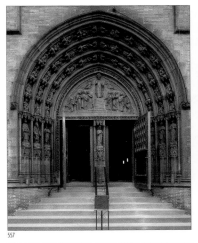

559

560

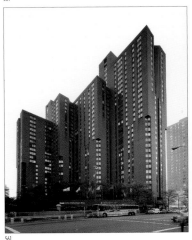

561

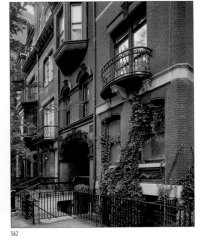

562

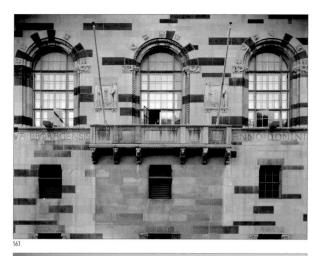

563

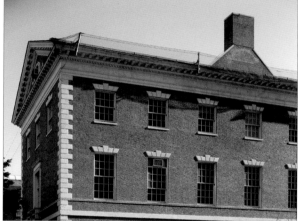

564

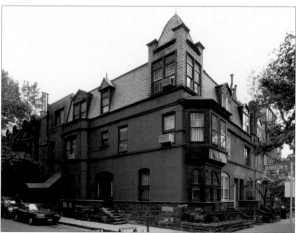

565

NEW YORK ACADEMY OF MEDICINE

563

1216 FIFTH AVENUE AT EAST 103RD STREET

1926, YORK & SAWYER

People in search of a second opinion on medical matters can do their own research here in the Academy's health collection, which has more than 700,000 items and a friendly staff to provide assistance. The world's largest collection of cookbooks is also here, donated by a physician who believed that the road to good health begins with good nutrition.

MUSEUM OF THE CITY OF NEW YORK

564

FIFTH AVENUE
BETWEEN EAST 103RD AND EAST 104TH STREETS

1930, JOSEPH H. FREEDLANDER

This Georgian building houses art and artifacts that reflect life in the city from Colonial times. The treasures include costumes and decorative materials related to the theater, and several fascinating period rooms. The Museum has announced plans to move from here down to the newly restored Tweed Courthouse behind City Hall.

HENDERSON PLACE

565

EAST 86TH STREET AT EAST END AVENUE

1882, LAMB & RICH

These twenty-four Queen Anne houses grouped together in a little enclave were built as speculative housing for "persons of moderate means" by John C. Henderson, who had grown rich himself selling fur hats.

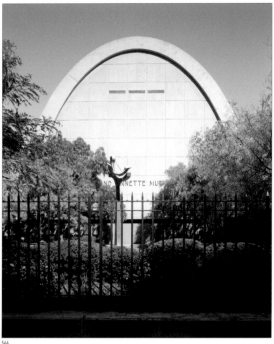

566

ASPHALT GREEN \mathcal{L}

EAST 91ST STREET AT FDR DRIVE

1944, KAHN & JACOBS

This was originally the Municipal Asphalt Plant, where they mixed the ingredients to repair all of the city's potholes. Based on principles pioneered by the French architect Le Corbusier, it was the first successful use of reinforced concrete to create a parabolic arch in America. Its arched steel frame allowed for an immense column-free room to house the massive machinery inside. Robert Moses condemned it as a "cathedral of asphalt," which he predicted would surely lead to "plenty of horrible stuff in statuary and architecture." After the plant was closed down in 1968, it stood empty and unused for almost fifteen years before it was recycled as a neighborhood recreation center.

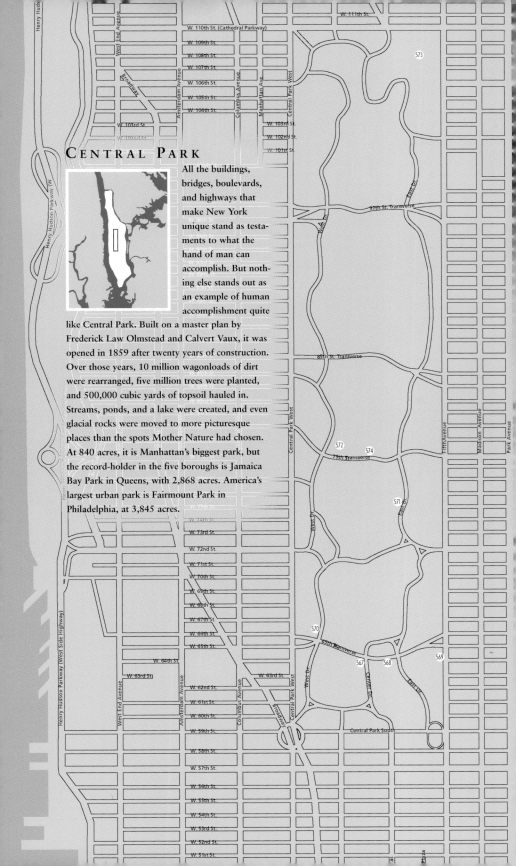

CENTRAL PARK

All the buildings, bridges, boulevards, and highways that make New York unique stand as testaments to what the hand of man can accomplish. But nothing else stands out as an example of human accomplishment quite like Central Park. Built on a master plan by Frederick Law Olmstead and Calvert Vaux, it was opened in 1859 after twenty years of construction. Over those years, 10 million wagonloads of dirt were rearranged, five million trees were planted, and 500,000 cubic yards of topsoil hauled in. Streams, ponds, and a lake were created, and even glacial rocks were moved to more picturesque places than the spots Mother Nature had chosen. At 840 acres, it is Manhattan's biggest park, but the record-holder in the five boroughs is Jamaica Bay Park in Queens, with 2,868 acres. America's largest urban park is Fairmount Park in Philadelphia, at 3,845 acres.

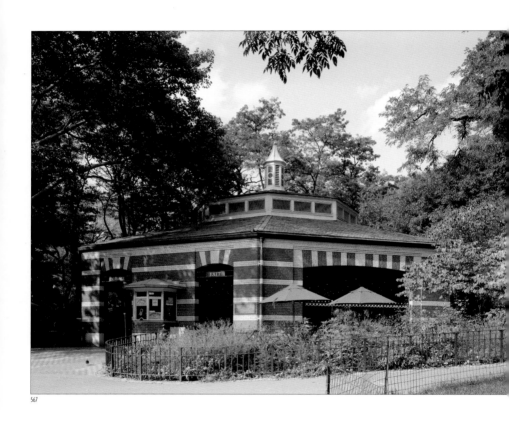

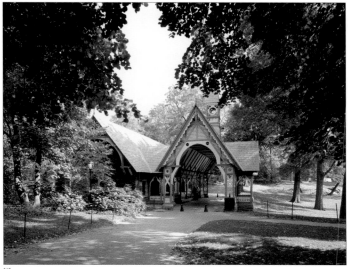

568

FRIEDSAM MEMORIAL CAROUSEL

SOUTHEAST CENTRAL PARK
NEAR THE 65TH STREET TRANSVERSE
AND CENTER DRIVE

There has been a carousel in Central Park for more than a century, but the original was virtually destroyed by a fire in 1950. This one was donated by the Michael Friedsam Foundation a year later. The remains of the original were reassembled at Bronx Beach Playland. The Foundation also rebuilt the carousel in Brooklyn's Prospect Park the following year. Both merry-go-rounds have horses that were recycled from Coney Island, when they'd outlived their usefulness there. They represent a proud tradition dating back to the 1870s, when animal carvers created the first—and the best—carousel horses in what was known as the "Coney Island Style." The Central Park horses were hand-carved by Harry Goldstein, a master of the style.

THE DAIRY

SOUTHEAST CENTRAL PARK AT 65TH STREET
1870, CALVERT VAUX

The entire southern end of Central Park was originally intended as the province of mothers and their children. There were no playgrounds in any other part of the park. The Dairy was used as a refreshment center for them back at a time when fresh milk was prohibitively expensive and of poor quality. A herd of cows, which grazed in the nearby meadows and added to the park's bucolic atmosphere, provided the milk. It has now been transformed into the park's information center. The hilltop immediately to the west was originally called the Kinderberg, or "children's mountain." In 1954, a small version of the carousel pavilion was built as a shelter, so that park visitors could enjoy games of chess and checkers out of reach of the noonday sun.

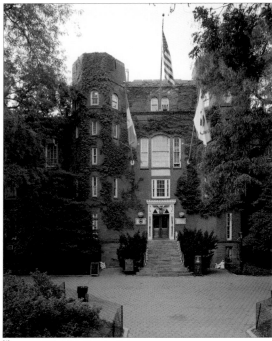

569

THE ARSENAL

FIFTH AVENUE AT EAST 64TH STREET

1848, MARTIN E. THOMPSON

This is the headquarters of the city's Parks Department, which moved here in 1934. Prior to that, it served as a police precinct, and the office of the weather bureau. For a time it was the home of the American Museum of Natural History, as well as the menagerie that later became the Central Park Zoo. In the beginning, though, it was an ammunition dump for the city's militia. Reminders of those glorious days live on in the central stairway, whose newell posts resemble cannons. The balusters on the railings represent rifles, and the artillery theme continues with cannonballs guarded by a carving of an eagle. Its eight crenellated towers complete the image. Despite all that, this is a peaceful place within the city's greatest sanctuary.

570

TAVERN-ON-THE-GREEN

CENTRAL PARK WEST AT WEST 67TH STREET

1870

Originally called the Sheep Fold because of its use as quarters for the herd of sheep that kept the grass clipped on the meadow across the Drive, this building was converted into a restaurant in the 1930s. After expansion and remodelling twenty years later, it became what it remains to this day: one of the most successful restaurants anywhere in the United States. Its new incarnation was the inspiration of the late Warner LeRoy, who added a highly theatrical dining room that could be the setting for a Viennese operetta. As he described it, he intended to make it "a kind of living theater in which the diners are the most important members of the cast." The glass walls of the dining room overlook a topiary-filled outdoor dining area with glittering lights shining from the trunks and branches of the surrounding trees. Eating there is like celebrating Christmas all year round.

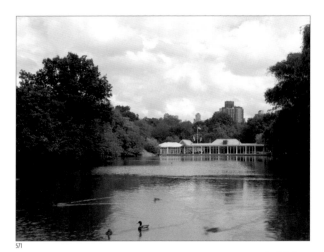

571

572

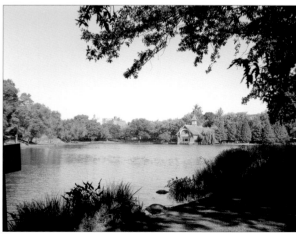

573

LOEB BOATHOUSE

CENTRAL PARK LAKE ON EAST DRIVE
NEAR 74TH STREET

1954, STUART CONSTABLE

The first boats were put on Central Park Lake in 1860, most of which were launched from a boathouse at 72nd Street. The second version of that boathouse, built in 1924, was torn down in 1954, and replaced by this one at the head of the lake, a gift of Adeline and Carl M. Loeb. This is where you can rent one of the lake's famous rowboats.

SWEDISH COTTAGE

CENTRAL PARK WEST DRIVE AT WEST 80TH STREET

Now a marionette theater, this charming structure, patterned after a Scandinavian schoolhouse, was built as the Swedish pavilion for the 1876 Centennial Exposition in Philadelphia. It was moved here when the fair closed, and has recently been restored to its original condition.

HARLEM MEER BOATHOUSE

CENTRAL PARK NORTH AT 110TH STREET

1947

All of the bodies of water in Central Park are man-made and filled with water from the city system. ("Harlem Meer" means "sea" in Dutch.) The boathouse was, for a time, a nightclub here at the edge of Harlem, and is now a discovery center offering such things as fishing rods and tackle for the fun of catch-and-release fishing by neighborhood youngsters.

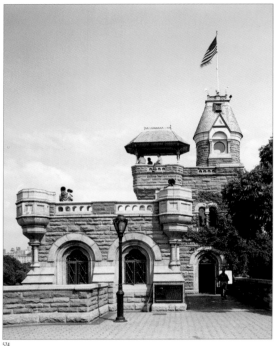

574

BELVEDERE CASTLE

VISTA ROCK, CENTER OF CENTRAL PARK AT 81ST STREET

1869, CALVERT VAUX

This information center operated by the Central Park Conservancy is also the local outpost of the U.S. Weather Service, which has been reporting temperature and rainfall measurements at this spot since 1919. In the park's original plan, the diminutive castle was built on this 135-foot rock (the highest point in the park) to present a vista for strollers down on the Mall. Because of its size, its appearance off in the distance makes it seem to be miles away rather than just a couple of blocks. It also looks down into the Delacorte Theater, providing unusual views of the free productions of Shakespeare in the Park presented there every summer. The best way to approach Belvedere Castle is from the West Drive at the Swedish Cottage, where a paved pathway climbs up through the Shakespeare Garden, among the best gardens Central Park has to offer.

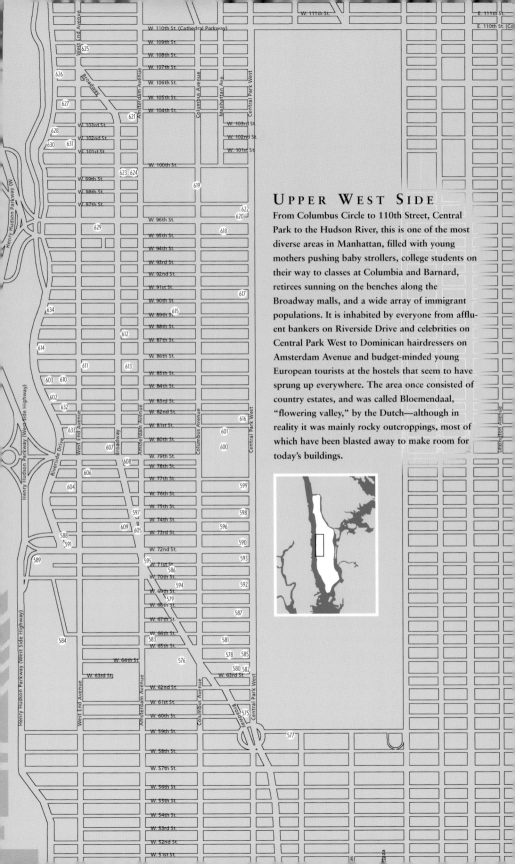

UPPER WEST SIDE

From Columbus Circle to 110th Street, Central
Park to the Hudson River, this is one of the most
diverse areas in Manhattan, filled with young
mothers pushing baby strollers, college students on
their way to classes at Columbia and Barnard,
retirees sunning on the benches along the
Broadway malls, and a wide array of immigrant
populations. It is inhabited by everyone from afflu-
ent bankers on Riverside Drive and celebrities on
Central Park West to Dominican hairdressers on
Amsterdam Avenue and budget-minded young
European tourists at the hostels that seem to have
sprung up everywhere. The area once consisted of
country estates, and was called Bloemendaal,
"flowering valley," by the Dutch—although in
reality it was mainly rocky outcroppings, most of
which have been blasted away to make room for
today's buildings.

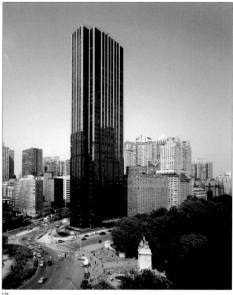

575

TRUMP INTERNATIONAL HOTEL AND TOWER

575

ONE CENTRAL PARK WEST AT COLUMBUS CIRCLE

1970, THOMAS E. STANLEY
REDESIGNED, MID-1990S, PHILIP JOHNSON
AND ALAN RITCHIE

Gulf+Western, the conglomerate that built this rectangular tower on a triangular lot, became known as Paramount Communications in 1989, the year it moved away without ever looking back. The building seemed to have been jinxed with leaks and drafts from the day they had moved in. Donald Trump grabbed it as a fixer-upper, then stripped it down to its steel skeleton and started over, with the help of first-class architects and even masters of feng shui, who showed him how to reconfigure it as an exclusive hotel and apartment tower.

LINCOLN CENTER FOR THE PERFORMING ARTS

576

COLUMBUS AVENUE, WEST 62ND TO WEST 66TH STREETS

1962–68, ARCHITECTURAL DIRECTOR,
WALLACE K. HARRISON

In the early 1950s, Robert Moses assumed responsibilty for developing a seventeen-block area called Lincoln Square, west of Columbus Avenue and Broadway, between 62nd and 70th Street. He had his own ideas, but he approached the Metropolitan Opera Association, which had been looking for a new home for twenty-five years, to see if they wanted to relocate here. His offer was accepted, followed closely by interest from the New York Philharmonic, and at the end of 1955, the decision was made to build a center for all the performing arts. Apart for the cost of the land, which came as federal aid, and the cost of building the New York State Theater, for which the state footed most of the bill, the money for all the buildings in the complex came from private contributions.

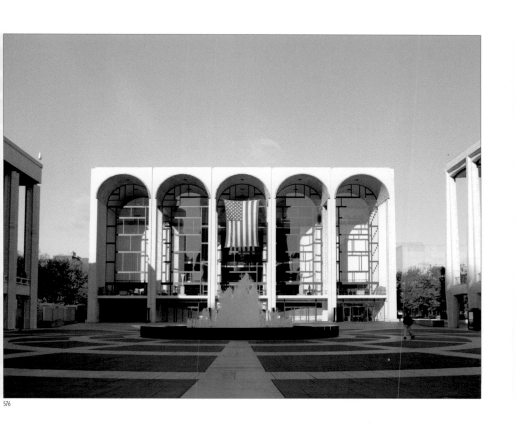

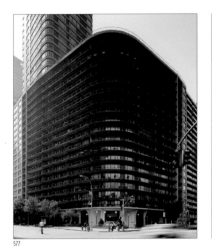

577

200 Central Park South

AT SEVENTH AVENUE

1964, WECHSLER & SCHIMENTI

A small apartment house and a row of brownstones were demolished, in spite of strong local protest, to make way for this Modernist apartment building, which many feel would be more appropriate in Miami Beach. Its mass is set back back forty feet from the intersection and swoops around it to create more park-facing apartments. The small plaza in front was considered a daring innovation when it was created.

577

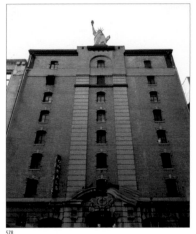

578

LIBERTY WAREHOUSE

43 WEST 64TH STREET
BETWEEN BROADWAY AND CENTRAL PARK WEST

1902

William H. Flattau, who owned this former storage warehouse, once took a trip to France and came home with a huge replica of the Statue of Liberty, which he placed on the roof of his building. He claimed, but was never able to prove, that it is the work of sculptor Frédéric-Auguste Bartholdi, who made it as a working model for his larger statue down in the harbor.

578

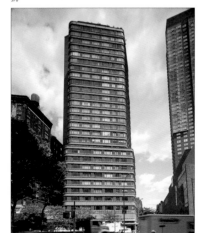

579

THE COPLEY

2000 BROADWAY AT WEST 68TH STREET

1987, DAVIS, BRODY & ASSOCIATES

Among the earliest of the new breed of apartment buildings that are still rising in the area north of Lincoln Center, the Copley has been imitated dozens of times, but few of the imitators have quite matched its presence. It's hard to beat for convenience, too. There's a post office around the corner, a supermarket downstairs, and the Loew's Lincoln Square theater complex is right across the street.

579

580
WEST SIDE YMCA

5 WEST 63RD STREET
BETWEEN BROADWAY AND CENTRAL PARK WEST

1930, DWIGHT J. BAUM

Designed in an Italianate style with Romanesque and Gothic details, this building's abundance of pressed brick and polychomed terra-cotta gives it an airiness that hides its bulk. Inside is a 600-room dormitory for men and a school for 300 boys, all finished with rough plaster walls, tile floors, and stencilled, wood-beamed ceilings. All of the rooms are furnished with reproductions of antiques.

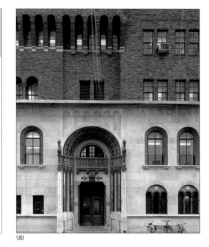

580

581
FIRST BATTERY ARMORY

56 WEST 66TH STREET
BETWEEN COLUMBUS AVENUE AND CENTRAL PARK WEST

1901, HORGAN & SLATTERY
ALTERED, 1978, KOHN PEDERSON FOX ASSOCIATES

When television came into our lives in the 1950s, the American Broadcasting Company bought a former stable at 7 West 66th Street and turned it into a broadcasting studio. Before long, ABC began expanding all over the neighborhood and eventually converted this National Guard armory into studio space as well. Fortunately for the neighborhood, they left the façade intact for everyone to enjoy.

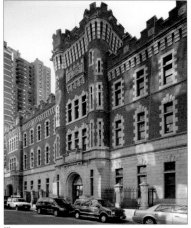

581

582
CENTURY APARTMENTS ♧

25 CENTRAL PARK WEST
BETWEEN WEST 63RD AND WEST 64TH STREETS

1931, IRWIN S. CHANIN

In 1909, the New Theater on Central Park West was built. It was the most elegant theater the city had ever seen. The trouble was that the acoustics were terrible and even season ticket holders stayed away. Changing its name to the Century didn't hide its defects and in 1930, the wreckers moved in to make way for this Art Deco masterpiece. Irwin Chanin, the developer, was so impressed that he moved here himself.

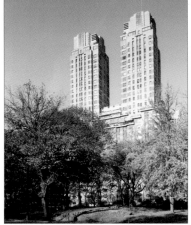

582

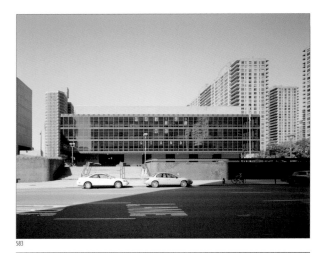

583

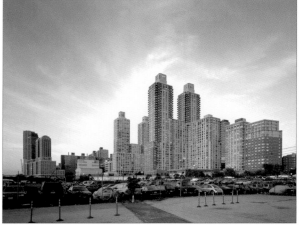

584

585

583

MARTIN LUTHER KING, JR. HIGH SCHOOL

122 AMSTERDAM AVENUE
BETWEEN WEST 65TH AND WEST 66TH STREETS

1975, FROST ASSOCIATES
WILLIAM TARR, SCULPTOR

The metal work on the glass façade of this building, and the King Memorial overlooking the sidewalk, is Mayari-R steel that is protected from further corrosion by a thin veneer of rust on its surface. It was built as part of the Lincoln Square Urban Renewal project, along with the nearby Fiorello LaGuardia High School of the Performing Arts, and the headquarters of the American Red Cross at 66th Street.

584

TRUMP PLACE

WEST END AVENUE TO THE WEST SIDE HIGHWAY
BETWEEN WEST 66TH AND WEST 67TH STREETS

1999, PHILIP JOHNSON & ALAN RITCHIE
WITH COSTAS KONDYLIS

A work in progress, these apartment buildings mark the first stage of Riverside South, a development planned to extend from West 59th Street along the Hudson River north to Riverside Park over the abandoned New York Central Railroad's freight yards.

585

ETHICAL CULTURE SOCIETY

CENTRAL PARK WEST AT WEST 64TH STREET

1910, ROBERT D. KOHN

The New York Society for Ethical Culture, which occupies the hall and the school next door, was founded in 1876 by Rabbi Felix Adler of Temple Emanu-El, based on a philosophy of ethical idealism. Much of its early work was aimed at social reforms, especially for working people, women, and the poor, and it established several of America's first settlement houses. Ethical Culture is recognized as a religion, but holds to no specific theology or doctrine, except for the value of human life.

PYTHIAN TEMPLE

135 WEST 70TH STREET
BETWEEN BROADWAY AND COLUMBUS AVENUE

1927, THOMAS W. LAMB
ALTERED, 1986, DAVID GURA

The building with its strange combination of Sumerian, Assyrian, Babylonian, and Egyptian motifs, is now a condominium apartment building. It was originally the home of the fraternal organization, the Knights of Pythias, which decorated its lodge rooms inside in even more different exotic styles. The twin towers are embellished with King Solomon's golden basin, complete with attendants.

HOTEL DES ARTISTES

ONE WEST 67TH STREET
BETWEEN CENTRAL PARK WEST AND COLUMBUS AVENUE

1918, GEORGE MORT POLLARD

The artists' studios behind double-height windows have been leased to such notables as Isadora Duncan, Norman Rockwell, and Noel Coward. The building is best-known for the Café des Artistes on the ground floor. Its menu makes it memorable, but diners get a bonus in the murals by Howard Chandler Christy, one of the most successful painters of pin-up girls in the 1920s, who was among the tenants upstairs.

THREE RIVERSIDE DRIVE

BETWEEN WEST 72ND AND WEST 73RD STREETS

1898, C. P. H. GILBERT

This mansion was perfectly designed with projecting bays to take full advantage of its generous curving lot. It is one of three (311 West 72nd Street and One Riverside Drive are the others) that were built on a divided single lot by the same architect. The original owner of this block of Riverside Drive sold the parcels with the stipulation that only high-quality houses could be built on them, and his wishes seem to have been followed to the letter.

THE CHATSWORTH

344 WEST 72ND STREET AT THE WEST SIDE HIGHWAY

1902–06, JOHN E. SCHARSMITH

A complex of three buildings, the early tenants here (who included a young songwriter named Irving Berlin) were lured to the edge of the Upper West Side not only by its beautifully decorated façade overlooking Riverside Park, but by a host of services from a billiard room to a hairdresser, a barber, and a tailor. The landlord also provided valet service and operated a café for his tenants. But the best part was an electric bus that whisked them to the subway on Broadway and over to Central Park.

CHRIST AND ST. STEPHEN'S CHURCH
(EPISCOPAL)

129 WEST 69TH STREET
BETWEEN BROADWAY AND COLUMBUS AVENUE

1880, WILLIAM H. DAY

This country church in the city, complete with a tile roof and a wide front yard, was originally St. Stephen's Church, which merged with Christ Church, its neighbor on 72nd Street. Dozens of Manhattan churches reach out into the city with impressive music programs, and this is one of the most active, not to mention one of the best.

309 WEST 72ND STREET

BETWEEN WEST END AVENUE AND RIVERSIDE DRIVE

1901, GILBERT A. SCHELLENGER

This limestone Renaissance Revival house was built by William E. Dillard, a doctor who dabbled in real estate. It was built as a speculative property, and Dillard never lived here himself. It was one of the earliest buildings at the west end of West 72nd Street, and it is likely that he wasn't interested in being so far off the beaten path in those days, when doctors were still expected to make house calls.

586

587

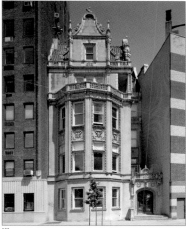

588

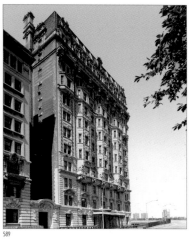

589

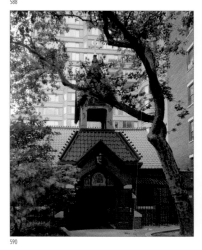

590

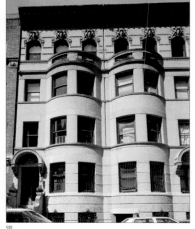

591

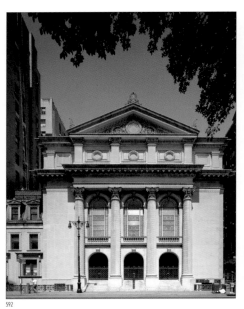

592

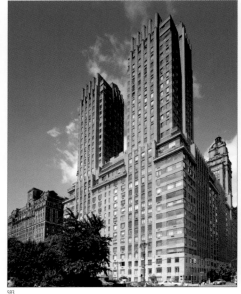

593

594

595

CONGREGATION SHEARITH ISRAEL ℒ
(SYNAGOGUE)

CENTRAL PARK WEST AT WEST 70TH STREET

1897, BRUNNER & TRYON

This, the oldest Jewish congregation in North America, was formed by Portuguese Jews in 1654. They were denied permission to build a synagogue in New York both by the Dutch and the British. When the restriction was lifted in 1729, they built one in lower Manhattan that served them for 100 years. They arrived at this location after several moves in a general uptown direction.

MAJESTIC APARTMENTS ℒ

115 CENTRAL PARK WEST
BETWEEN WEST 71ST AND WEST 72ND STREETS

1931, IRWIN S. CHANIN

When newspaper columnist Walter Winchell wasn't out chasing gangsters and gossip, this was what he called home. The Majestic was also home to Frank Costello, the "Prime Minister of the Underworld," who survived an assassination attempt in the lobby. The eleven-story hotel it replaced was home to such people as composer Gustav Mahler and novelist Edna Ferber. Its roof garden was the city's most fashionable in the 1890s.

DAKOTA APARTMENTS ℒ

ONE WEST 72ND STREET AT CENTRAL PARK WEST

1884, HENRY J. HARDENBERGH

Originally, only the first seven stories of this early luxury apartment building were used as residences. The two top floors were set aside for servants, who also had quarters in the apartments themselves. There were just sixty-five apartments, ranging from four to twenty rooms. Just before it became a co-op in 1961, a seventeen-room apartment with six baths and eight fireplaces was renting for $650 a month at the Dakota.

THE DORILTON ℒ

171 WEST 71ST STREET AT BROADWAY

1902, JANES & LEO

This is a litle bit of Paris overlooking what was known as "The Boulevard" before it was renamed Broadway in 1899. When it was built, the neighborhood was still largely undeveloped and wouldn't become prime real estate until four years later, when the subway arrived with an express stop just across the street. Before much longer, the area became one of Manhattan's largest upscale Jewish neighborhoods.

40–42 WEST 73RD STREET ℒ

BETWEEN CENTRAL PARK WEST AND COLUMBUS AVENUE

1880, HENRY J. HARDENBURGH

This block, along with its counterpart on West 74th Street, is the Central Park West–West 73rd Street–West 74th Street Historic District. The row houses were built to complement the same owner's Dakota apartment house, and were used as alternatives for renters on the waiting list for the bigger building. The high-rise building on the downtown side directly behind the Dakota replaced its gardens, croquet lawns, and tennis courts. They had been built over a vast underground space that held the building's heating plant and its electrical generators, which was made necessary by the fact that public electrical service had yet to reach this far uptown when the apartment house was built.

BEACON THEATER ℒ

2124 BROADWAY
BETWEEN WEST 74TH AND WEST 75TH STREETS

1929, WALTER W. AHLSCHLAGER

Although the exterior of this theater has been modernized to reflect its function as a port-of-call for top popular music groups, the landmarked interior behind it is reminiscent of the great movie palaces of the 1920s, and it is, in fact, the last of them. It was built for Samuel "Roxy" Rothafel, the entrepreneur who developed Radio City Music Hall, and who was the owner of the fabulous Roxy Theater, which was the model for this one.

SAN REMO APARTMENTS ℒ

145–146 CENTRAL PARK WEST
BETWEEN WEST 74TH AND WEST 75TH STREETS

1930, EMERY ROTH

At the time the San Remo was built, the city's building code allowed apartment buildings to rise to thirty stories as long as there was a base of at least 30,000 square feet and it had the prescribed setbacks. Emery Roth used the restrictions to his advantage by building two central towers instead of one, a pattern that was followed by three more Central Park West apartment buildings, the Century, the Majestic, and the El Dorado.

NEW-YORK HISTORICAL SOCIETY ℒ

170 CENTRAL PARK WEST
BETWEEN WEST 76TH AND WEST 77TH STREETS

1908, YORK & SAWYER
ADDITIONS 1938, WALKER & GILLETTE

This is the oldest continuously operated museum in the city and the second-oldest historical society in the United States. Founded in 1804, the collection now includes the papers of architects Cass Gilbert and McKim, Mead & White, as well as manuscripts, letters, and newspapers important to tracing the city's history. It has nearly all of the watercolor illustrations created by John James Audubon for his Birds of America.

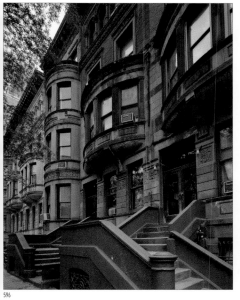

596

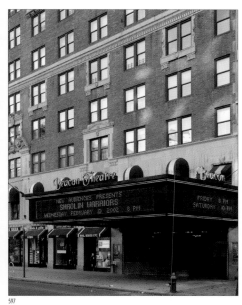

597

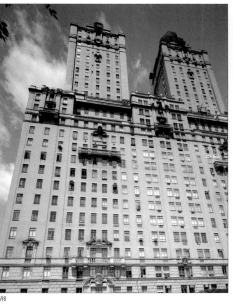

598

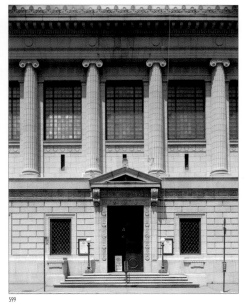

599

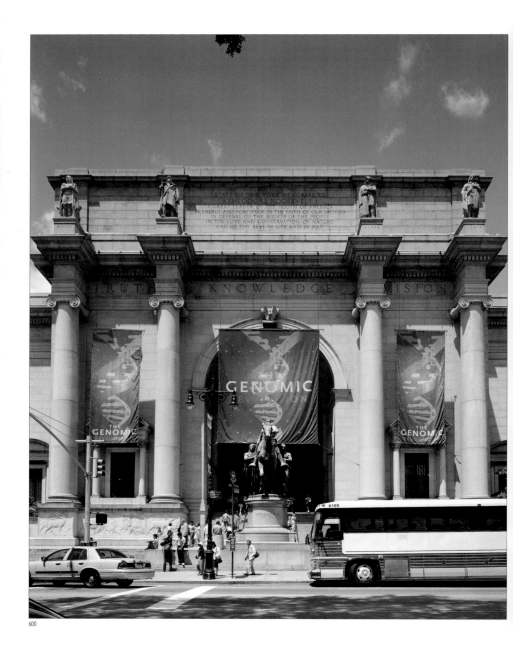

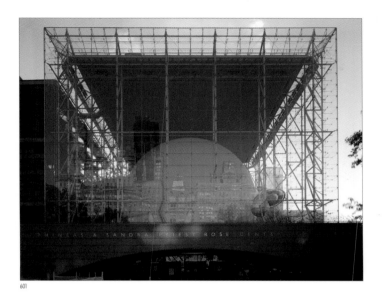

601

AMERICAN MUSEUM OF NATURAL HISTORY

CENTRAL PARK WEST TO COLUMBUS AVENUE
WEST 77TH TO WEST 81ST STREETS

1877, CALVERT VAUX AND JACOB WREY MOULD
1901, J.C. CADY & CO
1908, CHARLES VOLZ
1924, TROWBRIDGE & LIVINGSTON

This is where you'll find the dinosaur bones, but there are also plenty of unexpected surprises waiting for you. The museum's various departments conduct field studies in disciplines ranging from astronomy to anthropology, a department once headed by Margaret Mead. The new knowledge resulting from these expeditions have made its ever-changing displays among the most important of their kind in the world.

ROSE CENTER FOR EARTH AND SPACE

WEST 81ST STREET
BETWEEN CENTRAL PARK WEST AND COLUMBUS AVENUE

2000, POLSHEK PARTNERSHIP

The solar system is captured here in a glass box like a lightning bug in a jar. The American Museum of Natural History, of which this is a unit, established an astronomy program in 1930 and made it accessible to a fascinated public when it opened the Hayden Planetarium five years later. That building was demolished to become the site of this futuristic attraction that incorporates the knowledge of the space age through the technology of the computer age and presents it all in a whole new way. When the original planetarium was built, a visit there was as close as anyone could get to actually venturing into space.

602

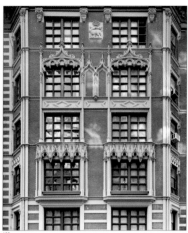

603

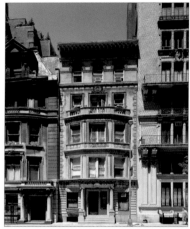

604

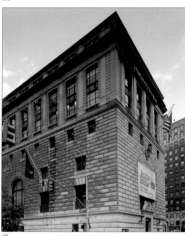

605

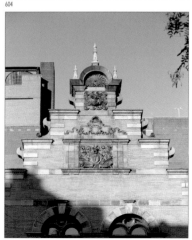

606

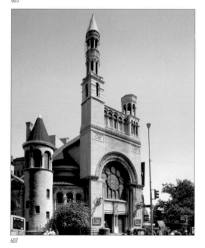

607

103–109 Riverside Drive 𝓛

AT WEST 83RD STREET

1899, CLARENCE TRUE

These five houses, and the row around the corner on West 83rd Street, were built as speculative row houses by developer Clarence True, who made them to resemble the great mansions, many of which he also designed, that were built in the 1890s on the Upper West Side. The difference between a row house and a mansion is that the former are connected with common party walls and the latter are freestanding, but that didn't stop anyone from calling these houses mansions.

The Red House 𝓛

350 WEST 85TH STREET
BETWEEN WEST END AVENUE AND RIVERSIDE DRIVE

1904, HARDE & SHORT

Apartment houses began to invade the Upper West Side at the beginning of the twentieth century, and this is one of the best of them. If the dragon represented in the cartouche looks familiar, you may have seen its cousins, the salamanders that cover the façade of the Alwyn Court Apartments on Broadway at 58th Streets, which is the work of the same architect.

301–305 West 76th Street 𝓛

AT WEST END AVENUE

1891, LAMB & RICH

These fabulous row houses, and others in the block between here and Riverside Drive, as well as on the other blocks between West 75th and West 78th Streets, and the west side of West End Avenue, are all part of the West End–Collegiate Historic District. There is an amazing variety of styles from one end of the district to the other, and all of them are represented at their best.

Central Savings Bank 𝓛

2100–2108 BROADWAY AT WEST 73RD STREET

1928, YORK & SAWYER

Now the Apple Bank for Savings, this freestanding high Renaissance structure is among the best of York & Sawyer's bank buildings. A smaller rendition of their Federal Reserve Bank on Liberty Street, it was originally named the German Savings Bank, but the name was dropped with the approach of World War I.

West End Collegiate Church 𝓛

WEST END AVENUE AT WEST 77TH STREET

1893, ROBERT W. GIBSON

This church and its school are designed with the stepped gables that were common among the houses the Dutch built when they arrived in New York in the seventeenth century. It is entirely appropriate because the Collegiate Church traces its unbroken roots to the Dutch Reform Church, which the original settlers brought with them from Holland. This church is a fair approximation of the Butcher's Market, built at Haarlem in the Netherlands in the seventeenth century.

First Baptist Church

265 WEST 79TH STREET AT BROADWAY

1894, GEORGE KEISTER

The two unequal towers on this church have been intentionally left that way. Some say it is to symbolize the fact that all life is a work in progress. The taller one represents Christ as the light of the world and the smaller, unfinished one represents the wait for His return. The lights inside are left on at night so that everyone can appreciate the beauty of its stained glass windows.

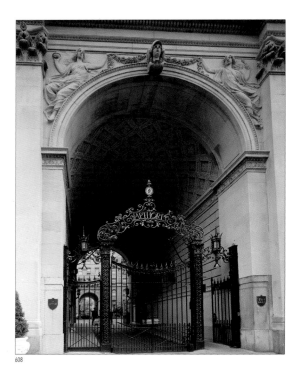

608

APTHORP APARTMENTS *L*

2201–2219 BROADWAY
BETWEEN WEST 78TH AND WEST 79TH STREETS

1908, CLINTON & RUSSELL

This full-square-block apartment house with a glorious interior courtyard was built by the Astor Estates, and remains the best of their apartments in the city. It was named for Charles Ward Apthorp, who built a mansion he called "Elmwood" in the 1770s at what is now Columbus Avenue and West 91st Street. Apthorp was highly regarded for his hospitality, but he was also a smart businessman who imported Spanish gold for the American Army and then sold them the supplies they needed, collecting handsome commissions at both ends. His estate in this area covered 300 acres of orchards and meadows.

ANSONIA HOTEL *L*

2109 BROADWAY
BETWEEN WEST 73RD AND WEST 74TH STREETS

1904, PAUL E. M. DUBOY

This confection was built for W. E. D. Stokes, a finicky West Side developer, as an apartment hotel. Stokes insisted on fireproof masonry construction and ordered that all of the apartments must be soundproof behind three-foot-thick walls, which made it attractive to such guests as singers Lauritz Melchior and Ezio Pinza, as well as Arturo Toscanini and Igor Stravinsky. Showman Florenz Ziegfeld lived here, too, but a name not often mentioned in the Ansonia's long and illustrious guest list is that of Babe Ruth. He was following a tradition already established by almost the entire New York Yankees baseball team.

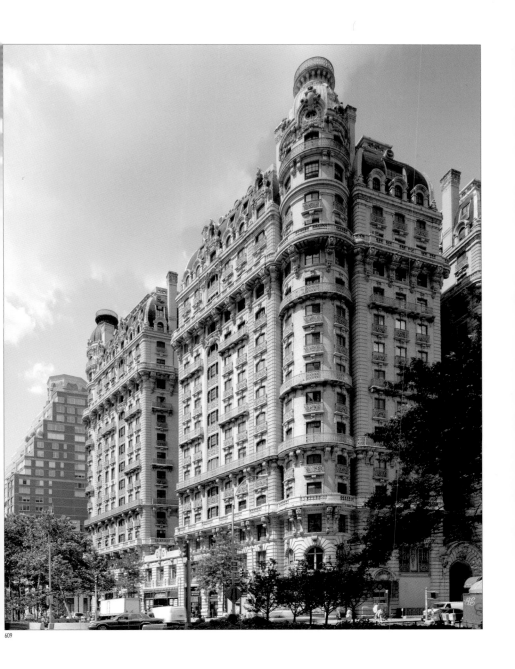

316–326 West 85th Street ℒ

BETWEEN WEST END AVENUE AND RIVERSIDE DRIVE

1892, CLARENCE TRUE

This row of six brick houses were designed and constructed by Clarence True, the master builder of the Upper West Side. The stonework at the entrance level and its unusual use of the brick are only part of their charm, which continues up to the Spanish tile at the roofline.

Church of St. Paul and St. Andrew ℒ
(Methodist Episcopal)

540 WEST END AVENUE AT WEST 85TH STREET

1897, R. H. ROBERTSON

This church was one of the first to break away from the Romanesque style that had become the most popular for churches in the late nineteenth century. Its design was intended to recall the Italian Renaissance, and to symbolize the bridge between faith as practiced during the Middle Ages and the Age of Enlightenment. One of its pair of towers is tall and octagonal, the other short and square, set at a forty-five-degree angle to the main façade. The architect called his design "unscrupulously picturesque."

The Montana

247 WEST 87TH STREET AT BROADWAY

1986, THE GRUZEN PARTNERSHIP

This is a latter-day interpretation of the twin-towered apartment buildings on Central Park West, with a name apparently intended to recall the Dakota, although the developers might have been thinking of the original Montana Apartments on Park Avenue that were demolished to make way for the Seagram Building.

Belnord Apartments ℒ

225 WEST 86TH STREET
BETWEEN AMSTERDAM AVENUE AND BROADWAY

H. HOBART WEEKES

A larger version of the Apthorp seven blocks downtown, this massive apartment building is overwhelming on the outside, but the garden court inside is wonderful. When the building opened, rents averaged $7,000 a year, $500 more than the Apthorp, possibly because its garden is bigger.

The Normandy ℒ

140 RIVERSIDE DRIVE AT WEST 86TH STREET

1939, EMERY ROTH

This is among the best apartment houses by Emery Roth (as well as his last), who was responsible for the best parts of the Central Park West skyline. Its streamlined Art Moderne corners made it necessary to design special venetian blinds for its curved corner windows. The builder thoughtfully provided a basement workshop to clean and maintain them.

Claremont Riding Academy ℒ

175 WEST 89TH STREET
BETWEEN COLUMBUS AND AMSTERDAM AVENUES

1892, FRANK A. ROOKE

If you see someone riding a horse in Central Park, chances are that horse lives here in Manhattan's last livery stable. Like most nineteenth-century stables, a few of which still exist for carriage horses in Clinton on the west side of midtown, the horses are kept on different levels above the ground floor, a necessity in a city so cramped for space.

610

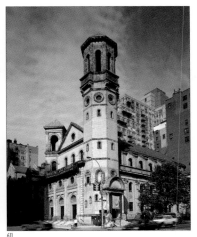

611

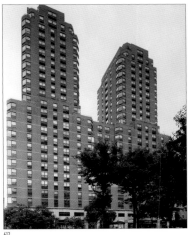

612

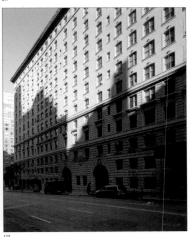

613

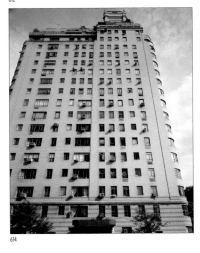

614

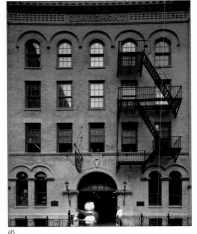

615

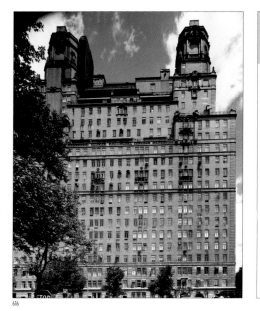

616

The Beresford ℒ

West 81st Street at Central Park West

1929, Emery Roth

In the race to build bigger apartment houses in the Roaring Twenties, the Beresford ended the decade as the clear winner. Its façade faces both Central Park and the patch of green that was called Manhattan Square in those days, and its twenty-two stories are topped by three towers, while most of its neighbors settled for two. It was among the first with elevators whose doors opened directly into the apartments rather than into a central hallway.

616

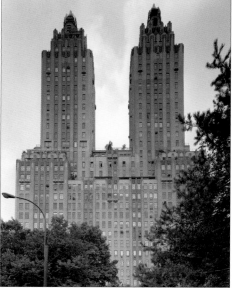

617

The Eldorado ℒ

300 Central Park West
between West 90th and West 91st Streets

1930, Margon & Holder, with Emery Roth

When novelist Sinclair Lewis came to live in New York, he chose an apartment in this building because it had a view of all of the city's bridges. It was also the fictional address of "Marjorie Morningstar," the heroine of Herman Wouk's popular 1955 novel.

617

6–8 WEST 95TH STREET

BETWEEN CENTRAL PARK WEST AND COLUMBUS AVENUE

This is among the best of the Upper West Side's "park blocks" that real estate agents love to lure their clients to. Besides the diversity of styles in its row houses, its trees, arching gracefully over the street, bring Central Park out into the city. This pair of mansions is among many in the area whose ground floor is the main floor. But their designer added gentle stoops in a bow to row house tradition.

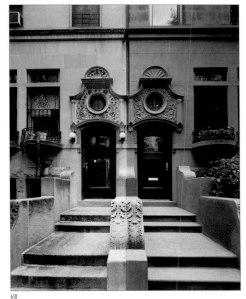

618

PARK WEST VILLAGE

CENTRAL PARK WEST TO AMSTERDAM AVENUE
WEST 97TH TO WEST 100TH STREETS

1960, SKIDMORE, OWINGS & MERRILL

Originally conceived by Robert Moses as a slum clearance project called "Manhattantown," the scheme became bogged down in scandal as civic groups accused the developers of improprieties. The furor resulted in turning the whole project over to new developers, who built these seven red brick slabs containing 2,700 apartments. In the meantime, the original developers had acquired the former buildings at bargain prices and collected rents from their hapless tenants for more than five years.

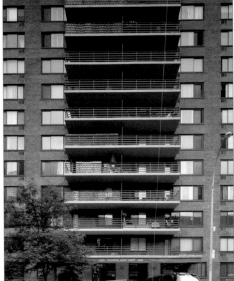

619

First Church of Christ, Scientist \mathcal{L}

620

One West 96th Street at Central Park West

1903, Carrère & Hastings

The Christian Science Society of New York was incorporated in 1887, and moved into this building sixteen years later. This structure is built of granite imported, like the religion itself, from New England. This was one of the first of the so-called "skyscraper" churches that included not only space for worship, but rooms for social activities as well. There is a fascinating example of a church within a skyscraper on the other side of West 96th Street, where an apartment tower completely surrounds a Presbyterian church.

American Youth Hostels \mathcal{L}

621

891 Amsterdam Avenue
between West 103rd and West 104th Streets

1883, Richard Morris Hunt

This was originally the Association Residence for Respectable Aged Indigent Females, an institution formed in 1814 to aid Revolutionary War widows. The word "respectable" in its name meant that it was not open to women who had previously worked as servants. The Association abandoned the building in 1975, and it was boarded up waiting for demolition until 1990, when it was converted into the city's first youth hostel with the help of the New York Landmarks Conservancy.

354 and 355 Central Park West \mathcal{L}

622

between West 96th and West 97th Streets

1893, Gilbert A. Schellenger

Nestled among the high-rise apartment buildings on Central Park West, these two houses were once part of a row of five such buildings, built at a time when most of the Upper West Side was considered a long way out of town. It wasn't until the 1880s that the hollows were filled and hills smoothed down to create the Central Park West street grade. Here in the upper '90s, the original landscape was raised more than twenty feet.

Metro Theater \mathcal{L}

623

2626 Broadway
between West 99th and West 100th Streets

1933, Boak & Paris

This movie theater, originally called the Midtown, is among the city's greatest Art Deco façades. It is clad in colored terra-cotta and decorated with a huge bas-relief medallion featuring figures representing comedy and tragedy. The chrome-banded marquee is unchanged from the original. In fact, about all that has changed here since the 1930s is the chopping up of the interior to make room for multiple auditoriums.

St. Michael's Church
(Episcopal)

624

225 West 99th Street at Amsterdam Avenue

1891, Robert W. Gibson

There are many church buildings in Manhattan with stained glass windows from the studios of Louis Comfort Tiffany, but those with Tiffany interiors are rare, and this is one of them. The altar, and much of the rest, is a dazzling display of mosaics and glass. The rectory behind it, like several in the area, is at odds with the regular grid pattern of the street. It probably conforms with the meandering route of the old Bloomingdale Road that was straightened to become Broadway.

The Manhassett \mathcal{L}

625

Broadway, between West 108th
and West 109th Streets

1901, Joseph Wol
Additions, 1905, Janes & Leo

This is one of the West Side's most imposing apartment houses. It is actually two buildings. After the first eight floors were built, the developer went broke and the new owner added three more floors and the massive mansard roof, as well as new grand entrances.

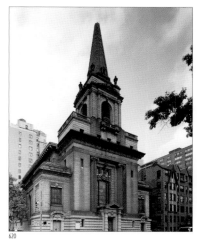

620

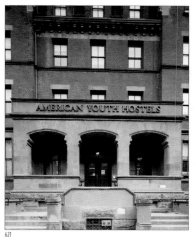

621

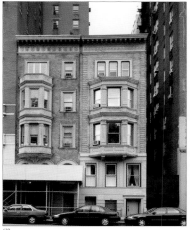

622

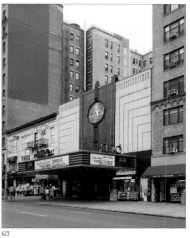

623

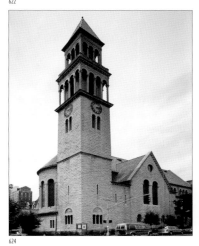

624

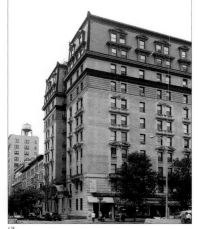

625

626

THE CHILDREN'S MANSION ℒ

351 RIVERSIDE DRIVE AT 107TH STREET

1909, WILLIAM B. TUTHILL

This chateau was built for Morris Schinasi, a millionaire cigarette manufacturer, whose brother and business partner owned 20 Riverside Drive, the only other remaining freestanding mansion on the drive. This one became a girl's finishing school in the 1930s, and was later used as a day-care center by Columbia University. It is now a school.

627

316 WEST 105TH STREET ℒ

BETWEEN WEST END AVENUE AND RIVERSIDE DRIVE

1900, JANES & LEO

This row of Beaux Arts marble townhouses, is part of the Riverside–West 105th Street Historic District. Among the people who lived in these houses was actress Marion Davies, best known as the object of William Randolph Hearst's affections. Hearst bought one of the houses and spent more than a million dollars on statuary, fountains, and other decorations to make her comfortable there.

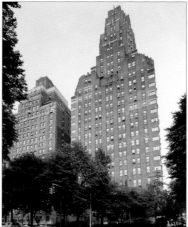

628

MASTER APARTMENTS ℒ

310–312 RIVERSIDE DRIVE, AT 103RD STREET

1929, HARVEY WILEY CORBETT

Among the best Art Deco apartment towers in New York, this building vaguely resembled the same architect's One Fifth Avenue at Eighth Street in Greenwich Village. The building also houses the Equity Library Theater in a space that was originally the auditorium of Nicholas Roerich's Master Institute of United Arts. The Institute is now a museum in a neighboring townhouse at 319 West 107th Street, dedicated to the work of Roerich, the Russian artist and mystic who wrote the scenario for Stravinsky's *Rite of Spring*.

629
POMANDER WALK 🕮

BETWEEN WEST 95TH AND WEST 96TH STREETS
BROADWAY AND WEST END AVENUES

1921, KING & CAMPBELL

This wonderful double row of twenty-four tiny
houses along a private path was modeled after
the stage set for a play called *Pomander Walk*.
Naturally, it became a popular place for actors
to call home, and among those who lived here
have been Humphrey Bogart, Gloria Swanson,
and Rosalind Russell.

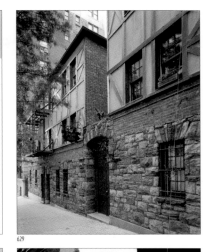

629

630
294 RIVERSIDE DRIVE 🕮

BETWEEN WEST 101ST AND WEST 102ND STREETS

1901, SCHICKEL & DITMARS

When this Beaux Arts townhouse was built for
William and Clara Baumgarten, it was one of
several similar buildings on Riverside Drive,
but is now a rare survivor. Mr. Baumgarten
was the head of Herter Brothers, a leading firm
of society decorators and cabinetmakers.

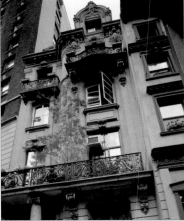

630

631
854–858 WEST END AVENUE 🕮

AT WEST 102ND STREET

1893, SCHNEIDER & HERTER

Before the huge apartment towers began lining
West End Avenue, several of its corners were
developed as rows of brownstone houses with a
larger one at the corner and another facing the
side street (in this case, 254 West 102nd Street).
This row is one of the few still remaining.

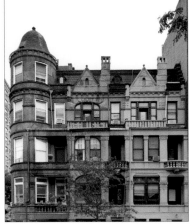

631

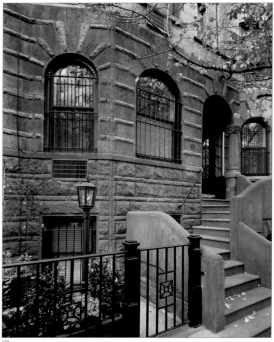

632

632

311 West 82nd Street

BETWEEN WEST END AVENUE AND RIVERSIDE DRIVE

A row house in the Queen Anne style, it
includes three-sided projecting bay windows
and an L-shaped stoop. But the most delightful
feature is one of the few remaining functional
gas lamps attached to private residences.
(You're not allowed to put one in nowadays,
but you can maintain one if it exists.) The gate
leads to an "English basement" level with the
sidewalk. Originally it would have contained
the kitchen, and the street-level entrance was
for the convenience of tradesmen making deliv-
eries. The service floor also had access to the
backyard for the convenience of the laundress.

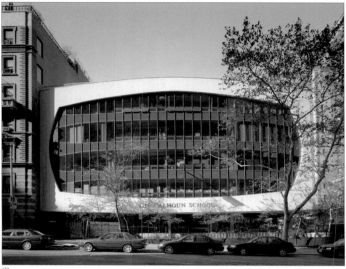

633

CALHOUN SCHOOL

433 WEST END AVENUE AT WEST 81ST STREET

1975, COSTAS MACHLOURZARIDES

If the parents who send their children to this private school hope to see them go on to Ivy League universities, it's not because they will already be familiar with the architecture. The neighbors here were enraged when several elegant row houses were demolished to make way for what looks very much like a giant television set. The space inside the building, which is known as the Learning Center, has been left open, without interior walls, in keeping with the school's progressive approach to learning. There are more than sixty so-called "independent" schools in the city, with a total enrollment of some 25,000 students.

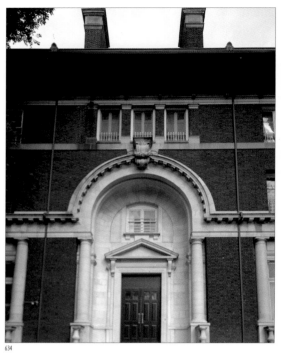

634

635

YESHIVA KETANA

346 West 89th Street at Riverside Drive

1903, Herts & Tallant

Now a school, this was originally the home of Isaac L. and Julia Barnett Rice, and there is a charming bas-relief at the side entrance representing the Rice children and their mother. Mrs. Rice, one of the first woman doctors, is best remembered for her "Society for the Suppression of Unnecessary Noise," which campaigned against the loud whistles of ships passing along the Hudson River. Her husband, a Columbia law professor, recruited his students to patrol the harbor in small boats recording offenses and filing charges against the skippers responsible. Her efforts didn't quiet things down that much, but they did result in the city's first anti-noise laws, and the creation of "quiet zones" around hospitals.

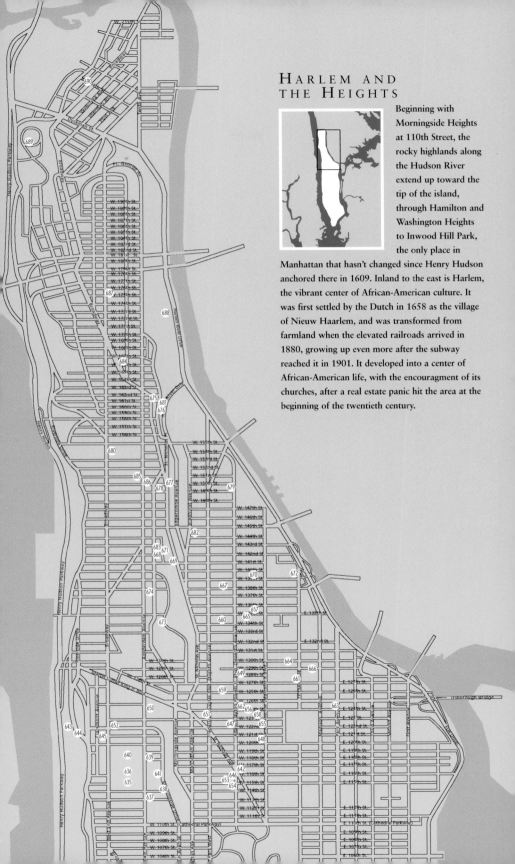

HARLEM AND THE HEIGHTS

Beginning with Morningside Heights at 110th Street, the rocky highlands along the Hudson River extend up toward the tip of the island, through Hamilton and Washington Heights to Inwood Hill Park, the only place in Manhattan that hasn't changed since Henry Hudson anchored there in 1609. Inland to the east is Harlem, the vibrant center of African-American culture. It was first settled by the Dutch in 1658 as the village of Nieuw Haarlem, and was transformed from farmland when the elevated railroads arrived in 1880, growing up even more after the subway reached it in 1901. It developed into a center of African-American life, with the encouragment of its churches, after a real estate panic hit the area at the beginning of the twentieth century.

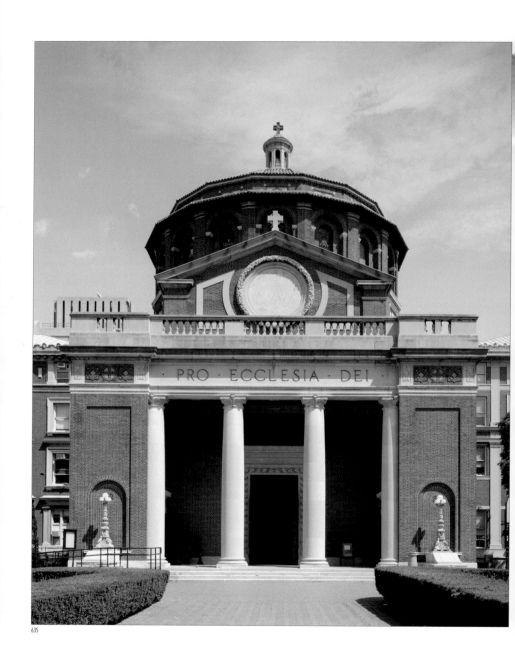

PRO · ECCLESIA · DEI

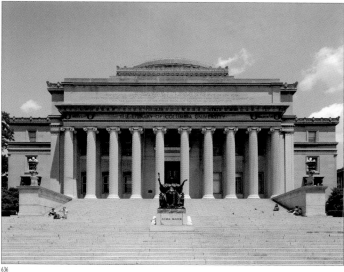

636

ST. PAUL'S CHAPEL
AND LOW MEMORIAL LIBRARY

COLUMBIA UNIVERSITY CAMPUS
NORTH OF WEST 116TH STREET
BETWEEN BROADWAY AND AMSTERDAM AVENUE

1897, MCKIM, MEAD & WHITE
CHAPEL, 1907, HOWELLS & STOKES

The Columbia campus was designed by Charles
F. McKim, and his Low Library is its center-
piece. It became the University's administrative
center in 1934, when the library collection was
moved to Butler Hall across the quadrangle.
This building was a gift of Seth Low, a former
mayor of the City of Brooklyn, who became
Columbia's president in 1890. The former
library honors the memory of his father, a ship-
owner. The non-denominational St. Paul's
Chapel, donated by Olivia and Caroline Phelps
Stokes, is a memorial to their parents, and was
designed by their nephew, I. N. Phelps Stokes.

637
CATHEDRAL CHURCH OF
ST. JOHN THE DIVINE (EPISCOPAL)

AMSTERDAM AVENUE AT WEST 112TH STREET

1892–1911, HEINS & LA FARGE
1911–42, CRAM & FERGUSON

All things considered, this is the world's largest cathedral. Some are longer, some wider, and some higher, but by any measure, it is easily one of the world's most impressive and inspiring houses of worship. Its cornerstone was laid in 1892, and it still isn't finished. Work stopped on Pearl Harbor Day in 1941, a week after the nave was dedicated, and didn't resume until 1978. Lack of funds has halted work once again.

638
ÉGLISE DE NOTRE DAME *L*
(ROMAN CATHOLIC)

40 MORNINGSIDE DRIVE AT 114TH STREET

1914, CROSS & CROSS

The interior of this church contains a replica of the Grotto at Lourdes, donated by Mrs. Geraldine Redmond, whose son had been healed by its miraculous waters. The original plan for the building called for a transparent dome over the crossing, which would have bathed the sanctuary in natural light. But, like its neighbor, the cathedral around the corner, the building remains unfinished. This parish was created for French-speaking chefs and maids who worked in the mansions along Riverside Drive.

639
CASA ITALIANA *L*

1151–1161 AMSTERDAM AVENUE
BETWEEN WEST 116TH AND WEST 117TH STREETS

1927, MCKIM. MEAD & WHITE

This building, appropriately designed in the manner of an Italian palazzo, was built to house Columbia University's center for Italian studies. It was financed by wealthy Italian-Americans.

640
AVERY HALL *L*
COLUMBIA UNIVERSITY CAMPUS

WEST 116TH STREET
BETWEEN BROADWAY AND AMSTERDAM AVENUE

1912, MCKIM, MEAD & WHITE

The home of Columbia's School of Architecture, the library here contains America's largest collection of architectural resources. Charles F. McKim proposed several buildings for the inner campus, but this was the only one actually built.

641
PRESIDENT'S HOUSE

60 MORNINGSIDE DRIVE AT WEST 116TH STREET

1912, MCKIM, MEAD & WHITE

As president of Columbia University, you get to live in this beautiful house overlooking Morningside Park. When Dwight D. Eisenhower retired from the army in 1948, he spurned offers by both political parties to run for President of the United States in favor of the Columbia presidency and lived here, rather than in the White House, until 1952.

642
GRAHAM COURT *L*

1923–1937 ADAM CLAYTON POWELL, JR. BOULEVARD
BETWEEN WEST 116TH AND WEST 117TH STREETS

1901, CLINTON & RUSSELL

Harlem's most elegant apartment house was built by William Waldorf Astor in the style of his Upper West Side buildings, the Apthorp and Belnord Apartments, with an interior garden court accessed through passageways lined with Gustavino tile. It did not accept black tenants until 1928.

637

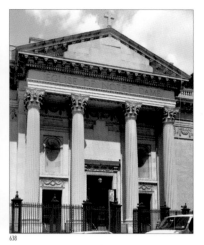

638

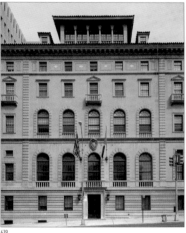

639

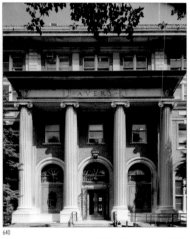

640

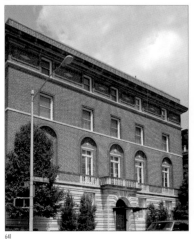

641

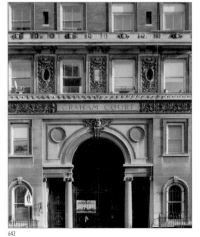

642

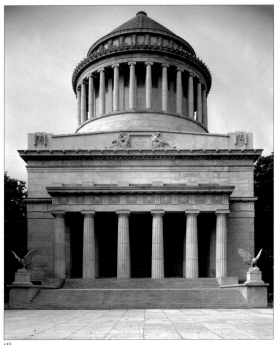

643

GRANT'S TOMB 🖉

RIVERSIDE DRIVE AT 122ND STREET

1897, JOHN H. DUNCAN

Who's buried in Grant's Tomb? The corrrect answer is nobody. The remains of President Ulysses S. Grant and his wife, Julia, are well above ground in the very impressive crypt inside. The design, a cube supporting a drum ringed by a colonnade and topped by a stepped roof, was inspired by Napoleon's Tomb at Les Invalides in Paris. Up until the end of the First World War, Grant's Tomb was far and away the most popular tourist attraction in the city, inspiring more crowds of visitors than the Statue of Liberty.

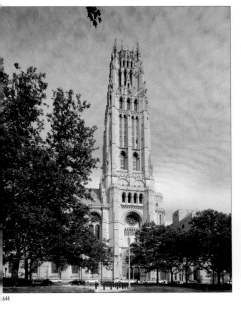

644

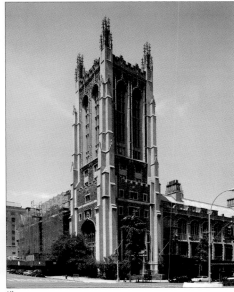

645

RIVERSIDE CHURCH

490 RIVERSIDE DRIVE
BETWEEN WEST 120TH AND WEST 122ND STREETS

1930, ALLEN & COLLENS

This interdenominational church is affiliated with the American Baptist Church and the United Church of Christ. Harry Emerson Fosdick, who served as pastor here from 1931 until 1946, had scandalized the Baptist Church by preaching against fundamentalism, resulting in charges of heresy. John D. Rockefeller, Jr. built this church as a forum for Fosdick's non-sectarian, international, and interracial beliefs. Its 392-foot tower houses offices up to the twenty-third floor, and the space from there to the twenty-eighth houses the Laura Spellman Rockefeller Memorial Carillon, the world's largest. There is an observation deck up there, too.

UNION THEOLOGICAL SEMINARY

BROADWAY, BETWEEN WEST 120TH
AND WEST 122ND STREETS

1910, ALLEN & COLLENS

This non-denominational school for future clergy is widely regarded as a center of liberal theology. Its faculty has included such well-known theologians as William Sloan Coffin and Reinhold Niebuhr, whose philosophies, which the latter described as "applied Christianity," reshaped Protestantism in the twentieth century. It had been an affiliate of the United Presbyterian Church for many years, and in the beginning it was dedicated to revivalism and the Reformed traditions that began to emerge in the mid-nineteenth century. The Seminary had become independent by the time it moved into this Gothic building from its original location on the Upper East Side. It has been a neighbor of Columbia University here in Morningside Heights since 1910.

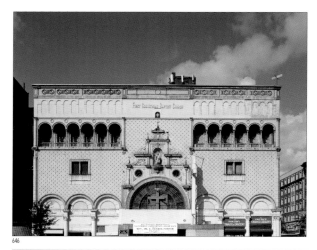

646

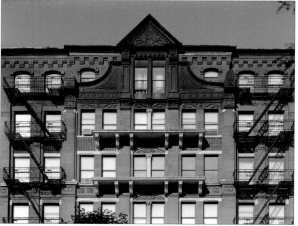

647

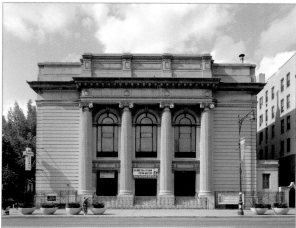

648

646

FIRST CORINTHIAN BAPTIST CHURCH ℒ

ADAM CLAYTON POWELL, JR. BOULEVARD
AT WEST 116TH STREET

1913, THOMAS W. LAMB

The church renovated this former theater for its own use in 1964. Prior to that, it had been a movie palace, called the Regent—one of the oldest, and most exuberant, in the United States. This was where the famous "Roxy" Rothafel got his first taste of the movie business.

647

WASHINGTON APARTMENTS ℒ

2034–2040 ADAM CLAYTON POWELL, JR. BOULEVARD
AT WEST 122ND STREET

1884, MORTIMER C. MERRITT

This was Harlem's first middle-class apartment building. It originally had thirty apartments that were rented to businessmen who commuted down to midtown on the new elevated railroad, which had a station nearby on 125th Street and Eighth Avenue.

648

MT. OLIVET BAPTIST CHURCH

201 MALCOLM X BOULEVARD AT WEST 120TH STREET

1907, ARNOLD W. BRUNNER

This once housed Temple Israel of Harlem, the area's most important Jewish congregation, and was designed in the Classical style of Jerusalem's Second Temple. The congregation occupied the building for just thirteen years before all of its affluent members abandoned Harlem. It then became a Seventh Day Adventist Church, and in 1925, it was bought by Mt. Olivet, which has given it tender, loving care ever since.

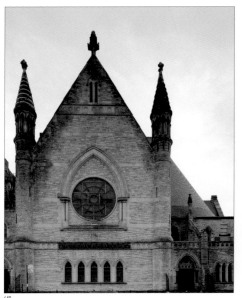

649

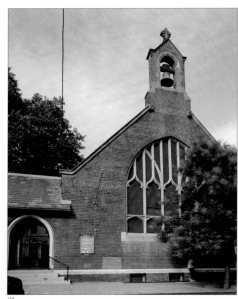

650

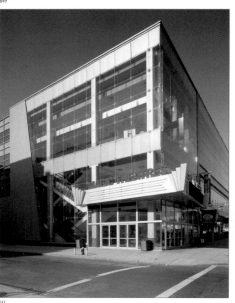

651

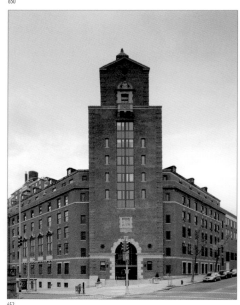

652

METROPOLITAN BAPTIST CHURCH 𝓛

151 WEST 128TH STREET
AT ADAM CLAYTON POWELL, JR. BOULEVARD

1885, JOHN ROCHESTER THOMAS

This church was built in two sections, but the marriage is a perfect match. The main sanctuary, designed by local architect, Richard R. Davis, was built five years after the rest. It is basically a Romanesque design but includes such Gothic features as flying buttresses and pointed arches. Originally the New York Presbyterian Church, Metropolitan Baptist was one of the first black churches in Harlem, and is still among the most influential.

ST. MARY'S CHURCH-MANHATTANVILLE 𝓛
(EPISCOPAL)

521 WEST 126TH STREET, OFF AMSTERDAM AVENUE

1909, CARRÈRE & HASTINGS AND T. E. BLAKE

In the mid-nineteenth century the little village of Manhattanville was surrounded by open fields, and this church reflects its original character. Home to several hundred working-class people, it was centered around the present-day intersection of 125th Street and Broadway, and was served by a ferry line on the Hudson River.

MAGIC JOHNSON THEATERS

WEST 124TH STREET AT FREDERICK DOUGLASS BLVD.

The former guard of the Los Angeles Lakers basketball team has established several businesses since his retirement, including a string of shopping malls and partnerships with Starbucks and T.G.I. Fridays. Among those ventures is Magic Johnson Theaters, which are operated by Loew's Cineplex Entertainment. The chain has movie theaters in five states, including this one in Harlem, which not only brings entertainment to the neighborhood but provides needed jobs as well.

JEWISH THEOLOGICAL SEMINARY

3080 BROADWAY
BETWEEN WEST 122ND AND WEST 123RD STREETS

1930, GEHRON, ROSS & ALLEY

This institution was founded in 1887 to train Conservative rabbis and to encourage traditional Judaism in America. It also has a school for training cantors, and began admitting women in the 1970s. The Seminary has been an active promoter of Zionism since the early 1900s.

653
115TH STREET BRANCH *L*
NEW YORK PUBLIC LIBRARY

203 WEST 115TH STREET
BETWEEN ADAM CLAYTON POWELL, JR. AND
FREDERICK DOUGLASS BOULEVARDS

1909, MCKIM, MEAD & WHITE

In 1901, Andrew Carnegie donated $5.2 million to build forty-two (a number that grew to 61) branch libraries in Manhattan, Staten Island, and the Bronx, and the firms of McKim, Mead & White, Carrère & Hastings, and James Brown Lord were hired to build them. This one, by Charles F. McKim, is among the very best of them.

654
WADLEIGH HIGH SCHOOL *L*

215 WEST 114TH STREET
BETWEEN ADAM CLAYTON POWELL, JR. AND
FREDERICK DOUGLASS BOULEVARDS

1902, C. B. J. SNYDER

This was the first high school in the city for girls only. It was named for Lydia F. Wadleigh, an early crusader for women's education, and was built in response to growing demand for girls' education. It was closed in 1954, but restored in the 1990s, when it became a Junior High School open to both sexes.

655
241–259 MALCOLM X BOULEVARD

BETWEEN WEST 122ND AND WEST 123RD STREETS

1885–1886

Malcolm X Boulevard, also known as Lenox Avenue, is one of the city's widest avenues, and these imposing brownstone houses, once shaded by long rows of lush trees, were typical of what added up to one of New York's grandest streetscapes. In the early part of the twentieth century, the avenue became the main boulevard of black Harlem and was where most of the neighborhood's most important businesses and clubs were located.

656
THERESA TOWERS *L*

2090 ADAM CLAYTON POWELL, JR. BOULEVARD
BETWEEN WEST 124TH AND WEST 125TH STREETS

1913, GEORGE AND EDWARD BLUM

Now an office building, this was the Hotel Theresa, long known as "the Waldorf of Harlem." After it was desegregated in 1940, it became a favorite meeting place for black celebrities. It gained a kind of fame in 1960, when Fidel Castro stayed here and entertained Soviet premier Nikita Khrushchev in his suite. It also housed the offices of Malcolm X's Organization of Afro-American Unity, and A. Philip Randolph's March on Washington Movement.

657
YMCA HARLEM BRANCH

180 WEST 135TH STREET BETWEEN MALCOLM X
AND ADAM CLAYTON POWELL, JR. BOULEVARDS

1932, JAMES C. MACKENZIE, JR.

The original Harlem Y across the street is now the Jackie Robinson YMCA Youth Center. This one carries on the tradition, offering vocational and literacy classes, as well as lectures, and theatrical and musical performances. Among the leaders of the Harlem Renaissance who lived here were writers Ralph Ellison, Claude McKay, and Langston Hughes. Its most famous member these days is former President Bill Clinton.

658
GREATER METROPOLITAN BAPTIST CHURCH *L*

127 WEST 123RD STREET BETWEEN MALCOLM X
AND ADAM CLAYTON POWELL, JR. BOULEVARDS

1898, SCHNEIDER & HERTER

Built as St. Paul's German Evangelical Lutheran Church to serve the large community of German immigrants who had settled in the Mount Morris neighborhood of Harlem, the original parish stayed in this building until 1939. A year later, it became the 12th Church of Christ Scientist and was sold in 1985 to the Greater Metropolitan Baptist Church, which had split from Metropolitan Baptist a few years earlier.

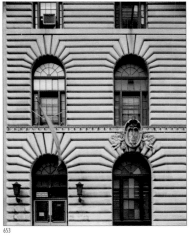

653

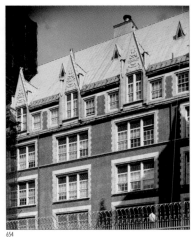

654

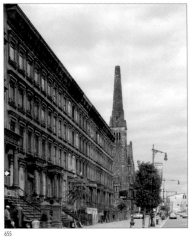

655

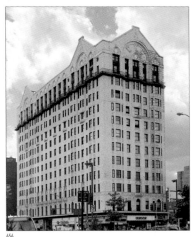

656

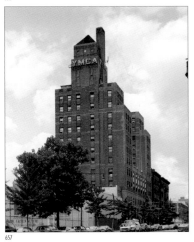

657

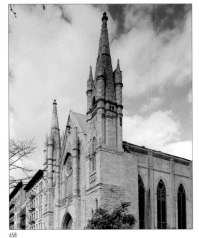

658

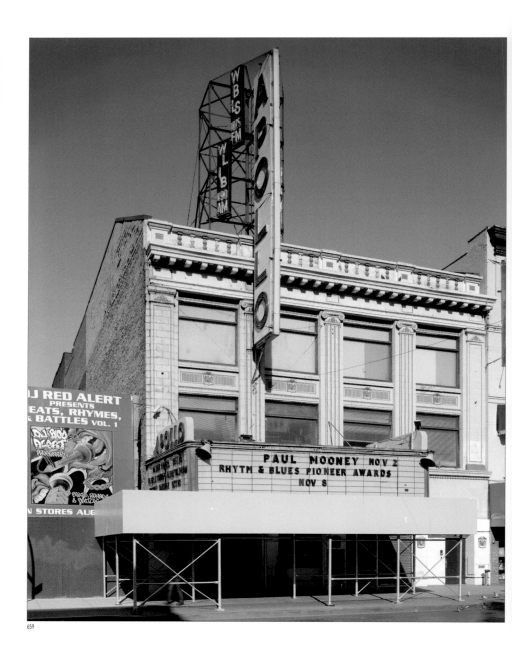

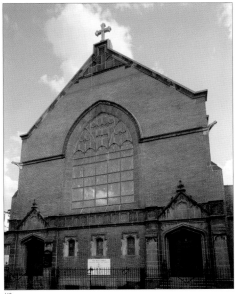

660

APOLLO THEATER

253 WEST 125TH STREET
BETWEEN ADAM CLAYTON POWELL, JR. AND
FREDERICK DOUGLASS BOULEVARDS

1914, GEORGE KEISTER

Originally a burlesque house, this theater became the black equivalent of the Palace Theater, *the* place to perform for musicians, comedians, and dancers. It led the way in the development of swing, bebop, rhythm and blues, modern jazz, gospel, soul, and funk, and launched the careers of countless important black artists since the 1930s. It became nationally known when its Wednesday "Amateur Nights" were broadcast live on twenty-three radio stations around the country, giving audiences their first taste of black swing music, and ushering in the Big Band Era. In later years, Elvis Presley honed his style through regular visits to the Apollo, and when the Beatles first came to New York, this was the first place John Lennon asked to see.

ST. PHILIP'S CHURCH
(EPISCOPAL)

214 WEST 134TH STREET
BETWEEN ADAM CLAYTON POWELL, JR. AND
FREDERICK DOUGLASS BOULEVARDS

1911, VERTNER W. TANDY AND GEORGE W. FOSTER

Black churches were the key to the integration of Harlem, and this parish, Manhattan's oldest African-American Episcopal congregation, was one of the prime movers. Before making the move uptown, the church had land earmarked for a cemetery in the Penn Station neighborhood, which it was able to sell at a handsome profit in 1909. At the time, Harlem property owners had formed covenants pledging not to sell to blacks, but the church's rector, Rev. Hutchens Bishop, was light-skinned and passed for white, which opened the right doors for him to buy a considerable amount of land, including some apartment buildings, whose no-black tenancy rules were immediately dropped. Rev. Bishop also made it a point to hire black architects for this church building.

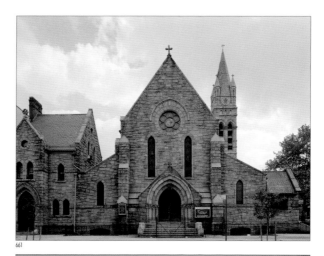

661

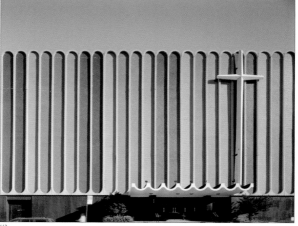

662

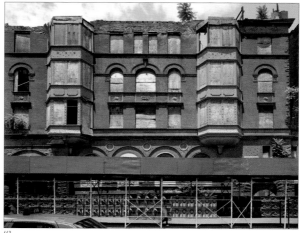

663

ST. ANDREW'S CHURCH ℒ
(EPISCOPAL)

2067 FIFTH AVENUE AT EAST 127TH STREET

1873, HENRY M. CONGDON

When its parish outgrew St. Andrews' original church building on East 127th Street, it was dismantled and moved a couple of blocks west, where it was rebuilt and expanded. It is among the very best Victorian Gothic structures anywhere in the city, and it is also one of the very few nineteenth-century Harlem churches that is still serving its original congregation.

REFUGE TEMPLE OF THE CHURCH OF OUR LORD JESUS CHRIST

2081 ADAM CLAYTON POWELL, JR. BLVD.
BETWEEN WEST 124TH AND WEST 125TH STREETS

RENOVATED, 1966, COSTAS MACHLOUZARIDES

When African-American churches relocated to Harlem from downtown locations, new arrivals from the deep South found most of them bland compared to what they had left behind. This Temple was founded to provide a setting for the old-time religion they craved, and nearly fifty years later it had grown big enough to fill this building, originally a cavernous dance hall called the Harlem Casino. Its rafters never rocked back then the way they do now, every Sunday.

THE MORRIS ℒ

81-85 EAST 125TH STREET AT PARK AVENUE

1884, LAMB & RICH

One of Harlem's most imposing buildings, this is also one of its most endangered landmarks. Built as the Mount Morris Bank, with six apartments above, it has been standing empty for more than thirty years. The building is city-owned, but the city says it can't afford to rehabilitate it, and it is waiting for a private developer to adopt it.

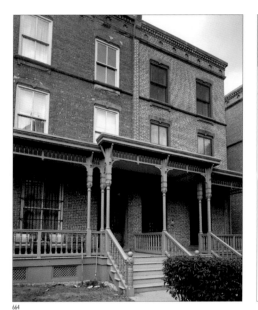

664

ASTOR ROW🏛

8–62 West 130th Street
between Fifth Avenue and Malcolm X Boulevard

1883, Charles Buck

These houses were built on land owned by William Astor. The ones nearest to Fifth Avenue were built as freestanding double houses, and the rest are connected at the rear. What makes them unique in New York are their fine wooden porches. Most of these houses have been restored with private and public funding by the New York Landmarks Conservancy, the Landmarks Commission, and the Abyssinian Development Corporation.

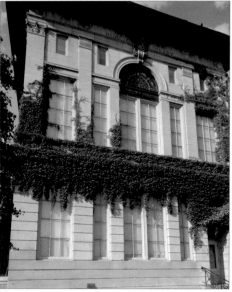

665

665

135th Street Branch🏛 New York Public Library

103 West 135th Street between Malcolm X
and Adam Clayton Powell, Jr. Boulevards

1905, McKim, Mead & White

During the early 1920s, Ernestine Rose, the branch librarian here, began building a collection of black literature and history. In 1926, the Carnegie Corporation purchased the extensive collection gathered by historian Arthur Schomberg and added it to Ms. Rose's rare treasures, making this the country's most important facility for research in black history. A new building was built to house it on an adjoining site in 1980, and this building became the exhibition hall of what is now known as the Schomberg Center for Research in Black Culture.

666
17 EAST 128TH STREET \mathcal{L}

BETWEEN FIFTH AND MADISON AVENUES

C. 1864

San Francisco, eat your heart out. Few of the "painted ladies" that make the West Coast city famous could possibly compete in a beauty contest with this charmer in the heart of Harlem. It is a rare survivor from a time when Harlem was a tiny farming village filled with small wooden houses. It has obviously been lavished with great loving care over the years.

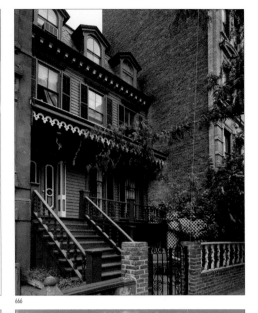

666

667
STRIVER'S ROW \mathcal{L}

WEST 138TH TO WEST 139TH STREETS
BETWEEN ADAM CLAYTON POWELL, JR. AND
FREDERICK DOUGLASS BOULEVARDS

1893, JAMES BROWN LORD, BRUCE PRICE,
AND STANFORD WHITE

Originally called The King Model Houses and now the St. Nicholas Historic District, these four block fronts, with 146 row houses and three apartment buildings, were the brainchild of developer David H. King, Jr., who described it as a neighborhood "independent of surrounding influences." All of the homes were intended for white middle-class families and were not open to blacks until the 1920s, when the area became known as Striver's Row, representing the aspirations of such residents as songwriter Eubie Blake, bandleader Fletcher Henderson, and musician W. C. Handy.

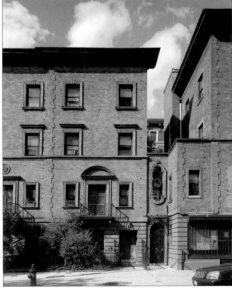

667

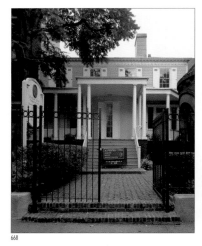

668

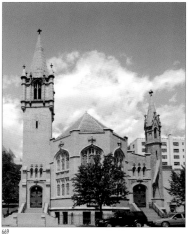

669

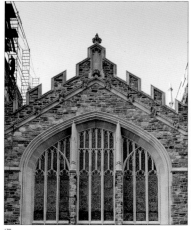

670

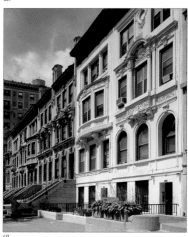

671

672

673

HAMILTON GRANGE ℒ

287 CONVENT AVENUE
BETWEEN WEST 141ST AND WEST 142ND STREETS

1802, JOHN McCOMB, JR.

This was the country home of Alexander Hamilton, located nine miles out of town. Hamilton himself lived here for just two years before being shot by Aaron Burr in a duel, but the house remained in his family for another thirty years. It was sold to St. Luke's Episcopal Church in 1899, and moved two blocks south of its original location. It is now operated by the National Park Service as a National Monument.

ST. JAMES CHURCH ℒ
(PRESBYTERIAN)

ST. NICHOLAS AVENUE AT WEST 141ST STREET

1904, LUDLOW & VALENTINE

This was among the last of the great Gothic Revival churches built in New York, and its tower stands as a monument to the best of them. The style came to America from England at the end of the eighteenth century on a wave of enthusiasm for high romance, begun by the novels of Sir Walter Scott. The first American structure to employ is was a suburban Philadelphia country house called "Sedgeley," built in 1799.

ABYSSINIAN BAPTIST CHURCH ℒ

132 WEST 138TH STREET BETWEEN MALCOLM X
AND ADAM CLAYTON POWELL, JR. BOULEVARDS

1923, CHARLES W. BOLTON & SONS

This church is famous for its prominent ministers, Adam Clayton Powell and his son, Congressman Adam Clayton Powell, Jr. The elder Powell lured thousands of blacks to Harlem, preaching a "social gospel" which combined spirituality with social activism. The church, which was organized downtown in 1808 by people who had split from the First Baptist Church, takes its name from the ancient name of Ethiopia.

280–298 CONVENT AVENUE

BETWEEN WEST 141ST AND WEST 142ND STREETS

1902, HENRI FOUCHAUX

Here, you'll find a wonderful variety of elegant styles, and the charm continues on uptown to 144th Street, where the houses are all slightly older, but not without a charm all their own. The avenue, an extension of Morningside Avenue, is named for the Convent of the Sacred Heart, which stood between St. Nicholas and Amsterdam Avenues for more than forty-five years before it burned down in 1888.

369TH REGIMENT ARMORY ℒ

2366 FIFTH AVENUE, BETWEEN 142ND AND 143RD STREETS

1924, TACHAU & VAUGHT

One of the last armories built in the city, this is the home of the "Harlem Hell Fighters," who served with distinction in France during World War I as a unit of the French Army, after the American Army refused to let them go into combat because of their race. One of its men earned the first Croix de Guerre ever awarded to an American, and the unit itself was presented with one as well.

135TH STREET GATEHOUSE ℒ
CROTON AQUEDUCT

CONVENT AVENUE AT WEST 135TH STREET

1890, FREDERICK S. COOK

Some people say they'd like to live in a lighthouse, and others dream of inhabiting a castle. Although this is neither, it has all the qualities of both—and it is standing empty. This was originally one of the pumping stations of the New Croton Aqueduct, successor to the smaller original pipeline from the upstate reservoirs that went into service in 1842. It is one of several surviving Gatehouses, but few of the others stir the imagination quite like this one does.

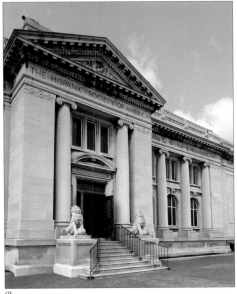

675

City College

674

WEST 138TH TO WEST 141ST STREETS
AMSTERDAM AVENUE TO ST. NICHOLAS TERRACE

1907

Although this is now officially part of the City University of New York, it is still most often called CCNY. This complex, built sixty years after the school's founding, is built of Manhattan schist, the stone that underlies most of the island, excavated during the building of the first subway. It originally included an amphitheater, donated by Adolph Lewisohn, that was used for summer concerts by the New York Philharmonic. The stadium was demolished in 1973 to help make way for the huge modern buildings that dominate the western edge of the campus. Among its graduates are Secretary of State Colin Powell, former Mayor Ed Koch, physician Jonas Salk, and former Supreme Court Justice Felix Frankfurter.

Audubon Terrace

BROADWAY, BETWEEN WEST 155TH
AND WEST 156TH STREETS

1908, CHARLES PRATT HUNTINGTON

This complex of small museums was built by railroad magnate Archer Huntington. It was designed by his cousin, Charles P. Huntington, and the wonderful sculptures in its court are by his wife, Anna Hyatt Huntington. One of its original institutions, the Museum of the American Indian, has been relocated. The Hispanic Society of America, reflecting one of Huntington's passions, contains an important collection of masterworks from Spain and Portugal. Other institutions here are the American Numismatic Society and the National Institute of Arts and Letters. Often overlooked is the wonderful Church of Our Lady of Esperanza, containing art and artifacts donated by King Alfonso XIII of Spain, located around the corner on 156th Street. This site was originally part of the estate and game preserve of the naturalist John James Audubon.

676

677

678

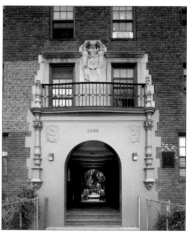

679

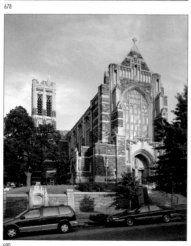

680

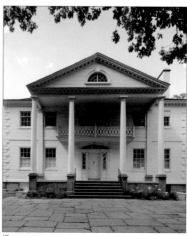

681

676
Roger Morris Apartments ℒ

555 Edgecombe Avenue
between West 159th and West 160th Streets

1916, Schwartz & Gross

When this building was opened it was exclusively for white tenants, but the policy was changed after twenty-five years and it became exclusively African-American, housing such illustrious tenants as jazz musician Count Basie, actor Canada Lee, singer Paul Robeson, boxer Joe Louis, and psychologist Kenneth Clark.

677
M. Marshall Blake Funeral Home ℒ

10 St. Nicholas Place at West 150th Street

1888, Samuel B. Reed

This mansion had a wonderful view out over Long Island Sound when it was built up here—"far out in the country." It was built as the home of James A. Bailey, who teamed up with P. T. Barnum to create the Barnum & Bailey Circus.

678
Church of the Crucifixion

Convent Avenue at W. 149th Street

1967, Costas Machlouzarides

This church, with its airfoil roof and undulating concrete walls, is almost a textbook definition of architecture in the 1960s, when the whole world seemed to be taking a bold step forward or a plunge into banality, depending on one's point of view. In this case, there isn't much wrong that a bit of imaginative landscaping couldn't fix, but nobody seems to have thought of that.

679
Dunbar Apartments ℒ

2588 Adam Clayton Powell, Jr. Boulevard
between West 149th and West 150th Streets

1928, Andrew J. Thomas

Financed by John D. Rockefeller, Jr., this was the first cooperative apartment development built for African-Americans, although it is now rental apartments. Named for poet Paul Lawrence Dunbar, it originally attracted such well-known blacks as Countee Cullen, W. E. B. Dubois, Paul Robeson, and Bill "Bojangles" Robinson.

680
Church of the Intercession ℒ
(Episcopal)

550 West 155th Street at Broadway

1914, Cram, Goodhue & Ferguson

The cemetery that surrounds this church on both sides of Broadway is a successor to Trinity Churchyard in the Wall Street area. Among those who are buried here are John Jacob Astor and Alfred Tennyson Dickens, the son of the novelist. The grave of Clement Clark Moore, who wrote the poem, "'Twas the night before Christmas," is the destination of a candlelight procession every year on Christmas Eve.

681
Morris-Jumel Mansion ℒ

Edgecombe Avenue
between West 160th and West 162nd Streets

1765

This house, built by Colonel Roger Morris, was occupied at various times during the Revolution by George Washington and the British army. It became a tavern before it was bought by Stephen and Eliza Jumel, who lavishly decorated the house in the French Empire style. After having been widowed, she was married to former vice president Aaron Burr. Her divorce from him was granted on the day he died in 1836, and she continued to live here for the rest of her life.

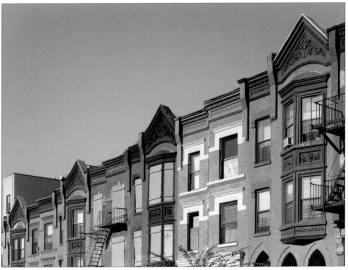

682

43–49 BRADHURST AVENUE

BETWEEN WEST 144TH AND WEST 145TH STREET

1888

After years of neglect and the destruction of their original stoops, this Victorian row is experiencing a new lease on life, thanks to the new Harlem Renaissance. And why not? Bradhurst Avenue is a quiet yet convenient Manhattanville thoroughfare just waiting to be rediscovered. The neighborhood surrounding the City College campus has definitely been on the upswing over the last several years, and, especially since the old college buildings have been restored, it doesn't show any signs of stopping. The area overlooking the Harlem Valley thrived in the mid-nineteenth century, when it was served by a ferry terminal on the Hudson River. It was also a thriving industrial community, anchored by a large brewery.

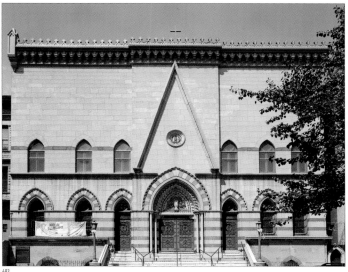

683

Our Lady of Lourdes Church
(Roman Catholic)

467 West 142nd Street
between Convent and Amsterdam Avenues

1904, O'Reilly Bros.

This is a great example of architectural recycling. Its marble and bluestone façade was originally on the National Academy of Design on 23rd Street and Park Avenue. Its apse and east wall were once the east end of St. Patrick's Cathedral, removed when its Lady Chapel was installed. The pedestals on the steps came from A. T. Stewart's marble mansion that stood on Fifth Avenue at 34th Street until 1901.

COLUMBIA PRESBYTERIAN HOSPITAL

BROADWAY, BETWEEN WEST 165TH
AND WEST 168TH STREETS

1928, JAMES GAMBLE ROGERS

This is the largest hospital in New York City, the most important organ transplant center in the Northeast, and is highly regarded as a cancer center, as well as for its work in neo-natal care and the treatment of Parkinson's disease. It is the teaching hospital of Columbia University's College of Physicians and Surgeons, and is affiliated with New York Hospital–Cornell Medical Center.

1854 AMSTERDAM AVENUE

AT WEST 152ND STREET

1871, NATHANIEL D. BUSH

Now a facility of the African Methodist Church Self-Help Program, this high Victorian structure was originally built as a police precinct. When the police were here, it was one of the few buildings in what was then a rural neighborhood. They probably wouldn't have had any need for it, but the original tenants would have been fascinated by that surveillance video camera mounted to the right of the front door.

THE NEW YORK CITY CHURCH OF CHRIST

1828 AMSTERDAM AVENUE
BETWEEN WEST 150TH AND WEST 151ST STREETS

1886, HUGO KAFKA

This was originally the Joseph Loth & Company ribbon mill, turning out "Fair and Square" silk ribbons by the thousands of yards and shipping them to every corner of the country. The mill was designed in an unusual K-shape that allowed more light into the work spaces and made them virtually column-free. At its most active, more than 600 people worked here.

UNITED CHURCH

BROADWAY AT WEST 175TH STREET

1930, THOMAS W. LAMB

Once the Loew's 175th Street movie theater, this is the headquarters of the flamboyant evangelist who calls himself Reverend Ike (his real name is Frederick Eikerenkoetter). His essential message is that "no one has to be poor, and no one has to be a failure," and in addition to preaching here, he spreads the word through a national network of some 1,500 radio stations.

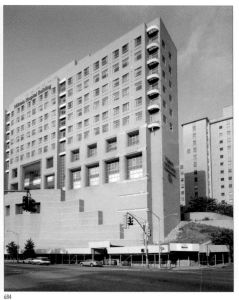

684

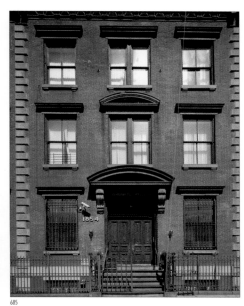

685

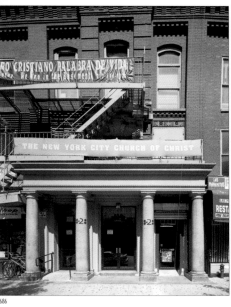

686

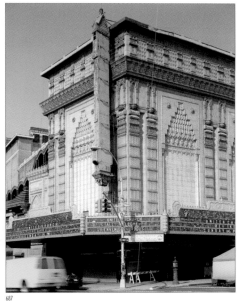

687

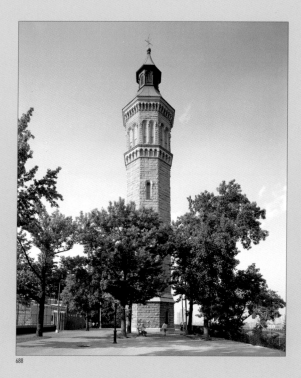

688

Keeping Up the Pressure

Not counting the kind that comes in bottles, New Yorkers consume more than 1.3 billion gallons of water a day. Most of it comes from an upstate watershed that covers more than 2,000 square miles. Because by nature water seeks its own level, it can only rise up to about the sixth floor of New York's buildings, matching the height of the mountain reservoirs. To guarantee enough water pressure in buildings taller than that, it must be pumped into a water tank on the roof where it can then flow down into kitchens and bathrooms. Although these tanks are visible on most buildings, many apartment towers hide them in gazebos and other architectural features, and most skyscrapers hide them away on service floors. Although most large buildings store water in steel tanks, those on exposed rooftops—and there are thousands of them—are made of grooved wooden staves, usually redwood or cedar, held together, like a barrel, by galvanized iron hoops, and topped with a conical plywood roof. The typical rooftop tank, which holds 10,000 gallons of water, is thirteen feet in diameter and twelve feet high. If you think you've spotted one bigger than that, count the number of metal hoops and add one to determine its height in feet. When a water tank needs replacing, which is almost never, builders like the Rosenwach Tank Company, which has been installing them for nearly ninety years, claim that they can dismantle an old one and have its replacement filled with water in less than an eight-hour working day.

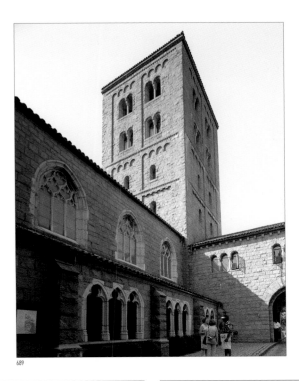

689

HIGHBRIDGE WATER TOWER ℒ

688

HARLEM RIVER AT WEST 173RD STREET

1872, JOHN B. JERVIS

This 200-foot tower originally housed a water tank that provided gravity water pressure for Manhattan's water supply. Without it, it would have been impossible to have running water on any but the lowest floors of the buildings downtown. The water was pumped into it from upstate reservoirs across the Harlem River via the nearby High Bridge aqueduct, which is the oldest of the 2,027 bridges in the city. The system of reservoirs wasn't put into service until 1842, before which New Yorkers relied on wells and occasional streams for bathing and drinking water. It has been modified and expanded several times since then, and one of the casualties of the progress is this tower, which is no longer needed.

THE CLOISTERS ℒ

689

FORT TRYON PARK

1939, ALLEN, COLLINS & WILLIS

This branch of the Metropolitan Museum of Art is built around fragments of cloisters and other Spanish and French medieval buildings that had been collected by George Gray Barnard. They were bought by John D. Rockefeller, Jr. for the museum, and he funded the construction of this building. It is not itself a historic structure, imported stone-by-stone, but a copy of a French Romanesque Abbey. It houses the museum's collection of medieval art, including the priceless Unicorn tapestries. When Rockefeller bought this site, he also bought a stretch of the Palisades across the Hudson River to guarantee that future development wouldn't spoil the view.

690

Dyckman House

4881 Broadway at West 204th Street

1785

This is the only eighteenth-century farmhouse still standing in Manhattan. It replaced an earlier version that was destroyed by British forces during the Revolutionary War. The farm itself was originally established by Jan Dyckman in 1661, and the present house was built by his grandson, William. The family lived here until it was sold in 1868. When it was threatened with demolition in 1915, his descendants bought it back, restored it, and gave it to the city, which operates it as a museum. The hilly landscape here in northern Manhattan is typical of what the whole island looked like when the Dutch arrived. Nearly all of the hills were leveled, often with nothing more than picks and shovels, and the low places were filled with the resulting debris. What was left over was dumped into the rivers, making Manhattan bigger as well as smoother.

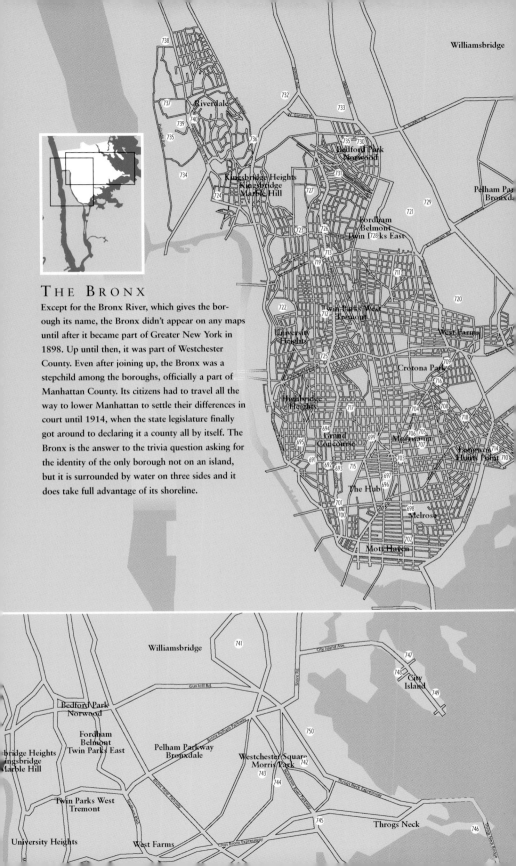

THE BRONX

Except for the Bronx River, which gives the borough its name, the Bronx didn't appear on any maps until after it became part of Greater New York in 1898. Up until then, it was part of Westchester County. Even after joining up, the Bronx was a stepchild among the boroughs, officially a part of Manhattan County. Its citizens had to travel all the way to lower Manhattan to settle their differences in court until 1914, when the state legislature finally got around to declaring it a county all by itself. The Bronx is the answer to the trivia question asking for the identity of the only borough not on an island, but it is surrounded by water on three sides and it does take full advantage of its shoreline.

Williamsbridge

Riverdale

Bedford Park
Norwood

Kingsbridge Heights
Kingsbridge
Marble Hill

Pelham Par
Bronxda

Fordham
Belmont
Twin Parks East

Twin Parks West
Tremont

University
Heights

West Farms

Crotona Park

Highbridge
Heights

Grand
Concourse

Morrisania

Longwood
Hunts Point

The Hub

Melrose

Mott Haven

Williamsbridge

City
Island

Bedford Park
Norwood

Fordham
Belmont
Twin Parks East

bridge Heights
ingsbridge
Marble Hill

Pelham Parkway
Bronxdale

Westchester Square
Morris Park

Twin Parks West
Tremont

University Heights

West Farms

Throgs Neck

YANKEE STADIUM

RIVER AVENUE AT EAST 161ST STREET

1923, OSBORNE ENGINEERING CO.
REBUILT, 1976, PRAEGER-KAVANAGH-WATERBURY

This illustrious ballpark was built by Colonel Jacob Ruppert for his team, the New York Yankees. They had been playing in the old Polo Grounds across the river in Manhattan, but with the signing of Babe Ruth, the owner decided that his star deserved a better showcase. He also took advantage of the opportunity to stack the deck with a short right field that would help the Babe hit more home runs. Whether the player needed the assist or not is still open to question, but he hit 659 of his career record of 714 home runs as a Yankee. Ruppert and his partner, Cap Huston, paid $675,000 for the land and $2.5 million to build the stadium—without any help from the city, the state, or anybody else. It's how things were done back in 1923. This was the first ballpark to be called a "stadium," and it was the first to have three decks of seats (no skyboxes, though). Its original seating capacity was 67,224. After a $100 million overhaul during the 1974–75 season, the stadium reopened with a capacity of 57,545. The renovation was prompted by the threat that the team would leave town, and resulted in a thirty-year lease with the landlord, the City of New York. Before the upgrade, the land had been owned by the Knights of Columbus and the structure itself by Rice University.

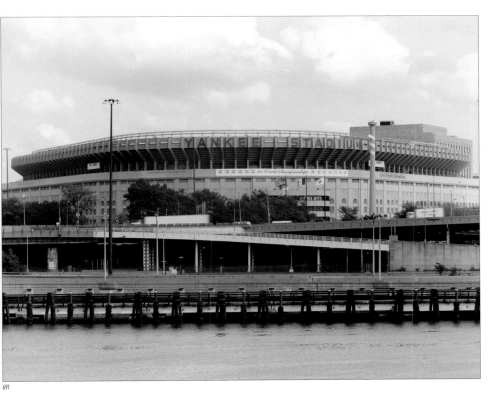

691

692

693

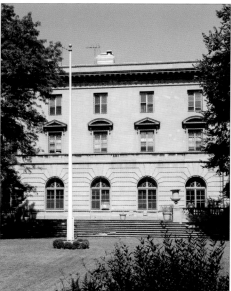

694

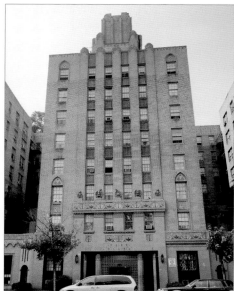

695

BRONX COUNTY BUILDING ℒ

851 GRAND CONCOURSE AT EAST 161ST STREET

1935, JOSEPH H. FREEDLANDER AND MAX L. HAUSLE

Also known as the Bronx County Courthouse, its scultpural elements are what make it appealing. The frieze, by Charles Keck, represents productive employment, a popular theme in the Depression years. The eight marble sculptures flanking the four entrances in pairs refer to achievement, progress, and the law. Two of them are the work of sculptor Adolph Weinmann, who also supervised the work for the others.

THOMAS GARDEN APARTMENTS

840 GRAND CONCOURSE
BETWEEN EAST 158TH AND EAST 159TH STREETS

1928, ANDREW J. THOMAS

This apartment development, named for its architect, was financed by John D. Rockefeller, Jr., as middle-income housing. The five-story walk-up apartments surround a Japanese garden in a central court, which includes huge concrete lanterns and a man-made stream crossed by little bridges.

ANDREW FREEDMAN HOME ℒ

1125 GRAND CONCOURSE
BETWEEN EAST 166TH AND McCLELLAN STREETS

1924, JOSEPH H. FREEDLANDER AND HARRY ALLAN JACOBS

This home for the aged was financed with a bequest of Andrew Freedman, a Tammany Hall stalwart who was involved in the construction of the IRT subway, and who was once the owner of the New York Giants baseball team. He stipulated in his will that the home should be restricted to poor people who had formerly been rich.

PARK PLAZA APARTMENTS ℒ

1005 JEROME AVENUE
BETWEEN ANDERSON AVENUE AND EAST 165TH STREET

1931, HORACE GINSBERG AND MARVIN FINE

There are a host of Art Deco apartments houses in the Bronx, but few of them are as well-done as this one, which was among the first. The façade is the work of Marvin Fine, who was influenced by the Chrysler Building in Manhattan. Among the colorful terra-cotta panels that adorn it, one is a representation of the architect offering a model of the building to the Parthenon.

696

IMMACULATE CONCEPTION CHURCH OF THE BLESSED VIRGIN MARY (ROMAN CATHOLIC)

389 EAST 150TH STREET AT MELROSE AVENUE

1887, HENRY BRUNS

This Romanesque Revival church with its imposing steeple, and the buildings that flank it on either side, were built to serve the very large community of Germans living and working in the South Melrose section of the Bronx toward the end of the nineteenth century.

697

614 COURTLAND AVENUE ℒ

AT EAST 151ST STREET

1882, HEWLETT S. BAKER

This three-story, mansard-roofed apartment house was built by saloon-keeper Julius Ruppert as a combination meeting hall and rathskeller for the pleasure of his German immigrant neighbors.

698

PUBLIC SCHOOL 27 ℒ

519 ST. ANN'S AVENUE
BETWEEN EAST 147TH AND EAST 148TH STREETS

1897, C. B. J. SNYDER

Also known as St. Mary's Park School, this is one of the early designs by C. B. J. Snyder, the Superintendent of School Buildings. Like most of his other work, its style reflects a city policy to build schools that would impress local parents with the importance of education.

699

CLAY AVENUE HISTORIC DISTRICT

BETWEEN EAST 165TH AND EAST 166TH STREETS

1901–10

These blockfronts on both sides of the avenue form a harmonious streetscape of Romanesque Revival houses. There are twenty-eight semi-detached two-family houses here, and three corner apartment buildings. They all occupy the site of Fleetwood Park, where trotting races were held until 1898.

700

HOSTOS COMMUNITY COLLEGE

GRAND CONCOURSE
BETWEEN WEST 144TH AND WEST 149TH STREETS

1994, GWATHMY SIEGEL & ASSOCIATES

This school was originally opened as the Eugenio Maria de Hostos Community College in 1968. It is highly regarded among the branches of the City University of New York for its early work in bilingual education. It also pioneered the concept for free day care for the children of its students. It serves an enrollment of more than 4,000.

701

BRONX POST OFFICE ℒ

558 GRAND CONCOURSE AT EAST 149TH STREET

1937, THOMAS HARLAN ELLETT

This building was designed as part of a federal program to provide jobs for architects affected by the Great Depression. The Federal Arts Program also brought a commission to artist Ben Shahn, whose murals in the lobby here are built around the theme of "America at Work," a subject that was on everybody's mind at the time.

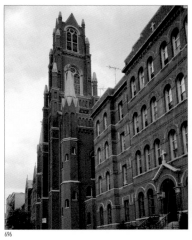

696

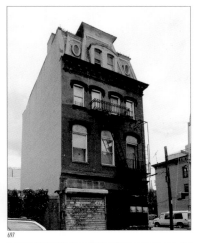

697

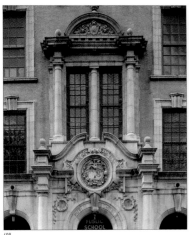

698

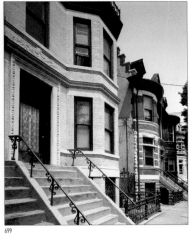

699

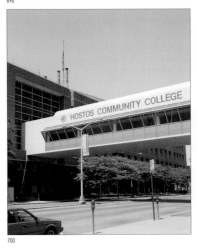

700

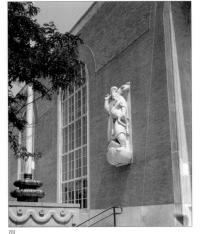

701

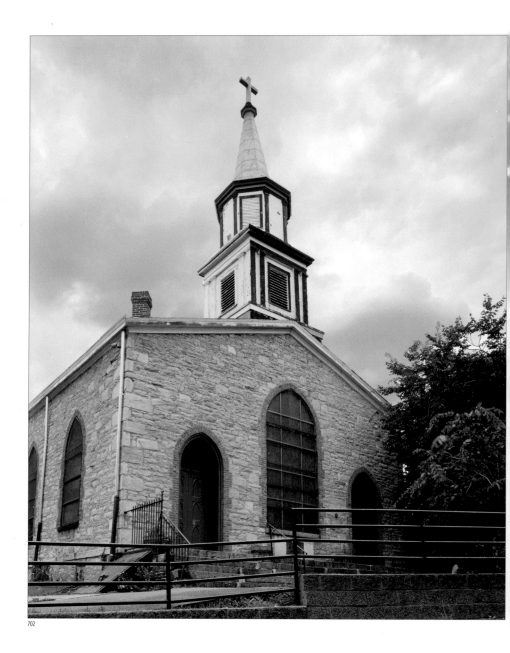

702

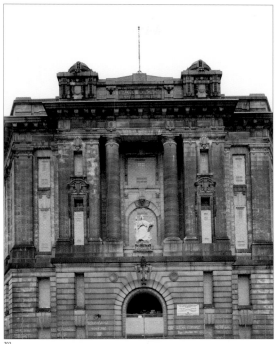

703

St. Ann's Church
(Episcopal)

295 St. Ann's Avenue
between East 139th and East 141st Streets

1841

The oldest church building in the Bronx stands on the original site of the estate of Gouverneur Morris. Active in the formation of the American Republic, Morris proposed turning his estate, Morrisania, into the nation's capital. His arguments were persuasive, and the Continental Congress took them seriously. After all the pros and cons were debated, and the time came to build the Capitol Building in Washington, its immense cast-iron dome was fabricated in this neighborhood.

Old Bronx Borough Courthouse

East 161st Street at Third Avenue

1915, Oscar Bleumner and Michael J. Garvin

After serving for a time as the Bronx County Branch of the City Criminal Court, this impressive Beaux Arts building was boarded up and forgotten. It was originally built as the borough's only courthouse by Michael J. Garvin, a friend of the borough president. He turned the actual design over Oscar Bleumner who, although he had architectural training, thought of himself as a painter.

SECOND BATTERY ARMORY *L*

1122 FRANKLIN AVENUE AT EAST 166TH STREET

1911, CHARLES C. HAIGHT

This massive fortress with battlements and narrow windows was the first armory built in the Bronx to serve the local militia. Its architect was famous for his Gothic touches and he seems to have gone after this project with a heavier hand than usual. His creation would make a perfect setting for a Gothic novel or a location for a movie adapted from one.

MORRISANIA BRANCH, NEW YORK PUBLIC LIBRARY

610 EAST 169TH STREET, AT FRANKLIN AVENUE

1908, BABB, COOK AND WILLARD

Andrew Carnegie contributed $5.2 million to build sixty-one branch libraries, and this is one of them. Designed by Walter Cook, who, along with John M. Carérre, and Charles F. McKim, set the standards for all of them, the Morrisania branch dominates The Bronx's McKinley Square. The bus stop out front serves the BX35 bus, which you can catch at the George Washington Bridge station in Manhattan. Enjoy the ride.

1074 AND 1076 CAULDWELL AVENUE

AT BOSTON POST ROAD

This Victorian house, and the one next to it at 1076, have survived more than a century of change in their South Bronx neighborhood with every bit of their elegance intact. The one pictured, built by F. T. Camp in 1874, still retains its distinctive front porch. Its next-door neighbor, whose porch seems more a part of the building itself rather than an extension from it, was built five years later by Charles C. Churchill.

MORRIS HIGH SCHOOL *L*

1110 BOSTON ROAD AT EAST 166TH STREET

1904, C. B. J. SNYDER

This Collegiate Gothic-style building is among the best public schools in any borough. Its auditorium, called Duncan Hall, has landmark status on its own. It is an unusually high space with an ornate balcony, elaborate plasterwork, and Tudor arches. It also has stained glass windows and decorative organ pipes. The room is decorated with a series of murals, including Auguste Gorguet's World War I memorial, called *After Conflict Comes Peace.*

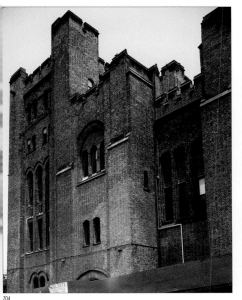

704

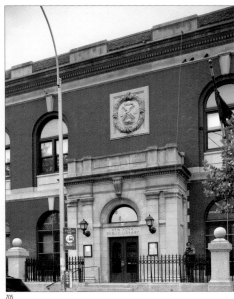

705

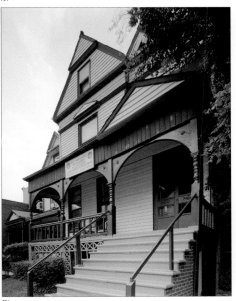

706

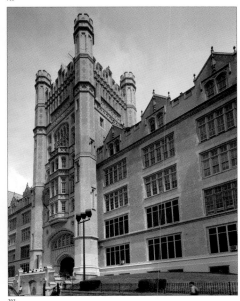

707

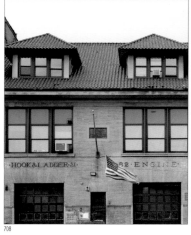

708

709

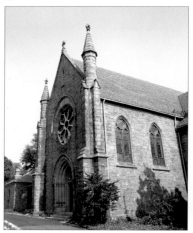

710

711

712

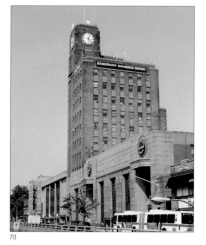

713

ENGINE COMPANY 82

1213 INTERVALE AVENUE AT EAST 169TH STREET

In 1972, firefighter Dennis Smith turned author with his bestseller, *Report from Engine Company 82*. At the time, this brick firehouse in the South Bronx, which also serves Ladder Company 31, was far and away the busiest of all the facilities of the FDNY, as everything for blocks around seemed to be burning down. The South Bronx is one of those New York neighborhoods with undefined borders. It originally included just Mott Haven and Melrose, but in the 1970s it expanded out to the stretch along the Cross Bronx Expressway.

CROTONA TERRACE

1714 CROTONA PARK EAST
BETWEEN EAST 173RD AND EAST 174TH STREETS

1994, LEIBMAN MELTING

A late adaptation of the Art Deco style, which extends into just about every corner of the Bronx, this apartment building manages to blend in unobtrusively with its older neighbors. This section of the west central Bronx near Crotona Park was for many years a Jewish neighborhood, but most of its residents moved to the suburbs in the 1950s. They were replaced by a large Puerto Rican and black population.

CORPUS CHRISTI MONASTERY

1230 LAFAYETTE AVENUE AT BARETTO STREET

1890, WILLIAM SCHICKEL

This is a cloistered community of Dominican nuns, a rarity in modern New York. The mendicant religious order was founded in the early seventeenth century by St. Dominic, also known as the Black Friar.

ARTHUR AVENUE

NORTH OF EAST 187TH STREET

This neighborhood, known as Belmont, a few blocks south of Fordham University and west of the Bronx Zoo, became an enclave of Italian immigrants in the 1890s when they were able to find plenty of jobs building the zoo. Their presence led to the dozens of food shops and restaurants that make this a Mecca for lovers of the best Italian food. Until the 1940s, there were also dozens of pushcart vendors lining Arthur Avenue, but Mayor Fiorello LaGuardia made them illegal and moved their businesses into a special market building.

1969–1999 MORRIS AVENUE ℒ

BETWEEN EAST 179TH STREET AND EAST TREMONT AVENUE

1910, JOHN HAUSER

This is part of the Morris Avenue Historic District, which continues across the street and around the corner on 179th Street. All of these houses were designed by the same architect and built by developer August Jacob. The three-story, two-family, neo-Renaissance brick row houses are notable for their full-height bays, as well as for their well-preserved wrought-iron details.

EMIGRANT SAVINGS BANK ℒ

2516–2530 GRAND CONCOURSE
BETWEEN FORDHAM ROAD AND EAST 192ND STREET

1933, HALSEY, McCORMACK & HELMER

Originally the Dollar Savings Bank, designed by the architects of Brooklyn's famed Dime Savings Bank, this structure was built in stages, culminating with the ten-story tower with its four-faced clock in 1938. The interior, lavished with marble and gold leaf, has a series of four murals by Angelo Magnanti tracing the history of the Bronx.

714

AMERICAN BANK NOTE COMPANY

LAFAYETTE AVENUE AT TIFFANY STREET

1911, KIRBY, PETIT & GREEN

The Yankee dollar begins its life at the United States Mint, but many Latin American countries once imported their pesos, cruzeiros, and sucres from this factory in the Hunts Point section of the Bronx. The fortress-like plant doesn't turn out money anymore, but in its heyday, it also produced stock certificates and travelers' checks and even millions of lottery tickets.

715

BRONX SOUTH CLASSIC CENTER

MORRIS AVENUE AT 156TH STREET

2000, AGREST & GANDLESONAS

Among the many attempts to revitalize the South Bronx, this community center is among the most succesful. It brings a touch of modernity to the neighborhood, whose modern history is probably best forgotten. In spite of the reputation it earned during the 1960s and '70s, the area has made a dramatic and welcome comeback.

716

CHARLOTTE GARDENS

CHARLOTTE AVENUE AND EAST 174TH STREET

1983

This part of the Bronx was in Westchester County until it was annexed by the city in 1895. But this wasn't an attempt to bring the suburbs back. It was the result of a promise made by President Jimmy Carter and fulfilled by his successor, Ronald Reagan, to fund the rebuilding of the South Bronx. The original development included ninety-four ranch-style houses that sold for $54,000 apiece.

717

DAUGHTERS OF JACOB GERIATRIC CENTER

321 EAST 167TH STREET AT FINDLAY STREET

1920, LOUIS ALLEN ABRAMSON

The columned entrance to the main building here was intended to convey dignity, but it also distracts from the multi-winged building behind it at the end of the Italianate garden. This was a plan common among prisons, as well as many hospitals, which made it easier to control the population inside. The two buildings that flank it were built as additions to the center in the 1970s.

718

OLD 41ST PRECINCT, NYPD ℒ

1086 SIMPSON STREET
BETWEEN WESTCHESTER AVENUE AND EAST 167TH STREET

1914, HAZZARD, ERSKINE & BLAGDON

This was known as "Fort Apache" when drugs, arson, and crime were rampant in this part of the South Bronx in the 1960s and 1970s. The precinct, which serves the neighborhoods of Hunts Point and Crotona Park East, moved to a new building on Longwood Avenue, near Bruckner Boulevard, in the 1990s, just as the crime wave was abating.

719

LOEW'S PARADISE THEATER ℒ

2417 GRAND CONCOURSE AT EAST 184TH STREET

1929, JOHN EBERSON

Now the Paradise Twins, an unremarkable pair of small theaters, this movie palace, called "Low-eys" by its patrons, had a lavish 4,200-seat auditorium and a lobby resembling a Spanish patio. Literally every inch of its interior was dripping with ornamentation, and its ceiling was studded with twinkling stars and lazily moving clouds. The balconies were decorated with artificial flowers, and there were potted palms and gigantic sculptures everywhere.

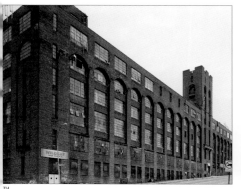

714

715

716

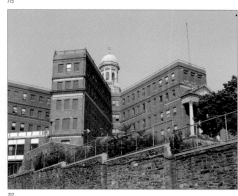

717

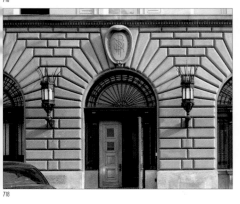

718

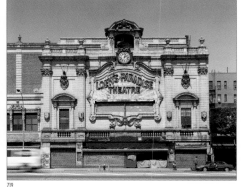

719

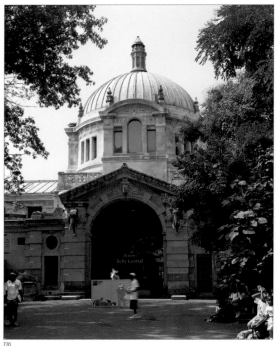

720

Bronx Zoo/Wildlife Conservation Park

Bronx Park, east of Fordham Road

1899, Heins & La Farge

Beginning with the aquatic bird house, completed in 1899, work has almost never stopped, with new exhibit space being added and older ones rebuilt in this park setting. A pioneer in the concept of allowing animals to live in naturalistic replicas of their native habitats, the Wildlife Conservation Society is also a world leader in breeding endangered species. Its 252-acre site here is small compared to some other urban zoos, but its practices have had a profound effect on all of them. The Society also operates four other zoos, one in each borough, and the aquarium at Coney Island.

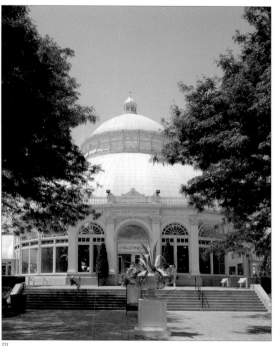

721

ENID A. HAUPT CONSERVATORY

NEW YORK BOTANICAL GARDEN
BRONX PARK NORTH AT FORDHAM ROAD

1902, LORD & BURNHAM
RECONSTRUCTED, 1997, BEYER BLINDER BELLE

This group of Victorian greenhouses, patterned
after the Palm House at the Royal Botanic Gar-
dens at Kew, England, is the centerpiece of the
Botanical Garden established here in the early
1890s and landscaped by Calvert Vaux and
Calvert Parsons, Jr. The Parsons family were
pioneer horticulturalists who imported many
trees and plants from abroad that we consider
native today, including the most common plant
in the city, the ailanthus tree, which they
brought from Asia as an ornamental plant,
never dreaming it would thrive in any nook
and cranny, and thus dominate entire urban
neighborhoods. The ailanthus inspired the theme
of the novel *A Tree Grows in Brooklyn*, but it
grows like a weed in every borough.

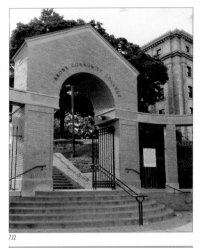

722

BRONX COMMUNITY COLLEGE

UNIVERSITY AVENUE AT WEST 180TH STREET

1902, McKIM, MEAD & WHITE

In the late nineteenth century, New York University moved its undergraduate school from Washington Square to a fifty-four-acre site in what came to be called University Heights. Among the treasures beyond its gates is the domed Gould Memorial Library and the colonnade behind it that is the setting for the Hall of Fame, honoring outstanding Americans. The campus was sold to the City University of New York in 1973.

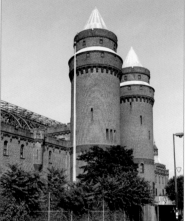

723

KINGSBRIDGE ARMORY

29 WEST KINGSBRIDGE ROAD AT JEROME AVENUE

1917, PILCHER & TACHAU

"Biggest in the world" is a source of pride to most New Yorkers, and this building can be added to the list as the world's largest armory, or at least it had the biggest drill hall in the world at the time it was built. The great space inside this turreted copy of a French medieval castle measures 300 by 600 feet.

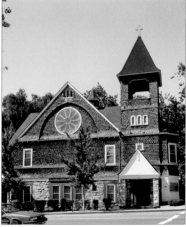

724

ST. STEPHEN'S METHODIST EPISCOPAL CHURCH

146 WEST 228TH STREET AT MARBLE HILL AVENUE

1897

This is the most prominent structure in Marble Hill, which is technically a part of Manhattan. It was once geographically in Manhattan, but was cut off in 1895, when the Harlem River Ship Canal was built to connect the Harlem and Hudson Rivers. At that time, this former marble quarry became an island itself, bounded by the canal and Spuyten Duyvil Creek. It became part of the mainland after the creek was filled in 1938.

725

LEWIS MORRIS APARTMENTS

1749 GRAND CONCOURSE AT CLIFFORD PLACE

1923, EDWARD RALDIRIS

The Grand Concourse is four-and-a-half miles long between 138th Street and Mosholu Parkway. Eleven lanes wide, with two tree-lined dividers and wide sidewalks, it was the grandest boulevard in the Bronx when it was built in 1909, and it became the government center as well as a major shopping and entertainment district. It quickly became the favorite destination of new arrivals who could afford to live here, and this thirteen-story apartment house became their most favored address.

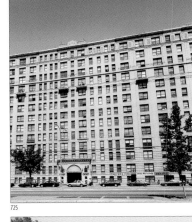

725

726

POE COTTAGE *L*

GRAND CONCOURSE AT EAST KINGSBRIDGE ROAD

C. 1812

This little cottage was moved here to Poe Park in 1913, from its original location on the other side of Kingsbridge Road. Edgar Allan Poe lived here for nearly three years before he died in Baltimore in 1913. It was here, one of several of his homes in the city, that he wrote "The Bells" and "Annabel Lee."

726

727

HIGHBRIDGE WOODYCREST CENTER

936 WOODYCREST AVENUE AT JEROME AVENUE

1902, WILLIAM B. TUTHILL

This is the successor to the American Female Guardian Society and the Home for the Friendless, built at a time when the Highbridge section was a resort area, generally accessible by excursion steamers. It began to change into a residential neighborhood when the Jerome Avenue elevated line crossed it in 1918.

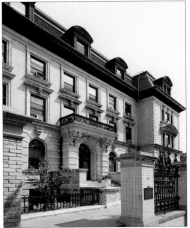

727

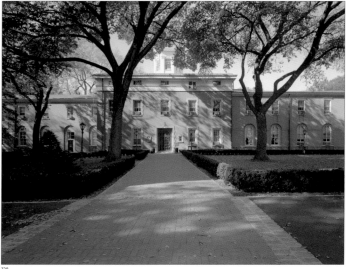

728

FORDHAM UNIVERSITY

ROSE HILL CAMPUS
FORDHAM ROAD AT WEBSTER AVENUE

1838–86

This Roman Catholic university opened in 1841
as St. John's College, and came under control of
the Society of Jesus, the Jesuits, five years later.
Although highly rated academically, Fordham
became known in the 1930s for its sports teams,
especially football, with its defensive line,
known as "the seven blocks of granite," one of
whom was Vince Lombardi. The university,
which has a campus that includes its famous
law school at the southern edge of Lincoln Cen-
ter, began accepting female students in 1964.

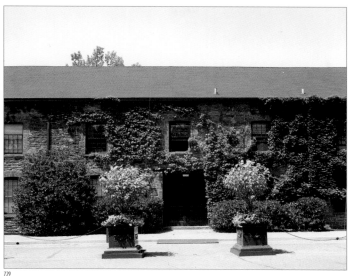

729

LORILLARD SNUFF MILL

NEW YORK BOTANICAL GARDEN

C. 1840

The setting for the Botanical Garden is the former estate of the Lorillard family, descendants of Pierre Lorillard, who established a snuff factory in lower Manhattan in 1760. The original mill on this site, built to take advantage of water power provided by the fast-moving Bronx River, ground more tobacco than any other in the United States by the end of the eighteenth century. This building stands at the edge of the Bronx River gorge, near the only remaining virgin hemlock forest remaining in New York City, which was once covered by them.

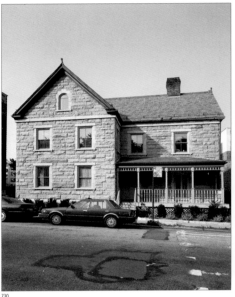

730

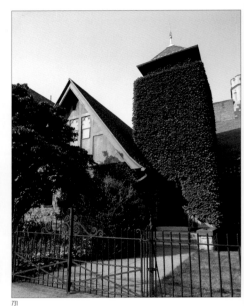

731

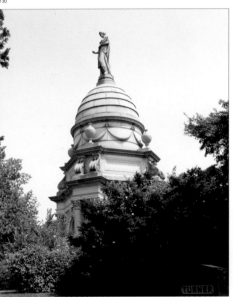

732

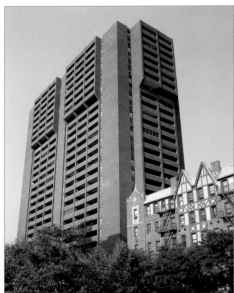

733

WILLIAMSBRIDGE RESERVOIR KEEPER'S HOUSE

WILLIAMSBRIDGE OVAL EAST AT PUTNAM PLACE

1890, GEORGE W. BIRDSALL

This is now the home of the Mosholu Preservation Organization, but it once served as an office and living quarters for the man who kept an eye on the reservoir across the street. The embankment that once contained the reservoir now encircles a large park and playground. The reservoir itself was drained in 1923, after thirty-five years of service to the city's water supply.

BEDFORD PARK PRESBYTERIAN CHURCH

2933 BAINBRIDGE AVENUE AT BEDFORD PARK BLVD.

1900, R. H. ROBERTSON

The Bronx's Bedford Park section is the remnant of a planned community established in the 1880s and named for a town in England, which inspired the construction of buildings like this that would be right at home in its namesake. Many of the houses near here are in the Queen Anne style with several fine examples of Art Deco added after the Third Avenue elevated line reached here in 1920.

WOODLAWN CEMETERY

EAST 211TH STREET AND BAINBRIDGE AVENUE
TO EAST 233RD STREET

1863, JAMES C. SIDNEY

This rural-style cemetery is the last resting-place of an incredible variety of historical figures and prominent New Yorkers. This list ranges from musician Duke Ellington to justice Charles Evans Hughes, from robber baron Jay Gould to songwriter George M. Cohan. There are Vanderbilts here, and Guggenheims, Belmonts, and Whitneys. Fiorello LaGuardia is buried here, and so is F. W. Woolworth. Many of them occupy mausoleums as impressive as the mansions they built in life. Among the architects who created them are Richard Morris Hunt, James Renwick, Jr., McKim, Mead & White, John Russell Pope, and Louis Comfort Tiffany.

MONTEFIORE APARTMENTS II

450 WAYNE AVENUE
BETWEEN EAST GUN HILL ROAD AND EAST 210TH
STREET

1972, SCHUMAN, LICHTENSTEIN & CLAMAN

One of the tallest apartment houses in the Bronx, you can see this building for miles. It serves the community around Montefiore Medical Center, which moved to the northern Bronx from Manhattan in 1913. The facility was originally established by Jewish philanthropists and was named for Moses Montefiore, a former London sheriff.

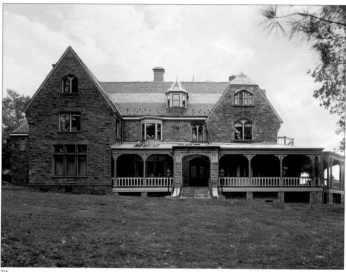

734

GREYSTON ℒ

690 West 247th Street at Independence Avenue

1864, James Renwick, Jr.

This is one of the earlier country houses in Riverdale, which has what may be the finest collection of them anywhere in the city. It was built for William E. Phelps Dodge, a founder of the Phelps Dodge mining company. The company, which also controlled several railroads during its history (dating back to 1833), still produces thousands of tons of copper every year. The villa was sold to Columbia University Teachers College, which used it as a conference center. It was later turned into a Zen Buddhist retreat before finally coming full-circle back to a private residence.

WAVE HILL ℒ

675 West 252nd Street at Sycamore Avenue

1843

This mansion was built by lawyer William Lewis Morris in 1843. It was acquired twenty-three years later by publisher William Henry Appleton, who added greenhouses and elaborate gardens. It was sold again to financier George W. Perkins, who added more land to the estate. He rented the stone house to Samuel Clemens (Mark Twain) for two years, and then to Bashford Dean, who added the impressive armor hall as a private museum. Other tenants since then have included conductor Arturo Toscanini and the British UN delegation. The property was deeded to the city in 1960 and converted to the Wave Hill Center for Environmental Studies, which includes a twenty-eight-acre garden, one of the finest anywhere in New York.

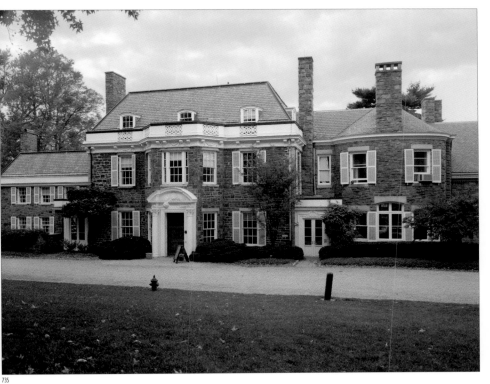

735

THE MAN WHO OWNED THE BRONX

Many place-names in the Bronx are reminders of the early settlers. Morrisania is named for the estate of the Morris family, Throgs Neck for pioneer town builder John Throckmorton, and the Hutchinson River for Anne Hutchinson, who emigrated from New England looking for religious tolerance. But the name of Adriaen Van der Donck is missing from the map, except for the City of Yonkers just across the border, which takes it name from his status as the "jonkheer," "the young patroon." As a means of developing the Hudson River Valley, the Dutch West India Company carved it up into great estates that it gave to so-called patroons in return for a promise to turn a profit for them. Van der Donck took advantage of their offer and established himself in the territory extending eight miles north from Spuyten Duyvil Creek between the Bronx and Hudson Rivers.

Although he set aside a plot of land for his own house and farm at what is now the Parade Ground in Van Cortlandt Park, the young patroon never got around to actually settling there. He had other things on his mind. His law degree from the University of Leyden made him the first lawyer to settle in Nieuw Amsterdam, and he used his status to file its first lawsuit. It was a petition to have Director General Peter Stuyvesant recalled to the Netherlands. Although his neighbors agreed that it was a good idea, Van der Donck wasn't very popular among the people who ran the colony from old Amsterdam; and when a war broke out with England while he was there pleading his case, the Company took it as an opportunity to cancel his passport. He eventually managed to get back to Nieuw Amsterdam, but his license to practice law had been revoked, and he spent the rest of his days second-guessing the wily old Stuyvesant.

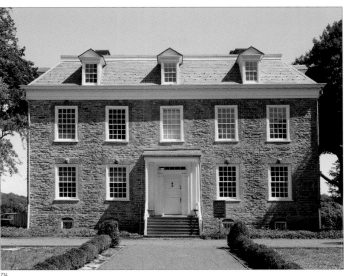

736

VAN CORTLANDT MANSION ℬ

BROADWAY, BETWEEN WEST 242ND
AND WEST 246TH STREETS

1749

Now a museum, this manor house was built on land given to Jacobus Van Cortlandt as a wedding gift by the Philipse family when he married Eva Philipse in 1691. The house served as George Washington's headquarters during the Revolution and later as a nerve center for General Lord Howe, who commanded the British forces. The Van Cortlandt family lived here until 1889, when they donated the estate to the city for use as a public park. The park covers 1,122 acres, and is part of a system of parkland that covers about sixteen percent of all the land in the Bronx. The borough has more park acreage within its borders than many cities, including Boston, Cleveland, and Detroit.

WILLIAM S. DUKE BARN

COLLEGE OF MOUNT ST. VINCENT ℒ

5286 SYCAMORE AVENUE AT WEST 254TH STREET

C. 1858, CONVERTED INTO A CARRIAGE HOUSE, 1886,
FREDERICK CLARK WITHERS

There are several of these former Shingle-style carriage houses and stables lining Sycamore Avenue, which was once called "Stable Alley." Nearly all of them have been converted into private homes. The impressive country homes they originally served are located on the hill rising to the east behind them, along Independence Avenue.

RIVERDALE AVENUE AT WEST 263RD STREET

1859, HENRY ENGLEBERT

This liberal arts college moved here to North Riverdale in 1857. It was established in 1847 by the Sisters of Charity of Mount St. Vincent, whose convent was located above McGown's Pass overlooking Central Park's Conservatory Gardens. Its present location was formerly the estate of actor Edwin Forrest, whose original home, the faux castle he called "Fonthill," was the college's library until 1962.

RIVERDALE PRESBYTERIAN CHURCH ℒ

CHRIST CHURCH ℒ
(EPISCOPAL)

4765 HENRY HUDSON PARKWAY W., AT W. 249TH STREET

1864, JAMES RENWICK, JR.

The owners of local estates donated the money to build this Gothic Revival church and its interesting stone manse, but William E. Dodge, Jr., whose nearby villa was under construction at the time, also donated the architect. He had hired James Renwick, Jr., the designer of Manhattan's Grace Church and St. Patrick's Cathedral, to build the house he would call "Graystone," two blocks from here, and also engaged him to do these buildings in his spare time, as it were. But, of course, the architect didn't stint with either his time or his talent.

HENRY HUDSON PARKWAY AT WEST 252ND STREET

1866, RICHARD M. UPJOHN

This High Victorian Gothic building, made of local stone and brick and featuring a charming belfry, was intended to resemble an English country church. It is the work of Richard M. Upjohn, the son of the architect of Manhattan's Trinity Church. Christ Church's parish house, which has a wonderful mansard roof, rounds out the setting perfectly.

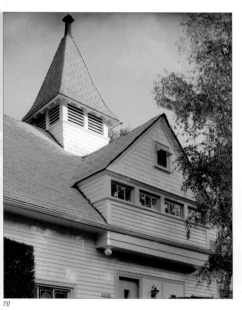

737

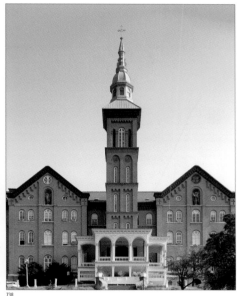

738

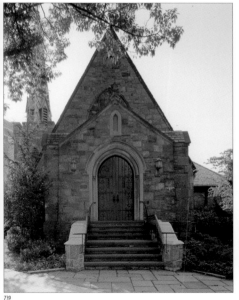

739

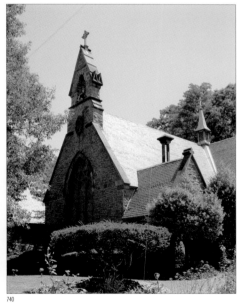

740

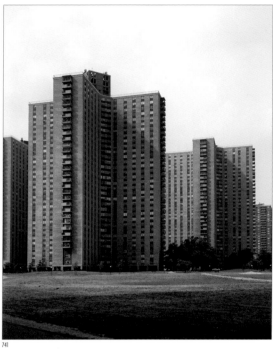

741

CO-OP CITY

NORTHERN SECTION: EAST OF NEW ENGLAND THRUWAY,
BAYCHESTER AVENUE BETWEEN CO-OP CITY BOULEVARD
AND BARTOW AVENUE;
SOUTHERN SECTION: EAST OF HUTCHINSON RIVER
PARKWAY EAST, BETWEEN BARTOW AND BOLLER AVENUES

1968–1970, HERMAN J. JESSOR

This monster complex of apartment buildings
is home to some 55,000 people (more than the
entire population of Binghamton, New York),
who occupy 15,372 individual units. In addition
to its 35 bulky towers and 236 townhouses,
the 300-acre site includes eight parking garages
for 10,500 cars, three shopping centers, two
junior high schools, four elementary schools, a
power plant, and police and fire stations. The
rest is landscaped open space. In spite of its
name, these are rental apartments, not cooper-
atives. They were largely funded by a consor-
tium of labor unions in a cooperative venture.

AMERICA ON THE THRUWAY

In the early 1960s, New York had its own answer to Disneyland in a 205-acre theme park known as Freedomland, built along the New England Thruway in the marshes of the East Bronx. Forty acres bigger than Disneyland in California, it offered more attractions, too, including simulations of the Chicago Fire (every twenty minutes), the landing at Plymouth Rock, the Lewis and Clark Expedition, and representations of several American cities (including a model of San Francisco, complete with scheduled earthquakes). All this was reached by monorail or a paddlewheel steamer. The park was built in the shape of a map of the United States, and included the Great Lakes (seven feet deep), and the Rocky Mountains (fifty feet high), but most of its visitors were from the New York area.

On opening day, the traffic on the Hutchinson River Parkway was already bumper-to-bumper two hours before the gates were scheduled to open, and the Thruway had slowed to a three-mile-an-hour pace. The thrill was over quickly, though, as it turned out, and Freedomland closed without ceremony after the World's Fair opened in Queens in 1964. In 1968 it became Co-op City.

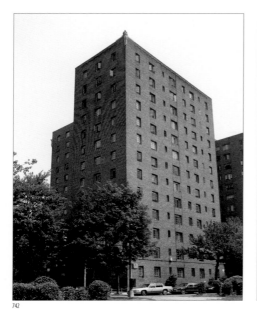

742

PARKCHESTER

EAST TREMONT TO McGRAW AVENUES
PURDY STREET TO WHITE PLAINS ROAD

1942, ASSOCIATED ARCHITECTS
RICHMOND H. SHREVE, CHAIRMAN

This development, with 12,273 apartments, was financed by the Metropolitan Life Insurance Company, which later built Stuyvesant Town in Manhattan. The buildings, which vary in height from seven to thirteen stories, are arranged around four quadrants in the midst of landscaped grounds. Unlike its Manhattan counterpart, Parkchester also includes a large shopping area with more than 100 stores. The insurance company sold the development in 1968 to the real estate firm of Helmsley-Spear, which converted one of the quadrants into condominium housing.

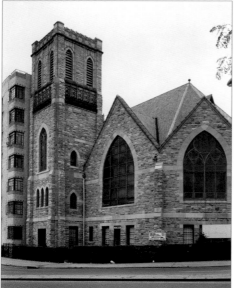

743

HUNTINGTON FREE LIBRARY AND READING ROOM 🔔

9 WESTCHESTER SQUARE

1883, FREDERICK CLARKE WITHERS

This free, noncirculating library was established in 1882, by philanthropist Peter C. Van Schaick for his neighbors in what was then the small village of Westchester. The villagers declined the gift until railroad magnate Collis P. Huntington bought it, enlarged it, and renamed it for himself in 1891. It still operates as a reading room.

744
ST. PETER'S CHURCH IN THE VILLAGE OF WESTCHESTER *L* (EPISCOPAL)

2500 WESTCHESTER AVENUE

1855, LEOPOLD EIDLITZ

This Gothic Revival stone building is the third church on the site for a parish that was organized in 1693. The church was altered by the architect's son, Cyrus L. W. Eidlitz, in 1879. Its churchyard contains the graves of many eighteenth-century residents of this former little village.

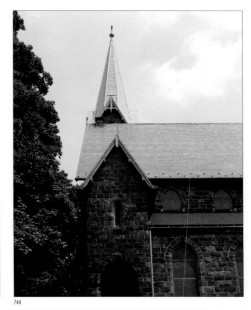

744

745
ST. JOSEPH'S SCHOOL FOR THE DEAF

1000 HUTCHINSON RIVER PARKWAY
AT BRUCKNER BOULEVARD

1898, SCHICKEL & DITMARS

This still-operating Roman Catholic school became isolated in 1939 when the Bronx-Whitestone Bridge and its Hutchinson River Parkway approach cut across part of its property. These days it stands as a curiosity for commuters and other travelers who are often backed up in traffic on the parkway.

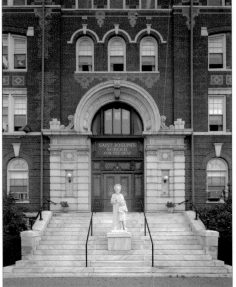

745

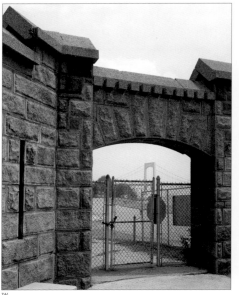

746

747

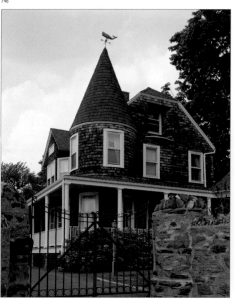

748

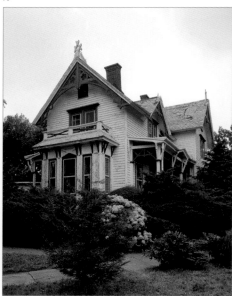

749

FORT SCHUYLER 𝓛

EAST END OF PENNYFIELD AVENUE

1856, CAPTAIN I. L. SMITH

Now the Maritime College of the State University of New York, this fortress and its mate, Fort Totten, on the other side of the Throg's Neck Bridge, were built to protect the Long Island Sound entrance to New York harbor. Its walls are eleven feet thick, with 300 cannons poking out from narrow ports. Fort Schuyler was abandoned in 1870 and remained unused until 1934, when it was converted to a school as a project of the Works Progress Administration. It is open to the public and well worth a visit.

CITY ISLAND AVENUE

CITY ISLAND

No, City Island isn't a New England fishing village, but a charming neighborhood in the Bronx. Its isolation is enhanced by its separation from other neighborhoods by Pelham Bay Park. Less than two miles long, the island, formerly known as Minnewits, got its present name in 1761 when a syndicate organized by Benjamin Palmer began planning a major seaport here to compete with New York harbor. The Revolutionary War upset the plan, and local residents turned their attention to fishing, clamming, and harvesting salt from the waters of Long Island Sound. The only enterprise that could be considered major here is boat building, although restaurateurs along City Island Avenue might take exception to that.

21 TIER STREET

WEST OF CITY ISLAND AVENUE

c. 1894

This is a classic example of the Shingle-style that was popular in suburban communities in the 1880s. But of course this isn't a suburb—it is as much a part of New York City as Times Square. It might qualify as a resort, though. With its endless water views, City Island is among the most tranquil, restorative spots anywhere inside the city limits.

173 BELDEN STREET 𝓛

EAST OF CITY ISLAND AVENUE

c. 1880

This is one of the most picturesque cottages anywhere in New York City. The view out over Long Island Sound from City Island's southern tip makes it all the more desirable. The only jarring note is a radio transmitter on a nearby island that sends a signal strong enough to turn any metallic object in the house, from a toaster to a radiator, into a radio receiver.

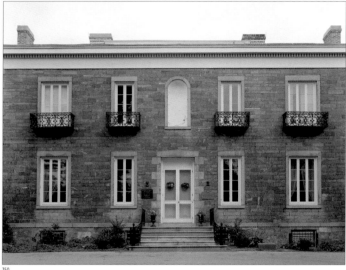

750

BARTOW-PELL MANSION

PELHAM BAY PARK,
SHORE RD. NEAR PELHAM SPLIT GOLF COURSE

1842, MINARD LAFEVER
RESTORED, 1914, DELANO & ALDRICH

Built on the site of the original Pelham Manor, this country house overlooking Long Island Sound was built by Robert Bartow, a descendant of the Pell family, who originally settled this area. Its restoration was undertaken by the International Garden Club, which built the charming formal terrace garden in front of the house. Its Greek Revival interiors are a sensitive approximation of the original.

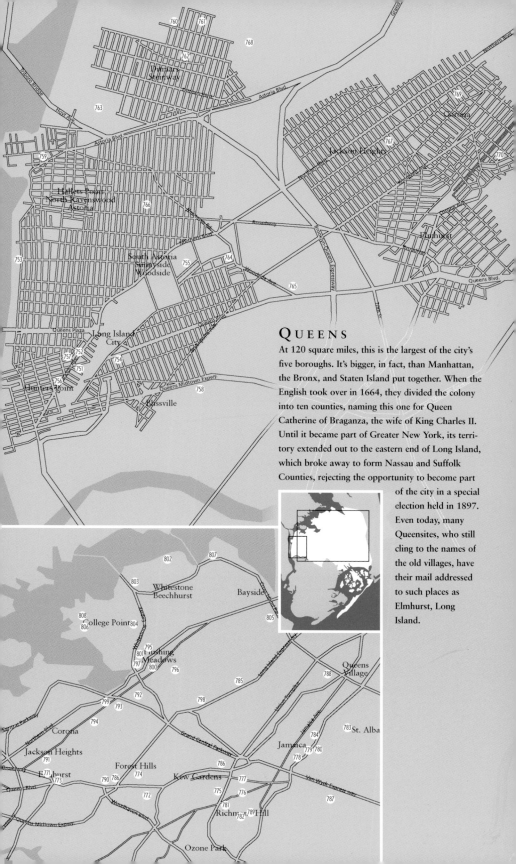

QUEENS

At 120 square miles, this is the largest of the city's
five boroughs. It's bigger, in fact, than Manhattan,
the Bronx, and Staten Island put together. When the
English took over in 1664, they divided the colony
into ten counties, naming this one for Queen
Catherine of Braganza, the wife of King Charles II.
Until it became part of Greater New York, its terri-
tory extended out to the eastern end of Long Island,
which broke away to form Nassau and Suffolk
Counties, rejecting the opportunity to become part

of the city in a special
election held in 1897.
Even today, many
Queensites, who still
cling to the names of
the old villages, have
their mail addressed
to such places as
Elmhurst, Long
Island.

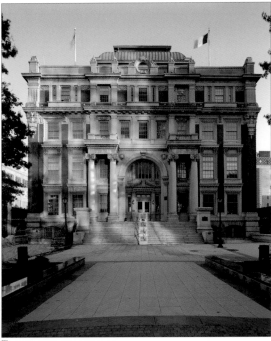

751

New York State Supreme Court
Long Island City Branch

Jackson and Thompson Avenues

1876, George Hathorn
Rebuilt, 1908, Peter M. Coco

In 1870, the Queens County Seat was moved from Jamaica to Long Island City, making this courthouse a necessity. The center of government moved back further east after the consolidation of the five boroughs in 1898, and the center of justice eventually wound up on Queens Boulevard in Kew Gardens. In the meantime, after the state constitution created a supreme court appellate division, the early twentieth century saw a flurry of courthouse construction, beginning with the ornate appellate court on Manhattan's Madison Square, and the refurbishing of this building on Courthouse Square in Queens.

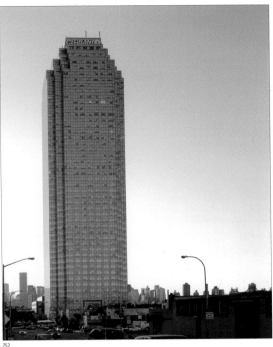

752

752

CITICORP BUILDING

44TH TO 45TH AVENUES, NEAR JACKSON AVENUE

1989, SKIDMORE, OWINGS & MERRILL

At 663 feet, this forty-eight-story glass building is New York City's tallest tower outside of Manhattan. It is still 251 feet shorter than the Citicorp Center just across the East River, only one subway stop away. This one provides back-office space for the company. The bank was chartered in 1912 as the City Bank of New York. A half-century later, the name was changed to First National City Bank of New York to reflect its membership in the national banking system. Mergers and whims dictated several more name changes until it finally settled on "Citibank" in 1976.

753

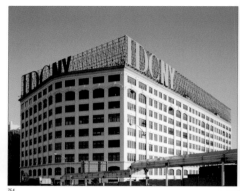

754

755

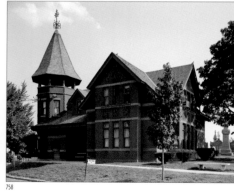

756

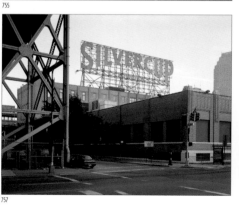

757

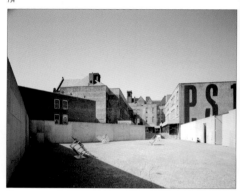

758

753

RAVENSWOOD POWER PLANT

36TH TO 40TH AVENUES AT VERNON BOULEVARD

1961

This was the largest of Con Edison's generating plants in the city. The biggest of its three units was called "Big Allis," from the Allis-Chalmers Company that built it. With a potential output of 1 million kilowatts, it was far and away the most powerful electrical generator in the world. For a while after it went on line in 1965, it didn't always operate as promised, and its eccentricities made it more famous than its capabilities.

754

QUEENS ATRIUM

THOMPSON AVENUE, BETWEEN 29TH AND 30TH STREETS

1914–19

This complex of three huge factory buildings included the Adams Chewing Gum factory, which turned out Chiclets by the millions, and the Sunshine Baking Company, which reproduced its "thousand windows" on every box of crackers. The complex was transformed into the International Design Center in 1988, providing showroom space for interior designers and furniture-makers. It has now been transformed again into a general corporate center.

755

NEW YORK PRESBYTERIAN CHURCH
(KOREAN)

43-23 37TH AVENUE, BETWEEN 43RD AND 48TH STREETS

1932, IRVING M. FENICHEL
ALTERED AND EXPANDED, 1999, GREG LYNN,
MICHAEL MCINTURF, AND DOUG GARIFALO

Buried here is a smooth Art Moderne concrete building for the Knickerbocker Laundry. It was converted to the Naarden-UOP Fragrances factory, and finally surrounded by an immense steel-framed building that swallowed it up. Traces of the graceful lines of the original building can still be seen at the center of the front façade.

756

P.S. I CONTEMPORARY ARTS CENTER

JACKSON AVENUE AT 46TH AVENUE

1900, SHAEL SHAPIRO
ALTERED, 1997, FREDERICK FISHER

This was originally Queens Public School No. 1, but is now given over to artists' studios and gallery space affiliated with the Museum of Modern Art. Its more formal name is the Institute for Arts and Urban Resources. Changing exhibitions here include video art, photography, architecture, and environmental art.

757

SILVERCUP STUDIOS

QUEENS PLAZA SOUTH, BETWEEN 21ST AND 22ND STREETS

1939

Now converted to television production studios (*Sex and the City* is filmed there, among many other popular shows), this building was formerly the bakery facility of the Gordon Baking Company, makers of Silvercup bread. The huge neon sign on its roof has served as a landmark across the river for generations of Manhattanites. It may be one reason why the new enterprise kept the old name.

758

CALVARY CEMETERY GATEHOUSE

GREENPOINT AVENUE OFF BORDEN AVENUE

1892

This marvelous Queen Anne structure marks the entrance to the Roman Catholic Calvary Cemetery, part of the view from the Long Island Expressway. In terms of interments (more than 3 million), this is America's largest burial ground. It was originally the last resting-place of children and poor immigrants from the slums of the Lower East Side. Today, burials are restricted to family plots and reused graves.

REMSEN HOUSE

9-26 27TH AVENUE AT 12TH STREET

C. 1835

This stuccoed house in the Greek Revival style is a reminder of a time when this part of Queens, called Halletts Point, was a quiet rural enclave. It was named for its original settler, William Hallett, who was given a Dutch land grant of 1,500 acres in 1654. It was developed in 1839 and renamed Astoria in honor of John Jacob Astor.

STEINWAY PIANO FACTORY

45-02 DITMARS BOULEVARD
BETWEEN 45TH AND 46TH STREETS

1902

This building, now a warehouse, replaced the original Astoria piano factory. At its peak in 1926, the firm built no fewer than 6,000 grand pianos. Competition from the phonograph and radio sent Steinway into decline, and during World War II, this factory turned out troop-carrying gliders. The Steinway name is still one to be reckoned with, though. It currently produces more than 2,000 grand pianos each year, at prices of up to $70,000.

STEINWAY MANSION 🕭

18-33 41ST STREET
BETWEEN BERRIAN BOULEVARD AND 19TH AVENUE

1858

After William Steinway moved his piano factory to Astoria, he bought this riverfront villa, originally built for Benjamin T. Pike, a manufacturer of scientific instruments. Steinway was the youngest of three sons of the company's founder, Henry Steinweg. His brothers refined the art of piano-making, but it was William who promoted the instrument as a symbol of refinement among the middle class.

STEINWAY WORKERS' HOUSING

TWENTIETH AVENUE
BETWEEN STEINWAY AND 42ND STREETS

1875

These brick Victorian row houses were built by the Steinway Company for rental to its employees. An early example of the company town, the settlement also included a church, a child-care center, a library, and a trolley line to ensure that everybody made it to work on time. The steel mesh fences separating them from the sidewalk, and the occasional aluminum awnings over some of the doorways, are later touches.

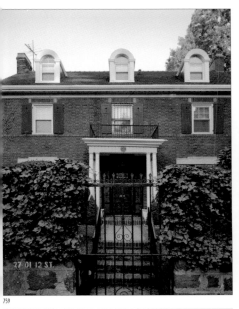

759

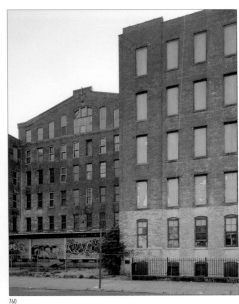

760

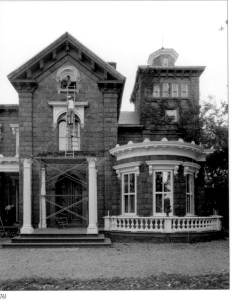

761

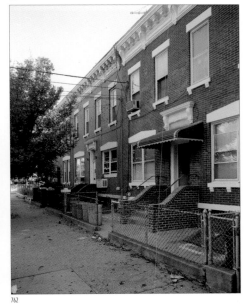

762

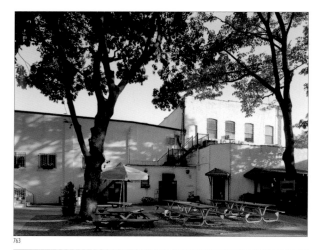

763

764

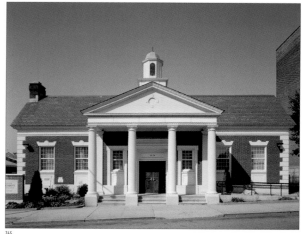

765

BOHEMIAN PARK BEER GARDEN

29-19 24TH AVENUE AND 29TH STREET

1910

This establishment, operated by the Bohemian Citizens' Benevolent Society of Astoria, is the last of hundreds of such social centers in many parts of Queens, featuring generous steins of beer, lights strung in the trees, and big picnic tables. They also featured music from the Old Country to ease the homesickness of immigrants from central Europe.

LATHAN LITHOGRAPHY COMPANY

3804 WOODSIDE AVENUE
BETWEEN BARNETT AND 39TH AVENUES

1923, MCDONNELL & PEARL

A refreshing change from the factory buildings of western Queens, this Tudor building with landscaping and wide lawns was originally a printing plant. Before its current high-tech occupant moved here, it was the home of the J. Sklar Manufacturing Company, a major producer of surgical instruments.

BULOVA SCHOOL OF WATCHMAKING

40-24 62ND STREET
BETWEEN WOODSIDE AND 43RD AVENUES

1958

The J. Bulova Company of watchmakers was founded in New York in 1875, and reached its peak with facilities here in Woodside and in Flushing in the mid-twentieth century. It was especially noted for its innovations in watchmaking tools, and this facility, along with the Arde Bulova Dormitory around the corner, was created to help watchmakers learn how to use them.

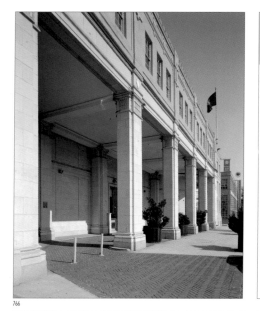

766

KAUFMAN'S ASTORIA MOTION PICTURE AND TELEVISION CENTER ℒ

35TH AVENUE, BETWEEN 34TH AND 38TH STREETS

1921, FLEISHMAN CONSTRUCTION COMPANY (LAK)

This building was built for Famous Players-Lasky Studio, which became Paramount Pictures, when New York was the major center for making movies. More than a quarter of its movies were made here up until 1927. During World War II, it became a center for the Army Signal Corps, which produced training films here, and feature films came back in 1960. Among them were *The Wiz* (1977), *All That Jazz* (1979) and Woody Allen's *Radio Days* (1987). Among the television shows filmed here was *The Cosby Show* in the 1980s. The complex also includes the Museum of the Moving Image, opened in 1988.

766

767

34-19 TO 34-47 90TH STREET

BETWEEN 34TH AND 35TH AVENUES

1931, HERBERT ATTERBURY SMITH

These two groups of six-story apartment buildings were built on land that had been farms only fifteen years earlier. Many of the early Jackson Heights farms specialized in Asian produce to meet the demands of restaurants in Manhattan's Chinatown. Back then, the farmers were virtually the only Asian people living anywhere in Queens. Today, well over 100,000 Chinese and Koreans live in Queens neighborhoods.

767

ABRAHAM LENT HOMESTEAD 🏛

78-03 NINETEENTH ROAD AT 78TH STREET

c. 1739

This Dutch Colonial house serves as a reminder that Queens was originally part of Dutch Nieuw Amsterdam. Director General Peter Stuyvesant laid down some tough rules before allowing immigrants from New England and eastern Long Island to settle here, but they were the majority right from the beginning.

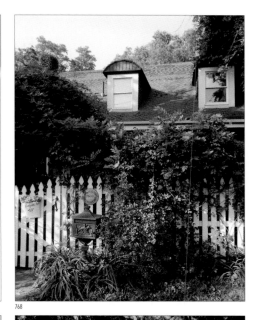

768

LOUIS ARMSTRONG HOUSE

769

34-56 107TH STREET
BETWEEN 34TH AND 37TH AVENUES

1910, ROBERT W. JOHNSON

The great "Satchmo" lived in this Corona house, now a museum, from 1943 until he died in 1971. He was one of several prominent jazz artists who lived in Queens. The Addisleigh Park section of St. Albans was the home of Lena Horne, Count Basie, and Fats Waller.

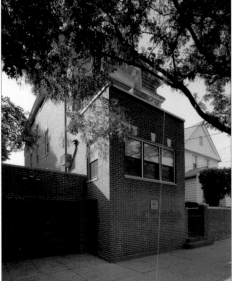

769

770

EDWARD E. SANFORD HOUSE℗

102-45 47TH AVENUE
BETWEEN 102ND AND 104TH STREETS

1871

This small two-story building was originally the home of a farmer whose fields were at the edge of the little village of Newtown. The detail on the porch, the gable, and the wooden fence makes it an architectural treasure.

771

REFORMED DUTCH CHURCH OF NEWTOWN℗

85-15 BROADWAY AT CORONA AVENUE

1831

The cupola on this charming wooden Georgian church is the most prominent anchor of the Newtown community. Its partner, the Greek Revival Fellowship Hall, was built in 1860, and moved to this site in 1906.

772

ADRIAN ONDERDONK HOUSE℗

18-20 FLUSHING AVENUE
BETWEEN CYPRUS AND ONDERDONK AVENUES

1731

Restored by the Greater Ridgewood Historical Society after a fire nearly destroyed it, this is a rare survivor of many Dutch Colonial farmhouses that once existed in Central Queens. It was the home of a farmer who had married a daughter of the prominent Wyckoff family. His own descendants lived here until 1908.

773

STERN'S
(FORMERLY MACY'S)

88-01 QUEENS BOULEVARD
BETWEEN 55TH AND 56TH STREETS

1965, SKIDMORE, OWINGS & MERRILL

When this circular structure was built, it was impossible to create a perefect circle because Mary Sendek wouldn't sell her house on the 55th Street corner. All that was needed was fourteen feet of her back yard, and she was offered $200,000 for the house she had bought for $4,000. But she wouldn't yield. The builders were forced to cut a notch in one side of the building while Mrs. Sendek stayed put.

774

WEST SIDE TENNIS CLUB

FOREST HILLS GARDENS

When the West Side Tennis Club moved here in 1915, it had already been in existence for twenty-three years, having played on leased courts on the west side of Central Park. They built this facility to host the Davis Cup matches, and later it became home to the prestigious U.S. Open. The club moved from Forest Hills to Flushing Meadows in 1978, when the larger USTA Tennis Center was built.

775

FOREST HILLS GARDENS

CONTINENTAL AVENUE TO UNION TURNPIKE

1913, GROSVENOR ATTERBURY

The original development of 1,500 houses on a 142-acre site resembled an English country village, with a green, an inn, and its own railway station. The brick-paved station square included a town clock and arched passageways leading to garden apartments resembling English town houses. Roads through the development are narrow and winding to discourage traffic and to make wide lawns possible.

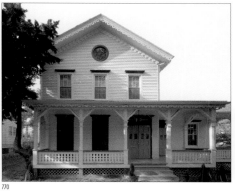

770

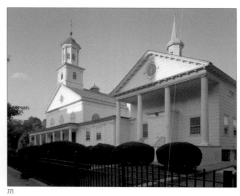

771

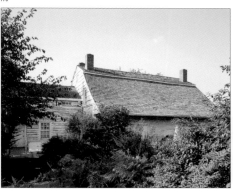

772

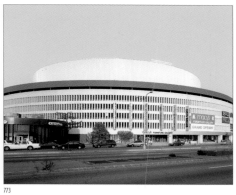

773

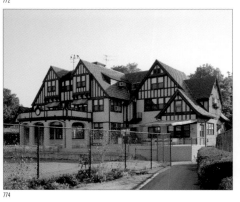

774

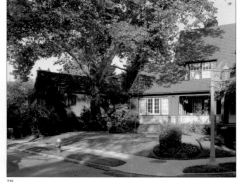

775

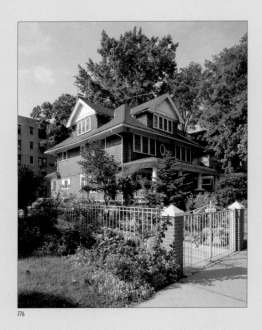

776

English Country Towns

Towns with names like Elmhurst and Kew Gardens imply that Queens began as an English settlement. But it was really part of Dutch Nieuw Amsterdam. When Peter Stuyvesant reluctantly allowed the English to relocate here from New England and Eastern Long Island, he ordered them to keep the place names the Dutch had established. But the English, who had trouble wrapping their tongues around foreign words, gave the names their own spin. Among the translations was Flushing, which the Dutch insisted was Vlishingen. One name that vanished completely was Rust Dorp, "Rest Town." The English could pronounce it, but preferred the Indian name Yamecah, meaning "beaver." Of course, it was changed, too, becoming Jamaica. All was forgiven, and the last Dutch names vanished when the British took over the colony.

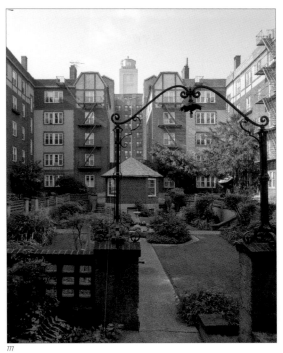

777

84-40 AND 84-50 ABINGDON ROAD

BETWEEN LEFFERTS BOULEVARD, AND BREVOORT STREET

C. 1910

These fine Colonial revival homes reflect the aspirations of the developers of Kew Gardens, who conceived a quiet country retreat within easy commuting distance of Manhattan. They were among the first built on what had originally been a golf course, and it wasn't until a few years later that streets were laid out and utilities brought in.

KEW HALL APARTMENTS

83-09 TALBOT STREET
BETWEEN 83RD DRIVE AND LEFFERTS BOULEVARD

C. 1929

Apartment buildings arrived in Kew Gardens after 1921, and Kew Hall was one of the first of them. In spite of the slow start, there were more than twenty of them by the mid-1930s. This block-square cooperative apartment development surrounds an immense inner courtyard, which is closed to all but residents and their guests.

RUFUS KING HOUSE

JAMAICA AVENUE AT 150TH STREET, IN KING PARK

1755

Also known as the King Manor Museum, this house was bought by Rufus King in 1805. The former member of the Continental Congress immediately added a new kitchen wing and in a few years he completely altered the front. Over the years, his descendants made even more alterations, including the addition of the columned front porch. After the last of the family died in 1896, the house became city property and was completely restored, almost a century later, as a museum.

JAMAICA BUSINESS RESOURCE CENTER ℒ

90-33 160TH STREET

C. 1936

An outstanding example of the streamlined Art Moderne style, this building was originally a nightclub and restaurant called La Casina. Its stainless steel façade was saved from the scrap heap in 1995.

JAMAICA ARTS CENTER ℒ

161-04 JAMAICA AVENUE
BETWEEN 161ST AND 162ND STREETS

1898 A. S. MACGREGOR

This neo-Italian Renaissance building was constructed at the time Queens became a part of Greater New York (as a registry for property deeds). Until its conversion to an arts center, it was always known, simply, as "the Register."

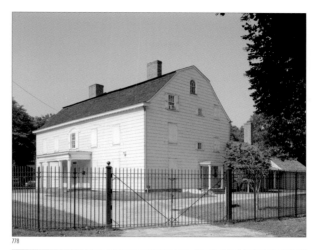

778

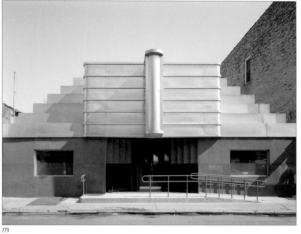

779

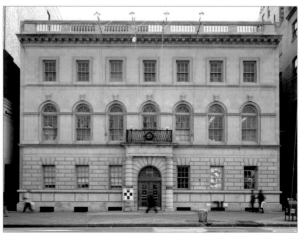

780

781

782

783

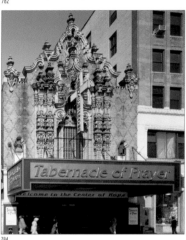

784

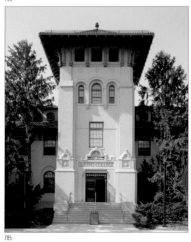

785

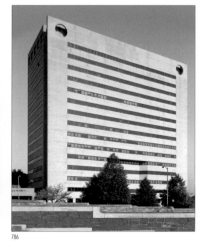

786

STOCKHOLM STREET

BETWEEN ONDERDONK AND WOODWARD AVENUES

C. 1905, LOUIS BERGER & CO.

This charming street in the Ridgewood section is paved with the same brick that was used for the happy row of houses pictured here, with their impressive front bays. Yellow brick seems to be everywhere in this part of central Queens. Nearly all of it was made by the Kreischer Brick Manufacturing Company on Staten Island. Most of the bricks are speckled with red spots caused by the iron content of the clay that was baked to make them.

114TH STREET, RICHMOND HILL

BETWEEN 85TH AND 86TH AVENUES

The entire block is a fabulous example of Victorian detail, and this house is just a taste of all the things it has to offer. Most of the great houses of Richmond Hill were built in the 1890s by wealthy Manhattan businessmen. All of them had large yards and, by our standards, small prices. One of these beauties cost anywhere from $2,500 to $5,000. There was no vacant land left in the area by 1920.

MURDOCK AVENUE

ST. ALBANS, OFF LINDEN BOULEVARD

This section, known as Addisleigh Park, is an affluent black community. The neighborhood was established in 1892 after developers bought a large farm, laying out streets and building lots. This section was developed, overlooking the St. Albans Golf Club, in 1926. The golf course became the site of a large naval hospital during World War II.

TABERNACLE OF PRAYER

165-11 JAMAICA AVENUE
BETWEEN 165TH STREET AND MERRICK BOULEVARD

1929, JOHN EBERSON

Now a house of worship, this was once Loew's Valencia movie house, an example of what was called an "atmospheric theater." Its auditorium recalled the Baroque plaza of a Spanish town, with outlines of buildings framing the sky, twinkling starlight, and moving clouds. The same architect created the exuberant Paradise Theater in the Bronx, as well as Loew's 72nd Street in Manhattan, where he chose an Indo-Persian theme.

QUEENS COLLEGE

65-30 KISSENA BOULEVARD
AT THE LONG ISLAND EXPRESSWAY

MAIN BUILDING, 1908

A division of the City University of New York, the college moved to this campus in 1937. The site originally consisted of nine Spanish-style buildings comprising the New York Parental School, called a "reform school" in those days. The complex has been expanded throughout the years to include, among others, the Colden Center, one of the city's premier music auditoriums.

FOREST HILLS TOWER

118-35 QUEENS BOULEVARD, AT 78TH CRESCENT

1981, ULRICH FRANZEN & ASSOCIATES

This fifteen-story office complex is a highly visible anchor to Flushing Meadows–Corona Park on one side and the Forest Hills community on the other. It is among the best postwar buildings in Queens.

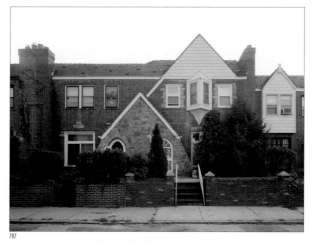

787

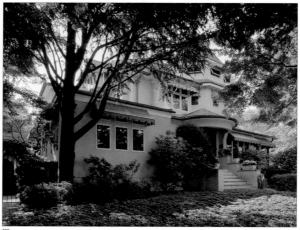

788

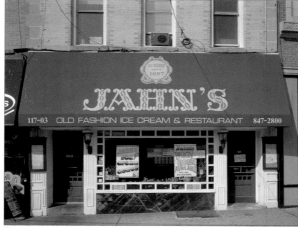

789

787
LAURELTON ESTATES

C. 1925

This row house development is part of a little 300-acre community established by state senator William H. Reynolds in 1906. Before he finished the project, Reynolds moved further out on Long Island to develop the city of Long Beach. Laurelton thrived without him.

788
JAMES J. CORBETT HOUSE

221-04 CORBETT ROAD AT 221ST STREET

C. 1900

This is the former home of the world's heavyweight boxing champion known as "Gentleman Jim" for more than thirty years, until his death in 1933. Corbett was champion from 1892 until 1897, and was the first to win the title under the Marquis of Queensberry Rules.

789
JAHN'S

117-03 HILLSIDE AVENUE
OFF 117TH STREET AND JAMAICA AVENUE

It won't win any architectural prizes, but you'll never forget a visit to Jahn's. This surviving branch of a family-operated chain of ice cream parlors opened here in Richmond Hill in 1929. Among the house specialities is "The Kitchen Sink," a concoction of ice cream, syrup, and fruits that serves eight (or more). The emporium also features gaslights, a coin-operated player piano, and a soda fountain you have to see to believe.

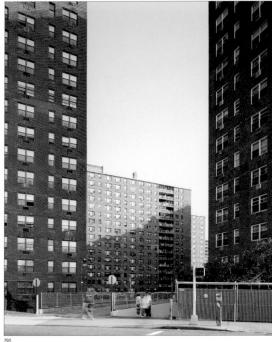

LeFrak City

JUNCTION BOULEVARD AT 99TH STREET

1967, JACK BROWN

This development of twenty slabs overlooking the Long Island Expressway is eighteen apartment buildings with five-thousand units of one- to two-bedrooms. There are also two office buildings and two theaters, and the space between them all has playgrounds and tennis courts. It even has its own post office and a Little League baseball team, not to mention parking for 2,800 cars. During its construction, developer Samuel LeFrak took advantage of the location by erecting huge signs inviting traffic-bound commuters to move back to the city (his city, anyway). Even before this "instant city" was built, he was already landlord to one out of every thirty-two New Yorkers.

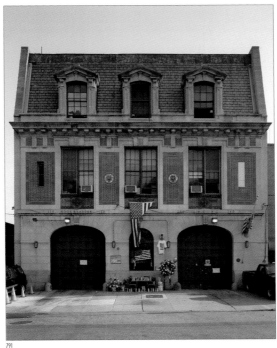

791

ENGINE COMPANY 289, NYFD

97-28 43RD AVENUE
BETWEEN 97TH PLACE AND 99TH STREET

This charming, diminutive French chateau houses a hook-and-ladder company under its dormered mansard roof. It is another beautiful example of the careful attention to architectural detail that makes firehouses in every part of the city assets to their neighborhoods. The neighborhood this one protects is Corona, in north-central Queens. Its name was changed from West Flushing in 1872, to signify its emergence as the "crown" of the Long Island villages. Among Corona's early institutions was the Tiffany glass factory that anchored the community from 1893 through the mid-1930s.

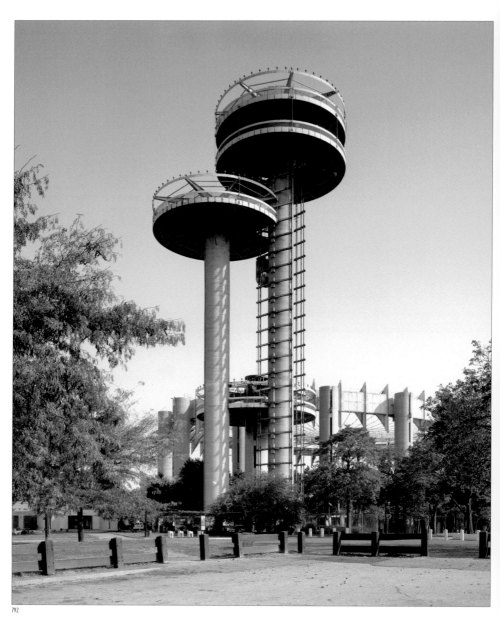

793

NEW YORK STATE PAVILION
1964–65 WORLD'S FAIR

FLUSHING MEADOWS–CORONA PARK

1964, PHILIP JOHNSON AND RICHARD FOSTER

Philip Johnson's concept for this now-neglected structure was an elliptical canopy of acrylic panels he called "The Tent of Tomorrow." They were supported by three towers and reached by glass-enclosed elevators. The space under the tent held exhibition space arranged around a grand promenade.

QUEENS MUSEUM OF ART

FLUSHING MEADOWS–CORONA PARK

1939

This was originally the New York City Building of the 1939–40 World's Fair, and again for the 1964–65 fair. Since then it has served as a facility of the United Nations. The main attraction here is the "Panorama of the City," a 9,335 square-foot model of New York. With representations of more than 800,000 buildings, it is the largest architectural scale model in the world. It was last updated in 1994.

USTA National Tennis Center

ROOSEVELT AVENUE AT WILLETT'S POINT BOULEVARD

1997, ROSSETTI & ASSOCIATES

This pair of stadiums for the United States Tennis Association is best known as the site of the U.S. Open. The matches were first played here in 1978, at Louis Armstrong Stadium, the former Singer Bowl built for the 1964–65 World's Fair. The other facility here today is Arthur Ashe Stadium, built in 1997.

Bowne House ℒ

37-01 BOWNE STREET, BETWEEN 37TH AND 38TH AVENUES

1661

This simple Saltbox-style house was built by John Bowne, who became a Quaker after moving to Flushing from New England. He was arrested for holding Quaker meetings here, but appealed his conviction directly to the Dutch West India Company, which ordered its Governor General, Peter Stuyvesant, not to persecute religious dissenters. The house, which still has its original details, is now a Colonial museum.

Hindu Temple Society of North America

45-57 BOWNE STREET AT 45TH AVENUE

1977, BARYN BASU ASSOCIATES

The ornate Indian sculpture on the façade of this temple came to Flushing courtesy of the Department of Endowments, Andrhra Pradesh, in India. After the Immigration Act of 1965, new arrivals from South Asia began arriving by the thousands, and many professionals from India, including engineers, doctors, and scientists, chose to live here in Flushing.

Lewis H. Latimer House ℒ

34-41 137TH STREET
BETWEEN LEAVITT STREET AND 32ND AVENUE

C. 1889

The famous African-American inventor lived in this house from 1902 until he died in 1928. During his life, Latimer worked closely with Alexander Graham Bell, as well as Thomas A. Edison, for whom he developed the long-lasting carbon filament that made lightbulbs affordable.

St. John's University

UNION TURNPIKE AT UTOPIA PARKWAY

1955–73

This Roman Catholic university was established in Brooklyn in 1870. It moved here to the former site of the Hillcrest Golf Club in the 1950s. It is America's largest Catholic university, with an enrollment of more than 21,000. It has eleven colleges offering ninety graduate and undergraduate degrees, but it is best known for its basketball team, the Redmen, a power in the Big East Conference and a frequent contender in the annual NCAA Championships.

Shea Stadium

BETWEEN NORTHERN BOULEVARD AND ROOSEVELT AVENUE
OFF GRAND CENTRAL PARKWAY

1964, PRAEGER-KAVANAUGH-WATERBURY

This stadium, which seats 55,101, is named for William A. Shea, who was instrumental in bringing National League Baseball back to New York with the formation of the Mets. The team's colors, which adorn the structure, are orange, representing the former New York Giants, and blue, for the Brooklyn Dodgers. Blue and orange also happen to be the official colors of the City of New York, which owns the stadium.

794

795

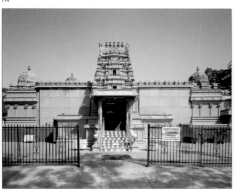

796

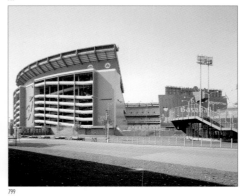

797

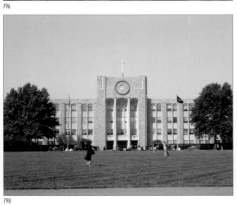

798

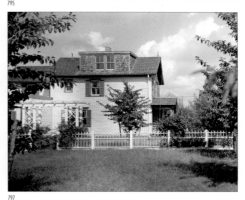

799

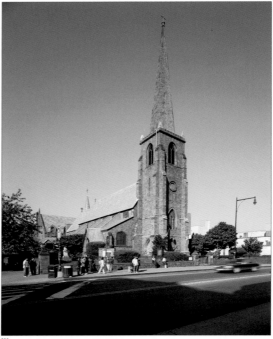

800

St. George's Church
(Episcopal)

Main Street, between 38th and 39th Streets

1854, Wills & Dudley

Francis Lewis, a signer of the Declaration of Independence, was a warden of this parish, established in the 1750s. This building replaced its original church, which had stood on the site for nearly a century.

Flushing Town Hall

137-35 Northern Boulevard at Linden Place

1862

Before Queens became part of Greater New York in 1898, each town had its own center of government, and this German-inspired Romanesque building is one of the few that remain. The Flushing Council on Culture and the Arts has occupied it since 1991.

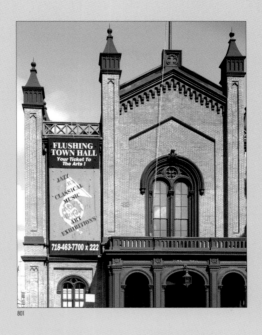

801

Garden Spot

When the English arrived in Queens in the 1640s, they brought their love of flowers with them, planting roses and hollyhocks in their dooryards. Their new Dutch neighbors added tulips and other spring flowers to the mix, and French Huguenots among them propagated apple trees. William Price turned his family's estate into America's first nursery. He encouraged missionaries and explorers to bring back trees and shrubs for his collection, and soon he had the most important horticultural station in the country. Other nurseries were created nearby, and many of the plants and trees we take for granted today first took root in America here in Queens.

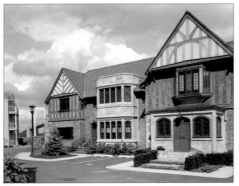

802

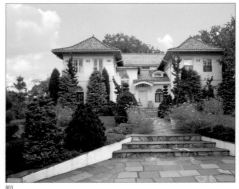

803

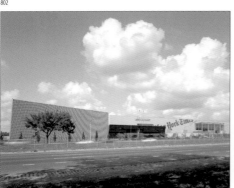

804

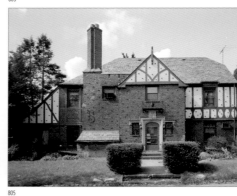

805

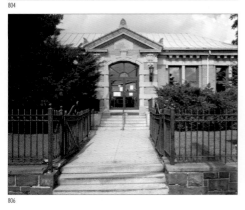

806

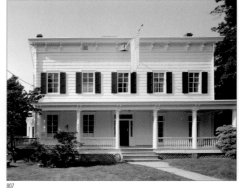

807

802

WILDFLOWER *L*

168-11 POWELLS COVE BOULEVARD
AT 166TH STREET

1924, DWIGHT JAMES BAUM

This neo-Tudor house was built by Broadway producer Arthur Hammerstein (who also built David Letterman's Ed Sullivan Theater), and named for one of his hit Broadway musicals. Originally part of a waterfront estate, it is now surrounded by condominium apartment buildings.

803

42 NORTH DRIVE

AT 141ST STREET

C. 1925

This tile-roofed Italian villa is typical of the fine housing that attracted people to this little community known as Malba. It was originally a private community with gorgeous views of Long Island Sound, which has now been enhanced by the majesty of the Bronx-Whitestone Bridge.

804

NEW YORK TIMES PRINTING PLANT

26-50 WHITESTONE EXPRESSWAY
BETWEEN TWENTIETH AVENUE AND LINDEN PLACE

1997, POLSHEK PARTNERSHIP

The presses installed in this building not only allowed the Times to eliminate the pressroom under its Times Square headquarters, but also paved the way for the Old Gray Lady to put on a more colorful face, thanks to its modern color printing capabilities.

805

146TH STREET

BAYSIDE, BETWEEN BAYSIDE AND 29TH AVENUES

C. 1925

This is just one of a whole enclave of Tudor houses tucked away in a corner of Bayside. They are guarded by the stone gateposts of an estate that once occupied the land they stand on. Most of the Bayside estates were subdivided in the 1920s and '30s, in many cases to make way for the mansions of such movie stars as Pearl White and Norma Talmadge. It became a middle-class community after highways such as the Cross Island Parkway and Clearview Expressway were built through it.

806

POPPENHUSEN BRANCH
QUEENSBOROUGH PUBLIC LIBRARY

121-23 14TH AVENUE AT COLLEGE POINT BOULEVARD

1904, HEINS & LA FARGE

This institution is named for Conrad Poppenhusen, who owned a large factory here in College Point, making hard rubber goods such as combs. Active in the community, he not only built housing for his workers but paved streets and established schools and a library, of which this is a successor. The Queensborough Public Library, like the Brooklyn Public Library, is not part of the New York Public Library system, but it still ranks among the five largest in the country.

807

BENJAMIN P. ALLEN HOUSE *L*

29 CENTER DRIVE AT FOREST ROAD, DOUGLASTON MANOR

1850

This former farmhouse overlooking Little Neck Bay was designed in the Greek Revival style, but it has some fine Italianate touches in its cornices and the brackets on the porches. This area, in the northeast corner of Queens near the Nassau County line, was once a thriving little port that produced some of the best clams and oysters for a city whose population never seemed to get its fill of them.

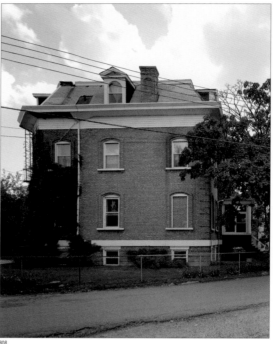

808

H. A. SCHLECTER HOUSE

11-41 123RD STREET AT 13TH AVENUE

1860

This imposing mansion sits on an island in the middle of 13th Avenue because it was built before the street was mapped. It was a resort hotel, called the Grandview, for many years, one of several resorts in the section of Queens called College Point. Beginning in the 1880s, the neighborhood became a German community and was filled with beer gardens and small amusement parks, which made it a popular destination for people on outings from all over the city. It all came to an end when Prohibition stopped the flow of beer in 1920.

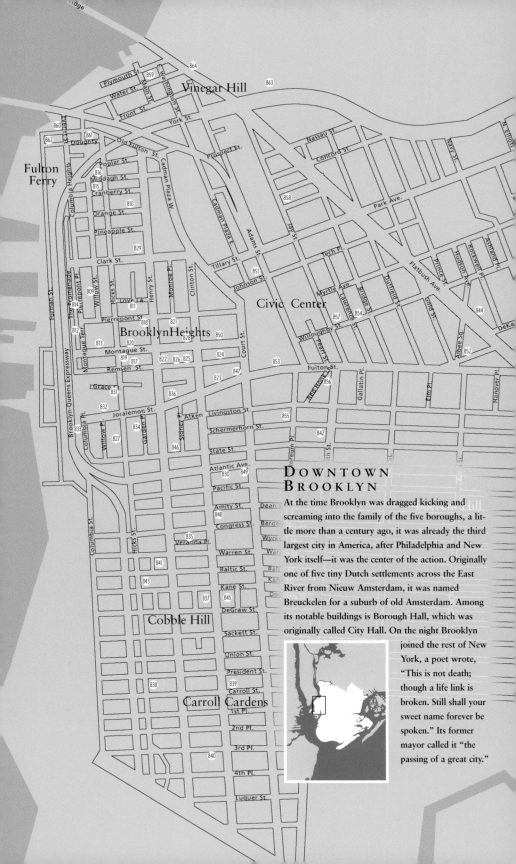

Downtown Brooklyn

At the time Brooklyn was dragged kicking and screaming into the family of the five boroughs, a little more than a century ago, it was already the third largest city in America, after Philadelphia and New York itself—it was the center of the action. Originally one of five tiny Dutch settlements across the East River from Nieuw Amsterdam, it was named Breuckelen for a suburb of old Amsterdam. Among its notable buildings is Borough Hall, which was originally called City Hall. On the night Brooklyn joined the rest of New York, a poet wrote, "This is not death; though a life link is broken. Still shall your sweet name forever be spoken." Its former mayor called it "the passing of a great city."

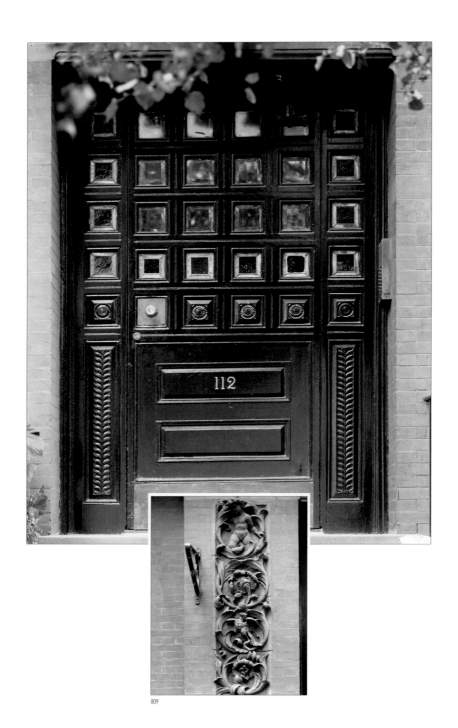

809

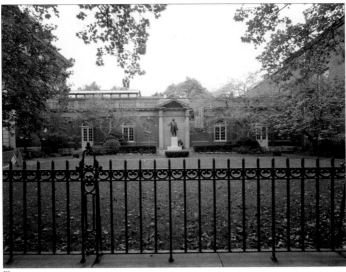

810

112 WILLOW STREET

809

BETWEEN CLARK AND PIERREPONT STREETS

1880, WILLIAM HALSEY WOOD

This is one of a trio of Queen Anne houses, along with its neighbors, nos. 108 and 110, that help make Willow Street one of the most impressive in all of Brooklyn Heights. All three houses have elaborate terra-cotta decorative elements, along with overstated doorways, bay windows, towers, and dormers that all combine for a delightful visual experience. The street offers a wide variety of styles, including one (no. 124) that recalls the city's Dutch roots with a wonderful stepped gable topped by a weathervane. Others are fine examples of the Federal style. Together they add up to an experience best described as "happy."

PLYMOUTH CHURCH OF THE PILGRIMS
(CONGREGATIONAL)

810

ORANGE STREET, BETWEEN HENRY AND HICKS STREETS

1850, JOSEPH C. WELLS

Henry Ward Beecher was its minister when the church moved into this building, which replaced an earlier church destroyed by fire. The congregation's members were ardent abolitionists and built a way station on the Underground Railroad here to help escaping slaves on their way to the Canadian border. When adultery charges were brought against Beecher in the 1870s, nearly all of the congregation supported him, and when he died in 1887, more than 50,000 mourners came here to pay their last respects. It merged with Congregational Church of the Pilgrims in 1934, and was renamed Plymouth Church of the Pilgrims.

43 LOVE LANE

BETWEEN HENRY AND HICKS STREET

1820s

When Brooklyn Heights was divided into building lots in 1816, it was laid out in orderly 250-foot square blocks. Somehow the scheme went awry, and less than a dozen of them are actually square. Some streets were never built, and others were lengthened. Still others, like Love Lane and College Place, were already there and resisted change. But a rigid grid would probably have robbed the Heights of its charm anyway.

2 AND 3 PIERREPONT PLACE

BETWEEN PIERREPONT AND MONTAGUE STREETS

1857, FREDERICK A. PETERSON

These are unquestionably the most elegant brownstone mansions anywhere in New York City. They were built for tea merchant A. A. Low (no. 3) and fur dealer Alexander M. White (no. 2). A third house, One Pierrepont Place, was torn down in 1946 to open an entrance to the Esplanade overlooking the river. It created a perfect way for strollers to study the impressive rear façades of the surviving pair.

HEIGHTS CASINO

75 MONTAGUE STREET
BETWEEN HICKS STREET AND PIERREPONT PLACE

1910, WILLIAM A. BORING

This was the original site of the H. P. Pierrepont mansion, "Four Chimneys." It was Pierrepont, a shipping merchant, who began selling lots here in Brooklyn Heights (called Brooklyn Ferry back then) to Manhattan businessmen in 1823. The Casino was established as a "city country club," with indoor squash and tennis courts.

210–220 COLUMBIA HEIGHTS

BETWEEN PIERREPONT AND CLARK STREETS

1860

These four buildings are fine examples of brownstone mansion rows. They originally had back yards extending out over the roofs of warehouses on Furman Street, below the Heights, which were torn down in the 1940s.

24 MIDDAGH STREET

AT WILLOW STREET

1829

This gem of a Federal-style house is one of the oldest in the neighborhood. It is often called the "Queen of Brooklyn Heights." Considering the competition on the surrounding streets, this is high praise indeed. But even people who have lavished boundless love on their own Brooklyn Heights homes don't dispute the title.

38 HICKS STREET

BETWEEN MIDDAGH AND POPLAR STREETS

c. 1830
RESTORED 1976

Along with the house behind no. 38, these little frame houses have been restored to more or less their original condition. No. 40 was built by Michael Vanderhoef, who added a shop to the ground floor. No. 38 was the home of Joseph Bennett, who called himself a "packer." He added the house out back for extra rental income.

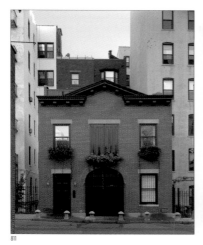

811

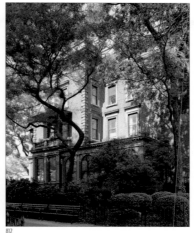

812

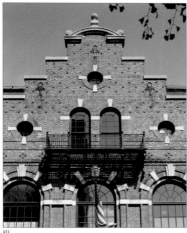

813

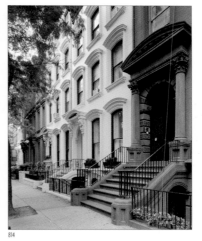

814

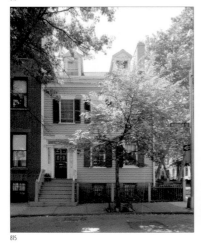

815

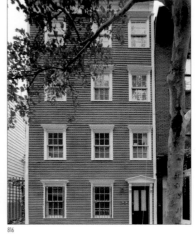

816

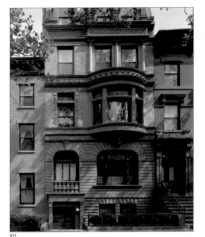

817

87 REMSEN STREET

BETWEEN HENRY AND HICKS STREETS

C. 1890

This outstanding brick mansion, with brownstone and terra-cotta details and a glorious copper roof, is a relatively late addition to the street. Remsen Street, which now connects with the south end of the Brooklyn Heights Promenade, was opened in 1825 by Charles Remsen, a local developer, and originally ended at Clinton Street.

817

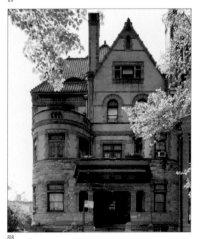

818

84 PIERREPONT STREET

AT HENRY STREET

1889, FRANK FREEMAN

This mansion, built for Herman Behr, was enlarged by six stories in 1919 and converted to the Hotel Palm, which lost its former elegance when, as the neighbors put it, "The Behr house is no longer a home." It was bought by St. Francis College, which turned it into a residence for novitiates. It was sold again, and converted to apartments, in 1976.

818

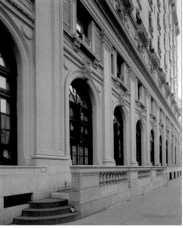

819

HOTEL BOSSERT

98 MONTAGUE STREET AT HICKS STREET

1913, HELMLE & HUBERTY

This hotel, now a Jehovah's Witnesses dormitory, was an "in" spot for flappers and their dates during the Roaring Twenties. Its Marine Roof, created by stage set designer, Joseph Urban, featured fine dining, vigorous dancing, and Brooklyn's best view of the Manhattan skyline.

819

820

105 MONTAGUE STREET

BETWEEN HENRY AND HICKS STREETS

1885, PARFITT BROS.

This Queen Anne confection is a bright spot in the eclectic mix that Montague Street has become over the years. Part of the old Hezekiah B. Pierrepont estate, it was named in honor of the English author, Lady Mary Wortley Montague, a member of the Pierrepont family. In the 1850s, the street led to the harbor and the Fulton Ferry.

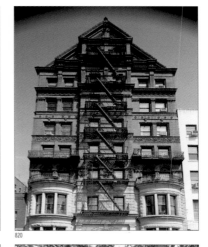

820

821

114 PIERREPONT STREET

AT MONROE PLACE

1840

This building was originally the twin of its Greek Revival neighbor, no. 108, and together they were hailed as the "noblest" residences on the street. But it was transformed in 1887 into the Romanesque Revival style by Alfred E. Barnes, whose bookstore still exists. You can decide for yourself whether he did the right thing by comparing the former twins from across the street.

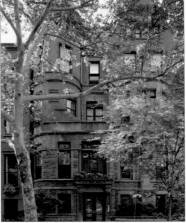

821

822

OUR LADY OF LEBANON CHURCH
(ROMAN CATHOLIC)

113 REMSEN STREET AT HENRY STREET

1846, RICHARD UPJOHN

This was originally the Congregational Church of the Pilgrims, founded by merchants from New England. It merged with the nearby Plymouth Church in 1834, and took its original Tiffany stained-glass windows along with it. The doors on the west and south sides were salvaged from the French ocean liner, *Normandie*, which was destroyed by fire at a Hudson River pier in early 1942.

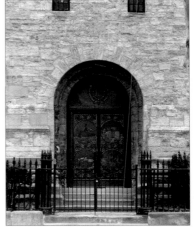

822

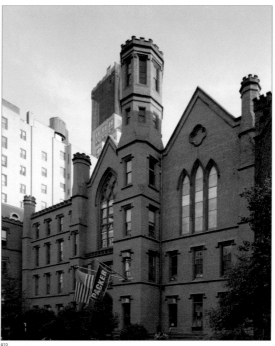

823

PACKER COLLEGIATE INSTITUTE

170 JORALEMON STREET
BETWEEN COURT AND CLINTON STREETS

1856, MINARD LAFEVER

This Gothic castle houses a private elementary
and secondary school that was founded in
1854 as the Brooklyn Female Academy. It
became co-educational in 1972. The building
and its chapel are impressive, but the real
beauty here is in its prize-winning Alumnae
Garden. In 1919, Packer's college division,
since discontinued, became the first junior col-
lege to be approved by the State Board of
Regents. The Annex around the corner on
Clinton Street was originally St. Ann's Episco-
pal Church, designed by James Renwick, Jr.

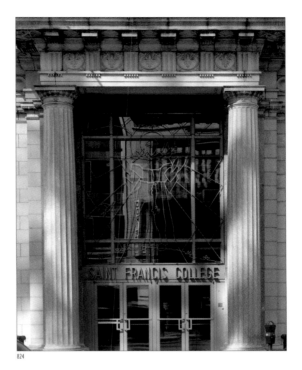

824

St. Francis College

176 REMSEN STREET
BETWEEN COURT AND CLINTON STREETS

1914, FRANK FREEMAN

The oldest Catholic school in Brooklyn, St. Francis was originally a boys' school administered by the Franciscan Brothers. It became a coeducational college in 1953 with the admission of nuns, followed by the acceptance of lay women sixteen years later. The college moved to this site, the former headquarters of the Brooklyn Union Gas Company, from Smith Street in 1962. The building next door at 180 Remsen Street, now the college library, was built in 1857 as the headquarters of the Brooklyn Gas Light Company, which became part of Brooklyn Union in 1895.

825

826

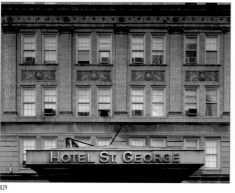

827

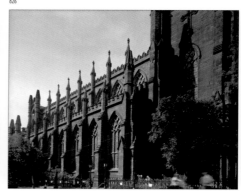

828

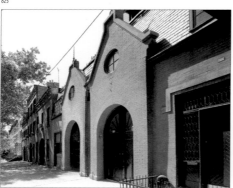

829

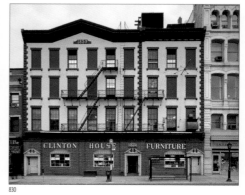

830

BROOKLYN HEIGHTS SYNAGOGUE

131 REMSEN STREET
BETWEEN CLINTON AND HENRY STREETS

C. 1858

Until 1996, this three-story brownstone with elaborate cornice and Corinthian columns at the entrance was the Brooklyn Club. It was built as the home of merchant Terrence McDonald.

BROOKLYN BAR ASSOCIATION

123 REMSEN STREET
BETWEEN CLINTON AND HENRY STREETS

C. 1875

This three-story building with a mansard roof has impressive stonework on its porch, a kind of oddity considering that it was built as the home of Charles Condon, an iron merchant.

276–284 HICKS STREET

BETWEEN JORALEMON AND STATE STREETS

These five buildings were originally carriage houses, which explains their beautiful arches. Hicks was one of the first streets to be developed in Brooklyn Heights at the beginning of the nineteenth century, and remains one of its longest. It was named by John and Jacob Middagh Hicks.

ST. ANN'S AND THE HOLY TRINITY CHURCH
(EPISCOPAL)

157 MONTAGUE STREET AT CLINTON STREET

1847, MINARD LAFEVER

St. Ann's Church, which was known as "the mother of churches" in Brooklyn because of the number of parishes that were spun off from it, merged with the Holy Trinity Church in 1966 and moved into its current building, three blocks away from its original home, which is now part of the Packer Collegiate Institute on Clinton Street. This neo-Gothic church building, which is deteriorating, has become a poster child for landmark preservation and restoration.

HOTEL ST. GEORGE

HICKS, HENRY, CLARK, AND PINEAPPLE STREETS

1885, AUGUSTUS HATFIELD

This hotel, which grew to eight buildings through succesive additions, was once the biggest in New York, with 2,632 rooms. Its grand Art Deco ballroom was the epitome of the Jazz Age, and it also had an immense salt water swimming pool surrounded by floor-to-ceiling mirrors, and a rooftop restaurant/night club with dazzling harbor views. No wonder it was the favorite hangout of the Brooklyn Dodgers and their fans. It was transformed into condominium apartments in the 1980s.

164–168 ATLANTIC AVENUE

BETWEEN CLINTON AND COURT STREETS

1864

These commercial loft buildings reflect the nineteenth-century idea that merchants could benefit by building attractive buildings that would impress their customers. The storefronts that were added here in the twentieth century are evidence of the death of such ideas.

GRACE CHURCH
(EPISCOPAL)

254 HICKS STREET, AT GRACE COURT

1849, RICHARD UPJOHN

This church, and its parish house, added in 1931, form a wonderful little shaded cul-de-sac, still charming in spite of an apartment building that was shoved into Grace Court in the 1960s.

29–75 JORALEMON STREET

BETWEEN HICKS AND FURMAN STREETS

1848

These twenty-five Greek Revival Houses are on what was known as Joralemon's Lane until 1842. This was once the southern boundary of a farm owned by the Remsen family, and was bought in 1803 by developer Teunis Joralemon. The slope of the street down toward the river makes it an especially picturesque setting for these houses.

RIVERSIDE APARTMENTS

4–30 COLUMBIA PLACE AT JORALEMON STREET

1890, WILLIAM FIELD & SON

This low-rent housing project, which originally contained nineteen stores and 280 two- to four-room apartments, was built at the river's edge by local businessman Alfred T. White. Its western unit was demolished to make way for the Brooklyn-Queens Expressway in 1953. The destruction also took several rows of brownstones, prompting the Brooklyn Heights Association to lobby highway czar Robert Moses to cover the resulting eyesore with an Esplanade overlooking the East River.

GARDEN PLACE

BETWEEN JORALEMON AND STATE STREETS

This block-long street was originally a garden on the estate of Philip Livingston. It was developed in 1842, and now a quiet street of private houses built for middle-class merchants, at least one of which (no. 21, a former stable) was built before the Civil War.

VERANDAH PLACE

BETWEEN CLINTON AND HENRY STREETS
NEAR CONGRESS STREET

1850

This little mews was created for carriage houses and stables. It was made more inviting when Cobble Hill Park was created after the demolition of the Second Unitarian Church. Its contemporary restoration has made it still more attractive. The new owners have added imaginative touches to their little houses. Haylofts have been replaced by large windows and, in some of them, the iron hoists have been left intact in their gables.

129 JORALEMON STREET

BETWEEN HENRY AND CLINTON STREETS

1891, C. P. H. GILBERT

This apartment house was originally the David Chauncy mansion. It is a fascinating combination of the Romanesque and Colonial Revival styles. A massive stone and yellow brick structure, it was intended to resemble a bungalow.

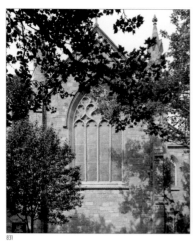

831

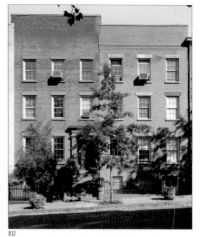

832

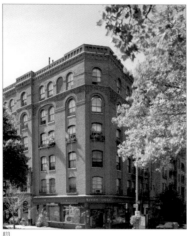

833

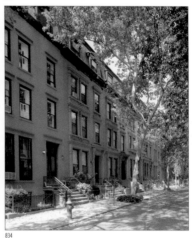

834

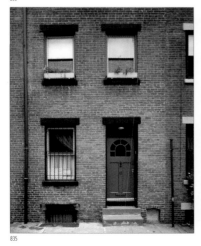

835

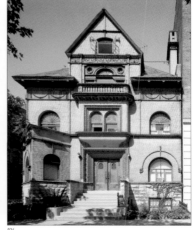

836

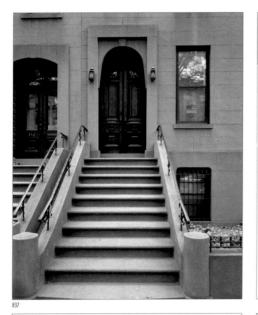

837

Dr. Joseph E. Clark House

340 CLINTON STREET
BETWEEN DEGRAW AND KANE STREETS

c. 1860

This is the biggest one-family house in Cobble Hill. In addition to being unusually wide, its floors are higher-than-average, and it has an attic built under its impressive mansard roof. During the Revolutionary War's Battle of Long Island, George Washington, observing the rout of his army, made the decision to retreat from a fort erected on what was known as "Cobbleshill." After the retreat, British engineers destroyed the fort and cut away the hill.

838

Roman Catholic Institutional Services

43-57 CARROLL STREET, AT HICKS STREET

1943, HENRY V. MURPHY

This Art Moderne structure built to resemble a lighthouse was originally an outpost of the Catholic Seaman's Institute, which served the thousands of sailors who once passed through the former seaport neighborhood. This section of Carroll Gardens was once a part of Red Hook, which was the busiest seaport anywhere in America as late as the 1960s. It was cut off from the city by construction of the Belt Parkway, the Gowanus Expressway, and the Brooklyn-Battery Tunnel.

838

St. Paul's Church of Brooklyn
(Episcopal)

423 Clinton Street at Carroll Street

1884, Richard Upjohn & Son

This high Victorian Gothic church is more interesting on the inside. The pulpit is set halfway down the nave, and there is a double row of pews directly in front of it to allow the clergy and acolytes to hear the sermons, which is difficult from the sanctuary. It is known as St. Paul's of Brooklyn to distinguish it from St. Paul's Flatbush. At the time the two parishes were formed, Flatbush was a separate town. It joined the City of Brooklyn in 1894.

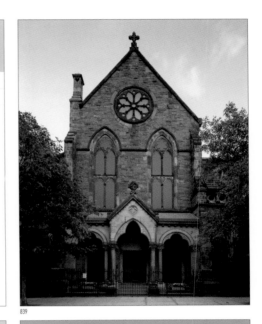

839

37–39 Third Place

between Henry and Clinton Streets

1875

The mansard roof on this house is among the best in town. It is part of the charm of Carroll Gardens, which has an atmosphere that is rare in this or any other big city. It was originally part of Brooklyn's Red Hook section, but the name was changed in the 1960s to attract upscale home buyers. It was originally settled by Irish immigrants, who moved away in the 1920s, when it became an Italian community. The neighborhood is known for its large front yards, an amenity it owes to the original development plan, laid out in 1846.

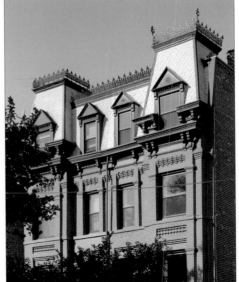

840

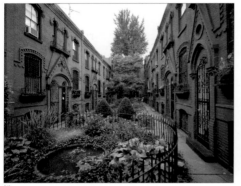

841

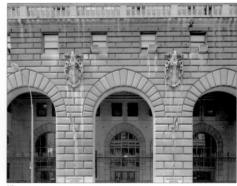

842

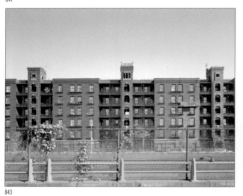

843

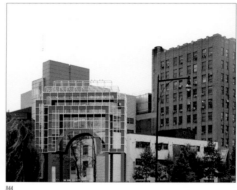

844

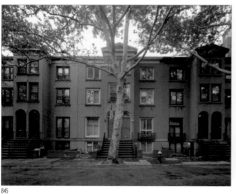

845

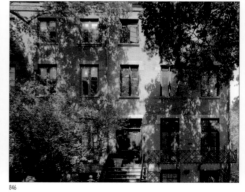

846

841

WORKINGMEN'S COTTAGES

WARREN PLACE, BETWEEN HICKS AND HENRY STREETS

1879

These thirty-four cottages were part of a development built by Alfred Tredway White as low-rent housing for working people. The eleven-and-a-half-foot houses line a charming little mews.

842

CENTRAL COURT BUILDING

120 SCHERMERHORN STREET AT SMITH STREET

1932, COLLINS & COLLINS

This bulky Renaissance Revival building overpowers the neighborhood, but it pays for the offense with its wonderful deep porch and grand arches.

843

HOME BUILDINGS

439–445 HICKS STREET AND 134–140 BALTIC STREET

1876, WILLIAM FIELD & SONS

Following the lead of socially conscious London Victorians, Alfred Tredway White built these 226 low-rent apartment buildings, providing good ventilation and sunlight. But White wasn't a garden-variety philanthropist. He set rents that guaranteed his investors a five percent return—but even at that, a typical four-room apartment rented for $7 a month. All of the apartments were floor-throughs with open balconies.

844

LONG ISLAND UNIVERSITY
(BROOKLYN CENTER)

385 FLATBUSH AVENUE
BETWEEN DEKALB AVENUE AND WILLOUGHBY STREET

This university was established in Brooklyn in 1926. It name reflects the fact that Brooklyn (as well as Queens) is geographically a part of Long Island. Like many other Brooklynites, it branched out further east on the Island with campuses in Brookville and Southhampton. It also established small campuses in Westchester and Rockland Counties in the 1980s. About 5,500 students are enrolled at this campus, which is still the university's home base.

845

301–311 CLINTON STREET

AT KANE STREET

1849–54

This beautiful row of Italianate houses, and its neighbors on Kane Street and Tompkins Place, are part of a development created by a New York lawyer named Gerard W. Morris. They avoid the monotony of many row houses through their projecting entranceways and joined pediments. The original ironwork, with a trefoil design, is still intact on most of them.

846

103–107 STATE STREET

AT SIDNEY PLACE

C. 1848

These three Gothic Revival rowhouses have beautiful tracery ironwork railings and fences, and all three originally had first-floor balconies resembling the one still remaining on no. 107, which also has an unusual relief motif that was probably rescued from a different house. Except for no.105, which was the home of the physician, these houses, like their neighbors, were occupied by merchants.

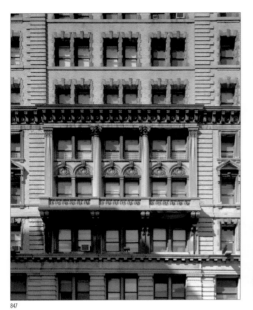

847

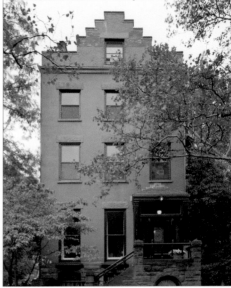

848

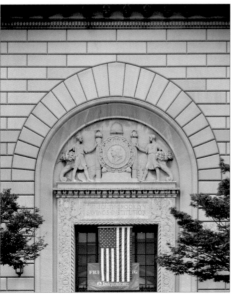

849

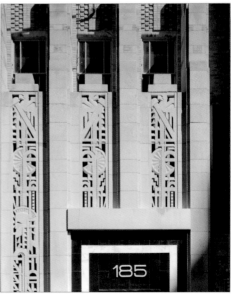

850

TEMPLE BAR BUILDING

44 COURT STREET AT JORALEMON STREET

1901, GEORGE L. MORSE

This a good example of why you should always look up when you are exploring the city. Its copper-clad cupolas are well worth an upward glace, but there are plenty of other interesting things going on up there. It's true of many buildings whose ground floors may not be worth a second look. This was Brookyn's tallest building at the beginning of the twentieth century.

DEGRAW MANSION

219 CLINTON STREET AT AMITY STREET

1845

This house, surrounded by a large landscaped garden, was built by Abraham J. S. DeGraw, a Manhattan commission merchant. It was enlarged in 1891 by Ralph L. Cutter, a dry goods merchant, who added the Romanesque detail on the ground floor and the Flemish stepped-gable roof, as well as the tower, which contained Brooklyn's first passenger elevator.

INDEPENDENCE SAVINGS BANK

130 COURT STREET AT ATLANTIC AVENUE

1922, McKENZIE, VOORHEES & GMELIN

Now known as the Independence Community Bank, this institution, which moved to Montague Street in 1994, was conceived as the "Little Man's Bank." Among its programs is the Independence Community Foundation, formed to promote health and human services, housing, the arts, and culture in Brooklyn. It is a major benefactor of Habitat for Humanity, whose New York base is on Furman Street, at the foot of Brooklyn Heights.

NATIONAL TITLE GUARANTY BUILDING

185 MONTAGUE STREET
BETWEEN CLINTON STREET AND CADMAN PLAZA

1930, CORBETT, HARRISON & MacMURRAY

This outstanding Art Deco bank was designed by the architectural team that went on to design Rockefeller Center. The main banking room once had sleek brass railings around the desks, marble counters, and a ceiling mural representing a summer sky.

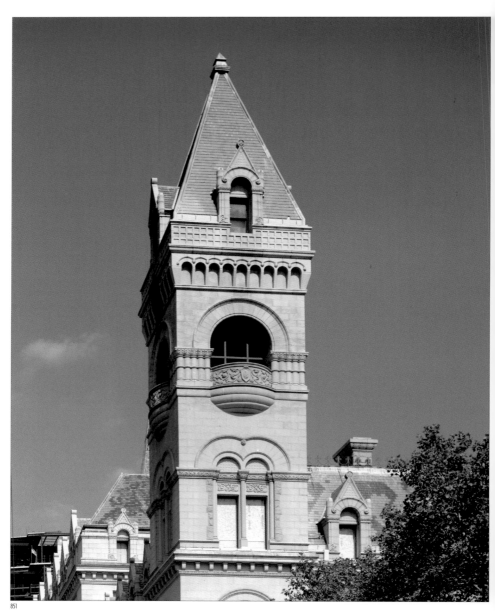

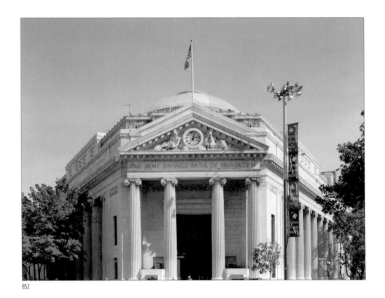

852

Post Office Building and Court House 𝓛

271–301 Cadman Plaza at Johnson Street

1891, Mifflin E. Bell

The original building here was designed in the Romanesque revival style by Mifflin Bell, the supervising architect of the U.S. Treasury Department. When he resigned as construction was just beginning, his replacement added bolder details. A new wing was added to house the U.S. Bankruptcy Court and U.S. Attorney's offices during the Depression era. Cadman Plaza, officially called the S. Parkes Cadman Plaza, was named for a Congregationalist minister who became well known as a radio preacher.

Dime Savings Bank 𝓛

9 DeKalb Avenue, off Fulton Street

1908, Mobray & Uffinger
Expanded, 1932, Halsey, McCormack & Helmler

This big building was designed to call attention to itself, in hopes that depositors would be lured in. The impressive dome was part of an addition created in 1932. At that time, the interior was made even more spectacular with a rotunda supported by twelve red marble columns whose gilded capitals are studded with Mercury-head dimes. As its name implies, the bank concentrated on small depositors, but before it merged with the Anchor Savings Bank in the 1990s, it had assets of more than $8.3 million. That's a lot of dimes.

Brooklyn Borough Hall \mathcal{L}

209 Joralemon Street at Cadman Plaza

1848, Gamaliel King
Cupola, 1898, Vincent C. Griffith and Stoughton
& Stoughton

Before Brooklyn reluctantly joined Greater New York in 1898, this was its City Hall. It was America's third-largest city at the time, after New York and Philadelphia. As if to show that there were no hard feelings after its absorption into New York, the impressive cast-iron cupola was added within months of its downgrading to Borough Hall. The upstairs room that had been the meeting place of the former city's Common Council was converted into a Beaux-Arts courtroom. After a long period of deterioration, the building was carefully restored in 1989.

New York & New Jersey Telephone Company Building

81 Willoughby Street at Lawrence Street

1898, R. L. Daus

The iconography on the Beaux Arts façade of this building is a dazzling array of old-fashioned telephones, bells, and other reminders that this was the headquarters of the telephone company. It was an early incarnation of the company now called Verizon, which originally included six companies serving New York, New Jersey, and parts of Pennsylvania. The marriage ended in 1927 with the formation of New Jersey Bell.

Brooklyn Friends Meeting House \mathcal{L}

110 Schermerhorn Street at Boerum Place

1857

As might be expected of a Quaker meeting house, this building is severe, but at the same time elegantly simple. One of the most discriminated-against religions in Colonial New York, the Society of Friends survived to become one of the state's most influential minorities. They were staunch supporters of civil rights for generations before the term was invented.

Gage & Tollner Restaurant \mathcal{L}

372–74 Fulton Street
between Smith Street and Red Hook Lane

1879

The famous restaurant moved to this brownstone building in 1882, after having already established its reputation in the neighborhood over the previous three years. Its dining room—famous for its seafood, especially oysters—has mahogany tables, mirrored walls, brocaded velvet, and cut-glass gaslit chandeliers.

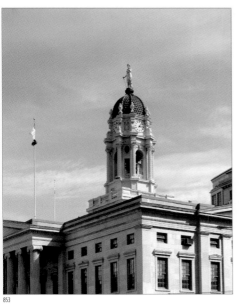

853

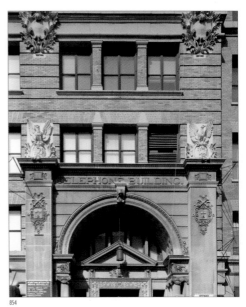

854

855

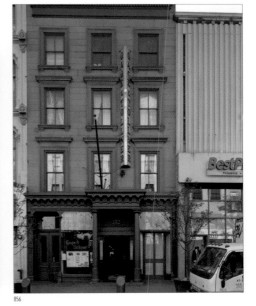

856

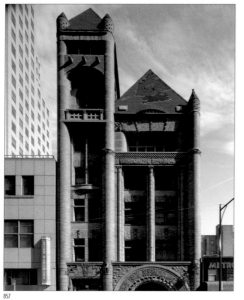

857

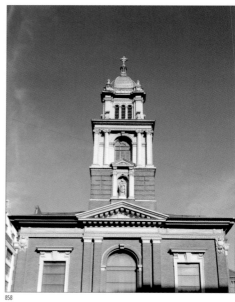

858

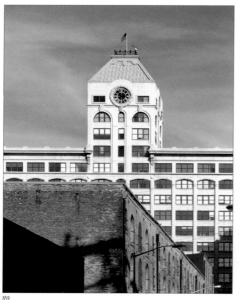

859

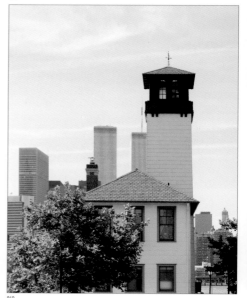

860

◆ DOWNTOWN BROOKLYN ◆

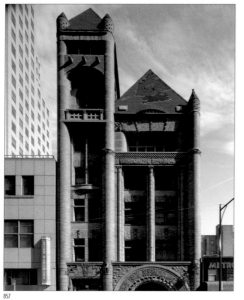

857

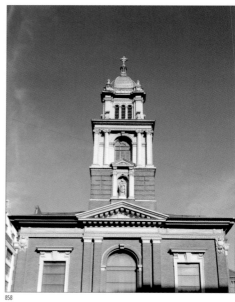

858

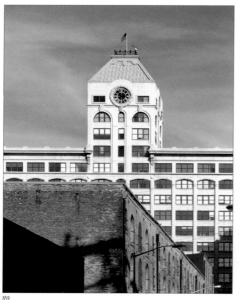

859

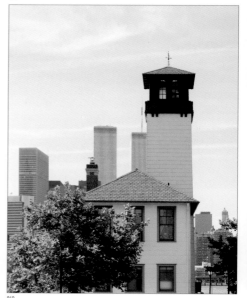

860

CITY OF BROOKLYN FIRE HEADQUARTERS

365–367 JAY STREET
BETWEEN WILLOUGHBY STREET AND MYRTLE AVENUE

1892, FRANK FREEMAN

This building, now an apartment house, is a powerful masterpiece of the Romanesque revival style made popular by Henry H. Richardson. It is the work of Frank Freeman, among the best architects ever to put his stamp on Brooklyn. The granite, brick, and sandstone structure with a red tile roof has a massive archway built to accomodate the horse-drawn fire apparatus that was housed on the ground floor. The tall tower rising above it was a lookout post for spotting fires. Brooklyn's Fire Department, along with commands in Queens, was absorbed into the NYFD six years after this building was finished.

ST. JAMES CATHEDRAL
(ROMAN CATHOLIC)

JAY STREET AT CATHEDRAL PLACE

1903, GEORGE H. STREETON

The first church on this site was the mother church of the Catholic Diocese of Brooklyn, but in 1896, the Bishop announced plans to build a new, more elaborate cathedral in the Fort Green area, and St. James was designated a pro-cathedral, meaning that it was a temporary seat of the Bishop. The new building was never built, but the designation wasn't changed back until 1972.

THE CLOCK TOWER

ONE MAIN STREET
BETWEEN BROOKLYN AND MANHATTAN BRIDGES

1888, WILLIAM HIGGINSON

This was originally one of a group of buildings (it was designated number seven of twelve) all representing the earliest use of reinforced concrete construction. They were built by Robert Gair for his corrugated box business. It is now condominium apartments, serving as an anchor for the emerging artists' colony called DUMBO, an acronym for "Down Under the Manhattan Bridge Overpass." There are literally hundreds of clocks like this one all over the city—on buildings, on street corners, and in store windows—but chances are good that if you take a walk today, someone will still ask you, "What time is it?"

FIRE BOAT PIER

FOOT OF OLD FULTON STREET

1926

This nearly-forgotten structure, with a tower for drying firehoses, was briefly the Fulton Ferry Museum, recalling busier days here when the ferry pulled up to a long-gone French Second Empire-style terminal on this spot. Steam ferries started regular service here in 1824, and by the last quarter of the nineteenth century, they were making twelve hundred crossings a day. Demand dropped after the Brooklyn Bridge opened in 1883, and service was suspended in 1924. Other attractions on this little plaza, apart from the bridge, include a converted barge that presents chamber music concerts, and another that has been converted into a restaurant called the River Café.

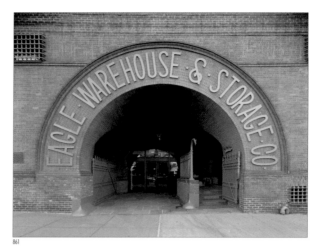

861

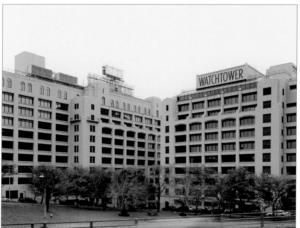

862

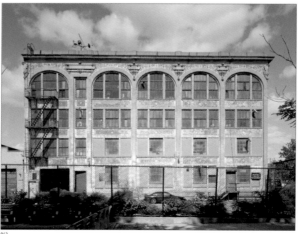

863

EAGLE WAREHOUSE

8 OLD FULTON STREET AT ELIZABETH STREET

1893, FRANK FREEMAN

This huge fortress-like former storage warehouse is on the site of the original building of the *Daily Eagle*, and the newspaper's old zinc eagle is displayed next to the entrance. The bronze lettering on its arched entry is unique in modern New York. The building is now divided into condominium loft apartments.

WATCHTOWER BUILDING

DOUGHTY, VINE, AND FURMAN STREETS,
COLUMBIA HEIGHTS

This massive building was the headquarters and manufacturing facility of E. R. Squibb and Co., a leading pharmaceutical firm founded in Brooklyn in 1858. After the drug company moved to New Jersey in 1938, the building was acquired by the Watchtower Bible and Tract Society of Jehovah's Witnesses. Its semimonthly publication, *The Watchtower*, averages 20 million copies per issue and is published in 125 languages.

ESKIMO PIE BUILDING

100–110 BRIDGE STREET
BETWEEN YORK AND TILLMAN STREETS

1910, LOUIS JALLADE

Glazed terra-cotta turns the façade of this building into a veritable garden, but for Brooklyn youngsters of another generation, it was what was inside that counted. This was the home of the company that made Eskimo Pies, the chocolate-covered ice cream bars on a stick.

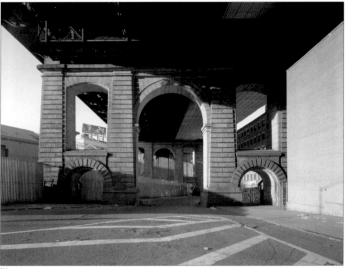

864

864

Manhattan Bridge Stanchion

CANAL STREET AT THE BOWERY IN MANHATTAN,
FLATBUSH AVENUE IN BROOKLYN

1910, LEON MOISSEIFF, ENGINEER
HENRY HORNBOSTEL, ARCHITECT

When planning began for this third bridge over the East River, north of the Brooklyn and Williamsburg Bridges, the goal was to create a thing of beauty, and after a great deal of controversy, the architects succeeded. The firm of Carrère & Hastings was hired to improve on the original designs, but they didn't change any of Hornbostel's basic concepts for the towers and anchorages. Henry Hornbostel had previously designed the Queensboro Bridge, which opened a year earlier.

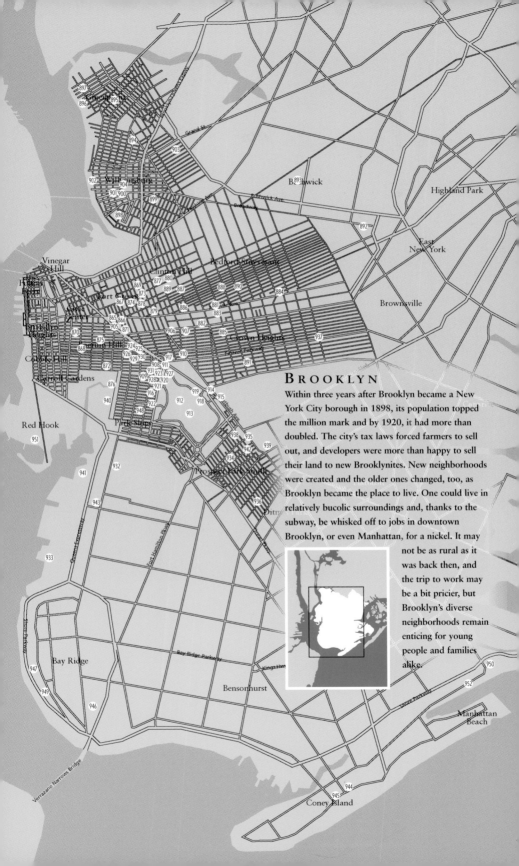

BROOKLYN

Within three years after Brooklyn became a New York City borough in 1898, its population topped the million mark and by 1920, it had more than doubled. The city's tax laws forced farmers to sell out, and developers were more than happy to sell their land to new Brooklynites. New neighborhoods were created and the older ones changed, too, as Brooklyn became the place to live. One could live in relatively bucolic surroundings and, thanks to the subway, be whisked off to jobs in downtown Brooklyn, or even Manhattan, for a nickel. It may not be as rural as it was back then, and the trip to work may be a bit pricier, but Brooklyn's diverse neighborhoods remain enticing for young people and families alike.

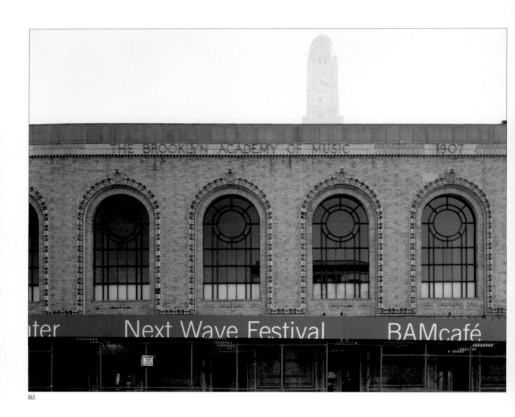

865

866

BROOKLYN ACADEMY OF MUSIC

865

39 LAFAYETTE AVENUE

1908, HERTS & TALLANT

This performing arts center includes three major spaces: the Opera House; the Playhouse (the former Music Hall); and Leperq Space (the former ballroom). It has a monumental 5,000-square-foot lobby. In 1981, the complex added several other performing venues nearby. Its resident orchestra is the Brooklyn Philharmonic. The institution, which calls itself BAM, concentrates on new and unusual productions in music, dance, and theater, and is perhaps best-known for its annual avant-garde Next Wave Festival.

BAM HARVEY THEATER
(FORMERLY THE MAJESTIC THEATER)

866

FULTON AT ROCKWELL STREETS

1903
RENOVATED, 1987, HARDY HOLZMAN PFEIFFER

This is one of the theaters restored by the Brooklyn Academy of Music, under the executive directorship of Harvey Lichtenstein, in 1967. Originally a movie theater, its flexible space is used for dance, drama, and musical events. In 1999, it was renamed the BAM Harvey Theater, in Lichtenstein's honor.

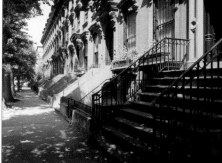

867

179–186 WASHINGTON PARK

BETWEN WILLOUGHBY AND DEKALB AVENUES

1886, JOSEPH H. TOWNSENS

This was the most desirable street in fashionable Fort Greene in the 1870s and '80s. The lure was the thirty-acre Washington Park, designed by Frederick Law Olmsted and Calvert Vaux. It featured cobblestoned walks theading under large chestnut trees. It was later renamed Fort Greene Park when the Prison Ship Martyr's Monument was dedicated in 1908. Designed by Stanford White, the 148-foot granite shaft honors the patriot prisoners of war held in British ships here during the Revolutionary War. Of an estimated 12,500 men who were held here, only 1,400 lived to tell about it.

867

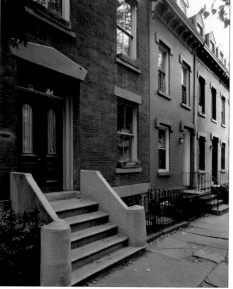

868

157 HOYT STREET

BETWEEN BERGEN AND WYCKOFF STREETS

C. 1860

Boerum Hill is a fairly recent name on the map of Brooklyn. It was named for a colonial farm that once covered most of its thirty-six-block area, owned and maintained by the Boerum Family. The three-story row houses lining Hoyt Street between Bergen and Wycoff Streets are among the oldest in the neighborhood. The street itself was named eponymously by Charles Hoyt, who joined with Charles Nevins to buy and develop land in the area in the early 1830s. Not to be outdone, Nevins also named a street after himself.

868

St. Joseph's College

232 CLINTON AVENUE
BETWEEN DEKALB AND WILLOUGHBY AVENUES

1875, EBENEZER L. ROBERTS

The entire block of Clinton Avenue between DeKalb and Willoughby Avenues is the most beautiful in Clinton Hill, thanks to four mansions built by members of the Pratt family, but this freestanding mansion is the grandest of all. It was the manor house of Charles Pratt, who made his fortune with an oil refinery in nearby Fort Greene. It had a daily output of more than 1,500 barrels of kerosene, which Pratt called "Astral Oil," fueling the lamps of America. He sold the company to John D. Rockefeller in 1874, and became an executive of Rockefeller's Standard Oil Company.

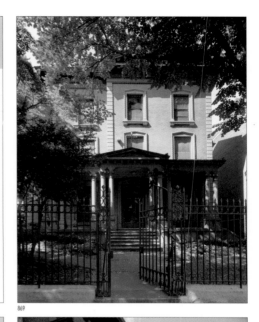

869

State Street Houses

BETWEEN SMITH AND HOYT STREETS

1847–74

These twenty-three well-preserved Renaissance Revival brownstone row houses were among the first to attract upper-middle class homebuyers into Boerum Hill. When they first arrived, mostly from Manhattan neighborhoods, they called themselves "pioneers." Most of them didn't know the difference between a paint brush and a hammer, but they learned quickly and the results of their self-taught skills as fixer-uppers have turned this into one of Brooklyn's most desirable neighborhoods.

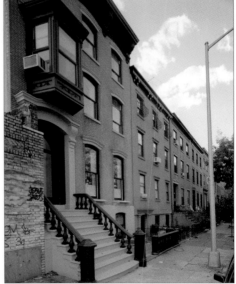

870

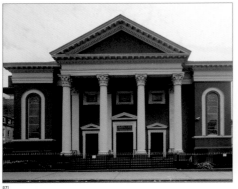

871

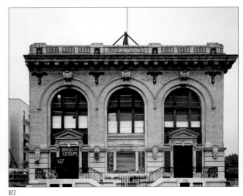

872

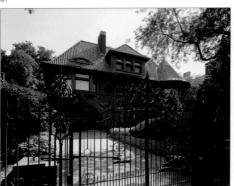

873

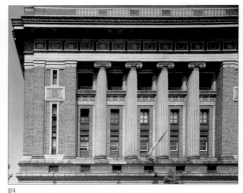

874

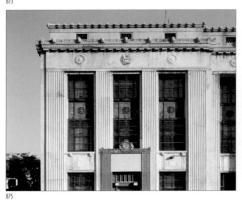

875

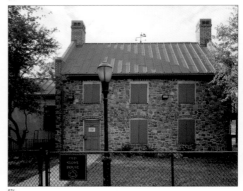

876

871
HANSON PLACE
SEVENTH DAY ADVENTIST CHURCH𝓛

88 HANSON PLACE AT SOUTH PORTLAND AVENUE

1860, GEORGE PENCHARD

Originally a Baptist Church, this glorious Classical building with cream-colored trim over a maroon façade was restored both inside and out in the 1970s. Following Biblical traditions, Seventh Day Adventists regard Saturday, and not Sunday, as a day of rest set aside for religious observances.

872
PUBLIC BATH No. 7𝓛

227-231 FOURTH AVENUE
BETWEEN UNION AND PRESIDENT STREETS

1910, RAYMOND F. AMIRALL

New York's first public bath house, a commercial enterprise called the "People's Bathing and Washing Establishment," opened on Mott Street in 1849. State law forced the city to open more of them after 1901. Although the architecture of most of them followed Roman precedents, this one broke the mold with white terra-cotta ornamentation evoking the sea.

873
RESIDENCE, BISHOP OF BROOKLYN
(ROMAN CATHOLIC)

241 CLINTON AVENUE
BETWEEN DEKALB AND WILLOUGHBY AVENUES

1890, WILLIAM E. TUBBY

This mansion was built for Charles Millard Pratt. The semi-circular conservatory on the south side features a spectacular bronze lamp, which undoubtedly burned the elder Pratt's "Astral Oil." It is now used as the residence of Rt. Rev. Thomas Daily, Bishop of the Catholic Diocese of Brooklyn, whose jurisdiction extends into Queens.

874
BROOKLYN MASONIC TEMPLE

317 CLAREMONT AVENUE AT LAFAYETTE AVENUE

1906, LORD & HEWLETT AND PELL & CORBETT

Thie elegant temple, with its imposing columns and colorful terra-cotta detail, reflected the grandeur of the entire Fort Greene neighborhood at the beginning of the twentieth century. Its architecture was inspired by ancient Greek temples, and the polychromed detail is a careful evocation of their painted façades.

875
BROOKLYN PRINTING PLANT
The New York Times

59–75 THIRD AVENUE
BETWEEN DEAN AND PACIFIC STREETS

1929, ALBERT KAHN

Visitors to Chicago are fascinated watching the *Sun-Times* come off the presses through sidewalk-level windows. But for years before that building was built, the same experience was available here in Brooklyn, where *The New York Times* had its presses behind block-long windows at this plant. It was built to take the load off the paper's printing plant in Times Square, which, like this one, has since been replaced by more modern facilities outside the city.

876
VACHTE-CORTELYOU HOUSE

3RD STREET AT FIFTH AVENUE

1699

Long known as "the Old Stone House at Gowanus," this Dutch farmhouse was reconstructed, using its original stones, in 1935, as part of the James J. Byrne Memorial Playground. During the Revolutionary War Battle of Long Island, a small garrison held off the British from the shelter of this house, allowing General Washington to evacuate his army to the safety of Manhattan.

877

Pratt Row 🔊

220–234 Willoughby Avenue

1907, Hobart Walker

This is part of three rows of twenty-seven houses, extending to Steuben Street and Emerson Place. Among many built by the Pratt family in Clinton Hill, they were intended for "people of taste and refinement, but of moderate means." They are used as Pratt Institute's faculty housing.

878

Joseph Steele House

200 Lafayette Street at Vanderbilt Avenue

c. 1850

This Greek Revival wood-frame house was built around an early Federal-style cottage that now forms its eastern wing. It has a New England–style widow's walk on the roof, but water views became a thing of the past generations ago.

879

415 Clinton Avenue

between Gates and Greene Avenues

c. 1865

This comfortable mansion was erected by Frederick A. Platt, a builder who shouldn't be confused with his more affluent neighbors of the same name, whose monumental mansions are further down the street. It is a lovely concoction of painted brick with a pink slate mansard roof.

880

Pratt Institute

south of Willoughby Avenue near DeKalb Avenue

1887–2000

Like Cooper Union in Manhattan, this liberal arts college established by Charles Pratt was originally intended to provide training for practical vocations. It now grants degrees in such areas as art, design, and architecture.

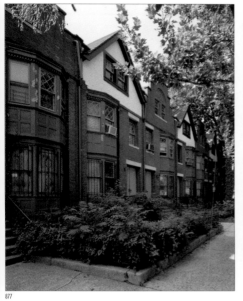

877

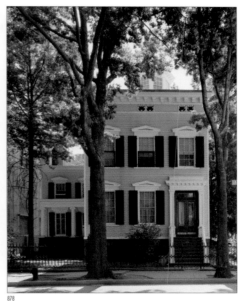

878

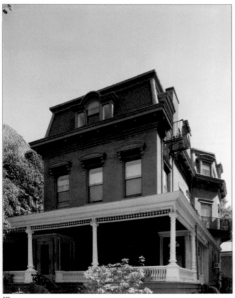

879

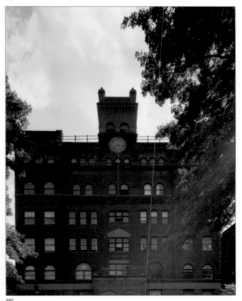

880

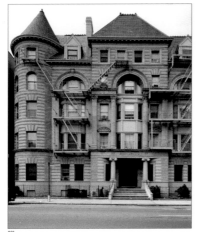

881

RENAISSANCE APARTMENTS℗

488 NOSTRAND AVENUE AT HANCOCK STREET

1892, MONTROSE W. MORRIS

This pale yellow brick and terra-cotta apartment house was left vacant for many years before it was restored to its original glory, both inside and out, in 1996. Among other restorations in the area, it was instrumental in bringing pride and dignity back to the Bedford-Stuyvesant neighborhood.

881

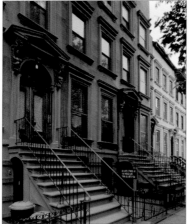

882

BREVOORT PLACE

BETWEEN FRANKLIN AND BEDFORD AVENUES
NEAR FULTON STREET

1860s

This well-preserved row of brownstones is typical of Civil War-era Bedford-Stuyvesant. The neighborhood takes its name from two older middle-class communities, Bedford and Stuyvesant Heights. By 1940, "Bed-Stuy" had become the largest black community in the city, eclipsing even Harlem.

882

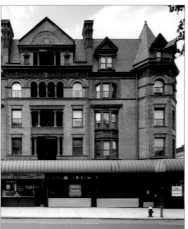

883

ALHAMBRA APARTMENTS℗

500–518 NOSTRAND AVENUE
BETWEEN HALSEY AND MACON STREETS

1890, MONTROSE W. MORRIS

This was the first of three major apartment houses built here in Bedford-Stuyvesant by developer Louis F. Seitz for affluent tenants. After a long abandonment, it was restored in 1998, to satisfy the need for solid housing in the neighborhood.

883

113–137 Bainbridge Street

BETWEEN LEWIS AND STUYVESANT AVENUES

C. 1900

Each of these thirteen houses makes an individual, playful statement along its roofline as if the builders were telling the world that the time had come, on the eve of a new century, to put away old ideas of propriety.

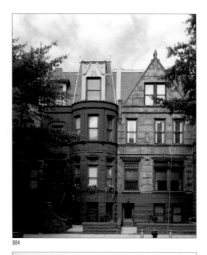

884

Imperial Apartments ⚿

1198 PACIFIC STREET AT BEDFORD AVENUE

1892, MONTROSE W. MORRIS

This elegant Crown Heights apartment building, which has since been subdivided into smaller units, has grand façades facing both Pacific Street and Bedford Avenue, and takes advantage of its location on Grant Square, formed by the convergence of Bedford and Rogers Avenues.

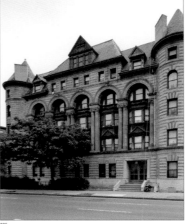

885

Independent United Order of Mechanics ⚿

67 PUTNAM AVENUE
BETWEEN IRVING PLACE AND CLASSON AVENUE

1889, RALPH L. DAUS

This was originally the Lincoln Club, formed in 1878 to promote the interests of the Republican Party. Politics soon gave way to old-fashioned socializing, which is still the main purpose of the Order of Mechanics, which moved here in the 1940s after the Lincoln Club disbanded.

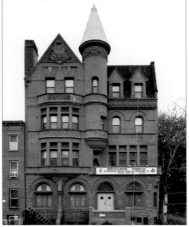

886

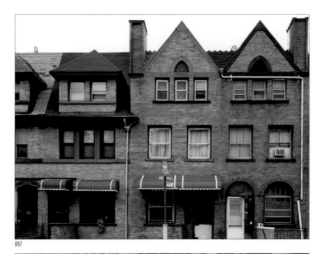

887

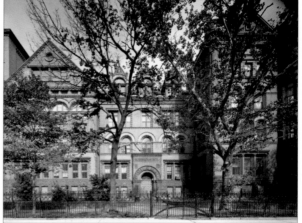

888

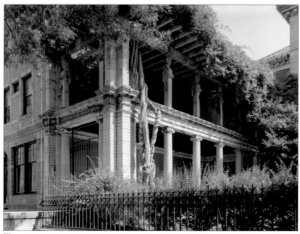

889

386–396 LAFAYETTE AVENUE

AT CLASSON AVENUE

C. 1888

This brick and brownstone row of terrace apartments extends around the corner onto Classon Avenue, providing a touch of serenity in the midst of a bustling neighborhood. The Bedford-Stuyvesant section has a population of well over 400,000 people, more than the popuation of Minneapolis, crammed into 2,000 acres.

888

BOYS' HIGH SCHOOL *L*

832 MARCY AVENUE
BETWEEN PUTNAM AVENUE AND MADISON STREET

1892, JAMES W. NAUGHTON

This is now the Street Academy, Brooklyn Literacy Center and Outreach Program; but, a century ago, it was one of the most important public schools in Brooklyn. Its enrollment increased with its prestige, and several additions were built between 1905 and 1910. Both this and Girls' High School on Nostrand Avenue, grew out of the Central Grammar School, Brooklyn's first high school, established in 1878.

889

CAROLINE LADD PRATT HOUSE *L district*

229 CLINTON AVENUE
BETWEEN DEKALB AND WILLOUGHBY AVENUES

1895, BABB, COOK & WILLARD

Now Pratt Institute's president's residence, this fabulous Georgian mansion was a wedding gift from Charles Pratt to his son, Frederic, and his bride, the former Caroline Ladd. It is an unusual example of a freestanding mansion attached to another along one side. Don't miss the pergola at the back of the rear garden. It has one of the most beautiful wisteria vines this side of the Brooklyn Botanic Garden.

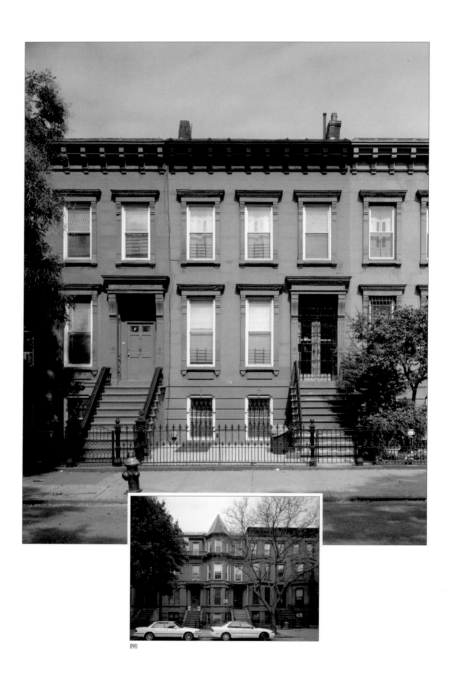

890

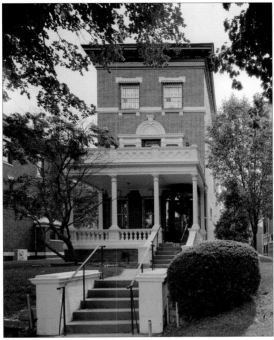

891

JEFFERSON AVENUE

BETWEEN NOSTRAND AND THROOP AVENUES

1870s

Among the illustrious early residents of this row of Renaissance Revival brownstone houses was F. W. Woolworth of the five- and ten-cent stores, as well as Abraham Abraham, one of the founders of the Abraham & Straus department store.

1281 PRESIDENT STREET

BETWEEN BROOKLYN AND NEW YORK AVENUES

1911, WILLIAM DEBUS

The southern section of Crown Heights was developed after 1900, and this imposing double house is a good example of the kind of housing that was built on what had previously been farmland.

THERE USED TO BE A BALLPARK...

The block in Crown Heights bounded by Montgomery Street, McKeever Place, Sullivan Place, and Bedford Avenue is now filled with a huge apartment development, but from 1913 until those dark days of 1957, it was Ebbets Field, the third home of the late, lamented Brooklyn Dodgers. The team had several different names before they won the National League pennant in 1920 and settled down as the Dodgers, but their fans usually called them "Bums." One reason for that was that after losing the 1920 World Series, they didn't come close to playing a championship game for another twenty-one seasons. But they were lovable, nonetheless, and thanks to such guys as Dixie Walker, Pee Wee Reese, Pistol Pete Reiser, and manager Leo Durocher, they finally won the pennant again in 1941. They lost the Series to the Yankees that year, though, and the watchword around Brooklyn became, "Wait 'til next year." Next year didn't come until 1947, when they won the pennant, but they lost the Series to the Yankees again, and then they did it again in 1952.

And so it went. The Bums lost the pennant in the last inning of the season's last game in both 1950 and '51. But it was in 1951 that Brooklyn's heart was really broken when the Giants' Bobby Thompson hit a grand-slam home run in the ninth inning, wiping out the Dodgers' 4-1 lead. Baseball writers called it, "The shot heard 'round the world," but Dodger fans could only say, "We wuz robbed." They took their revenge by winning their first, and only, world championship at Ebbets Field in 1955. Two years later, they were on their way someplace out beyond the Hudson River, and wreckers arrived to make way for those apartment towers. Brooklyn needed the housing, but not nearly as much as it needed dem Bums.

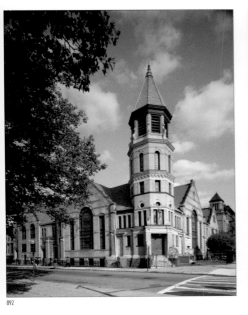

892

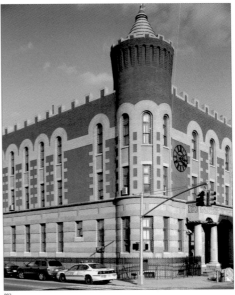

893

892

BUSHWICK AVENUE CENTRAL METHODIST EPISCOPAL CHURCH

1130 BUSHWICK AVENUE AT MADISON STREET

1886–1912

The octagonal tower on this Renaissance Revival church has become a symbol of the Bushwick neighborhood. This area was settled as a town in 1660, taking its name from the Dutch "Boswijck," meaning "Wooded District." It attracted large numbers of German immigrants after 1840 and, twenty years later, there were eleven breweries within a fourteen-block area here.

893

TWENTIETH PRECINCT, NYPD

179 WILSON AVENUE AT DEKALB AVENUE

1895, WILLIAM B. TUBBY

This police station and its stable, which became the 83rd Precinct before becoming the Brooklyn North Task Force, is a fanciful representation of a medieval fortress with battlements on the roof and a corner tower. It was restored by Ehrenkrantz & Eckstut in 1966, for the use of the Police Department.

Russian Orthodox Cathedral of the Transfiguration of Our Lord

228 North 12th Street at Driggs Avenue

1921, Louis Allmendinger

The five copper onion-domed cupolas here make an important statement in the lives of Eastern European immigrants who settled here in Williamsburg. The church is a tiny building but a powerful one. Inside, the altars are separated from the nave by an impressive hand-carved wooden screen with icons painted by monks in a Kiev monastery.

Greenpoint Savings Bank

807 Manhattan Avenue at Calyer Street

1908, Helmle & Huberty

This bank was founded here in Brooklyn's Greenpoint section in 1869. Today it is one of the largest savings institutions in the city, with more than twenty branches. In the nineteenth century, Greenpoint was an important industrial center, including shipbuilding and iron-making, which helped to give the bank a head start.

Eberhardt-Faber Pencil Factory

61 Greenpoint Avenue

In the the nineteenth century, Greenpoint was one of Brooklyn's busiest industrial neighborhoods, turning out everything from glass bottles to iron fences to wooden pencils. (Note that the exterior columns look like pencils, in a whimsical homage to the building's most recent function.) It was where Charles Pratt made kerosene, and the Continental Iron Works built the ironclad ship, *Monitor*. Most of the area factories closed after World War II, and the population began to change. New arrivals came from all over the world, but more than half were from Poland.

Astral Apartments

184 Franklin Street
between Java and India Streets

1886, Lamb & Rich

This apartment block was built by Charles Pratt, for the workers in his kerosene refinery. It was named for the product they made, which Pratt marketed as "Astral Oil." An example of the popular "model tenements" that were built in the 1880s, the building had eighty-five apartments, all with plenty of windows, hot and cold running water, and other amenities that nineteenth-century factory workers didn't expect to find.

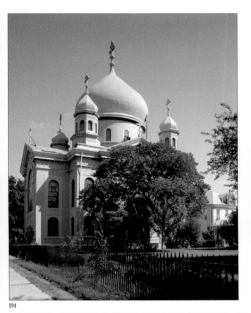

894

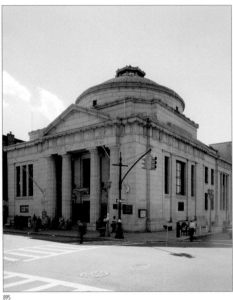

895

896

897

898

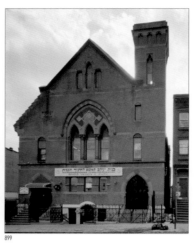

899

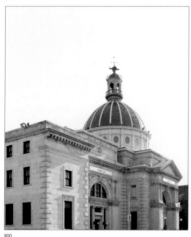

900

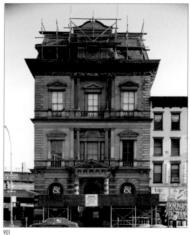

901

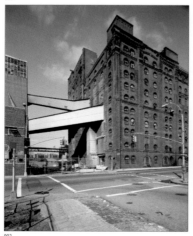

902

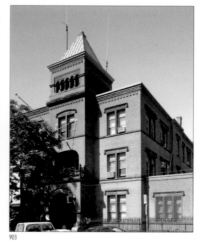

903

898
REBBE'S HOUSE

500 BEDFORD AVENUE AT CLYMER STREET

Among the Hasidic Jews who settled in Brooklyn, one of the largest groups is the Satmar sect, who were led here to Williamsburg from their native Romania and Hungary by Rabbi Joel Teitelbaum, who lived in this house. As many as 50,000 Satmars live in the vicinity of Division Street. They operate five synagogues, fifteen schools, and an incorporated village in the Catskill Mountains.

899
BNOS YAKOV OF PUPA
(SYNAGOGUE)

274 KEAP STREET
BETWEEN MARCY AND DIVISION AVENUES

1876

Originally Temple Beth Elohim, this was the first Jewish congregation in Brooklyn, dating back to 1851. It is a symphony of color, with polychromed brick, painted brownstone, stained glass, terra-cotta, and tile.

900
WILLIAMSBURGH SAVINGS BANK ℒ

175 BROADWAY AT DRIGGS AVENUE

1875, GEORGE B. POST

This was the third home of the bank, remaining here until it moved into its grand tower in downtown Brooklyn in 1929. The interior of this building is an unusual example of early post-Civil War design, including beautiful, colorful, stenciled decoration in the cast-iron dome. The entire building was restored in the 1990s by Platt & Byard.

901
WILLIAMSBURG ART AND HISTORICAL SOCIETY ℒ

135 BROADWAY AT BEDFORD AVENUE

1868, KING & WILCOX

Originally the Kings County Savings Bank, this is among the city's finest examples of a French Second Empire Building. The Historical Society has carefully preserved its Victorian interior, and it is constantly working to keep the exterior intact as well. At the time this building was built, it was at the heart of Brooklyn's most important industrial district.

902
AMERICAN SUGAR REFINING COMPANY

292–350 KENT AVENUE
BETWEEN SOUTH 2ND AND SOUTH 5TH STREETS

C. 1890

This was once the world's biggest sugar refinery, thanks to the machinations of Henry O. Havemeyer, who gained control of the sugar industry by forming the Sugar Trust in 1887. The trust went into decline after he died in 1907, but its successor company is still among the most important in the industry.

903
19TH PRECINCT STATION HOUSE ℒ

43 HERBERT STREET AT HUMBOLDT STREET

1892, GEORGE INGRAHAM

Although still a facility of the New York City Police Department, this building, which originally included a stable, is no longer a station house. It first served the Police Department of the City of Brooklyn, and set the standard for the layouts of all of its police stations.

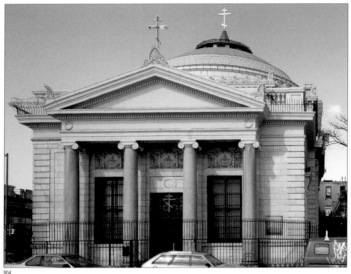

904

HOLY TRINITY CHURCH OF UKRANIAN AUTOCAPHALIC ORTHODOX CHURCH IN EXILE

117–185 SOUTH 5TH STREET AT NEW STREET

1906, HELMLE & HUBERTY

There are dozens of examples of New York churches that have become apartments, retail spaces, and even nightclubs. Hundreds were built for one denomination and converted to another. But this particular parish didn't buy an existing church. Their house of worship was originally a bank, the headquarters of the Williamsburg Trust Company. Its impressive terra-cotta façade and imposing dome provide just the right note of dignity for a church. The Ukrainian Autocephalous Orthodox Church was established in New York by immigrants from Ukraine in the 1920s. The name identifies them as independent of the main body of the church, with their own bishops, although in communion with it.

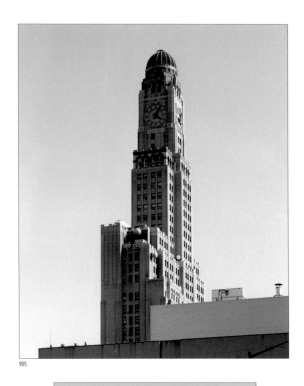

905

WILLIAMSBURGH SAVINGS BANK BUILDING ℒ

ONE HANSON PLACE AT ASHLAND PLACE

1929, HALSEY, MCCORMACK & HELMLER

At 512 feet, this is Brooklyn's tallest office building. The decoration on its base includes such icons of thrift as bees and squirrels, and even a couple of pelicans. The interior, which its landmark citation identifies as a "cathedral of thrift," is decorated with twenty-two different kinds of marble on the walls, floors, columns, and trim. The mosaic ceiling is designed around the signs of the zodiac, and another mosaic masterpiece is an aerial view of Brooklyn. The bank, which takes its name from Brooklyn's Williamsburg section, retained the original spelling after the neighborhood dropped the last letter in 1855, when it joined the City of Brooklyn.

906
Grant Square Senior Center

BEDFORD AVENUE AT DEAN STREET

1890, P. J. LAURITZEN

The American Eagle supporting the bay window and the images of Lincoln and Grant in the spandrels between its brownstone arches provide clues to this Richardson Romanesque building's original use. Now a gathering place for senior citizens, it was once the Union League Club of Brooklyn, an organization founded by members of the Republican Party in this Brownsville neighborhood. There is an equestrian statue of General Grant in the small park across the street. It was placed there six years after his admirers moved into their clubhouse.

907
1164–1182 Dean Street

BETWEEN BEDFORD AND NOSTRAND AVENUES

1890, GEORGE P. CHAPPELL

These well-maintained Queen Anne houses, which are constructed of a variety of materials, from brick to terra-cotta and Spanish tiles, all have different treatments of their rooflines, from steps to peaks to domes, making this stretch of Dean Street one of Brooklyn's most interesting and colorful blocks. The houses were built a year after the Fulton Street elevated line began running, making Brownsville more accessible to the rest of the city. Small houses like these were soon joined by large apartment buildings, and the neighborhood became one of Brooklyn's most crowded in less than ten years.

908
The Montauk Club

25 EIGHTH AVENUE AT LINCOLN PLACE

1891, FRANCIS H. KIMBALL

This is a reminder of Venice in Park Slope, except in this case the Venetian palazzo is decorated with representations of the lives of American Indians and the plants and animals that were part of their world. This men's club was named for the Montauks, a Native American people that once dominated Long Island. Still one of New York's most prestigious clubs, its most famous member in the late nineteenth century was lawyer Chauncey Depew, a president of the New York Central Railroad who went on to become a U.S. Senator.

909
Congregation Beth Elohim
(Synagogue)

EIGHTH AVENUE AT GARFIELD PLACE

1910, SIMON EISENDRATH AND B. HOROWITZ

This five-sided Beaux Arts Temple, whose name means "House of God," was said to have been designed as a representation of the five books of Moses. The large dome over the entrance, which is set into a chambered corner of the building, is outstanding. It is supported by a beautiful pair of composite columns. Park Slope, the neighborhood it serves, was almost completely built in less than thirty years, beginning in the late 1880s, after the Brooklyn Bridge went into use and the area was connected to it by streetcar lines.

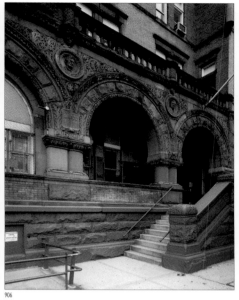

906

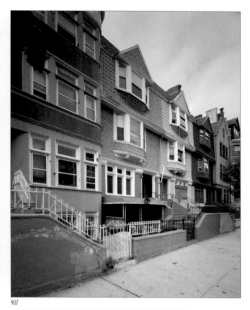

907

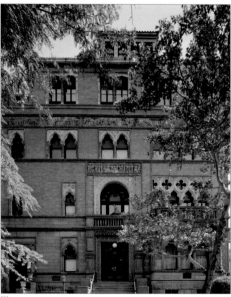

908

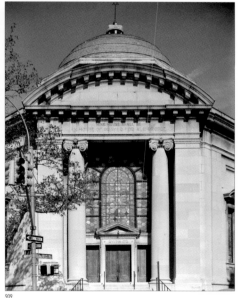

909

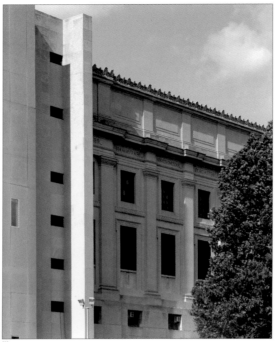

910

Brooklyn Museum of Art 🔏

200 Eastern Parkway at Washington Avenue

1915, McKim, Mead & White

Its original design would have made this the world's largest museum. That grand plan called for a series of square pavilions around a glass-enclosed central courtyard. Only one of them was ultimately built. A grand stairway at the front entrance was ordered removed in 1935 by a director who thought it was too imposing. The allegorical sculptures there, representing Brooklyn and Manhattan, were created by Daniel Chester French for the Brooklyn entrance to the Manhattan Bridge. They were moved because they got in the way of traffic.

Soldiers' and Sailors' Memorial Arch 🔏

Grand Army Plaza
Flatbush Avenue, Eastern Parkway

1892, John H. Duncan

This memorial to the Civil War dead was created by the same architect as Grant's Tomb on Manhattan's Riverside Drive. Topping the eighty-foot structure is a marvelous bronze, *Triumphal Quadriga* by sculptor Frederick MacMonnies, depicting a female figure carrying a banner and a sword, flanked by two winged Victory figures. On the south side are military groupings, also by MacMonnies, representing the Army and the Navy.

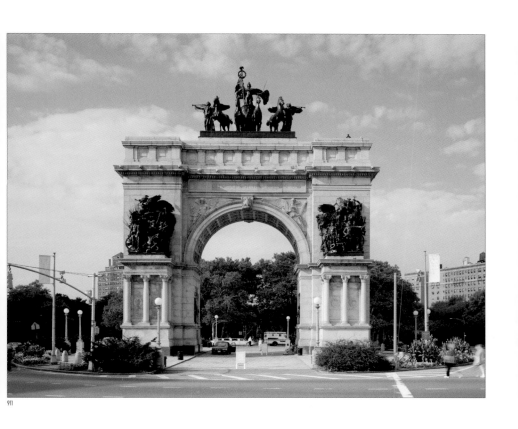

911

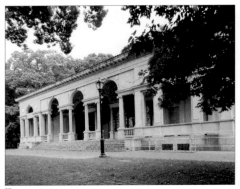

912

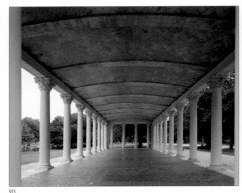

913

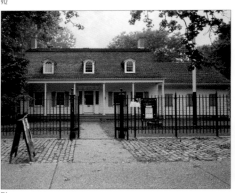

914

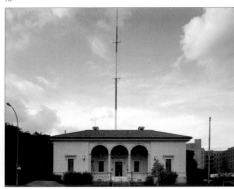

915

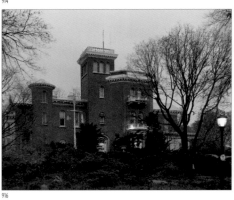

916

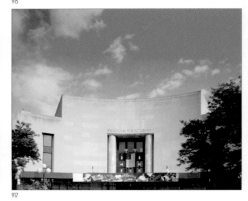

917

912
PROSPECT PARK TENNIS HOUSE

1910, HELMLE & HUBERTY

Prospect Park was built on designs by Frederick Law Olmsted and Calvert Vaux, the creators of Manhattan's Central Park, in 1868. This Palladian structure, like other later additions, distressed Olmstead, who had envisioned a naturalistic, rustic landscape.

913
PROSPECT PARK CROQUET SHELTER

1904, McKIM, MEAD & WHITE

This is also known as the Grecian Shelter because of its resemblance to a Corinthian Temple. While nobody plays croquet here these days, this structure is one of the park's Classical treasures.

914
LEFFERTS HOMESTEAD

FLATBUSH AVENUE
NEAR EMPIRE BOULEVARD IN PROSPECT PARK

1783

This Dutch Colonial farmhouse was built by Peter Lefferts to replace the home burned by American troops during the Revolutionary War Battle of Long Island. It was moved into Prospect Park from its original location in 1918, and is now used as museum offering children's educational programs.

915
BUREAU OF FIRE COMMUNICATIONS

35 EMPIRE BOULEVARD
BETWEEN WASHINGTON AND FLATBUSH AVENUES

1913, FRANK J. HELMLE

This wonderful early-Renaissance building is a communications center for the New York City Fire Department. Although McKim, Mead & White designed most of the structures in Prospect Park, Helmle & Huberty, who designed this one, also contributed the Tennis House and the Boathouse on the Lullwater.

916
LITCHFIELD VILLA

PROSPECT PARK, BETWEEN 4TH AND 5TH STREETS

1857, ALEXANDER JACKSON DAVIS

Now the Brooklyn headquarters of the Parks Department, this was originally the manor house of Edwin C. Litchfield, a successful railroad lawyer, whose one-square-mile estate encompassed nearly all of today's Park Slope section. The property was the center of the social life of pre-Civil War Brooklyn. The house, which is within what is now Prospect Park, was built more than a decade before the park was developed.

917
BROOKLYN PUBLIC LIBRARY

GRAND ARMY PLAZA
AT FLATBUSH AVENUE AND EASTERN PARKWAY

1941, ALFRED MORTON GITHENS AND FRANCIS KEALLY

Although construction on this building was begun in 1912, because funding was slow in coming, it wasn't completed for almost thirty years. The original library, opened in Bedford, in 1897, had two separate reading rooms, one for men and one for women. This Main Branch has large collections of sheet music, films, videocassettes, records, and compact discs, as well as books available in sixty-four languages.

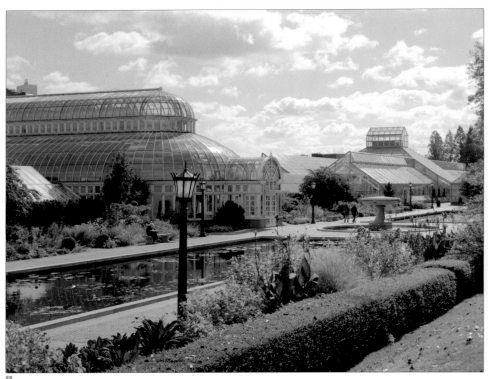

918

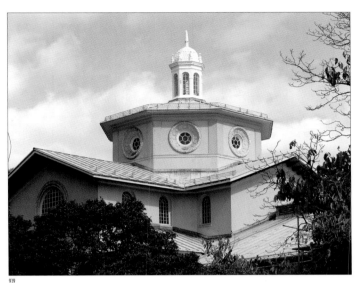

919

BROOKLYN BOTANIC GARDEN GREENHOUSES

1987, DAVIS, BRODY & ASSOCIATES

These sixteen glass structures are built over a series of below-ground gardens whose climatic zones range from a humid tropical jungle to a scorching dry desert. They also house the largest collection of bonsai trees in the western hemisphere. Outside, the greenhouses overlook a plaza with pools covered by water lillies, and, on the hillside beyond, a large grove of flowering magnolia trees. The Botanic Garden, which covers fifty acres, was established in 1910 with a donation from philanthropist Alfred Tredway White and matching funds from the city. The site was a wasteland then, but the soil had been enriched with the "byproducts" of breweries and stables of an earlier generation. The plant collections here include more than 13,000 species in specialized gardens of related types. New York's largest such institution is the Botanical Garden in the Bronx, and there are also smaller versions in Queens and on Staten Island.

BROOKLYN BOTANIC GARDEN

1000 WASHINGTON AVENUE AT EMPIRE BOULEVARD

1918, McKIM, MEAD & WHITE

This oasis between the Brooklyn Museum and Prospect Park is famous for its Japanese Hill and Pond Garden (1915), and for its rose garden (1927). This is an especially wonderful place to welcome spring, admiring the blossoms in the grove of Japanese cherry trees (more than you'll find in Washington, DC) and, a few weeks later, wandering along its seemingly endless rows of lilacs. But delights are to be found here in every season, especially the fall, when the leaves turn and the Garden hosts its annual Chili Pepper Festival.

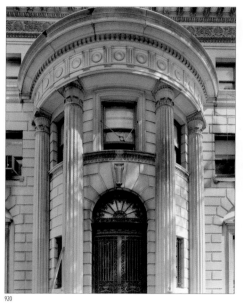

920

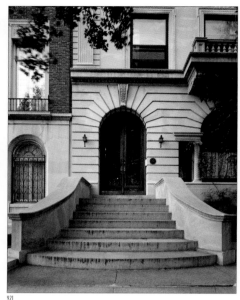

921

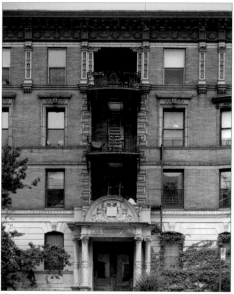

922

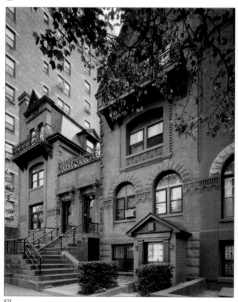

923

MONTESSORI SCHOOL

105 EIGHTH AVENUE
BETWEEN PRESIDENT AND CARROLL STREETS

1916, HELMLE & HUBERTY

This bow-fronted mansion was designed by Frank J. Helme, who also designed the Boathouse on Prospect Park's Lullwater, as well as many banks. The school that occupies it today follows a system of motivating youngsters to educate themselves, developed in 1910 by the Italian educator, Maria Montessori.

19 PROSPECT PARK WEST

BETWEEN CARROLL STREET AND MONTGOMERY PLACE

1898, MONTROSE W. MORRIS

This pair of Renaissance Revival houses are fine examples of an architectural movement called "Classical Eclecticism" that took the country by storm after it was introduced at the Columbian Exposition in Chicago in 1893. It was houses like these along Brooklyn's so-called "Gold Coast" that prompted the name-change from Ninth Avenue to Prospect Park West, just as Manhattan's Eighth Avenue became Central Park West.

LITCHFIELD APARTMENTS

571–577 NINTH STREET, AT PROSPECT PARK WEST

The section of Park Slope known as the North Slope was considered the "Fifth Avenue of Brooklyn" in the years right after the Civil War, when well-heeled Manhattanites began relocating here in search of some fresh air to complement the elegance of their lifestyle. Most of them built brownstones and Victorian mansions, but for those who longed for the comforts of their former homes, apartment houses were added to the mix as well. This one was named for Edwin C. Litchfield, the millionaire railroad lawyer whose mansion still stands in the park at Fourth Street. The park maintenance buildings nearby, at Eighth Street, were originally the Litchfield stables.

944–946 PRESIDENT STREET

BETWEEN PROSPECT PARK WEST AND EIGHTH AVENUE

1885, CHARLES T. MOTT

This elegant pair of mansions, featuring beautiful stained glass and terra-cotta as well as perfect wrought-iron work, are early examples of the glories of Park Slope. Their round-arch doorways and windows are the signature of the Romanesque style, which became the dominant statement in American architecture in the 1880s and 1890s. It died as suddenly as it emerged in New York, when homeowners became bored with its massive scale, which didn't adapt well to the demands of the standard rowhouse pattern. This was especially true in Manhattan, which limited rowhouse façades to twenty-five feet each.

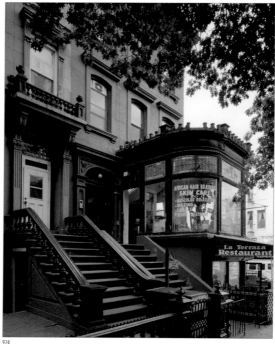

924

182 SIXTH AVENUE

AT ST. MARK'S PLACE

1880s

Many of the middle-class brownstone houses along Sixth Avenue have been altered over the years, and in this case the alteration included the addition of retail space. These late nineteenth-century rowhouses were built in the Italianate style with unusually high stoops that served to distance the parlor floor from the bustle of the busy street below. It made the added storefronts seem as though they had been part of the original design. The busy street, of course, also assured that the stores would thrive. In this particular case, the high basement allowed for a two-story extension without encroaching on the house itself.

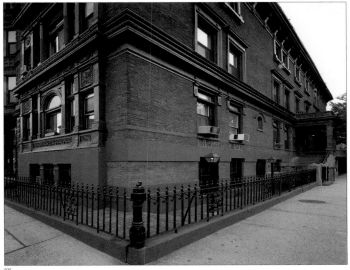

925

CATHEDRAL CLUB OF BROOKLYN

85 SIXTH AVENUE AT ST. MARK'S AVENUE

1890

This was originally an exclusive men's club called the Carlton. It later sheltered the rich as the Monroe Club and then the Royal Arcanum Club. It became the Cathedral Club, a Roman Catholic fraternal organization, in 1907, through the efforts of Father George Mundelein, who later became Cardinal of Chicago. In a rare happenstance in New York, an apartment building next to the club on St. Mark's Avenue, as well as the one just beyond, carry out its architectural theme and complement it quite well.

926
ST. JOHN'S PLACE

BETWEEN SIXTH AND SEVENTH AVENUES

1890S

Park Slope, bounded by Fourth and Flatbush Avenues, Prospect Park West and Fifteenth Street, was developed after the park was built and streetcar service arrived in the 1870s. These houses, lovingly restored in the 1980s, were originally the homes of professional people just like them who commuted by trolley from the neighborhood to downtown Brooklyn, and even over to Manhattan across the Brooklyn Bridge.

927
838 CARROLL STREET

BETWEEN PROSPECT PARK WEST AND EIGHTH AVENUE

1887, C. P. H. GILBERT

This is one of several houses here on Carroll Street, and on Montgomery Place, designed by C. P. H. Gilbert. They rank among the best Romanesque Revival mansions anywhere in America, and this is the crowning jewel. Although it has many fine details, the corner tower with its peaked slate roof is especially outstanding. The house was built for James H. Remington, who was president of the United States Law Association.

928
MONTGOMERY PLACE

BETWEEN PROSPECT PARK WEST AND EIGHTH AVENUE

1892

This is regarded as Park Slope's most beautiful block. The short street was developed as a single unit by real estate entrepreneur Harvey Murdoch; and twenty of the forty-six houses here were designed by C. P. H. Gilbert, who was responsible for the Warburg Mansion, now the Jewish Museum, on Fifth Avenue in Manhattan, as well as the DeLamar Mansion on 37th Street at Madison Avenue.

929
176 AND 178 ST. JOHN'S PLACE

BETWEEN SIXTH AND SEVENTH AVENUES

1888

These two Queen Anne houses were built by a pair of doctors, which explains the caduceus worked into the ornate decoration in the gable of no. 178. Although two separate buildings, they blend together as one. They present a glorious array of fanciful detail, bursting forth with dormers, gables, arches, a conical roof, and a tower.

930
LILLIAN WARD HOUSE

21 SEVENTH AVENUE AT STERLING PLACE

1887, LAWRENCE B. VALK

This was the first house in the impressive row of four Romanesque Revival houses between the Grace United Methodist Church and Sterling Place. As is usually the case with corner houses establishing a row, it is more elegant than its neighbors, although each of them has a wonderful personality. It was originally owned by opera singer Lillian Ward.

931
12–16 FISKE PLACE

BETWEEN CARROLL STREET AND GARFIELD PLACE

1896

This charming little street is typical of nineteenth-century Brooklyn. Although there are apartment houses on the block's east side, this trio in the late Romanesque Revival style, along with its neighboring townhouses, managed to escape twentieth-century development. These three houses have nearly identical twins behind them at 11–17 Polhemus Place.

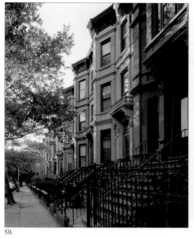

926

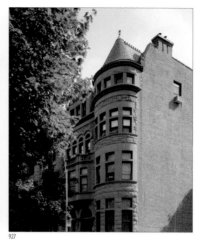

927

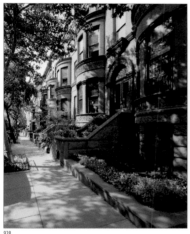

928

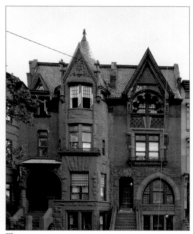

929

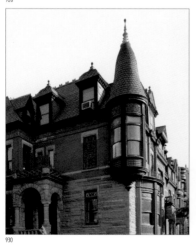

930

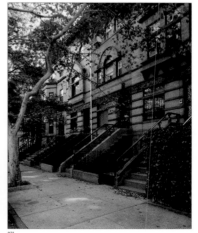

931

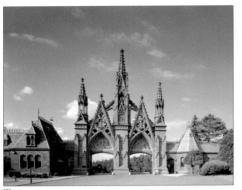

932

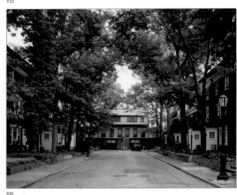

933

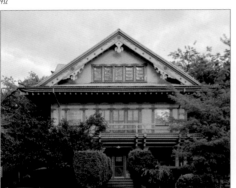

934

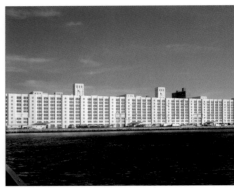

935

936

937

932

Greenwood Cemetery

BETWEEN 21ST AND 37TH STREET, FORT HAMILTON
PARKWAY AND FIFTH AVENUE AND McDONALD AVENUES

MAIN GATE AND GATEHOUSE, 1875, RICHARD UPJOHN

Before America's cities had public parks, cemeteries served as sylvan retreats, and this was considered the best of them. The Gothic entrance gate and its surrounding buildings are only a hint of what can be seen inside. There are more than 550,000 souls interred in its 478 acres, amid lakes and slowly-moving streams. The memorials that mark their last resting places are generally quite elaborate.

933

Brooklyn Army Terminal

SECOND AVENUE, BETWEEN 58TH AND 65TH STREETS

1918, CASS GILBERT

This no-nonsense warehouse complex served as the major Port of Embarkation for troops and supplies on their way to Europe during two world wars. It was also where troops first touched American soil when they returned, and a faded sign can still be seen on the water side that says, "Welcome Home."

934

Frederick S. Kolle House

125 BUCKINGHAM ROAD
BETWEEN CHURCH AVENUE AND ALBEMARLE ROAD

1903, PETIT & GREEN

This unusual mansion, with its Japanese decoration, is part of the Prospect Park South Historic District, which is one of Brooklyn's most elegant suburban developments. It was created in 1899 by Dean Alvord, who advertised it as "a rural park within the limitations of the conventional city block." The variety of styles here range from a Swiss chalet to a Japanese pagoda.

935

Albemarle Terrace

EAST 21ST STREET
BETWEEN CHURCH AVENUE AND ALBEMARLE ROAD

1917, SLEE & BRYSON

This little dead-end street is lined on both sides with Georgian Revival homes that have Palladian windows interspersed with bay windows. They also have slate mansard roofs, often pierced with charming dormers. Of course, the best feature of Albemarle Terrace is that there is never a problem with traffic.

936

East 16th Street

BETWEEN NEWKIRK AND DITMAS AVENUES

1909, ARLINGTON ISHAM

This row was part of a suburban development called the Arts and Crafts Bungalows, and its name was aptly chosen. It is part of the Ditmas Park neighborhood, developed in the early part of the twentieth century into an enclave of 175 large frame houses on tree-lined streets. Even before these houses were built, a local neighborhood association, one of the city's first, had drawn up its own rules for zoning intended to preserve the character of the area.

937

Engine Company 240, NYFD

1309 PROSPECT AVENUE
BETWEEN GREENWOOD AVENUE AND EASTERN PARKWAY

1896

Here is another fine example of the care lavished on the design of New York's firehouses. The city was dominated by volunteer fire companies until 1865, when the state legislature formed the Metropolitan Fire Department, with 700 paid firefighters in Brooklyn and Manhattan. It became the Fire Department of the City of New York in 1874. It has more than 9,000 men and women on its payroll today.

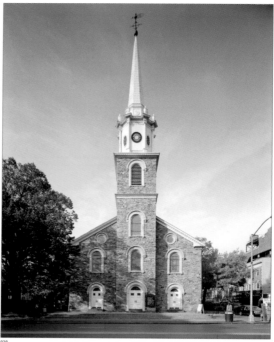

938

FLATBUSH REFORMED DUTCH CHURCH

890 FLATBUSH AVENUE AT CHURCH AVENUE

1798, THOMAS FARDON

This church was established through an edict set forth by Peter Stuyvesant, in his continuing effort to turn the colonists of Nieuw Amsterdam away from what he considered their wicked ways. This building, the third on the site, continues the tradition in what is the oldest continuous church location in the city. Its seventeenth-century churchyard contains the graves of pioneering Brooklynites with names like Lefferts, Corte-lyou, and Lott. The parsonage, built in 1853, is at the edge of a small Historic District that includes a row of charming cottages.

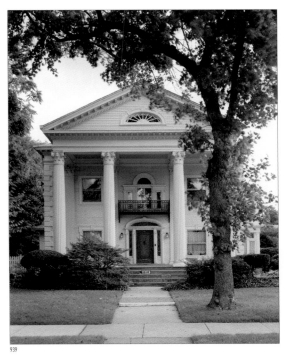

939

LOUISE McDONALD HOUSE

1519 ALBEMARLE ROAD, AT BUCKINGHAM ROAD

1902, JOHN J. PETIT

This elegant Colonial revival mansion brings
an all-American touch to a neighborhood filled
with the best of foreign architectural influences.
When he developed this section of Park Slope,
builder Dean Alvord hired a landscape archi-
tect to design the gardens around the homes,
and formed an architectural staff, headed by
John Petit. They were instructed to let their
imaginations run wild in the creation of fine
homes that would be "acceptable to people of
culture." Home-buyers were free to hire archi-
tects of their own, but few of them did.

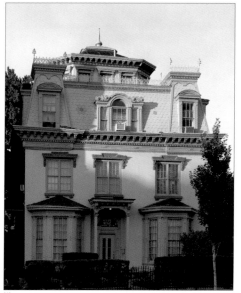

WILLIAM B. CRONYN HOUSE

271 NINTH STREET, BETWEEN FOURTH AND FIFTH AVENUES

1857

Originally the suburban villa of a Wall Street merchant, built at a time when this area was open farmland, it followed the trend toward the neighborhood's industrialization and, in 1895, it was transformed into the headquarters and factory of the Charles M. Higgins India Ink Company. It is now an apartment building.

940

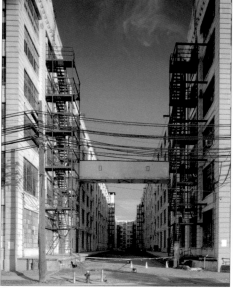

BUSH TERMINAL

28TH TO 50TH STREETS, UPPER BAY

1890–1926, WILLIAM HIGGINSON

This sixteen-building complex was built by Irving Bush as a distribution center. In its prime, it had eighteen piers leased to more than twenty-five different steamship companies. It handled more than 50,000 railroad freight cars a year, and employed some 25,000 workers. Today it is used primarily as a manufacturing center, with tenants making garments and fashion accessories, printed materials, processed foods, electronics, and plastics.

941

942

ERASMUS HALL MUSEUM ℒ

911 FLATBUSH AVENUE
BETWEEN CHURCH AND SNYDER AVENUES

1786

This building, in the courtyard of Erasmus Hall High School, originally housed the Erasmus Academy, a private school for boys. It was the first secondary school chartered in New York State. The high school complex that surrounds it, designed by C. B. J. Snyder in 1903, is a public high school, the most prominent in the Flatbush section, and among the best-known schools in all of Brooklyn.

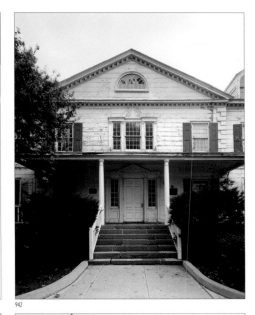

942

943

SUNSET PARK SCHOOL OF MUSIC ℒ

4302 FOURTH AVENUE AT 43RD STREET

1892, GEORGE INGRAHAM

This medieval fortress was built as a police precinct, and its stable and main building have been converted to a music school. The Sunset Park neighborhood was renamed in the 1960s for a local park that had been established in the 1890s. The area this police station served was Gowanus in the northern part, and Bay Ridge to the south.

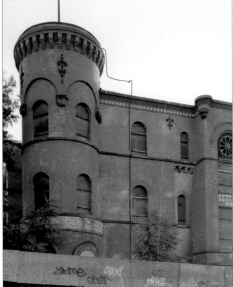

943

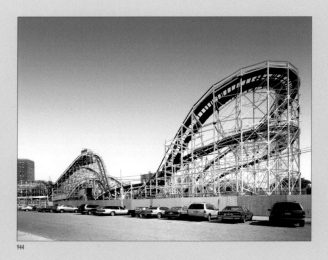

944

THE FUNNY PLACE

About halfway between Coney Island's Wonder Wheel and the new stadium for the minor league Brooklyn Cyclones stands the huge steel tower that was once the Life Savers Parachute Jump, brought to the Brooklyn shore after thrilling visitors at the 1939 World's Fair in Queens. It was part of Coney's Steeplechase Park, which closed in 1965, after outlasting the Great Depression and World II, and even the emergence of television. The park, billed as "The Funny Place," was built by George C. Tillyou in 1897. A testimony to his brand of showmanship were the huge crowds of people who showed up after the park burned down in 1907, and eagerly paid him a dime apiece to have a look at the ruins.

What they also got for their money was a look at the new park he was building on the site. It included a great glass and iron shed called the "Pavilion of Fun," erected upon a fifteen-acre hardwood floor, and containing nearly all of his rides, which made the park just as much fun on rainy days as when the sun was shining. The main attraction under the glass was the "The

Gravity Steeplechase Race Course," which simulated a horse race on eight parallel tracks. Tillyou claimed that a ride on one of the horses, "straightens out wrinkles and irons out puckers." Whatever that meant, the public responded with enthusiasm, and more than a million people per season lined up for the experience.

Other attractions could be enjoyed there, too, many of them free with the 25-cent admission price. Among them were air jets that caused women's skirts to billow, and a stairway that became a sliding board without warning. The "Human Roulette Wheel," a spinning polished disk that sent people flying across the floor, and the "Barrel of Love," which tumbled them into each other, were also great crowd-pleasers, as was the carousel, whose three tiers of platforms each went around at a different speed. The great park was dismantled after the 1964 season by the Trump Corporation (established by Donald's father), for a real estate development that was never realized. The city ultimately bought the resulting rubble.

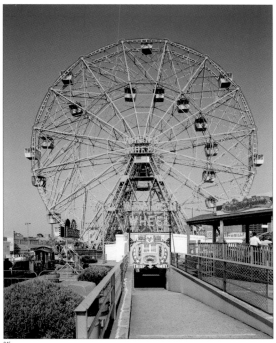

945

CYCLONE ℒ

CONEY ISLAND BOARDWALK AT WEST 10TH STREET

1927, HARRY C. BAKER
INVENTOR, VERNON KEENAN, ENGINEER

Although just about every theme park in the country touts its roller coaster as the best, people in the know say that this is the one to beat, and that nobody has succeeded. A chain drive hauls the three-car train to the highest point on the wooden structure, and then gravity takes over as it plunges through nine gut-wrenching drops and around six sharp curves at a speed of sixty-eight miles an hour.

WONDER WHEEL ℒ

CONEY ISLAND BOARDWALK AT WEST 12TH STREET

1920, CHARLES HERMAN

This isn't your garden-variety Ferris wheel. Only eight of the cars are stationary; the other sixteen swing violently along a serpentine track as they race down from the 150-foot apex of the steel wheel. It was built by a company that called itself the Eccentric Ferris Wheel Amusement Company.

ST. JOHN'S EPISCOPAL CHURCH

9818 FORT HAMILTON PARKWAY AT 99TH STREET

1890

Here you'll find all the charm of a country church—in the shadow of the Verrazano Bridge. St. John's association with nearby Fort Hamilton has given it the nickname of the "Church of the Generals," because at various times its list of parishioners has included such men as NATO Commander Matthew B. Ridgeway. Robert E. Lee served as a vestryman here, and Stonewall Jackson was baptized here at the age of 30.

HOWARD JONES HOUSE 𝓛

8220 NARROWS AVENUE AT 83RD STREET

1917, J. SARSFIELD KENNEDY

This mansion is a rare example of an architectural style known as Arts and Crafts. It was built for a shipping merchant, who was able to watch his ships moving through the Narrows from its big yard here in Bay Ridge. The neighborhood was developed in the years after the Civil War when the bluffs overlooking the Narrows began to fill with mansions serving as retreats for the very wealthy.

ANSONIA COURT

420 12TH STREET
BETWEEN SEVENTH AND EIGHTH AVENUES

1881

This apartment building, with a landscaped central court, was the biggest clock factory in the world for exactly 100 years before its conversion. At the height of its success, the Ansonia Clock Company employed more than 1,500 workers at this site.

JAMES F. FARRELL HOUSE

119 95TH STREET
BETWEEN MARINE AVENUE AND SHORE ROAD

1849

The Bay Ridge Section was once filled with imposing mansions, but over the years most of them have been replaced with comparatively simple one-family houses and uninspired red-brick apartment developments. There are some reminders of the neighborhood's better days, though, and this is one of them. Though not quite a mansion, its columned veranda and pristine condition would make it a traffic-stopper in any neighborhood.

WYCKOFF-BENNETT HOUSE 𝓛

1669 EAST 22ND STREET AT KINGS HIGHWAY

1652

This is one of the oldest houses in New York State, and the first to be designated a New York City landmark after the creation of the Landmarks Commission in 1965. It was originally a farmhouse, built by Pieter Claesen Wyckoff, and was used to house British soldiers during the Revolutionary War. It remained in the Wyckoff family until 1901. They later repurchased it and donated it to the city in 1970, for use as a museum.

VAN BRUNT'S STORES

480 VAN BRUNT STREET, ON ERIE BASIN

1869

After the Erie Canal connected New York to the heartland, a huge man-made harbor was built here in Red Hook to accommodate the hundreds of barges that arrived every day. Buildings like this were added to store and reship the produce floated down from Buffalo. After the canal shut down in the 1990s, this one became a self-storage facility. Parts of it now serve as gallery space for the artists who have recently discovered the neighborhood.

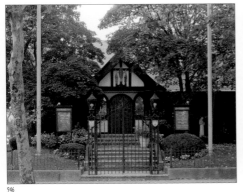

946

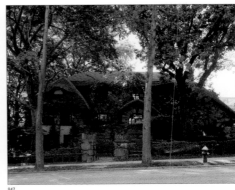

947

948

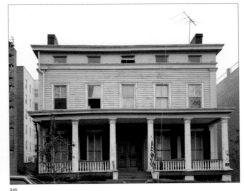

949

950

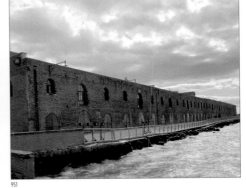

951

952

952

F.W.I.L. Lundy Brothers Restaurant ℒ

1901–1929 Emmons Avenue at East 19th Street

1934, Bloch & Hesse

Now reopened after having been closed for nearly twenty years, this Sheepshead Bay landmark hasn't lost a bit of its original boisterousness and would-be patrons still hover over diners hoping to claim their seats. One ot the best seafood restaurants anywhere in the city, Lundy's served more than 15,000 people a day at the height of its popularity during the 1950s. It was founded in 1920 by Frederick William Irving Lundy and his brothers, taking advantage of the abundance of fish and clams from Sheepshead Bay across the street. Before it closed in 1979 because of its owner's failing health, it employed 220 waiters who never seemed to stop running. Until it finally reopened, millions of Brooklynites and Long Islanders were in deep mourning for their favorite Sunday pastime.

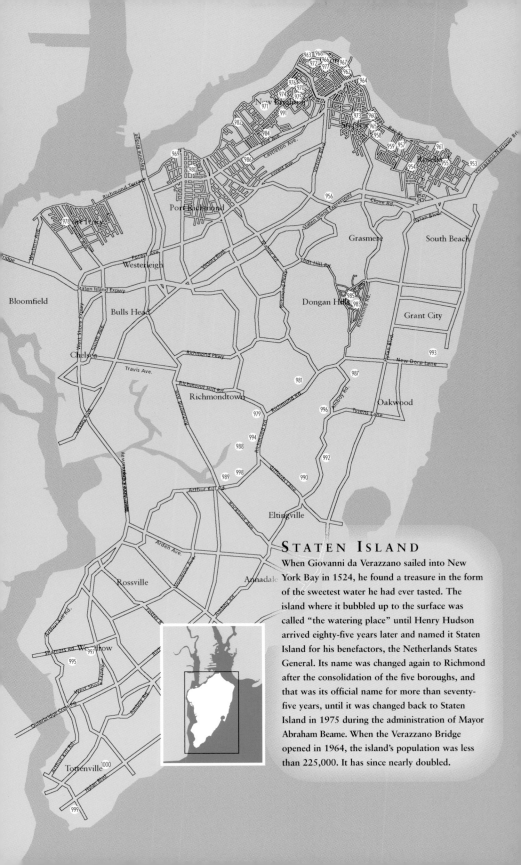

STATEN ISLAND

When Giovanni da Verazzano sailed into New York Bay in 1524, he found a treasure in the form of the sweetest water he had ever tasted. The island where it bubbled up to the surface was called "the watering place" until Henry Hudson arrived eighty-five years later and named it Staten Island for his benefactors, the Netherlands States General. Its name was changed again to Richmond after the consolidation of the five boroughs, and that was its official name for more than seventy-five years, until it was changed back to Staten Island in 1975 during the administration of Mayor Abraham Beame. When the Verazzano Bridge opened in 1964, the island's population was less than 225,000. It has since nearly doubled.

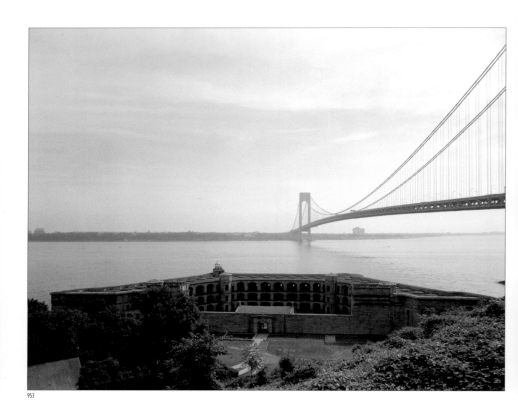

953

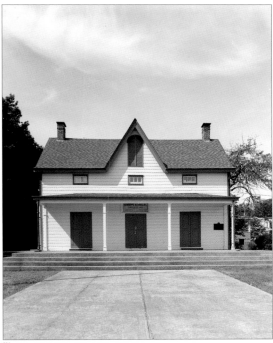

954

Fort Wadsworth Military Reservation ℒ

END OF BAY STREET

1861, JOSEPH G. TOTTEN

Also known as Battery Weed, in honor of General Stephen Weed, who died during the Civil War Battle of Gettysburg, this is the oldest military post in the country in continuous operation. The complex consists of a trapezoidal granite fortress, and a smaller installation above it, whose gun emplacements are carved out of the hillside. Parts of the facility have been incorporated into the Gateway National Recreation Area, whose visitors' center describes all of the city's numerous military installations.

Garibaldi-Meucci Memorial Museum ℒ

420 TOMPKINS AVENUE AT CHESTNUT AVENUE

C. 1845

The Italian patriot Guiseppe Garibaldi came here to the home of his friend, inventor Antonio Meucci, after fighting unsuccessfully for Italy's independence in 1849. Meucci, who is buried here, claimed to have invented the telephone in 1841, thirty-five years before Alexander Graham Bell took credit for the same thing. Meuccci's wife had thrown away all the evidence, and he could never prove his accomplishment in court.

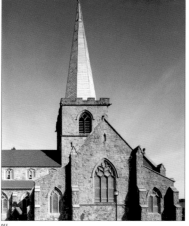

955

ST. JOHN'S EPISCOPAL CHURCH

1331 BAY STREET AT NEW LANE

1871, ARTHUR D. GILMAN

The steeple of this grand Gothic church is what mariners call a "day mark," a structure on land that functions as a positioning point, much as lighthouses do. The plan of the church follows the design of medieval English country churches.

955

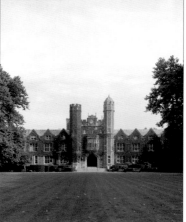

956

WAGNER COLLEGE

HOWARD AVENUE
BETWEEN CAMPUS AND STRATFORD ROADS

This liberal arts college was founded in Rochester, NY, as the Lutheran Pro-Seminary. In 1918, it moved here to the eighty-six-acre former Cunard estate, formerly owned by a branch of the steamship family, and was renamed in honor of George Wagner, an important donor. The school kept its Lutheran affiliation until the early 1990s. The site is at the top of Grymes Hill, 370 feet above sea level. It is to the north of a valley, called the Clove, which became the right-of-way of the Staten Island Expressway.

956

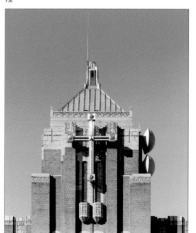

957

BAYLEY-SETON HOSPITAL
(ROMAN CATHOLIC)

732–738 BAY STREET AT VANDERBILT AVENUE

1837, ABRAHAM P. MAYBIE

This complex of buildings was originally the Seaman's Retreat, established for the care of merchant seamen. It later became the U.S. Marine Hospital and then, until 1981, a hospital run by the U.S. Public Health Service, whose medical research led to the establishment of the National Institute of Health. As a private hospital, it is named for Dr. Richard Bayley and his daughter, who became St. Elizabeth Ann Seton.

957

53 HARRISON STREET

958

BETWEEN QUINN AND BROWNELL STREETS

1895, CHARLES SCHMEISER

This huge mansion, dominating the entire block, was built as the home of a very important person: the brewmaster of Rubsam & Hohrmann's Atlantic Brewery. The last survivor of a dozen extremely successful Staten Island breweries, it was sold to Piel Brothers in 1954 and, when Piel's itself was sold in 1963, the old brewery closed its doors and a tradition died.

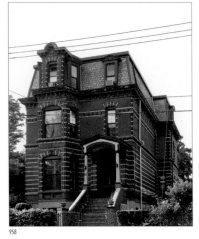

958

110–144 VANDERBILT AVENUE

959

BETWEEN TALBOT PLACE AND TOMPKINS AVENUE

1900, CARRÈRE & HASTINGS

This is one of a row of eight Tudor houses commissioned by George W. Vanderbilt as a speculative venture. The youngest son of William H. Vanderbilt and grandson of Cornelius Vanderbilt, George was born at the family home in New Dorp, and showed no interest in the family's Manhattan social life. He eventually moved to Asheville, N.C., where he built the famous "Biltmore Estate," designed by Richard Morris Hunt.

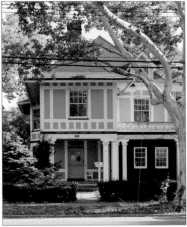

959

PARAMOUNT THEATER

960

560 BAY STREET
BETWEEN PROSPECT STREET AND UNION PLACE

1935, RAPP & RAPP

No, this isn't Times Square, it's Stapleton, but the Paramount Theater here was designed by the same architects. Like their other masterpieces, this Art Deco building is no longer a movie palace. For several years, the Staten Island Paramount was turned into a nightclub that retained all of its original 1930s glories. But that is history, too, and now the building stands empty, waiting for someone with a vivid imagination to walk past.

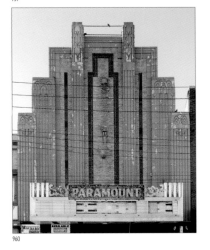

960

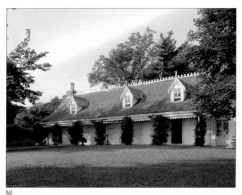

961

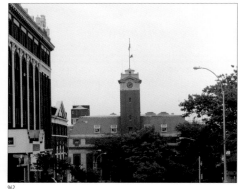

962

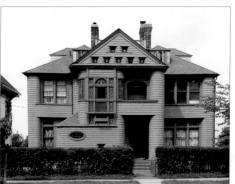

963

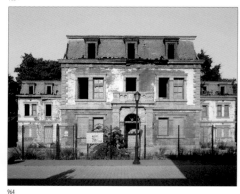

964

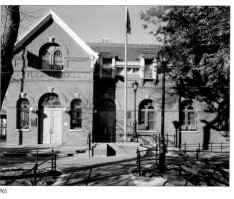

965

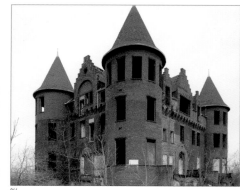

966

ALICE AUSTEN HOUSE &

2 HYLAN BOULEVARD
BETWEEN BAY AND EDGEWATER STREETS

1750

This picturesque farmhouse overlooking New York Bay was built by a Dutch merchant, and sold in 1844 to a wealthy New Yorker named John Austin, who remodeled it and named it "Clear Comfort." His granddaughter, Alice, came to live here when she was two years old. Her life as a pioneer photographer is commemorated here in a small museum that houses more than 7,000 of her images of New York, captured between 1880 and 1930.

STATEN ISLAND BOROUGH HALL

12-24 RICHMOND TERRACE, ST. GEORGE

1906, CARRÈRE & HASTINGS

Every day, thousands of people take the Staten Island ferry just for the ride, and never get off at St. George. Among the things they miss is the view of Manhattan from dry land and the hills rising up from the water that provide a strange feeling that you aren't in New York at all, but in San Francisco. They also miss a close-up look at Staten Island's Borough Hall, directly across from the ferry terminal. Is this Paris, or just an "outer borough"?

FREDERICK I. RODEWALD HOUSE

103 ST. MARK'S PLACE
BETWEEN NICHOLAS STREET AND WESTERVELT AVENUE

1890, EDWARD A. SARGENT

This monumental Shingle-style house has porches on three levels at the rear. They not only capture the breezes off the bay but provide a great view of the harbor and the Manhattan skyline.

ADMINISTRATION BUILDING U.S. COAST GUARD &

ONE BAY STREET AT THE ST. GEORGE TERMINAL

1865, ALFRED B. MULLETT

This small but imposing French Second Empire building was originally part of the Staten Island Lighthouse Service depot, where materials were stored for use in lighthouses up and down the East Coast. It was also used as a testing center for refining lighthouse operations. This building, which was used for storage of its records, has been abandoned for decades, but it has a bright future as a lighthouse museum.

EDGEWATER VILLAGE HALL &

111 CANAL STREET IN TAPPEN PARK

1889, PAUL KUHNE

This brick Victorian building sits among the trees of Stapleton's Tappen Park. The village it served, Edgewater, was incorporated into Stapleton. The park is part of the farm where young Cornelius Vanderbilt grew up and where, as a teenager, he cleared and plowed an eight-acre field to secure a $100 loan from his mother to buy the flat-bottom boat that became the first Staten Island Ferry.

S.R. SMITH INFIRMARY

CASTLETON AVENUE AT CEBRA AVENUE

1889, ALFRED E. BARLOW

What are your plans for Halloween? You'd have to search far and wide to find a better place to spend it than at this spooky relic. For a time, it was the home of Staten Island Hospital, which added a larger building next door before moving on to South Beach and becoming Staten Island University Hospital. That was well over thirty years ago, and the old infirmary has been deteriorating ever since. Several new uses have been proposed, but none has materialized.

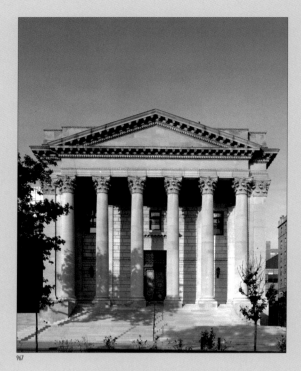

967

THE STATEN ISLAND CASINO

Growth among Staten Island's towns slowed to a crawl after the Civil War. It was plagued by mosquitoes, and the ferries had been neglected to the point that every once in awhile one of them exploded. The mosquito problem was eliminated by draining swamps, but it took some imagination to tackle the transportation problem, and Erastus Weiman had imagination to spare.

He started by building the Staten Island Transit Line and then connected it to a modern, reliable ferry line from Manhattan to a terminal he built at St. George. There had been no town there before then, so Weiman built one. Then he went hunting for customers. He built a three-story casino and restaurant across from the ferry slip. One side overlooked the harbor and another a park with grand, illuminated fountains. He staged band concerts and baseball games in the park, but the fountains were

the main event. New Yorkers had seen water before, but never illuminated by colored electric lights, and they came by the thousands to marvel at it. Then, in the summer of 1886—without warning—the novelty wore off.

He was stuck with an empty casino and, worse, empty ferryboats, but Erastus Weiman wasn't a quitter. He sold his electrical generator to the Edison Company, and replaced the fountains with an outdoor theater featuring dazzling displays of feminine pulchritude. To attract the family trade, he also built an entertainment park along his railroad's right-of-way that could accommodate 12,000 fun-seekers. During its first season, Buffalo Bill's Wild West show filled the park every afternoon. Most of the patrons rode Weiman's ferry from Manhattan, and all of them used his railroad to get out into the country.

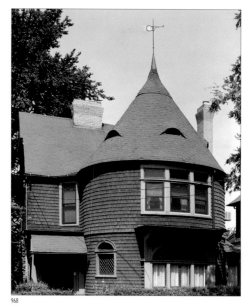

968

RICHMOND COUNTY COURTHOUSE 🏛

12–24 RICHMOND TERRACE AT SCHUYLER PLACE

1913, CARRÈRE & HASTINGS

Along with its neighbor, Borough Hall, this Classical building, which compares favorably to the same architect's New York Public Library on Fifth Avenue in Manhattan, was part of a grand plan for a Staten Island Civic Center. The plan never went any further than the two buildings. The courthouse stands overlooking the harbor, a short walk from the St. George ferry terminal. Its newest neighbor is the waterfront stadium of the Staten Island Yankees, a minor league team with a major league view from its stands.

HENRY H. CAMMANN HOUSE

125 NICHOLAS STREET AND WESTERVELT AVENUE

1895, EDWARD A. SARGENT

This modest Shingle-style house is part of New Brighton, developed by Thomas F. Davis, an immigrant from England, who envisioned a resort in the style of the English seaside. The architect, Edward Sargent, was a local man who designed the best houses in the district.

ST. JAMES HOTEL

11–15 PORT RICHMOND AVENUE AT RICHMOND TERRACE

1844, RESTORED, 1990

Not many people these days think of Staten Island as a vacation destination, but in the 1880s, wealthy families from the Deep South came here every summer for the sea breezes and easy access to the delights of Manhattan. This hotel was one of the first to hang out a "no vacancy" sign each season. Among its guests was former Vice President Aaron Burr, who spent the last weeks of his life here when it was known as Winant's Inn. Before its conversion to a nursing home, it had become the Port Richmond Hotel.

PRITCHARD HOUSE

66 HARVARD AVENUE AT PARK PLACE

1853

This Italianate stucco house was one of the original mansions in Hamilton Park, one of the earliest limited-access suburban developments in the United States. Today, they are called "gated communities."

SNUG HARBOR CULTURAL CENTER

914–1000 RICHMOND TERRACE

1831–80

This former retirement home called Sailors' Snug Harbor is now a complex for cultural activities. Its five Greek Temples and other structures on sixty acres of landscaped grounds all have individual landmark status, most both inside and out. The institution was founded upon a bequest from Robert Richard Randall, to care for "aged, decrepit, and worn-out sailors." The institution, which had 150 residents at the time, moved to North Carolina in 1975, and this property was sold to the city.

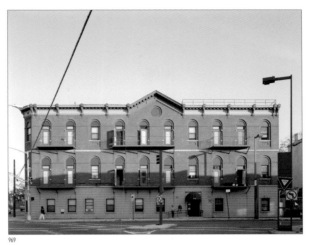

969

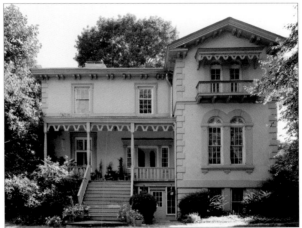

970

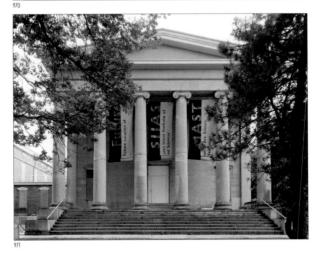

971

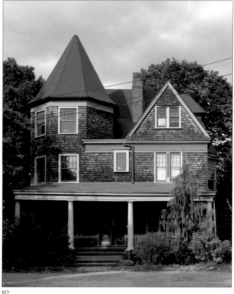

972

11 PHELPS PLACE

AT HAMILTON AVENUE

1880

This short but sweet little street with its three Shingle-style cottages was named for the family of Anson Phelps Stokes, whose impressive mansion at the opposite end has been replaced by the St. George Garden Apartments, now welfare housing. Stokes was the brother of I. N. Phelps Stokes, who was a crusader for better housing for the poor, as was their father, Anson Phelps Stokes, Sr. Phelps, incidentally, was also their mother's maiden name, which may help explain why this is not called "Stokes Place."

364 VAN DUZER STREET

BETWEEN WRIGHT AND BEACH STREETS

1835, ROBERT HAZARD

This house, constructed in the style of a Dutch farmhouse with a Greek Revival portico, is believed to have been the home of Richard G. Smith. His wife, Susannah, was the daughter of Governor Daniel Tompkins, who went on to become the U.S. Vice President under the administration of James Monroe. Tompkins developed the Staten Island community of Tompkinsville and built the Richmond Turnpike, now Victory Boulevard, to connect ferry lines at both ends of Staten Island and shorten the stagecoach ride between New York and Philadelphia.

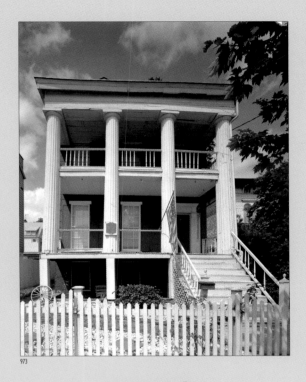

973

HAVE ANOTHER BEER

During the 1876 Centennial Exposition at Philadelphia, gold medals were awarded to what was judged to be America's eleven best beers. Three of them went to Staten Island breweries. The art of beer-making arrived with German immigrants who found their way to Staten Island after escaping political troubles back home in 1848. Many of them settled in the brand-new village of Stapleton, where they found cool caves in the hills nearby that were perfect for fermenting beer. They also found some of the best spring water anywhere on the East Coast, and by the 1870s, there were a half dozen breweries in the neighborhood, turning out what was generally considered to be the best suds in the New York area. When Prohibition made the breweries illegal, they switched to making soft drinks, but the one-two punch of the Great Depression forced most of them out of business.

New Brighton Village Hall 𝓛

66 LAFAYETTE AVENUE AT FILLMORE STREET

1871, JAMES WHITFORD, SR.

Vacant since the 1960s and cut off behind a chain-link fence, this mansard-roofed structure is another of New York's endangered landmark buildings. There have been several attempts to recycle it, but finding the right use seems to have proved elusive. It was built a few years after the Village of New Brighton was carved out of a corner of Castleton in northeastern Staten Island. The town had several names in its early days, including Goosepatch, but none of them stuck.

W. S. Pendleton House 𝓛

22 PENDLETON PLACE
BETWEEN FRANKLIN AND PROSPECT AVENEUES

1855, CHARLES DUGGIN

William Pendleton built several houses in this part of New Brighton and included this one for himself. He had a special interest in the development of Staten Island, as he was the owner of one of the ferry companies.

Ambassador Apartments

30 DANIEL LOW TERRACE
BETWEEN CRESCENT AVENUE AND FORT HILL CIRCLE

1932, LUCIAN PISCIATTA

The doorway on this Art Deco gem is worth a trip to Staten Island all by itself. This neighborhood was originally the estate of businessman Daniel Low. Nearby Fort Hill was the site of earthwork fortifications built by the British during the Revolutionary War.

Hamilton Park Cottage

105 FRANKLIN AVENUE
BETWEEN EAST BUCHANAN STREET AND CASSIDY PLACE

1864, CARL PFEIFFER

Not everybody's idea of a "cottage," this house was built at the time when Hamilton Park became an idea whose time had finally come, a decade after its first three houses were built. What made the difference this time around was the architect, German-born Carl Pfeiffer, who designed a dozen houses in a less ornate style than the original row along Harvard Avenue. This was his first commission in America.

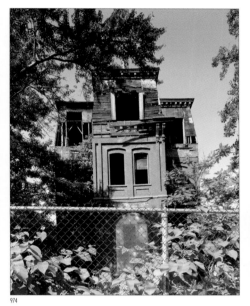

974

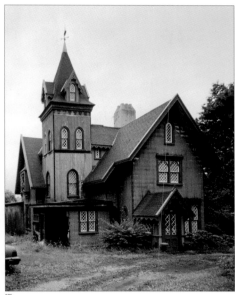

975

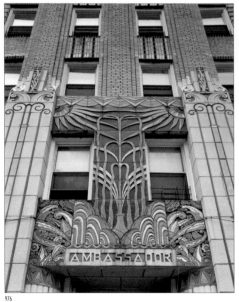

976

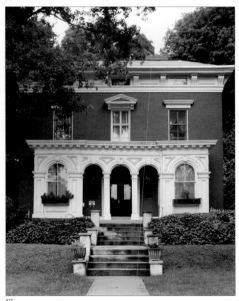

977

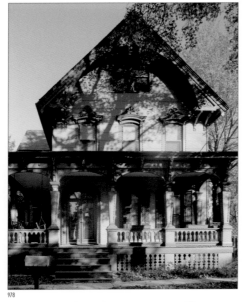

978

109 SOUTH AVENUE

BETWEEN RICHMOND TERRACE AND ARLINGTON TERRACE

1885

This is part of a glorious row of Victorian houses that line both sides of the avenue. All of them were built at about the same time, as part of a large housing development that covered much of Mariner's Harbor. The area is bounded on the north by the Kill Van Kull, which had originally made it a center for commercial fishing and ship-building. It was especially famous for the quality of its oyster harvest, but the industry vanished at the beginning of the twentieth century because of polluted waters. During World War II, the Bethlehem Steel Shipyard dominated Mariner's Harbor, which returned to its quieter ways after the war was over.

978

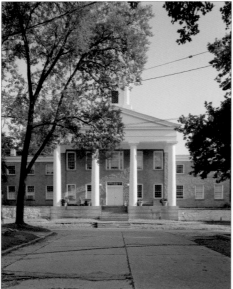

979

THIRD COUNTY COURTHOUSE

RICHMONDTOWN RESTORATION
411 CLARKE AVENUE, NEAR ARTHUR KILL ROAD

1837

This building, which served its original purpose as a court of law through 1919, is now the Visitors' Center of the Richmondtown Restoration, a project of the Staten Island Historical Society, begun in 1936. The ninety-six-acre site contains more than thirty structures that are examples of village life from the seventeenth to the nineteenth centuries. The original village of Richmondtown dates back to 1685.

979

NORTHFIELD TOWNSHIP SCHOOL ℒ

160 HEBERTON AVENUE AT NEW STREET

1891

This Romanesque Revival building was converted into low-income senior citizen housing in 1994. It was originally built in two sections, seven years apart, and each has its own distinctive, lavishly ornamented tower. Northfield was one of the four administrative districts that were established on Staten Island after the Revolutionary War. The township system was abandoned after consolidation of the five boroughs, but not before this building, one of the most elaborate school buildings on the island, was built.

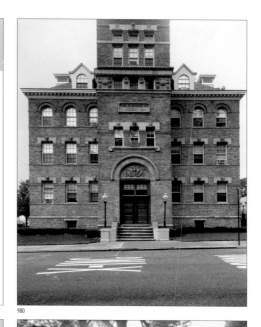

980

JACQUES MARCHAIS CENTER OF TIBETAN ART

338 LIGHT HOUSE ROAD, NEAR WINDSOR AVENUE

1947, JACQUES MARCCHAIS

These two stone buildings, with a terraced garden, were designed to resemble a Tibetan monastery. They house the largest collection of Tibetan art outside of Tibet itself. It was assembled by a dealer in Oriental art, Mrs. Harry Klauber, whose professional name is Jacques Marchais. The collection began with twelve bronze figures brought back from the East by her grandfather, a merchant sea captain.

981

982

983

984

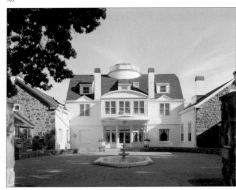

985

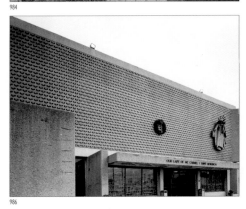

986

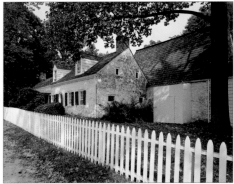

987

982
CORNELIUS CRUSER HOUSE *L*

1262 RICHMOND TERRACE AT PELTON PLACE

1722

Also known as Kreuzer-Pelton House, this structure was built in stages by successive owners, and it is easy to see where each addition was made. The original house was the one-room Dutch Colonial home of Cornelius Van Santvoord, minister of the local Dutch Reformed Church. The central wing, with its high roof, was added in 1770 by its next owner, Cornelius Cruser. The brick Federal-style addition was done in 1836 by Daniel Pelton, only the third owner over more than a century.

983
BOWCOTT *L*

9594 WEST ENTRY ROAD AT FLAGG PLACE

1918, ERNEST FLAGG

This is the first of several cottages, each having its own personality, but all made of local stone. Flagg built these cottages adjacent to his own estate in an experiment to construct low-cost middle-class suburban housing. Three of them are landmarks.

984
HENDERSON ESTATE COMPANY HOUSES

33 AND 34 ST. AUSTIN'S PLACE

1893, MCKIM, MEAD & WHITE

This imposing pair of Shingle-style mansions face one another across the street. Although the architecture firm of McKim, Mead & White is known for its work in the Beaux Arts style, it first became known for summer homes in the Shingle style, which it made popular from upstate New York to Boston and Newport. Charles F. McKim also created the style we call Colonial Revival, and these houses pay homage to it as well as the firm's famous summer houses.

985
ERNEST FLAGG ESTATE *L*

COVENTRY ROAD

1898–1917, ERNEST FLAGG

Originally called "Stone Court," this is now St. Charles Roman Catholic Seminary. The famous architect built his house and its companion buildings on Todt Hill, the second-highest point on the Eastern Seaboard after the Fresh Kills Landfill on the other side of Staten Island. A large portion of Flagg's former estate is now filled with new houses that were designed in the 1980s by Robert A. M. Stern.

986
OUR LADY OF MT. CARMEL CHURCH-
ST. BENEDICTA CHURCH (ROMAN CATHOLIC)

1265 CASTLETON AVENUE AT BODINE STREET

1969, GENOVESE & MADDALENE

This is as good as the architecture of the 1960s gets. The main event at this boxy-looking church is inside. Light streams in through colorful stained-glass windows, and the main altar is dramatically lit by a skylight above it. It's a long way from traditional Gothic churches, but the feeling of peace and serenity more than makes up for what might otherwise be a jarring break with tradition. The exterior is a welcome break from an otherwise drab neigborhood filled with strip malls.

987
BILLIOU-STILLWELL-PERINE HOUSE *L*

1476 RICHMOND ROAD
BETWEEN DELAWARE AND CROMWELL AVENUES

1660s

This is the oldest house on Staten Island. Its original section was built by Pierre Billiou in what was then known as the village of Olde Dorp. Thomas Stillwell, Billiou's son-in-law, expanded the building with the first of many additions. The Perine family, who also made additions, acquired the house in 1764 and its members lived here for 150 years. It is now a colonial museum.

988
STATEN ISLAND LIGHTHOUSE ℒ

EDINBORO ROAD
BETWEEN WINDSOR AND RIGBY AVENUES

1912

Surrounded by homes, this structure doesn't fit the mold of seaside lighthouses, but, unlike many of them, it is still operational. Its 350,000 candle-power beacon shines out from this perch, 231 feet above the sea, serving as a coordinate for the Ambrose Light Station at the entrance to New York Harbor. Like all the other lighthouses maintained by the Coast Guard, this one is automated, and there is no lighthouse keeper living at its base.

989
ST. ANDREW'S CHURCH ℒ
(EPISCOPAL)

4 ARTHUR KILL ROAD AT OLD MILL ROAD

1872

This country church is designed in the style of English parish churches of the twelfth century. Its setting, here at the edge of the marshes of LaTourette Park, serves to enhance the connection. The park has a popular city-owned golf course (one of thirteen municipal courses) that is considered one of the most challenging in the New York area. It boasts a par of 72.

990
SON-RISE CHARISMATIC INTERFAITH CHURCH ℒ

1970 RICHMOND AVENUE
BETWEEN RIVINGTON AVENUE AND AMSTERDAM PLACE

1849, REMODELED, 1878

This was originally the Asbury Methodist Church, named for Francis Asbury, who was sent to America by the church's founder, John Wesley, and who became the first bishop of the American Methodist Church. He preached here on Staten Island for more than forty-five years.

991
CONVENT OF ST. VINCENT'S MEDICAL CENTER

710 CASTLETONE AVENUE AT HOYT AVENUE

C. 1850

This imposing Victorian mansion was built for T. F. McCurdy, a prominent wholesale merchant. It later became the home of Henry M. Taber, a cotton merchant, and then of William T. Garner, a cotton mill owner. According to local legend, when Ulysses S. Grant retired from the Presidency and moved to New York, he came out to Staten Island to have a look at this house, but his wife dissuaded him from moving in because of the swarms of mosquitoes she encountered here.

992
GATEHOUSE

OCEAN VIEW MEMORIAL PARK
AMBOY ROAD AT HOPKINS AVENUE

1925

This towered Gothic stone structure stands guard at the entrance to the cemetery once known as the Valhalla Burial Park, at the northern edge of Great Kills. It is part of a small greensward of cemeteries that includes the Frederick Douglass Memorial Park and the United Hebrew Cemetery. There are genuine ocean views in this part of east-central Staten Island.

993
WORLD WAR II BUNKER

ON THE BEACH AT GATEWAY NATIONAL RECREATION AREA
NORTHEAST FOOT OF NEW DORP LANE

C. 1942

This reinforced concrete tower is one of the last remaining of hundreds like it that were built up and down the East Coast as defenses during World War II. Although no shots were ever fired from the ocean-facing slits near the top, they were very much needed. There was a constant threat of attack by German submarines and, indeed, several were spotted from these towers.

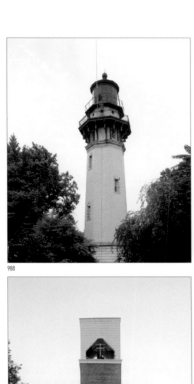

988

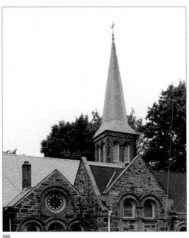

989

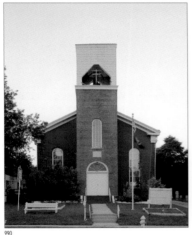

990

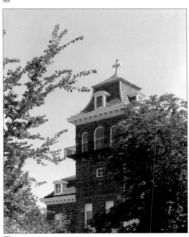

991

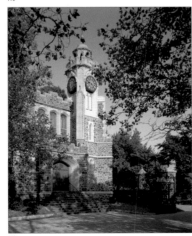

992

993

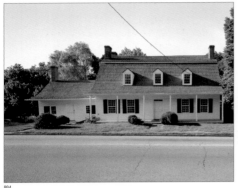

994

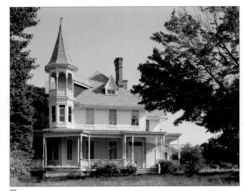

995

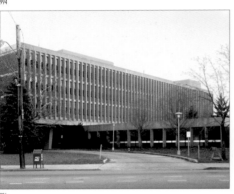

996

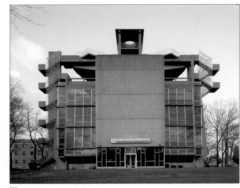

997

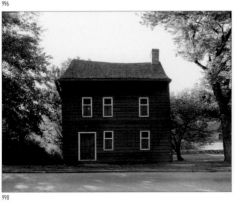

998

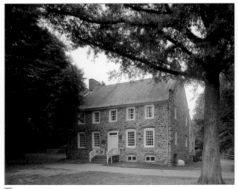

999

GUYON-LAKE-TYSON HOUSE ℒ

RICHMONDTOWN RESTORATION

C. 1740

Many of the buildings in Richmondtown were moved here from other parts of Staten Island. This Dutch-Colonial gem was originally built at New Dorp by Joseph Guyon, a Huguenot settler in what was then a British colony. It was slated for demolition before being relocated here in 1962.

CHARLES C. KREISCHER HOUSE

4500 ARTHUR KILL ROAD, AT KREISHER STREET

1888, ATTRIBUTED TO PALLISER & PALLISER

This section of Charlestown was once called Kreischerville for the huge brickworks built here for B. Kreischer & Sons. When the sons built their own houses, they chose the wooden stick style instead of brick (their father obviously never told them the story of the Three Little Pigs). Originally a matching pair, one of them has vanished, which might not have been the case if the Kreischer brothers had used the family product.

MONSIGNOR FARRELL HIGH SCHOOL
(ROMAN CATHOLIC)

2900 AMBOY ROAD AT TYSEN'S LANE

1962, CHARLES LUCKMAN ASSOCIATES

Here is an example of what passed for architectural style in the 1960s, by the folks who gave us the Madison Square Garden Center six years later. This school was constructed at a time when Catholic school attendance was heading for an all-time high in the United States, which it reached in 1965. By then, there were 183 schools in the New York Archdiocese, a tradition that began in 1800 when St. Peter's church in Lower Manhattan opened what was to be the only Catholic school in New York for more than fifteen years.

SOCIETY OF ST. PAUL SEMINARY
(ROMAN CATHOLIC)

2187 VICTORY BLVD. AT INGRAM AVENUE

1969, SILVERMAN & CIKA

Smile when you pass by. This may be one of the strangest buildings anywhere within the city limits, and it is big enough to dominate the view for miles around. It houses the Catholic publisher, the Society of St. Paul. The Society also maintains a Montessori school on the grounds, but architecture probably isn't part of its curriculum. This area, known as Westerleigh, was founded by Prohibitionists in the 1880s. If you drank—or even thought about taking a nip for medicinal purposes—you were not welcome here.

VOORLEZER'S HOUSE ℒ

RICHMONDTOWN RESTORATION

C. 1695

This little frame structure was built by the Dutch Reformed Church for its "voorleezer," a lay reader, who conducted church services here. He also taught school here, making this the oldest school building still standing anywhere in America.

THE CONFERENCE HOUSE

HYLAN BOULEVARD

C. 1675

The builder of this house was British naval officer Christopher Billop. After defeating the Americans in the 1776 Battle of Long Island, Admiral Lord Howe invited a delegation that included Benjamin Franklin and John Adams to meet him here for a peace conference. When they informed him that they had no intention of giving up their quest for independence, his lordhsip responded, "I am sorry, gentlemen, that you have had the trouble of coming so far for so little purpose."

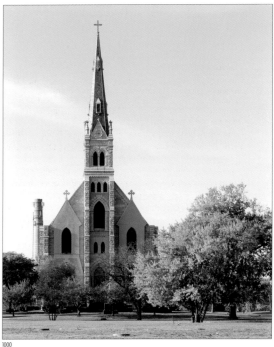

1000

Church of St. Joachim and St. Anne

Hylan Blvd.,
between Sharrott and Richard Avenues

1891, rebuilt, 1974

This grand Gothic Revival church on the grounds
of the Mount Loretto Home for Children was
nearly destroyed by a disastrous fire in 1973. It
was rebuilt as a simple A-frame structure with
the original façade restored in front of it, creat-
ing an unusual mix of styles that works very
well. A year before the fire the church was
immortalized when it was used as the location
for the opening wedding sequence in Francis
Ford Coppola's 1972 film, *The Godfather*.

GLOSSARY

Arcade	A series of arches, or a building built around a series of arches. Also a roofed passageway, usually lined with shops.
Arch	A curved construction that spans a recess or an opening.
Architectural Orders	Consisting of a column divided into three parts: a base, shaft, and capital beneath an entablature. There are five different Orders, ranging from the simple Tuscan to the elaborate Corinthian. The other three are Doric, Ionic, and Composite, the latter containing elements of the the others. Classical buildings themselves usually follow the Order in their façades.
Architrave	The bottom section of an entablature, resting on a column or pilaster.
Art Deco	A style of decoration made popular in Paris in the 1920s. In America, it borrowed heavily from Native American art.
Ashlar	Stone that has been dressed for building by hewing or squaring.
Balustrade	A series of balusters, upright supports in turned shapes, usually wider at the base.
Barrel Vault	A semicylindrical ceiling constructed as an extended arch.
Bay Window	An alcove in a room, with windows projecting outward with no foundation.
Beaux Arts	A Classical style preferred by American architects who studied at France's Ecole des Beaux-Arts.
Belt Course	Also called a string course, a horizontal band of masonry extending across the façade of a building.
Bracket	A support for a projection, such as a cornice, usually scroll-shaped.
Brownstone	A generic term for any New York town house, most of which were once faced with brownstone, a soft, easy-to-cut sandstone common in the New York area.
Bungalow	A one-story house with a low-pitched roof.
Buttress	A projecting structure intended to support a wall.
Cantilever	A projection supported at only one end.
Capital	The decorated top of a column or pilaster.
Cartouche	An ornamental panel that usually bears an inscription.
Castellated	Built to resemble a castle with turrets and battlements.
Cast Iron	Iron, usually hard and brittle, that has been shaped in a mold.
Chicago School	The art of the skyscraper as developed by Chicago architects of the late nineteenth century.
Classical	An architectural style reflecting the styles of ancient Greece and Rome.
Coffer	A sunken panel in a ceiling or dome or on the underside of an arch.
Column	A round vertical support.
Condominium	A multiple-unit building where the tenants each own their own spaces, much as they might own a house, but contribute "common charges" for upkeep of the areas they share (e.g., the lobby).
Co-Op	An apartment building where all of the tenants are shareholders in the building "corporation," but retain dominion over their own living spaces for buying and selling purposes by virtue of a proprietary lease.
Cornice	The projecting part of an entablature.
Course	A horizontal layer of masonry.
Crocket	In Gothic architecture and in Victorian houses, projections carved in the shape of stylized leaves to decorate the edges of gables and pinnacles.
Cupola	A light structure rising above a roof or a dome.
Curtain Wall	An exterior wall with no structural function.
Dome	A convex roof or ceiling.
Dormer	A projection built from a sloping roof.
Entablature	The horizontal upper part of an order, generally supported by columns.
Façade	The front elevation of any building, most often a decorated one.
Fanlight	A fan-shaped, semicircular window with radiating sections, set over doors and windows.
Federal	A style originated by the Scottish architects the Adam Brothers; the style of choice in New York from the late 1700s until the 1830s.
Flemish Bond	Brickwork with alternating rows of the sides and ends of the bricks.
Frieze	The middle horizontal section of an entablature between the architrave and the cornice.
Gable	The front or side of a building enclosed to mask the end of a pitched roof.

Gambrel	A ridged roof with two slopes on each side.
Georgian	Inspired by the Venetian architect Andrea Palladio and the work of English architect Sir Christopher Wren, a dominant American style for most of the eighteenth century.
Gothic Revival	A style distinguished by highly adaptable pointed arches, developed in England but refined in America in the post-Civil War years.
Greek Revival	An architectural style based on that of ancient Greece, often used for banks and other official edifices built since the 1830s.
Half-Timbered	Construction of a wall with the timber frame exposed and the spaces between filled with brick or stone.
International Style	A style based on the use of modern materials, its defining feature is the heavy use of windows and rejection of exterior decoration.
Italianate	A style based on the architecture of Italy. It could be as decorative as Gothic, and restrained as Classical, and it became the dominant style all over America in the second half of the nineteenth century.
Keystone	The wedge-shaped top stone of an arch.
Leaded Glass	Pieces of glass, either clear or stained, held in place by thin strips of lead.
Marquee	A rooflike shelter extending out above a doorway.
Mansard Roof	A hip roof with a steep lower part and shallower upper part.
Moldings	Rectangular or curved strips either above or below the surface, intended to enhance light and shade.
Mullion	Thin strips that separate window panes in a series.
Newell Post	An upright supporting the handrail at the top or bottom of a stairway.
Niche	A recess in a wall, usually intended to hold statuary.
Palladian Window	A window divided into three parts, with a large central portion flanked by rectangular sidelights.
Party Wall	A common wall shared by two adjoining buildings.
Pavilion	A projecting part of a building, or a structure in a garden or a park.
Pediment	A gable, usually triangular but sometimes half-round, framed by a cornice. The surface within it is called a tympanium. Pediments are placed over doorways and windows and are often decorated, sometimes with the name of a building or its address.
Pier	A heavy rectangular masonry support, usually left plain, unlike columns.
Pilaster	A vertical, rectangular, projection from a wall decorated like a column.
Polychrome	The use of color in decorating a building or statuary.
Project	An urban term for a large complex of buildings, often with shared outdoor space or services, erected as public housing.
Queen Anne	An elaborate style of homebuilding, with roots in English manor houses. A variety of materials contribute to the effect, with lower floors often in brick and the upper faced with stucco or shingles.
Reredos	A screen behind the altar of a church.
Romanesque	Adapted from the pre-Gothic buildings of Europe, this style was Americanized by Henry Hobson Richardson.
Rustication	Cut stone in a wall channeled with deep grooves.
Second Empire	Borrowed from France and named for the reign of Napoleon III, which transformed Paris, the style's defining feature is the mansard roof.
Setback	Moving back the upper stories of tall buildings to allow more light to reach the street.
Shingle Style	A less ornate version of the Queen Anne style, developed in the 1880s.
Soffit	The exposed underside of an arch or beam.
Spandrel	The triangular space between arches within a vertical line rising from the springing of the arch and a horizontal line from its top. In steel-framed buildings, the term describes the space between the head of a window and the sill of the window above it.
Stick Style	Characterized by asymmetry, angularity, and verticality, houses in this style usually have roofs made up of steep intersecting gables. Exterior ornament generally reflects the house's inner structure.
Terra-cotta	Fired clay, usually brownish-red, used for roofing or for the decoration of building façades.
Town House	A private home in the city.

INDEX

INDEX OF LANDMARKS